AMERICAN WATERCOLORS

CHRISTOPHER FINCH

AMERICAN WATERCOLORS

ABBEVILLE PRESS
PUBLISHERS · NEW YORK

FOR LINDA

EDITOR: Nancy Grubb

DESIGNER: Nai Chang

PRODUCTION SUPERVISOR: Hope Koturo

PICTURE RESEARCHER: Laura Yudow

FRONT COVER: Winslow Homer. *The New Novel* (detail), 1877. SEE PLATE 148.
BACK COVER: John Singer Sargent. *White Ships* (detail), 1908. SEE PLATE 211.
FRONTISPIECE: John Singer Sargent. *Reading* (detail), 1911. SEE PLATE 208.

Library of Congress Cataloging-in-Publication Data

Finch, Christopher.
 American watercolors.
 Bibliography: p.
 Includes index.
 1. Watercolor painting, American. I. Title.
ND 1805.F56 1986 759.13 86-1031
ISBN 0-89659-654-0

FIRST EDITION

CONTENTS

INTRODUCTION

A Brief History of Watercolor 9

CHAPTER ONE

First Views of the New Land 27

CHAPTER TWO

A Grass-Roots Tradition 47

CHAPTER THREE

Frontiers and Waterways 61

CHAPTER FOUR

Academics and Originals 85

CHAPTER FIVE

Winslow Homer 111

CHAPTER SIX

Americans Abroad 135

CHAPTER SEVEN

John Singer Sargent 157

CHAPTER EIGHT

John Marin 175

CHAPTER NINE

New Directions 191

CHAPTER TEN

Charles Burchfield 217

CHAPTER ELEVEN

Edward Hopper and the Realists 237

CHAPTER TWELVE

The Postwar Avant-Garde 261

CHAPTER THIRTEEN

The Postwar Realists 281

NOTES 303

SELECTED BIBLIOGRAPHY 306

INDEX 308

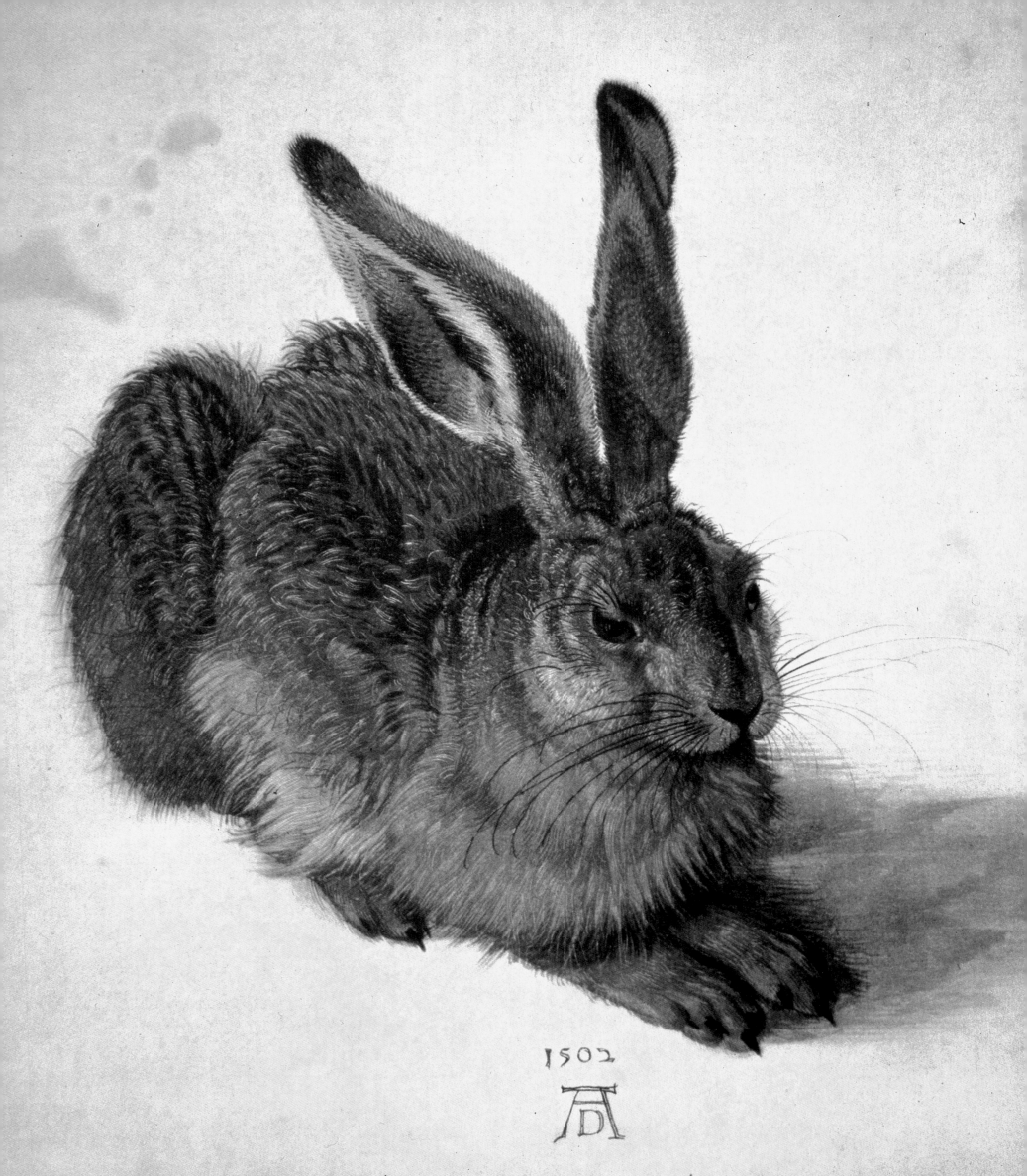

1502

INTRODUCTION

A BRIEF HISTORY OF WATERCOLOR

Some of the greatest masterpieces of American art are missing from the walls of our museums and public galleries, confined to dark rooms and storage cabinets. This sad state of affairs is due not to any sinister conspiracy but to the fact that these masterpieces are painted in watercolor and the pigments are therefore somewhat fugitive when exposed to light for any length of time. Thus it is possible to imagine oneself familiar with the great collections of American art and yet be only peripherally aware of a key facet of work by painters such as Winslow Homer, John Singer Sargent, and Edward Hopper. It may be for this reason that the role played by watercolor in the evolution of American art has gone relatively unsung. Nor is it generally recognized that America's contribution to the international watercolor tradition is second to none. Certainly the British dominated that tradition for many decades and established its classic idioms, but during the past century—since the 1880s—American artists have produced a substantial and varied body of work in the medium that is unmatched elsewhere.

Before investigating this tradition, however, it is necessary to know a little about the character of watercolor, since it is a uniquely challenging medium, one that can frustrate even the most accomplished artist. Painting in watercolor is a little like skippering a sailboat. When sailing, you set a destination and plot the course that will get you there, but you do not expect to arrive by following a straight line. Winds, tides, and currents may either help or hinder, causing you to tack, forcing you to take a more or less circuitous route. Painting in watercolor is similarly unpredictable. The expert watercolorist learns how to take advantage of the accidents of the medium, so that a blot is magically transformed into a cloud, a blurred edge into a hazy bank. In watercolor, as practiced by most of its greatest masters, spontaneity is everything. The artist must learn to improvise, which he can do effectively only with experience.

In this book the term *watercolor* is used to describe painting with water-soluble pigments on a suitable surface, usually paper. Prior to use, the pigments are suspended in a solution of glue or gum (the most common binder is gum arabic). Such paints may be purchased in cakes, pans, or tubes. The classic technique, perfected in England during the eighteenth and nineteenth centuries, calls for the pigment to be applied in a series of transparent washes that allow light to be reflected from the surface of the paper through the layers of color. It is this that gives watercolor its unique glow.

Washes are brushed on top of existing washes to increase the density and transform the colors already laid down, a process that permits a wonderful freshness of tint quite

1. Albrecht Dürer (1471–1528).
The Hare, 1502.
Watercolor and gouache on paper,
9⅞ x 8¹⁵⁄₁₆ in.
Graphische Sammlung Albertina,
Vienna.

9

unlike anything that can be obtained by mixing pigments on a palette. It is almost as if the colors are mixed in the viewer's eye, and most of the artists discussed in this book turned to watercolor because of this unique characteristic. A few, however, preferred gouache, also known as *body color,* a form of watercolor in which the pigments are mixed with Chinese white so that they are opaque when applied to the painting surface. Gouache shares enough qualities with transparent watercolor to demand inclusion here, but in many respects it is handled in a way that is closer to that required by denser media, such as oil paint. The synthetic-polymer paints—acrylics—that have become so popular in recent years are also soluble in water, and some artists have used them in a manner that can legitimately be seen as an extension of the watercolor tradition.

In a broader sense, watercolor can be said to include such techniques as fresco, distemper, and tempera. The use of distemper and tempera involves the binding of a mixture of color and water with an emulsion such as casein or egg yolk. Distemper is used primarily by theater scenery painters. Tempera was a favorite medium of panel painters during the Renaissance. Fresco is a method of great antiquity that, as practiced by artists such as Michelangelo, was in certain respects very similar to watercolor. Pigments mixed with water, or water and lime, were applied to wet lime plaster, which, as it dried, served as the binder. Like modern watercolor, it was a process that demanded decisiveness and speed. Fresco, of course, lent itself most readily to large-scale works, whereas watercolors in the modern era are generally—though not always—made on a relatively small scale. Indeed, in this context smallness is frequently a virtue, since it complements the sense of intimacy that is central to the medium.

Requiring a minimum of paraphernalia, watercolor is a very portable medium that can be taken just about anywhere. James Abbott McNeill Whistler and John Singer Sargent had gondolas fitted out as mobile studios, and Winslow Homer had no trouble taking his equipment by canoe deep into the Canadian wilderness. That the watercolorist can place the viewer on the Grand Canal or beside some remote trout stream contributes to the sense of intimacy the medium evokes. Watercolor is far better suited to capturing the fleeting moment than to depicting heroic subjects. Above all, the intimacy of the medium springs from the fact that it encourages, even demands, improvisation, so that frequently we seem to see the artist's thought processes recorded on paper.

To understand the approach of American artists to the medium it is necessary to consider the watercolor tradition on a worldwide basis. That tradition can be said to date back to the cave paintings of Lascaux and Altamira. Primitive man used pigments mixed with water to create these murals, applying the paint with his fingers, with sticks and fragments of bone, with primitive brushes, and even—anticipating airbrush techniques— by blowing color onto the limestone walls through bone tubes. Ancient Egyptian artists used water-based paints to decorate the walls of temples and tombs and also created some of the first works on paper, made from the pulp of the papyrus plant. Cretans, Etruscans, and Romans had fresco traditions, but it was in the Far and Middle East that watercolor schools in the modern sense first emerged.

Chinese artists—and later Japanese masters, too—painted with watercolor on silk and on exquisite handmade paper. The art form that evolved was replete with literary allusion and intimately entwined with its brother art form, calligraphy. Yet one of its primary elements was a contemplative appreciation of landscape, and in that way it anticipated what was to be a central aspect of the Western watercolor tradition. Oriental artists used delicate washes in a range of hues that rivals what is available to the modern watercolorist (PLATE 2). In the end, though, the Sino-Japanese tradition depended more on ink than on watercolor, and many of the greatest of these artists dispensed with color entirely, working only with the velvety shades of black and gray that could be nursed

from the ink block. Even the most colorful Oriental works do not quite meet the criteria that would make them watercolor *paintings* in the modern, Western sense. More properly they could be described as tinted drawings.

On the Indian subcontinent as well as in Persia and some other parts of the Islamic world a distinctive miniature painting carried out in opaque body color became an important art form (PLATE 3). Often depicting religious myths or incidents from court life, these miniatures derived in part from the Byzantine art of the Christian Middle East. Both narrative and decorative, the Indian and Persian miniatures had their counterpart in the West in the illuminated manuscripts of the Middle Ages.

In a time when libraries were few and books were made by hand the illuminated manuscript represented literary decoration carried to sublime heights in the service of God, an offering rooted in almost mystical devotion to the worth of holy labor. Often taking many years to complete, the finest illuminated manuscripts are portable equivalents of the great Gothic cathedrals. With quill pens monks copied the Scriptures and other texts onto sheets of parchment or vellum. (Parchment was made from sheepskin, the finest coming from the skins of stillborn lambs. Vellum was manufactured from calfskin.) Some monks decorated majuscules, or even entire pages, with elaborate scroll-work and imagery—often symbolic in nature or illustrative of the text—using body color along with inks and gold leaf to create elaborate designs such as those found in *The Book of Kells.* The illuminated book broke fresh ground within a more secular context with the Limbourg brothers' famous book of hours, *Les Très Riches Heures du Duc de Berry,* dating from the early fifteenth century. The brothers' portrayal of February is said to be the first snowscape in Western art (PLATE 4).

Medieval artists also worked in fresco, a tradition that continued into the Renaissance. The next phase in Western watercolor painting proper, however, depended on the development of a European paper industry. The Chinese had been manufacturing paper since ancient times, and the Arabs had learned the secrets of modern papermaking from Chinese captives during the eighth century. Soon high-quality rag paper was being produced throughout the Islamic world—in Moorish Spain, for example—but it was some time before papermaking techniques became known in Christian Europe. During the thirteenth century, however, this situation was remedied. Moreover, for a variety of reasons, Islamic sources for paper began to dry up, and this encouraged European entrepreneurs to establish mills in several different countries. One of the earliest centers was Fabriano, in Italy, where mills were in operation by 1276. Today some of the finest watercolor paper available still bears the Fabriano watermark. France, Germany, and Switzerland had thriving paper industries by the end of the fourteenth century, but, interestingly, England did not have its first mill manufacturing white paper until 1495; very little high-quality paper was made in the British Isles until the eighteenth century.

2. Ch'ien Hsuan.
Home Again, 13th century.
Ink and color on paper, 10¼ x 42 in.
The Metropolitan Museum of Art, New York; Gift of John C. Ferguson.

3. Lal (outline) and Sanwalah (painting).
 Akbar Viewing a Wild Elephant
 Captured near Malwa in 1564, c. 1564.
 Opaque watercolor on paper,
 14¾ x 9¾ in.
 Courtesy of the Board of Trustees of
 the Victoria and Albert Museum,
 London.

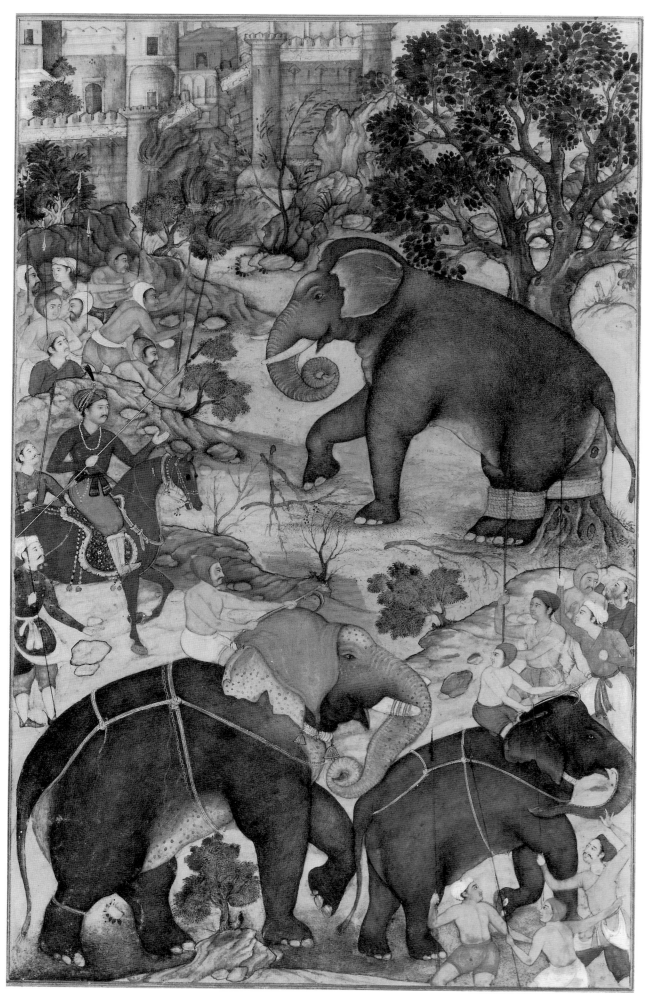

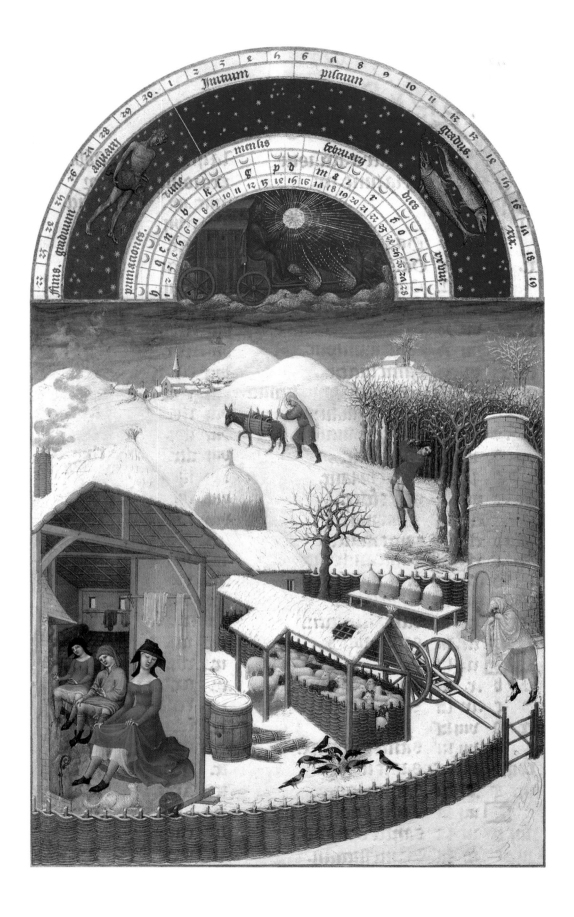

4. The Limbourg Brothers.
February, from *Les Très Riches Heures
du Duc de Berry,* 1413–16.
Illuminated manuscript, 8⅞ x 5⅜ in.
Musée Condé, Chantilly, France.

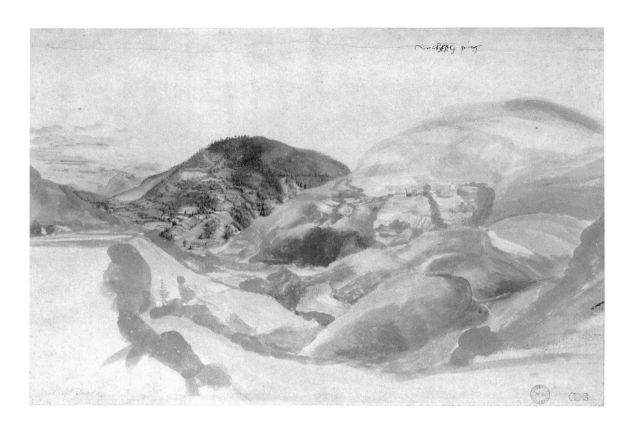

5. Albrecht Dürer (1471–1528).
Wehlsch Pirg—Landscape, c. 1495.
Watercolor and gouache on paper,
8¼ x 12½ in.
Ashmolean Museum, Oxford.

Paper was, therefore, somewhat of a luxury item, and this in itself may have retarded the evolution of watercolor painting.

Nonetheless, by the fourteenth century the increased availability of paper did give rise to a new emphasis on drawing as an independent activity. Often the drawings of this period were done with a metal point on a specially prepared ground of Chinese white, but soon inks and chalks and a variety of other materials were used to create works directly on the untreated surface of a sheet of paper. In the latter half of the fifteenth century artists like Leonardo da Vinci and Michelangelo carried the art of drawing to new heights, and it was their younger Northern contemporary, Albrecht Dürer, who was the first master of watercolor in the modern sense. Considering his work in the context of his time, it seems reasonable to discuss the early history of watercolor as a branch of the history of drawing.

Dürer was born at Nuremburg in 1471 and traveled to Italy in 1494–95 (at about the time that Leonardo was beginning work on his *Last Supper*). In Venice, Dürer was exposed to the influence of Giovanni Bellini, which opened his mind to the possibilities inherent in landscape painting. Traveling through the Alps on his way home, Dürer used watercolor to capture on paper scenes such as *Wehlsch Pirg* (PLATE 5), an amazingly modern treatment conceived in free-flowing washes that displays a lyrical approach unmatched among watercolorists until the nineteenth century. Dürer also painted magnificent small-scale studies from nature such as *The Great Piece of Turf* and *The Hare* (PLATE 1), which were eloquent expressions of his own humanist philosophy and which paved the way for botanical and zoological artists such as Pierre Joseph Redouté and John James Audubon.

Over the next 250 years a number of other major figures turned to watercolor on occasion, and to good effect. Peter Paul Rubens and Anthony van Dyck painted skillful watercolor landscapes, Adriaen van Ostade composed genre scenes, while Jean Honoré Fragonard used gouache for a variety of subjects. Lesser but still fascinating figures such as Allart van Everdingen, Gabriel de Saint Aubin, Nicholas Lavreince, Hubert Robert, and Abraham Louis Rodolphe Ducros extended the boundaries of the medium, and many artists of all persuasions—Rembrandt and Claude Lorrain were great exponents—

worked in monochrome wash. It was not, however, until the latter half of the eighteenth century, in Britain, that a national school of watercolorists first emerged.

British art during the Tudor period had been marked by a sturdy school of miniaturists who worked in gouache, usually applied to parchment or vellum, sometimes to ivory or card. Artists such as Nicholas Hilliard achieved a high degree of skill and originality as miniaturists and occasionally introduced landscape elements into their work, as is the case with Isaac Oliver's *Portrait of a Young Man* (PLATE 6). The true roots of the British watercolor tradition, however, are to be found in the topographical drawings that began to proliferate in the late seventeenth and early eighteenth centuries.

This was a period when Britain was flexing its muscles as a world power, and the British were obsessed with a sense of place: both a sense of Britain as a unique place and a sense of the world as being full of interesting places that would reward the attention of the British ruling class, whether for purposes of conquest, commerce, or culture. As a great maritime nation, Britain had spawned a formidable naval bureaucracy (Samuel Pepys was a prominent member) that wanted to build a file of visual information about its own ports and facilities (PLATE 7) and, where possible, about the naval installations of potential enemies and uncertain allies. In an age before the invention of the camera the topographical drawing was a vital tool in the gathering of strategic information and the recording of military events (PLATE 8). And British sailors exploring the far limits of the known world routinely traveled with a sketch artist.

Meanwhile, young English bucks were taking the Grand Tour, visiting the capitals and historic sites of Europe. These travelers bought Canalettos and Guardis like postcards, and it became quite the fashion to take along one's own sketch artist, preferably someone versed in a sense of the picturesque, as defined by Reverend William Gilpin, to record the topographical highlights of the trip. Soon the Romantic movement began to focus attention on Britain's own natural wonders, and these, too, became the objects of the topographer's scrutiny.

Typically, these topographers made monochrome drawings that were shaded with ink washes, then lightly tinted with watercolor. Sometimes they composed their views

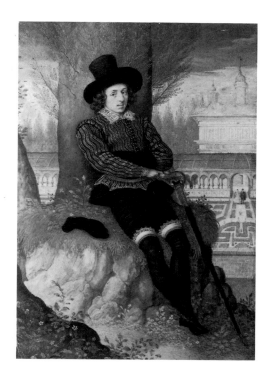

6. Isaac Oliver (d. 1617).
Portrait of a Young Man, n.d.
Watercolor on ivory, 4⅝ x 3¼ in.
Collection Her Majesty Queen
Elizabeth II.

7. Thomas Phillips (1770–1845).
*A Prospect of St. Peters Port and Castle
Cornett—in the Island of Guernsey,* 1680.
Watercolor on paper, 19⅞ x 41⅛ in.
National Maritime Museum, London.

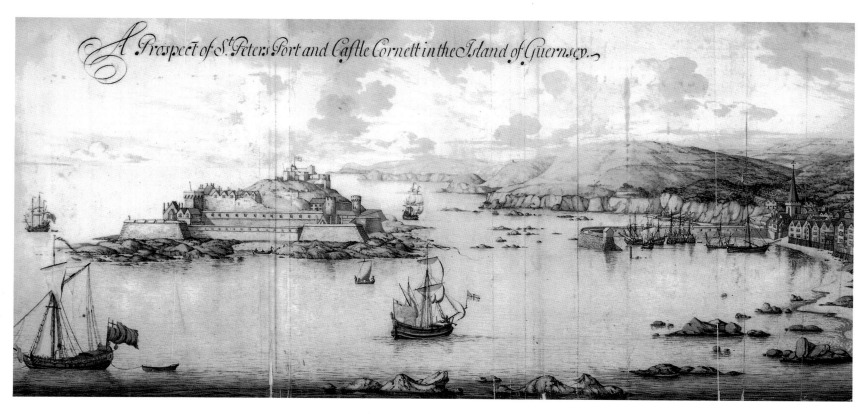

with the aid of a portable camera obscura to help make an accurate rendition of the scene. Paul Sandby was one of those who brought the topographer's art to a peak. He helped introduce the taste for British scenery (PLATE 9), and, as an influential founding member of the Royal Academy, he was instrumental in establishing watercolor as a medium to be taken seriously. Largely because of his example, the Academy, which was given its royal charter in 1768, allowed watercolorists to take their place from the outset alongside their colleagues using more exalted materials, such as oil paint and marble.

Other watercolorists, such as Sandby's contemporary Alexander Cozens and his gifted son John Robert Cozens, began to push the British tradition forward, beyond the achievements of the topographers. The younger Cozens was among the first to brush colored washes over a virgin white ground instead of over a drawing already tinted with monochrome (PLATE 10). This may seem a small advance, but it was in fact a crucial breakthrough, since it permitted that special quality of glowing color that makes true

8. Thomas Sandby (1723–1798).
A View of Diest from the Camp at Meldart, 1747.
Pen and ink and watercolor on paper, 15⅛ x 27¾ in.
Collection Her Majesty Queen Elizabeth II.

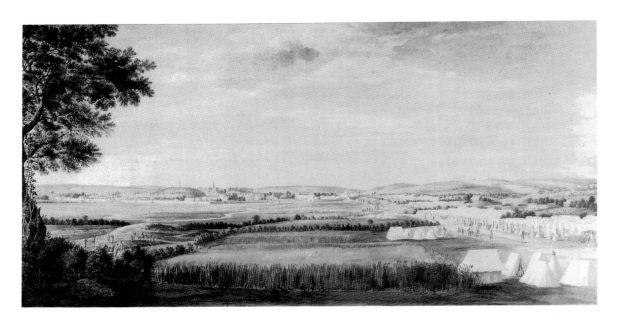

9. Paul Sandby (1725–1809).
A View of Windsor Forest, n.d.
Watercolor on paper, 12¾ x 23⅛ in.
Courtesy of the Board of Trustees of the Victoria and Albert Museum, London.

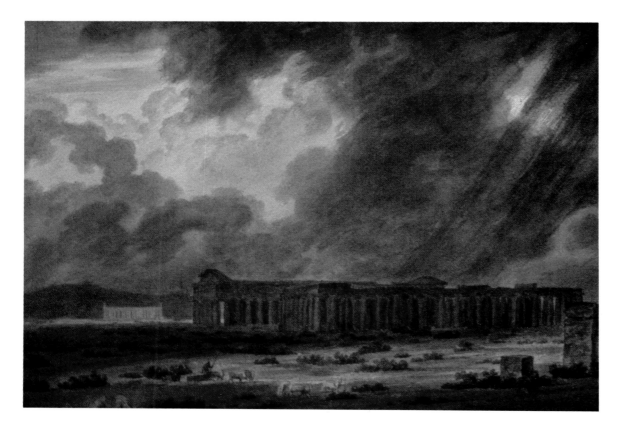

10. John Robert Cozens (1752–1797).
The Ruins of Paestum, near Salerno, 1782.
Watercolor on paper, 10 x 14½ in.
Oldham Art Gallery, Oldham,
England.

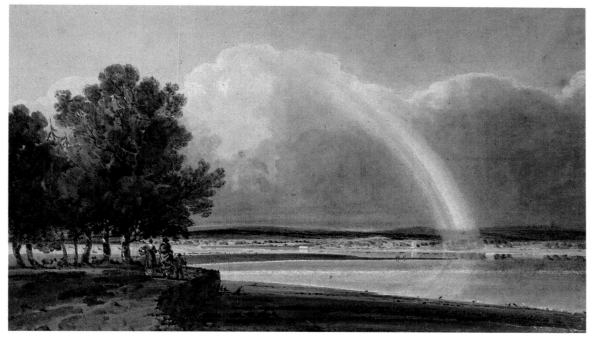

11. Thomas Girtin (1775–1802).
Rainbow over the Exe, c. 1800.
Watercolor on paper, 11¼ x 19¾ in.
Henry E. Huntington Library and
Art Gallery, San Marino, California.

watercolor what it is. This quality was exploited at the very end of the eighteenth century by two brilliant young men who were first employed by a wealthy amateur to make copies of paintings by J. R. Cozens and to work up finished paintings from his unfinished sketches. Thomas Girtin was one of these young men (PLATE 11). A precocious talent, he had a handful of productive years before dying at the age of twenty-seven. His friend and rival, Joseph Mallord William Turner, went on to become one of the greatest painters of the nineteenth century and arguably the most prodigiously talented of watercolorists.

It may be true, in fact, that it was watercolor that made Turner the unique master he was, since it was the translucent beauty of the medium that taught him to be a painter of light, even when working in oil. Many of his exhibition watercolors—large-

scale works finished with a considerable degree of detail—were shown in America and had a pronounced effect on artists there. His most extraordinary watercolors, though, are paintings such as *Sunset on Wet Sands* (PLATE 12), which evokes the scene with an economy of touch and a pellucidity of wash that has never been surpassed. Paintings like this make it easy to understand why Turner was so extravagantly admired by the Impressionists.

The Impressionists' other great English influence, John Constable, also painted fluently in watercolor (PLATE 14). In fact, the first half of the nineteenth century spawned a whole generation of gifted watercolorists, including John Sell Cotman, who distilled an elegant classicism from the emerging tradition (PLATE 15), and David Cox, less contemplative than most of his British contemporaries, more given to evoking the fiercer face of nature, whose style in some ways anticipates developments in America later in the century (PLATE 16). Original as they were, Cox and Cotman were very much in the mainstream, but Britain did produce some splendid eccentrics who worked primarily in watercolor.

12. Joseph Mallord William Turner (1775–1851).
Sunset on Wet Sands, n.d.
Watercolor on paper, 9 x 11½ in.
Whitworth Art Gallery, Manchester, England.

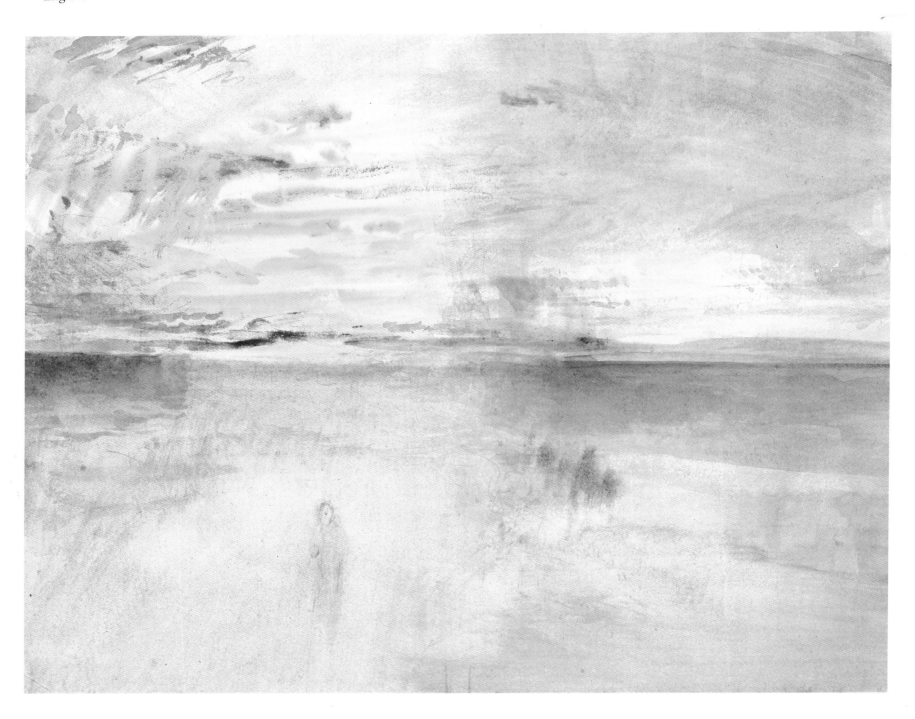

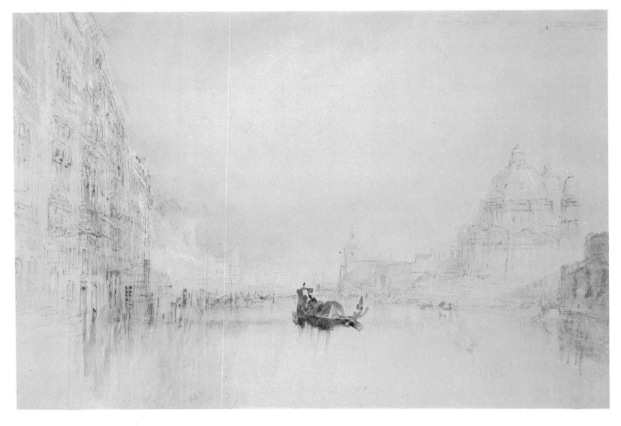

13. Joseph Mallord William Turner
(1775–1851).
Venice: The Grand Canal with the Salute,
1840.
Watercolor on paper, 8½ x 12½ in.
Ashmolean Museum, Oxford.

14. John Constable (1776–1837).
Stonehenge, 1836.
Watercolor on paper, 15¼ x 21¾ in.
Courtesy of the Board of Trustees of
the Victoria and Albert Museum,
London.

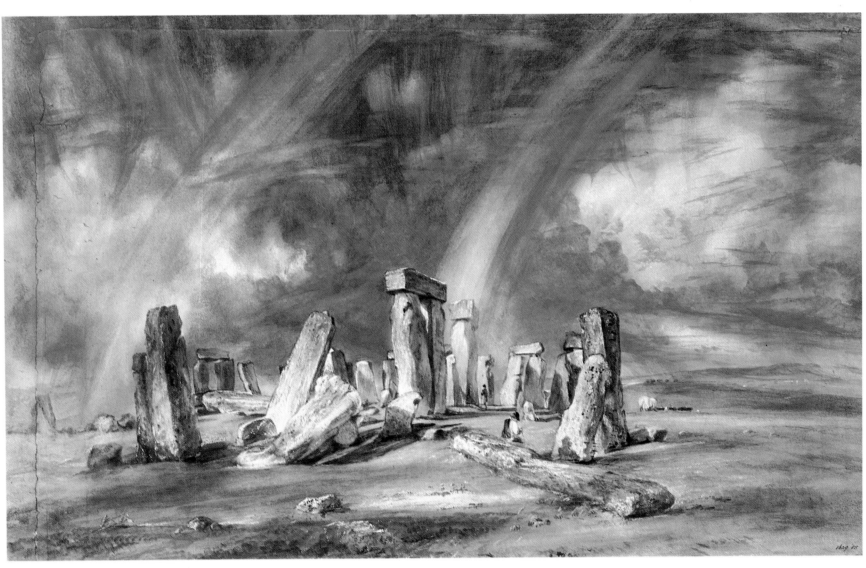

William Blake is the best known of these. A visionary artist and poet inspired by Dante, Milton, and the Bible, he practiced a highly personal form of watercolor that was dominated by the human figure (PLATE 17). His sometime disciple Samuel Palmer blended Blake's mystical approach with his own highly charged vision of rural England to produce some unique images during the first half of the nineteenth century, many of them conceived on a minute scale (PLATE 18).

Concurrent with the rapid evolution of the British school was the development of the technology of watercolor. Early watercolorists had to grind their own pigments and

ABOVE:

15. John Sell Cotman (1782–1842).
Backwater in a Park, c. 1803.
Watercolor on paper, 5¹¹⁄₁₆ x 12⅜ in.
British Museum, London.

RIGHT:

16. David Cox (1783–1859).
Rhyl Sands, n.d.
Watercolor on paper, 10¼ x 14¼ in.
Courtesy of the Board of Trustees of the Victoria and Albert Museum, London.

20

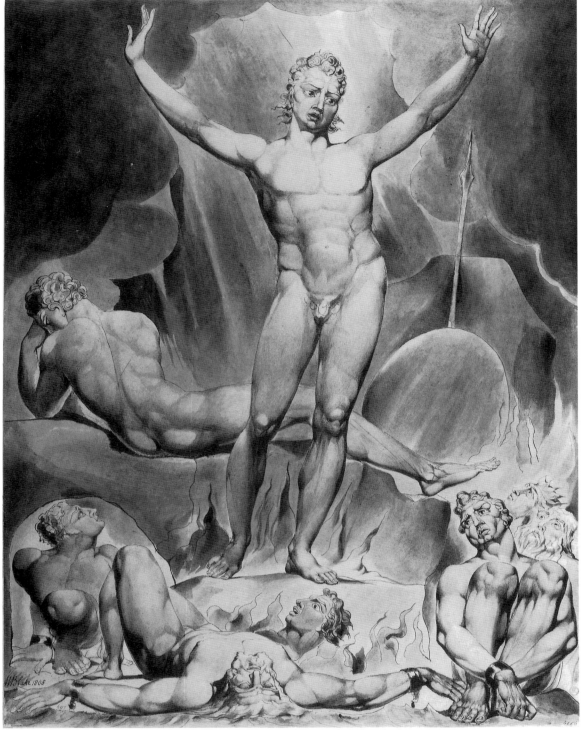

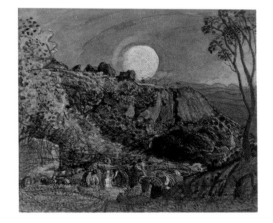

work on whatever paper came to hand, sizing it themselves so that the fibers would not soak up the paint. By the late eighteenth century, however, the English "colorman" William Reeves was selling pigments made up into easily portable cakes, and in 1846 Winsor and Newton introduced colors packaged in metal tubes. In the 1780s another British company, headed by James Whatman, began to produce papers specially for watercolorists. These came in smooth ("hot-pressed"), medium ("cold-pressed" or "not"), and rough finishes, all of which were treated with a special hard size that prevented washes from sinking in. These papers were tough enough that paint could be wiped off with a rag or even scraped off with a blade or the pointed end of the brush, and they set the standard by which watercolor papers are judged even today.[1]

This technology spread abroad, and the example of the British school, which was much admired, encouraged many European artists to try their hand at watercolor. The

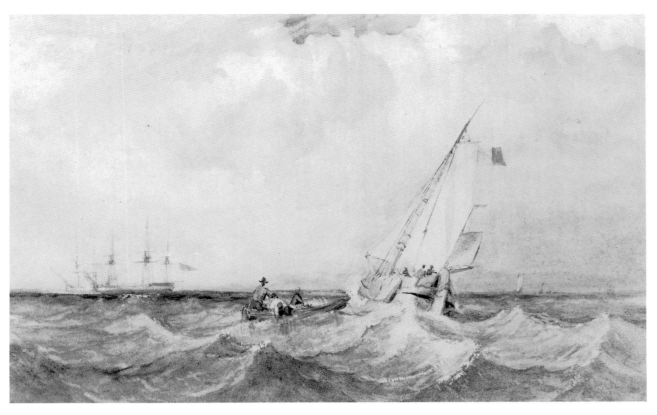

19. Richard Parkes Bonington
(1801/2–1828).
Shipping in a Swell, c. 1827–28.
Watercolor on paper, 5 x 7¹³⁄₁₆ in.
The Metropolitan Museum of Art,
New York; Robert Lehman
Collection.

BELOW:
20. Eugène Delacroix (1798–1863).
The Old Bridge, n.d.
Watercolor on paper, 9⅛ x 13 in.
The Art Institute of Chicago.

OPPOSITE:
21. Paul Cézanne (1839–1906).
Study of Rocks and Trees, 1890–95.
Watercolor on paper, 19⅛ x 12¼ in.
The Brooklyn Museum.

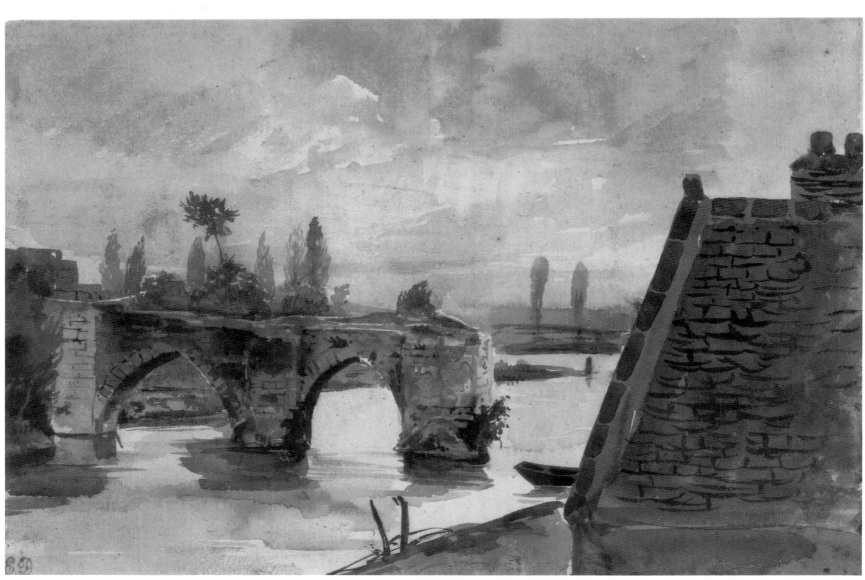

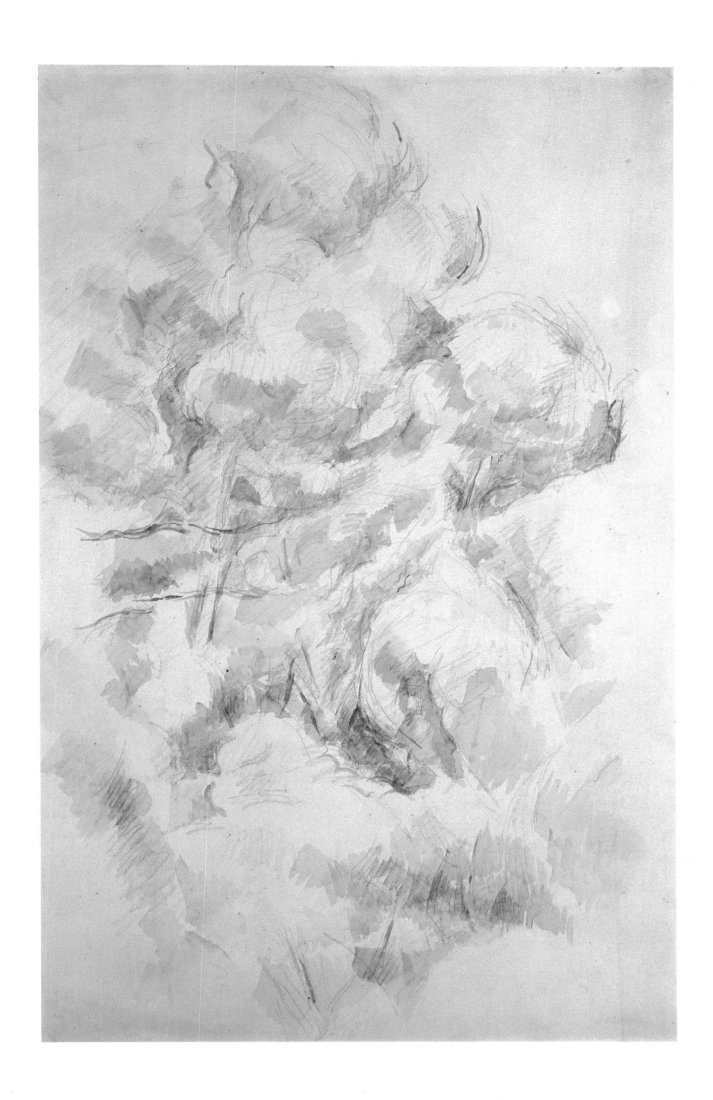

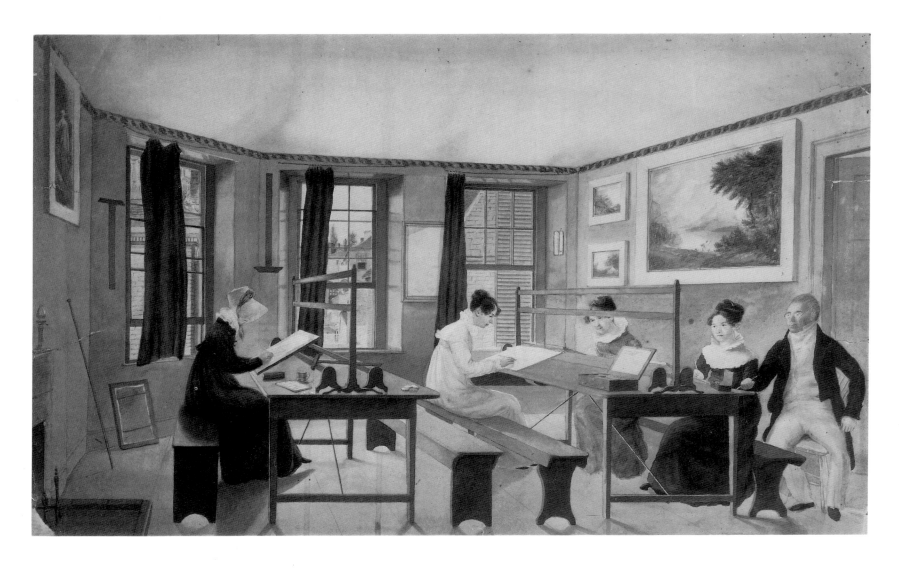

22. Anonymous.
The Watercolor Class, c. 1815–20.
Watercolor on paper, 14⅝ x 23⅝ in.
The Art Institute of Chicago; Emily
Crane Chadbourne Collection.

British painter Richard Parkes Bonington, a virtuoso watercolorist (PLATE 19), befriended the young Eugène Delacroix, who was fired by Bonington s example and learned to handle the medium with fluency and imagination (PLATE 20). Other major figures such as Théodore Géricault, Honoré Daumier, Edouard Manet, and Gustave Moreau also put watercolor to good use, and these French artists bequeathed to us the lovely words *aquarelle* and *aquarelliste*—words that, unfortunately, are seldom appropriate when discussing the work of John Marin or Charles Burchfield.

In France the nineteenth century culminated in the exquisite and innovative watercolors of Paul Cézanne, in which areas of white paper are allowed to sing out as part of the total harmony (PLATE 21). These paintings would have their impact on future American artists, but meanwhile, across the Atlantic, Americans such as Thomas Eakins and Winslow Homer were already making highly original use of the watercolor medium.

Eakins and Homer were not the first Americans to apply themselves seriously to watercolor. The century that preceded their breakthroughs was crowded with skillful practitioners of the medium, not all of them wholly derivative. Indeed, the history of watercolor in America stretches back to earliest colonial times, but—with the exception of some gifted primitives who owed allegiance to no one—American artists worked in the shadow of European masters until, in the second half of the nineteenth century, a handful of men made a claim for independence and equality. Some of them, like James Abbott McNeill Whistler, challenged the Europeans by taking them on on their own ground. Others, like Eakins and Homer, visited the Old World and then returned to their native haunts to stalk their personal conceptions of reality. The notion that reality—

that elusive goal—could not be won by the study of other painters but could be reached only through direct observation may have lent impetus to the watercolor movement.

All that can be said with certainty about the rise of American watercolor is that it coincides precisely with the rise of American painting as a whole to international stature and that it was, in fact, achieved largely at the hands of the same artists. What is significant, perhaps, is the fact that these artists were so willing to embrace watercolor as a primary medium capable of holding its own against oil paint. Such an attitude toward watercolor was not common in Europe during the nineteenth century, except in England. The fact that an artist like Eakins turned so readily to watercolor for important works must be attributed, in part at least, to the persistence of British influence on the United States. British drawing masters had been instrumental in popularizing the medium in the New World, and the continuing cultural ties that kept alive an interest in all things British brought many British paintings into American collections. English critics such as John Ruskin exerted considerable influence in the United States, and trade links with Britain brought Whatman's paper and Winsor and Newton's colors to stores in Philadelphia and Boston. So keen was the interest in watercolor by the final quarter of the nineteenth century that in 1866 the American Society of Painters in Water Color was founded, under the presidency of Samuel Colman. In America, as in England, galleries showed watercolors on an equal footing with oils.

During this same period England still boasted some fine watercolorists—Philip Wilson Steer and Hercules Brabazon are good examples—but they were not artists of the stature of Eakins or Homer. Britain's period of greatness in the visual arts had passed, and, as far as watercolor was concerned, it was the most natural thing in the world that American artists would pick up the torch. They did not, however, pick up the bag and baggage of the British tradition. Eakins and Homer were too obsessed with Yankee verities to look over their shoulders, and their immediate successors were more interested in the artistic experiments on the Continent than they were in the offshore activities of the English. What Americans inherited from the British was a mature technique with unique properties. What they did with it was wholly their own, or else it was inflected with the accents of the new visual dialects that found voice in the wake of Impressionism.

This is why American watercolor proved to be so vigorous, so protean. Whereas the British school—eccentrics like Blake aside—had evolved relatively slowly along a single path, the American school exploded like a starburst, sending flares on half a dozen different trajectories. Consider some of the more important figures—Eakins, Homer, Whistler, Sargent, Marin, Maurice Prendergast—who emerged between the 1870s and the Armory Show in 1913, and it will be seen that there were almost as many approaches to watercolor as there were American watercolorists of note. There is, then, no one American school of watercolor. Rather, there are many gifted artists who have worked in the medium and whose fields of influence have sometimes overlapped and interlocked. For the most part, though, American watercolorists have guarded their individuality and eschewed stylistic alliances.

At the same time, we can detect two distinct traditions that run through the art of the past century. On the one hand, there is the realist tradition, epitomized by Eakins and Homer, carried on by artists like Edward Hopper and Reginald Marsh, and practiced today by a surprisingly large group of accomplished watercolorists. On the other hand, there is the tradition that chooses to break with tradition, the ever-changing tradition of the avant-garde, which has found plenty of room for the watercolorist in America. But even this broad distinction is far from foolproof—a major figure like Charles Burchfield easily straddles both camps—and again we are thrown back on the realization that individualism is always a key factor of American art.

CHAPTER ONE

FIRST VIEWS OF THE NEW LAND

In 1562, more than half a century before the *Mayflower* set sail, a band of French Huguenots under the leadership of Jean Ribault crossed the Atlantic Ocean and landed in Florida, near the mouth of the St. Johns River, and at Parris Island, South Carolina. At each place they erected a marble column bearing the coat of arms of the king of France. Ribault's party then returned home, bearing the news that it had scouted sites suitable for the establishment of a Huguenot colony. (Like the Pilgrims, these Protestants looked to the New World as a land where they could practice their religion without interference.)

In 1564 another Huguenot expedition made its way to Florida, this time under the leadership of René de Laudonnière. On board was Jacques Le Moyne de Morgues, a cartographer and artist from the port of Dieppe. It was Le Moyne's assignment to map the Florida coast and to make a visual record of the natives and their customs. Le Moyne also left a detailed written account of the expedition, from which we learn that the Huguenots were warmly greeted by the natives:

> Laudonnière . . . went on shore with five and twenty arquebusiers . . .
> obtaining friendship signs from the Indians, who had gathered in crowds to
> see them. . . . After an exchange of presents had been made, accompanied
> by demonstrations of all manner of kind feelings, the chief (Athore) gave
> them to understand that he wished to show them something remarkable.
> . . . He . . . conducted them directly to the island where Ribault had set up
> a stone column ornamented with the arms of the King of France. On
> approaching they found that these Indians were worshiping the stone as an
> idol.[1]

The only New World painting of Le Moyne's to survive shows the Florida natives worshiping the marble column (PLATE 24). Painted in gouache on vellum, the scene is composed with little regard for accurate topography or perspective; but it offers a vivid rendition of the spectacle that the Huguenots witnessed and contains much interesting detail, especially concerning Indian costume. After his return to Europe, Le Moyne was soon forced to flee France because of the anti-Huguenot sentiment that culminated in the St. Bartholomew's Day Massacre of 1572. Settling in England, he made a significant contribution to the origins of the British watercolor school by painting exquisite botani-

23. Jacques Le Moyne de Morgues.
*Athore and Laudonnière at Ribault's
Column*, 1564.
Detail of plate 24.

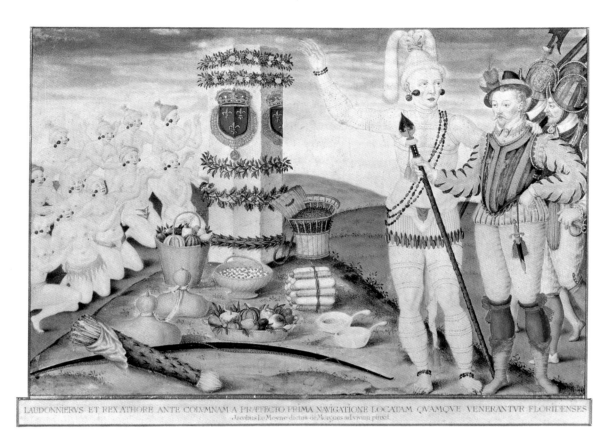

LAVDONNIERVS ET REX ATHORE ANTE COLVMNAM A PRÆFECTO PRIMA NAVIGATIONE LOCATAM QVAMQVE VENERANTVR FLORIDENSES
Jacobus le Moyne dictus de Morgues advivum pinxit

24. Jacques Le Moyne de Morgues
(d. 1588).
Athore and Laudonnière at Ribault's Column, 1564.
Gouache on vellum, 7 x 10¼ in.
New York Public Library.

cal studies—executed in transparent wash, occasionally highlighted with body color—a number of which have survived.

In England, Le Moyne was befriended by Sir Philip Sidney and Sir Walter Raleigh, both Huguenot sympathizers. Raleigh, Queen Elizabeth's favorite, a gifted poet, and an adventurer of great daring, must have taken special interest in Le Moyne's accounts of his visit to the New World; Raleigh had ambitions to found a British colony there. In 1584 he obtained from the queen a patent giving him the right to settle Virginia in the name of the English crown. As applied in Tudor times, *Virginia* was the name used to describe a vast area of the eastern seaboard of North America; it was, in fact, in North Carolina, on Roanoke Island, that Raleigh's colony was established in 1585. Threatened with starvation and menaced by hostile Indians, the entire colony returned to England the following year. In 1587 Raleigh tried again, sending 121 people to Roanoke Island in the charge of John White.

This was not White's first transatlantic voyage, nor his first visit to Roanoke Island: he had been there two years earlier as a member of an expedition commanded by Sir Richard Grenville. On that occasion, however, he traveled not as prospective governor of Virginia but as the expedition's cartographer and artist. White was indeed an artist of considerable talent. Somewhat unsophisticated with regard to such matters as perspective, he nonetheless mastered a firm draftsmanship that displays awareness of the Mannerist style that was then spreading through Europe.[2] Most important, though, White had a fine feel for transparent watercolor, a gift that was decidedly uncommon in the sixteenth century. As a member of Raleigh's circle he was very likely familiar with Le Moyne's botanical studies, which may have influenced his technique.[3] Also of possible significance is the fact that both Le Moyne and White were cartographers, and maps were commonly tinted with watercolor, a fact that would have made these artists thoroughly familiar with the medium.

On the 1585 expedition to America, White proved himself to be, like Le Moyne, an able naturalist, making drawings of such native fauna as the iguana and the loggerhead turtle. It is, however, for his drawings of Indian subjects that he is best known.

There is no way that we can verify the accuracy of these drawings—and White is known to have exercised his fantasy on other occasions, such as his imaginary portraits of ancient Britons—but the solidity of his draftsmanship and his true renditions of flora and fauna suggest that he drew what he saw to the best of his ability. If there is any distortion it is that of someone imposing the ideals and biases of his own civilization on an alien culture (a comparable instance might be the way that nineteenth-century Japanese artists portrayed Westerners). Thus a drawing captioned, "One of their Religious Men," shows a personage who might be taken for a Roman senator, until note is made of his decidedly un-European hairstyle.

The drawing that White made of the Indian village of Secoton (PLATE 26) is so full of information that his portrayal of "their rype corne," "their greene corne," and "corne newly sprong" has enabled scholars to date the picture very accurately as to the time of year (the three crops could have stood in this relationship only during a brief period). At

BELOW, LEFT:
25. John White (active 1577–1593).
Indian Conjurer, c. 1585.
Watercolor on paper, 9¹¹⁄₁₆ x 5⅞ in.
British Museum, London.

BELOW, RIGHT:
26. John White (active 1577–1593).
Indian Village of Secoton, c. 1585.
Watercolor on paper, 12¾ x 7¾ in.
British Museum, London.

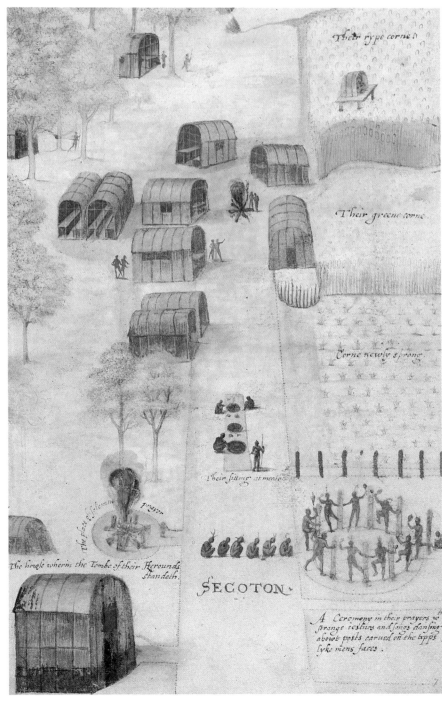

the same time, one questions the straightness of the village's "main street" and "side roads," which conjure up memories of Europe.

Remarkable, though, is that here, thirty-five years before the Pilgrims set foot on American soil, an English artist was already recording his impressions of the New World, impressions so skillfully wrought that they make John White not only a part of the history of exploration but also a significant, if modest, figure in the evolution of the watercolor tradition.

After Jacques Le Moyne de Morgues and John White, the history of watercolor in America skips a century and a half with little to show except an occasional topographical subject such as *View of New Amsterdam,* painted in 1650 (PLATE 27). Certainly the colonies were not devoid of artistic activity: Dutch portraitists were active in New Amsterdam from the 1630s, and anonymous limners were at work in the English colonies not much later. But the great majority of these artists seem to have favored oil on canvas or panel, though during the first half of the eighteenth century some artists, such as Henrietta Johnston and John Watson, made portraits on paper or vellum, using pastel (in Johnston's case) or pencil and wash.

One remarkable watercolor from this period is the 1720 *View of the Camp of Mr. Law's Concession at New Biloxi, Coast of Louisiana,* painted by Jean Baptiste Michel Le Bouteux, a Frenchman who either visited or settled in what is now part of the state of Mississippi (PLATE 28). Nothing is known about the artist, and this is his only surviving

BELOW:

27. Unknown artist after an original watercolor by Laurens Block.
View of New Amsterdam, 1650.
Watercolor on paper, 5⅞ x 19⅜ in.
New-York Historical Society.

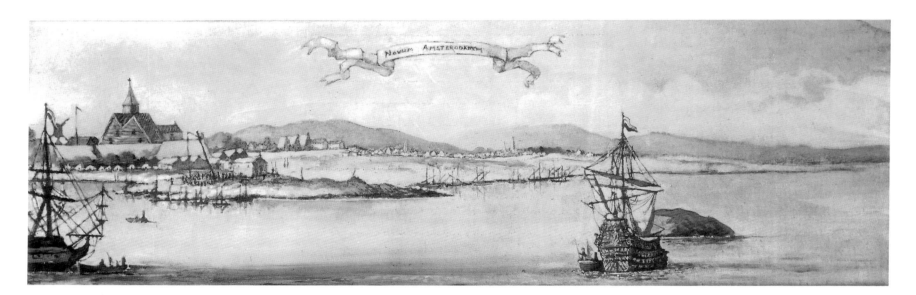

RIGHT:

28. Jean Baptiste Michel Le Bouteux (active c. 1720).
View of the Camp of Mr. Law's Concession at New Biloxi, Coast of Louisiana, 1720.
Watercolor on paper, 19½ x 35⅜ in.
Courtesy of the Edward E. Ayer Collection; The Newberry Library, Chicago.

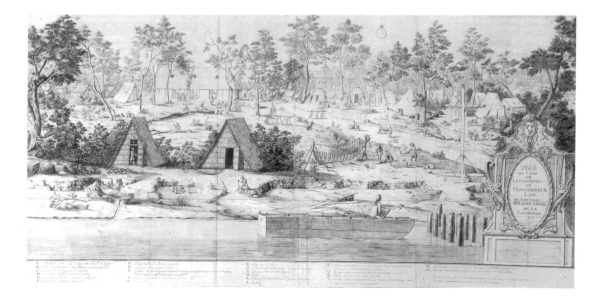

30

work, but it is clear that he was an accomplished draftsman of some sophistication, well versed in the laws of perspective and capable of handling the watercolor medium with considerable subtlety. Le Bouteaux was removed from the mainstream of American culture, however, and probably had little or no impact on his contemporaries outside the French colony.

By the late colonial period watercolor began to play a significant part in the evolution of American art, making its impact felt in several different ways. Just as the portrait miniature had helped pave the way for the British watercolor tradition, so it played a comparable role on the other side of the Atlantic, attracting the talents of some of the finest American artists of the generation that fought the War of Independence, such as Benjamin West, John Singleton Copley, and Charles Willson Peale. It must be remembered that many of the leading American painters now spent time in England, perfecting their craft and furthering their careers, and there they were exposed to the work of the emerging watercolor school. Meanwhile, British artists trained in watercolor techniques arrived in America and began to spread the gospel throughout the colonies. Native and immigrant artists alike began to paint topographical views in watercolor, often to serve as the basis for prints that were sometimes published in cities such as New York and Boston and frequently published back in Europe, where interest in the New World remained intense. These topographical drawings vary in accomplishment from the highly skillful to the decidedly amateur. Indeed, watercolor had a special appeal for the amateur—one that was to earn it a bad name among some professionals—and by the early nineteenth century watercolor painting had joined piano playing and embroidery as an activity suitable for young ladies of quality. Inevitably, most of this amateur work was insipid, but alongside it emerged a vigorous school of sometimes naive grass-roots painting in which watercolor was a favored medium.

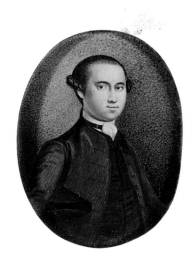

The art of the portrait miniature flourished all over Europe from the Renaissance to the Romantic era—Hans Holbein, François Boucher, and Goya all painted fine examples—but it was the British model that was foremost for American artists. In particular, Americans were drawn to the art of painting in transparent watercolor on tablets of ivory, a technique perfected in Europe early in the eighteenth century and made fashionable in England by the public exposure it received at the Royal Academy, whose annual exhibitions were inaugurated in 1769.

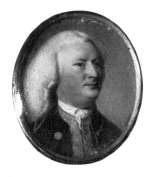

Such miniatures on ivory were current in America at an even earlier date, as evidenced by the rather prim but still delightful self-portrait that Benjamin West, then eighteen, painted in 1756—four years before he departed for Europe—as a gift for a young Philadelphia woman (PLATE 29). West had studied under William Williams, an Englishman resident in Philadelphia, and the style of this self-portrait owes a good deal to the work of the British limners active on the East Coast in the mid-eighteenth century. What makes it of interest in the present context, however, is the way that West used transparent color: although form is defined by stippling and hatching, light is reflected off the ivory support so that it warms the subject, especially the skin tones.

The same warmth of transparent color laid over ivory is present in another miniature, this one painted by West's great Boston contemporary John Singleton Copley (PLATE 30). Painted four years before his departure for England, this is a more accomplished painting than West's piece of juvenilia and reflects Copley's mastery of the essentials of English Rococo portraiture. Even on this tiny scale, however, Copley was able to infuse the image with the New England frankness and authoritative sense of characterization that made him much more than a talented colonial imitator of European models.

West and Copley painted numerous miniatures, as did their slightly younger con-

temporary Charles Willson Peale. Peale spent two years studying with West in London, and it was there that he painted the relatively large miniature of Matthias and Thomas Bordley (PLATE 31), two young American boys who had been sent to England to complete their educations at Eton. Unlike West and Copley, who chose to remain in England, Peale returned to America, where, after 1796, he enjoyed success first in Annapolis, then Philadelphia. He ended his long career at age eighty-six, having taken time out from painting to serve as an officer of militia in the War of Independence, to become a member of the Pennsylvania Assembly (voting to abolish slavery), and to found both the first art gallery in the United States and the first natural history museum. Peale was also the head of a distinguished family of artists, of which both his brother James and his eldest son, Raphaelle, enjoyed considerable success as miniaturists. In the late 1780s Charles painted his brother at work on a miniature (PLATE 32), providing some information about the miniaturist's methods and showing that the type of fine brushes needed for certain kinds of watercolor work were already standard equipment in the miniaturist's studio.

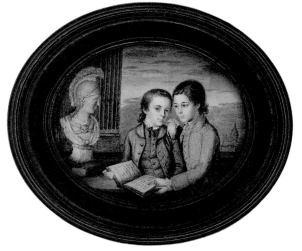

ABOVE:
31. Charles Willson Peale (1741–1827). *Matthias and Thomas Bordley,* 1767. Watercolor on ivory, 3⅝ x 4¼ in. National Museum of American Art, Smithsonian Institution, Washington, D.C.; Museum Purchase and Gift of Mr. and Mrs. Murray Lloyd Goldsborough, Jr.

RIGHT:
32. Charles Willson Peale (1741–1827). *Portrait of James Peale,* c. 1789. Oil on canvas, 30 x 25 in. Mead Art Museum, Amherst College, Amherst, Massachusetts; Bequest of Herbert L. Pratt.

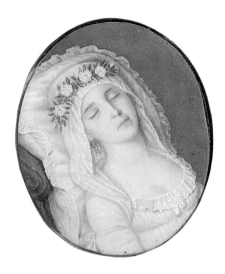

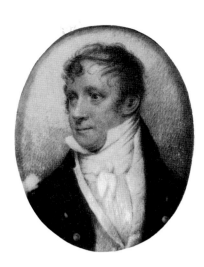

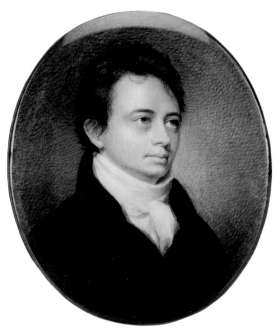

33. Jean François de Vallée (active c. 1815).
Harriet Mackie (*The Dead Bride*), c. 1804.
Watercolor on ivory, 2½ x 2 in.
Yale University Art Gallery, New
Haven, Connecticut; Mabel Brady
Garvan Collection.

34. William Dunlap (1766–1839).
Self-Portrait, n.d.
Watercolor on ivory, 2½ x 1⅞ in.
Yale University Art Gallery, New
Haven, Connecticut.

35. Edward Greene Malbone (1777–1807).
Washington Allston, n.d.
Watercolor on ivory, 3⅜ x 2⅞ in.
Museum of Fine Arts, Boston; Otis
Norcross Fund.

Miniatures could be displayed in many different ways, sometimes even being worn as costume jewelry. Besides being portraits in the conventional sense they were also portable mementos—almost like snapshots—and were sometimes asked to serve as memorials, as in the remarkable record of a dead bride (PLATE 33) made by French-born Jean François de Vallée, who was active in the Charleston area in the early 1800s. The art of the miniaturist thrived well into the nineteenth century and was practiced by many lesser but still skilled artists, such as William Dunlap, a painter and dramatist who, in 1834, published *A History of the Rise and Progress of the Arts of Design in the United States,* the first history of American art. One thing that makes Dunlap's miniatures particularly interesting is the fact that he was, as will be seen, also a pioneer landscape watercolorist and therefore provides a bridge between the two genres (PLATE 34).

Considered in his day to be the greatest of all American miniaturists—an opinion that has been sustained by posterity—was Edward Greene Malbone. Born in Rhode Island, Malbone was self-trained and, unlike West, Copley, and the Peales, concentrated his talents solely on the miniature, completing more than seven hundred by the time of his death at age thirty. Malbone had a matchless touch for small-scale work, and his talent for characterization is fully displayed in his portrait of his friend the Romantic painter Washington Allston (PLATE 35). Here the opaqueness of the jacket and the texture of the background are used to set off the luminosity of the sitter's face (the eyes are especially fine), which is achieved by exploiting the unique properties of the watercolor medium. The shading of the features is delicate, so that the quality of transparency is preserved, and it is easy to understand how Allston, quoted in Dunlap's pioneering history, could say of Malbone that "he had the happy talent among his many excellencies of elevating the character without impairing the likeness."

Contemporary with the practice of painting miniature portraits on ivory, some artists specialized in making small-scale portraits in line and watercolor on paper or board. Possibly the most gifted practitioner in this field was Henry Inman. Apprenticed to the popular portraitist John Wesley Jarvis, Inman went on to paint competent full-scale portraits on canvas, but his gifts are best displayed in works on paper, such as his study of William Cullen Bryant (PLATE 36).

36. Henry Inman (1801–1846).
William Cullen Bryant, 1827.
Watercolor and ink on paper,
4½ x 4 in.
New-York Historical Society.

Artists such as West and Copley—along with younger painters such as Thomas Sully, John Trumbull, and John Vanderlyn—made a conscious effort to transcend the limits of provincialism, and this, allied with the social and political climate of the times, tended to push them toward the established convention of producing large oil paintings of heroic subjects. In their sketches and studies, however—work not intended for the public eye—they occasionally dabbled in watercolor, sometimes with pleasing results.

West's undated *Hagar and Ishmael* (PLATE 37) makes subtle use of blue wash to create a sense of depth in what would otherwise look like a sketch of a bas-relief. Trumbull's study for *The Death of General Mercer at the Battle of Princeton* (PLATE 38) is actually an ink drawing but merits reproduction here because of its skillful and evocative use of transparent washes. Vanderlyn's study for his famous *Ariadne Asleep on the Island of Naxos* (PLATE 39)—the first great American nude—is brilliantly executed, exemplifying how thoroughly the artist had absorbed the European classical tradition while in Paris under Aaron Burr's sponsorship.

Of this generation of European-trained pioneers, two major figures resisted the magnetism of the heroic and the mythical. Gilbert Stuart never aspired to be anything but a portraitist. Charles Willson Peale also remained primarily a portraitist but eschewed the classicism that marked Stuart's output—three-quarter-length figures posed against neutral grounds—and experimented extensively with full-length portraits in which the figure is treated as one feature of a larger composition that might include architectural or still-life elements. Typical of these efforts is his 1822 self-portrait entitled *The Artist in His Museum.* For the background of this work Peale and another of his gifted sons, Titian Ramsay Peale, made a detailed and accurate study on paper (PLATE 40), the father execut-

37. Benjamin West (1738–1820).
Hagar and Ishmael, n.d.
Pen, sepia ink, and blue watercolor on paper, 17½ x 20¼ in.
Addison Gallery of American Art, Phillips Academy, Andover, Massachusetts.

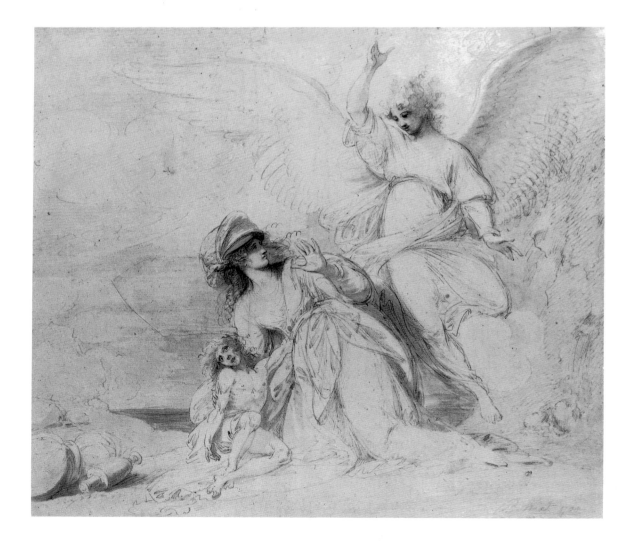

38. John Trumbull (1756–1843).
*Preliminary Sketch for "The Death of
General Mercer at the Battle of Princeton,"*
c. 1786.
Ink and wash on paper, 10½ x 15½ in.
Princeton University Library,
Princeton, New Jersey.

39. John Vanderlyn (1775–1852).
Study of Ariadne, 1809–10.
Watercolor on paper, 4⅛ x 5½ in.
Yale University Art Gallery, New
Haven, Connecticut; Gift of Albro N.
Dana.

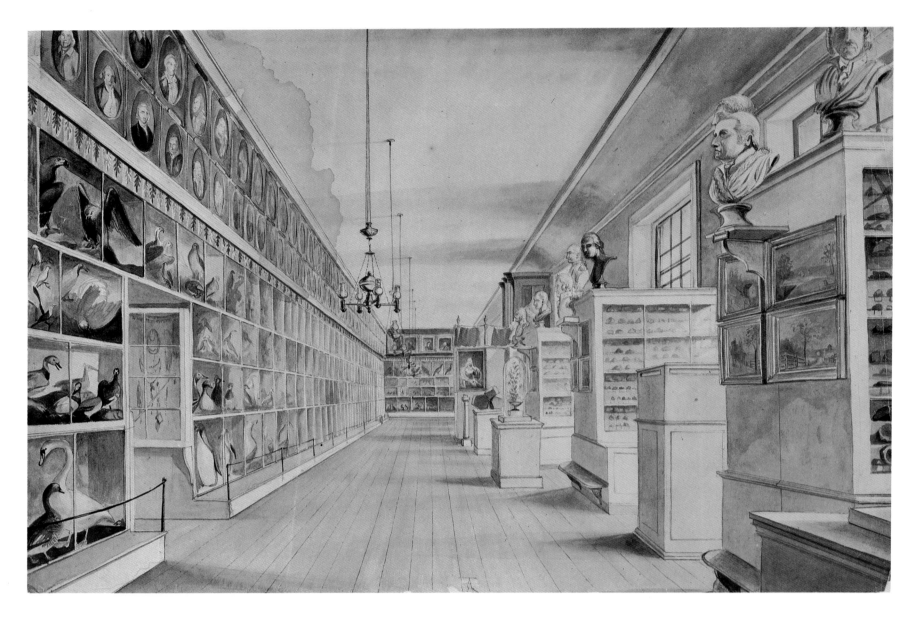

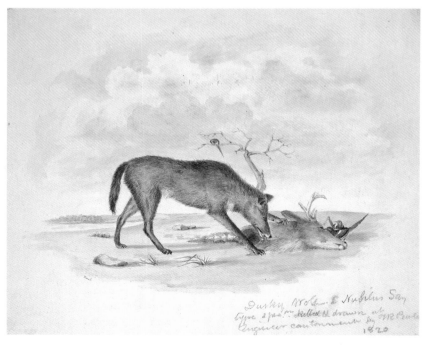

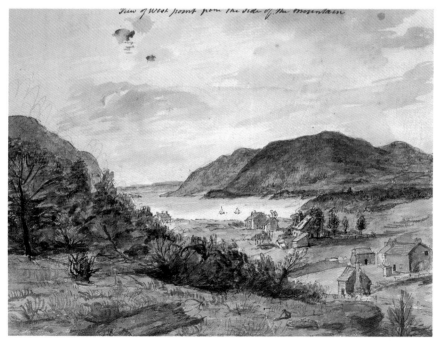

ing the perspective drawing and the son adding washes of watercolor. Titian Ramsay clearly benefited from growing up in his father's museum and went on to have a distinguished career as an artist-naturalist, making many lively sketches in watercolor (PLATE 41). His father also possessed a nice, informal touch with watercolor, as can be seen from the sketches he made during an 1801 expedition to New York State (PLATE 42).

Having studied in London, Peale, Sr., was no doubt familiar with examples of the English topographic school, and during the last quarter of the eighteenth century that style began to take root in the New World. One talented amateur who found himself swept to America by the tides of history was Captain Archibald Robertson, a Scot attached to British headquarters in New York during the Revolutionary War. His view of what is now called the Verrazano Narrows, drawn from a hillside in Staten Island, is in an already slightly dated British style (PLATE 43). It is the pen rather than the washes that delineates the scene, and the trees are undifferentiated clumps of vegetation, like sprigs of parsley. But the picture communicates a genuine pleasure in the view, with its rolling hills and clustered battle fleet, and there is a compositional sophistication in the way shadows are dispersed throughout the foreground.

It may be that Robertson had a good deal of leisure in which to practice his watercolor technique during the years he served as engineer and deputy quartermaster general to the New York garrison. In any case, his *View of the North River Looking towards Fort Washington* (that is, the Hudson), painted five years later than his view of the Narrows, is both more ambitious in conception and more accomplished in execution (PLATE 44), having something of the look of a mature work by Paul Sandby. The view is from Manhattan, then more hilly than today, looking to the north from a spot near the present site of Grant's Tomb. The artist's approach this time is far more painterly. Robertson no longer depends on line to define form, and he displays a mastery over his washes that allows him to build an effective pattern of dense and light areas, although the relatively low horizon line limits the abstract possibilities of the subject.

Another British officer who took part in the capture of New York, Captain Thomas Davies of the Royal Regiment of Artillery, painted a slightly primitive but convincingly detailed portrayal of the attack on Fort Washington, as seen from the vantage point he enjoyed as commander of a battery of twelve pounders (PLATE 45). Painted from an eminence in the Bronx, the view is across the Harlem River to the

OPPOSITE, COUNTERCLOCKWISE FROM TOP:

40. Charles Willson Peale (1741–1827) and Titian Ramsay Peale (1794–1885). *Interior of Peale's Museum,* 1822. Watercolor on paper, 14 x 20¾ in. Detroit Institute of Arts; Founders Society Purchase, Director's Discretionary Fund.

41. Titian Ramsay Peale (1794–1885). *Dusky Wolf Devouring a Mule Deer Head,* 1820. Watercolor on paper, 7½ x 9¼ in. American Philosophical Society Library, Philadelphia.

42. Charles Willson Peale (1741–1827). *View of West Point from the Side of the Mountain,* 1801. Watercolor on paper, 6¼ x 7⅝ in. American Philosophical Society Library, Philadelphia.

43. Captain Archibald Robertson (c. 1745–1821). *View of the Narrows between Long Island and Staten Island,* 1776. Watercolor on paper, 11½ x 18¾ in. New York Public Library; Spencer Collection.

44. Captain Archibald Robertson
 (c. 1745–1821).
 *View of the North River Looking towards
 Fort Washington*, 1781.
 Watercolor on paper, 17⅞ x 21½ in.
 New York Public Library; Spencer
 Collection.

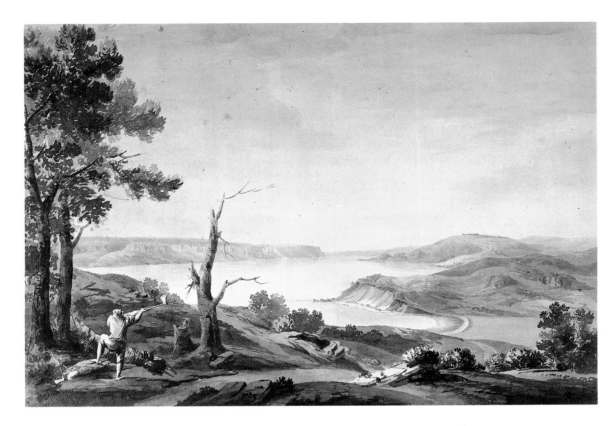

45. Captain Thomas Davies (c. 1737–1812).
 Attack against Fort Washington, 1776.
 Watercolor on paper, 14⅝ x 21½ in.
 New York Public Library; Spencer
 Collection.

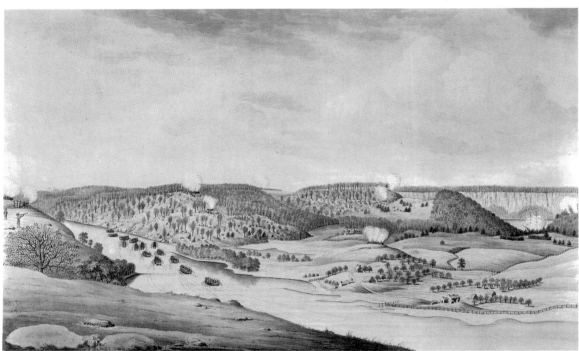

wooded slopes of upper Manhattan. Fort Washington is on the ridge near the center of
the composition. British troops cross the Harlem River by barge, while a British frigate,
just visible at far right, bombards the positions held by the Continental Army.

　　Captain Davies was not a great artist, but he had received drawing instruction as
part of his training at the Royal Military Academy, Woolwich,[4] and he put it to use
with considerable sensitivity. Minute brushstrokes convey what he considered to be
essential detail, and he was careful to portray the foliage just as it would have appeared
on the day of the attack (November 16, 1776). The meadows of Harlem are nicely
washed with earth colors, and the sky is handled with particular delicacy.

　　Little is known about Captain William Pierie, another British artillery officer who,

during the War of Independence, made some highly picturesque watercolors of the Hudson Valley and Lake George (PLATE 46). Presumably Pierie also received training as a military topographer, but his paintings are not purely functional, as is the case with Davies. Rather, he seeks to capture the mood of a place in a way that anticipates the spirit of the Romantic movement.

New York City and State provided popular subject matter for nonmilitary topographers, too, and, confusingly, one of the best in the immediate postwar period was another Archibald Robertson. The civilian Robertson was also born in Scotland, as was his brother Alexander. After emigrating to New York, they established one of the city's first art schools, the Columbian Academy. Watercolor painting was prominently featured in the school's prospectus, and the brothers themselves made both miniatures and many watercolors on paper. Archibald's view of New York from Long Island (PLATE 47), thought to have been painted in about 1796, is well made but has a touch of clumsiness in the drawing that makes it seem a little amateurish by contemporaneous European standards. Although it presents a view of New York that was to become a favorite with nineteenth-century artists—the inner harbor busy with water traffic—this watercolor still cleaves to an eighteenth-century ideal of the city by emphasizing its relationship to an Arcadian countryside, the rural paradise being represented here by the chain of hills that would soon become Brooklyn Heights. The large house at the right is the Cornell mansion, which had served as Washington's headquarters during the Battle of Long Island.

46. Captain William Pierie (active c. 1768–1777). *Narrows at Lake George,* 1777. Watercolor on paper, 8⁷⁄₁₆ x 10¼ in. The Brooklyn Museum; Dick S. Ramsay Fund.

47. Archibald Robertson (1765–1835). *New York from Long Island,* c. 1794–96. Watercolor on paper, 17¼ x 24½ in. Columbia University, New York; Gift of J. Pierpont Morgan.

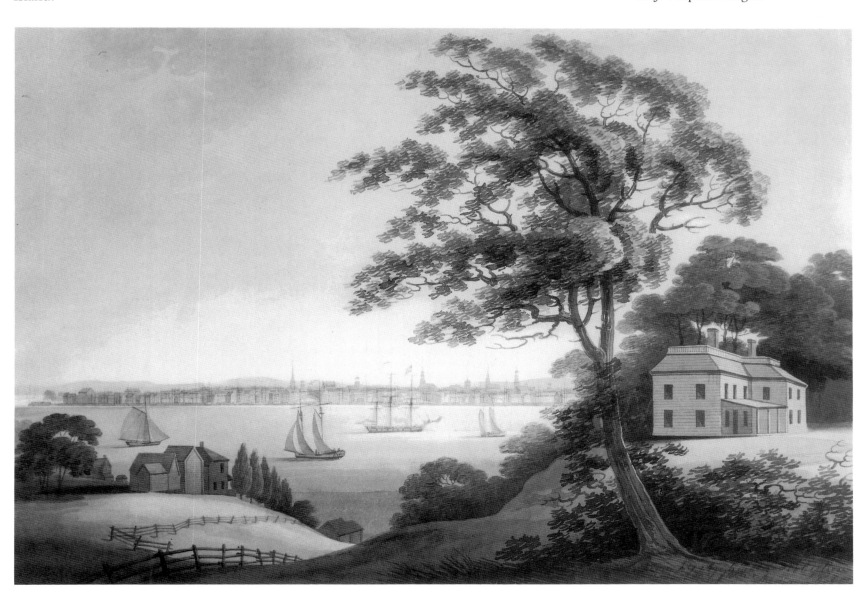

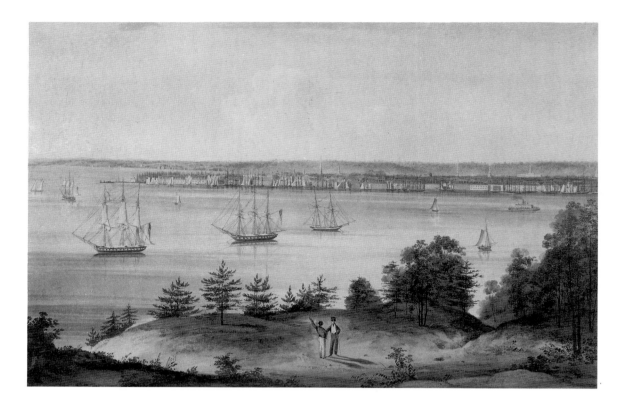

48. William Guy Wall (1792–after 1864).
New York Taken from Brooklyn Heights,
c. 1820–25.
Watercolor on paper, 21⁵⁄₁₆ x 32¾ in.
The Metropolitan Museum of Art,
New York; Bequest of Edward W. C.
Arnold.

49. William Guy Wall (1792–after 1864).
Falls of the Passaic, c. 1820.
Watercolor on paper, 17⅜ x 23¹⁵⁄₁₆ in.
The Brooklyn Museum; Presented in
memory of Dick S. Ramsay.

It is instructive to compare Robertson's drawing with another watercolor made a quarter of a century later by William Guy Wall, who, viewing Manhattan from another rise in Brooklyn, came up with an interpretation of the scene that displays an entirely different sensibility (PLATE 48). Wall, it is apparent, did not choose to see himself as recording a view purloined from Virgil's *Eclogues*. Instead, he knew himself to be at the suburban edge of a rapidly expanding modern metropolis, and he made no attempt to

50. Henry Inman (1801–1846).
Forest Glen, n.d.
Watercolor on paper, 11¼ x 21⅝ in.
The Brooklyn Museum; Gift of
Ferdinand Davis.

hide such evidence of change as the steamboat—then still a relative novelty—that shares the harbor with a variety of sailing vessels.

Wall had arrived in America in 1818, after receiving his training in England, and he painted views of the Hudson Valley area (PLATE 49) that were engraved in aquatint by another British expatriate, John Hill, as *The Hudson River Portfolio.* These prints did much to spread interest in landscape painting in the United States and gave impetus to the Hudson River School. Wall became one of the founding members of the National Academy of Design and was for years a figure of consequence in the American art world.

Henry Inman and William Dunlap, already remarked as portraitists, were also topographers. Inman, in fact, on occasion went beyond the merely topographic to display a feel, rare in his day, for the intimate aspects of landscape (PLATE 50). Dunlap was perhaps more conventional in his aspirations, but his approach was appropriate enough when he was making paintings, such as those reproduced here, in which he was confronting a world that was literally newly made, a world that conformed to no set of European ideals but demanded to be recorded. When he set down the view that he came upon between Troy and Lansingburg (PLATE 51), he was documenting one of the first American housing tracts. With streets laid out, waiting for homes to be built, it calls to mind the San Fernando Valley in the 1930s or the outskirts of Tucson today. Dunlap also had a taste for portraying novel structures, as his painting of the Mohawk Bridge makes quite clear (PLATE 52). He was an early master of reportage, and the portability of watercolor helped make this possible. His dedication to watercolor was occasionally rewarded with a painting such as *View on the Seneca River* (PLATE 53), which displays a real grasp of the medium, rare for an American of his generation.

One of the men who were building the new America that Dunlap painted was Benjamin Henry Latrobe. English born and trained in England and Germany, Latrobe came to America as a young man and established himself as the new Republic's leading Greek Revival architect, responsible for rebuilding the U.S. Capitol after the fire of 1814 and for the design of such landmark buildings as the Bank of Pennsylvania, in Philadelphia, and the Baltimore cathedral. He was also a proficient watercolorist, very much in the tradition of Sandby, who made both architectural drawings and topographic studies that display the same economy and restraint typical of his buildings (PLATE 54).

The nation's first Capitol had been in New York, at the junction of Broad and Wall streets. The structure had been built as New York's City Hall and had reverted to that

ABOVE:
51. William Dunlap (1766–1839).
Between Troy and Lansingburg, 1815.
Watercolor and ink on paper,
7⁵⁄₁₆ x 11½ in.
The Brooklyn Museum; Dick S.
Ramsay Fund.

RIGHT:
52. William Dunlap (1766–1839).
Bridge over the Mohawk at Schenectady,
1815.
Pencil and watercolor on paper,
7⅜ x 13¼ in.
Addison Gallery of American Art,
Phillips Academy, Andover,
Massachusetts.

53. William Dunlap (1766–1839).
View on the Seneca River, 1815.
Watercolor on paper, 8⁷⁄₁₆ x 11⅞ in.
The Brooklyn Museum; Dick S.
Ramsay Fund.

54. Benjamin Henry Latrobe (1764–1820).
*Entrance to Lake Drummond, Dismal
Swamp,* 1797.
Watercolor on paper, 7⅛ x 10⅝ in.
Maryland Historical Society, Baltimore.

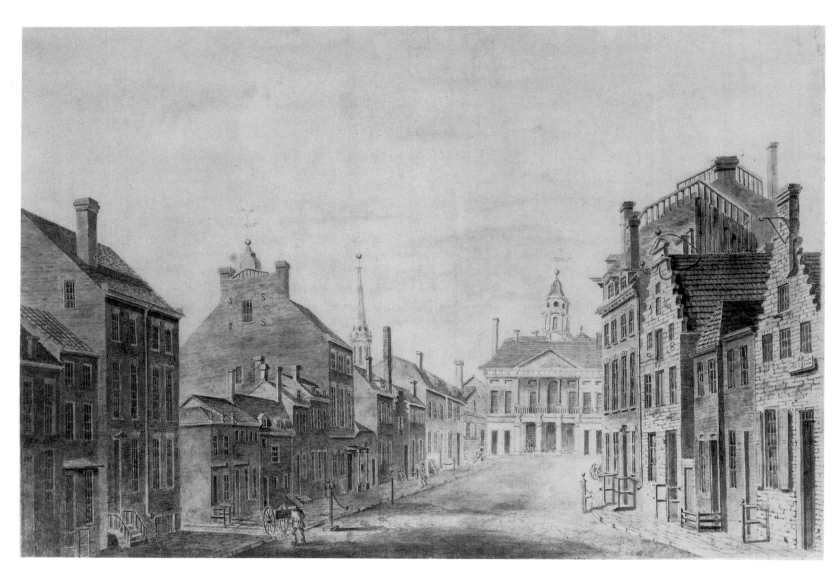

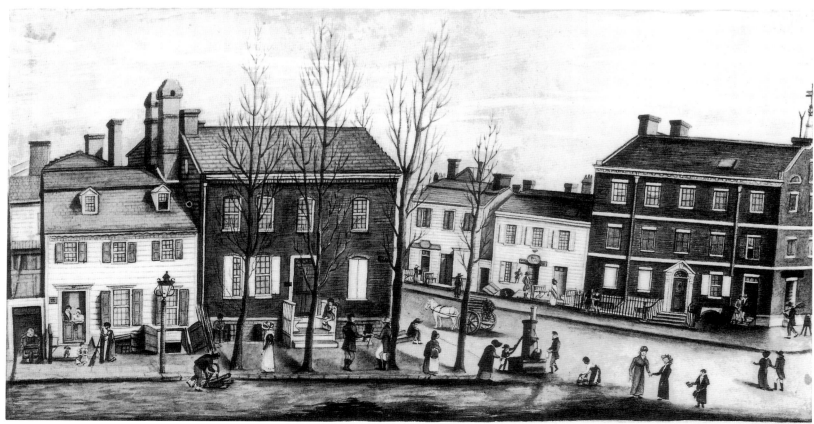

function again by the time John Joseph Holland painted Broad Street in 1797 (PLATE 55). Holland's watercolor concentrates on the architecture rather than on the street life of the city. By contrast, when Baroness Hyde de Neuville made a drawing of another Lower Manhattan street in 1810, she portrayed it as teeming with activity (PLATE 56). The baroness had come to America three years earlier, her husband having been banished from France for his alleged involvement in a conspiracy against Napoleon. They remained in exile for seven years, until the monarchy was restored and the baron was appointed French minister to the United States. Whenever they traveled during their American sojourn, the baroness made lively little watercolor studies full of meticulously recorded detail that more than compensates for the awkwardness of her draftsmanship.

Some of her drawings present a single individual—her maid, for instance—but the most delightful are those such as the one seen here, which records the minutiae of street life in old New York. Here, on an apparently mild winter day (the drawing is dated "Janvier, 1810"), New Yorkers go about their business, sweeping the sidewalk, selling wood, drawing water from the city pump. A child sits on her front doorstep with her dog, and the inclusion of an Oriental figure (behind the wood vendor) indicates that New York was already a cosmopolitan city. The drawing is full of touches of great interest to the social historian. All but one of the houses are fronted by the so-called gossip benches (a small boy is seated on one), which permitted neighbors to visit informally during good weather. The only building not furnished with gossip benches is the handsome brick townhouse of John Stoutenburgh, at right, which "flaunts a weathervane, drain pipes, an iron fence and a Federal-style entrance."[5]

Baroness Hyde de Neuville's drawing is typical in one way of the watercolors that have come down to us from the early days of the Republic. They vary in sophistication and are often marked by charm rather than real accomplishment, but they are an invaluable source of information. Because the artist could make them on the spot, they capture the atmosphere of that lost world as nothing else can. Rarely do they achieve the level of great art, but they are nonetheless an important, and pleasurable, resource.

OPPOSITE, TOP:

55. Attributed to John Joseph Holland (c. 1776–1820).
A View of Broad Street, Wall Street, and the City Hall, 1797.
Watercolor on paper, 12⅜ x 17⁷⁄₁₆ in.
New York Public Library; Stokes Collection.

OPPOSITE, BOTTOM:

56. Baroness Hyde de Neuville (c. 1779–1849).
Corner of Greenwich Street, 1810.
Watercolor on paper, 7⅜⁄₁₆ x 13¹⁄₁₆ in.
New York Public Library; Stokes Collection.

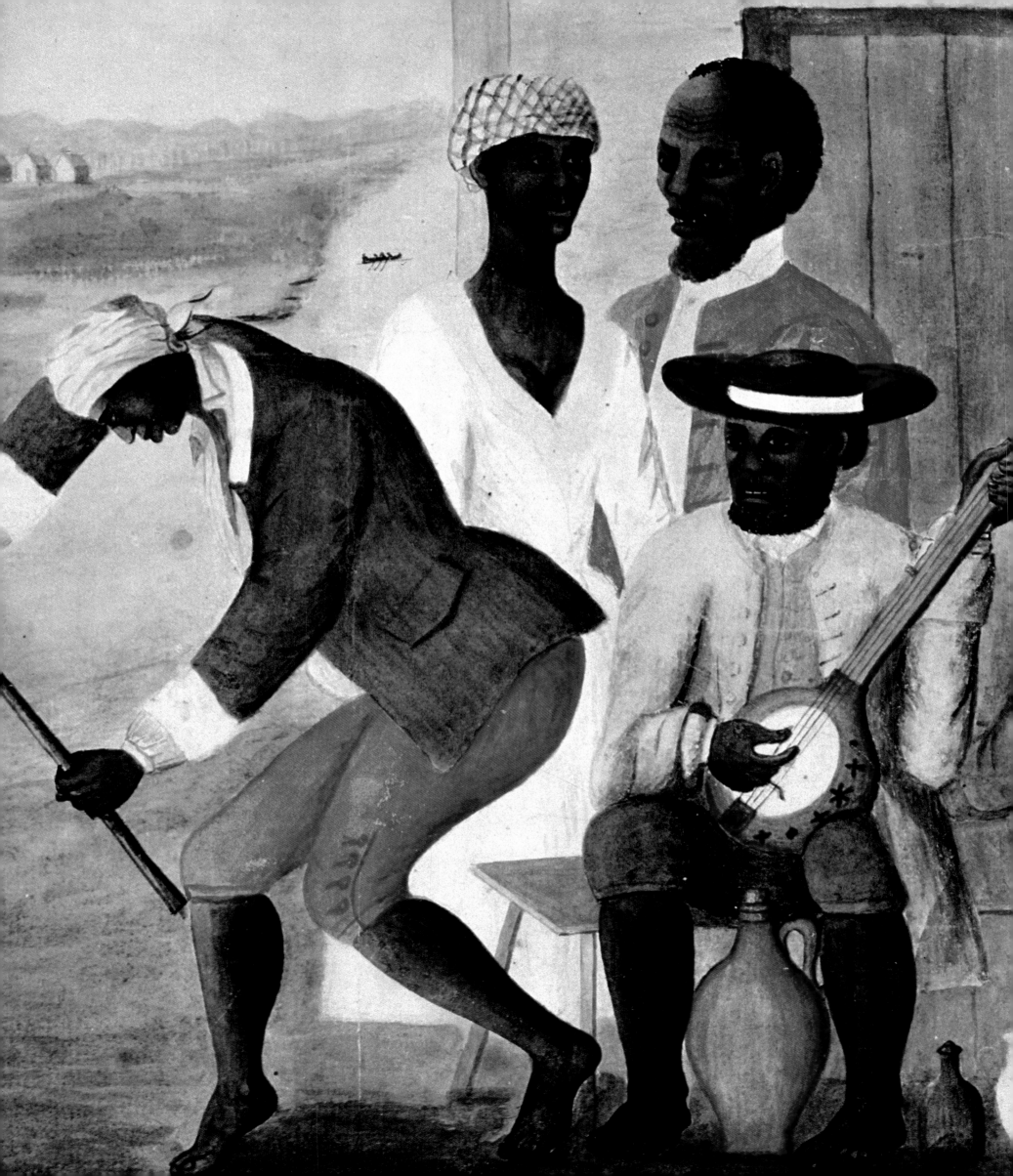

CHAPTER TWO

A GRASS-ROOTS TRADITION

Some of the artists discussed in the last chapter may have been somewhat primitive or amateurish technically, but they all possessed a relatively sophisticated world view, which disqualifies them from being considered as representatives of the various American naive traditions that flourished during the eighteenth and nineteenth centuries. The term *naive* is itself misleading, since it is sometimes used to describe an artist's entire outlook, sometimes to mark deficiencies in draftsmanship. To avoid confusion, then, it would be best to say that the artists discussed in the present chapter are those who sprang from a grass-roots tradition rather than from the world of official art.

Certain of these grass-roots traditions—such as the Pennsylvania Dutch "fraktur" paintings, which originated in the medieval illuminated manuscript—were imported from Europe by various ethnic groups. The term *fraktur* is used to describe a form of Gothic lettering brought to the New World by German immigrants. After settling in Pennsylvania, these German artists and their descendants continued to practice their native calligraphy, weaving it into birth and marriage certificates and various devotional items, many of which were decorated with intricate ink and watercolor drawings (PLATE 58).

The Pennsylvania Dutch were, of course, united by their religious beliefs, and it is of interest to consider their folk art alongside that of another tightly knit religious group, the Shakers. An offshoot of the Quakers, the Shakers built splendidly functional architecture and furniture, but for the most part their two-dimensional art was totally nonfunctional, except insofar as it was used as a meditational aid or as the record of a mystical experience or concept.

Hannah Cahoon's delightful still life is likely to strike the modern viewer as charming (PLATE 59). For her, however, it was a kind of visual prayer, and she described how it was inspired by the sight of "Judith Collins bringing a basket full of beautiful apples for the Ministry, from Brother Calvin Harlow and Mother Sarah Harrison."[1] Clearly this is no conventional portrayal of a basket of fruit. Rather, it is the Shaker equivalent of a Platonic archetype, symbolic fruit placed within a mystical translucent basket. According to Cahoon's own description, the chain around the basket was placed there to represent the "combination" of the donors' blessing (that is to say, the blessing of Brother Harlow and Mother Harrison). Every aspect of this painting had its own significance, and this is true of most of the Shaker art of the mid-nineteenth century.

An apparent exception to this general rule is George Kendall's "map" of the Shaker

57. Anonymous.
The Old Plantation, late 18th century.
Detail of plate 62.

47

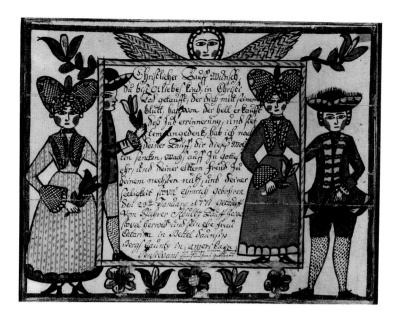

58. Attributed to Sussel-Washington (active
c. 1771–1780).
Baptismal Wish (Tauf-Wunsch),
c. 1771–80.
Watercolor and ink on paper,
7⅜ x 9⅛ in.
Henry Francis du Pont Winterthur
Museum, Winterthur, Delaware.

59. Hannah Cahoon (1788–1864).
Basket of Apples, 1856.
Watercolor on paper, 10⅜ x 8⅛ in.
Hancock Shaker Village, Pittsfield,
Massachusetts.

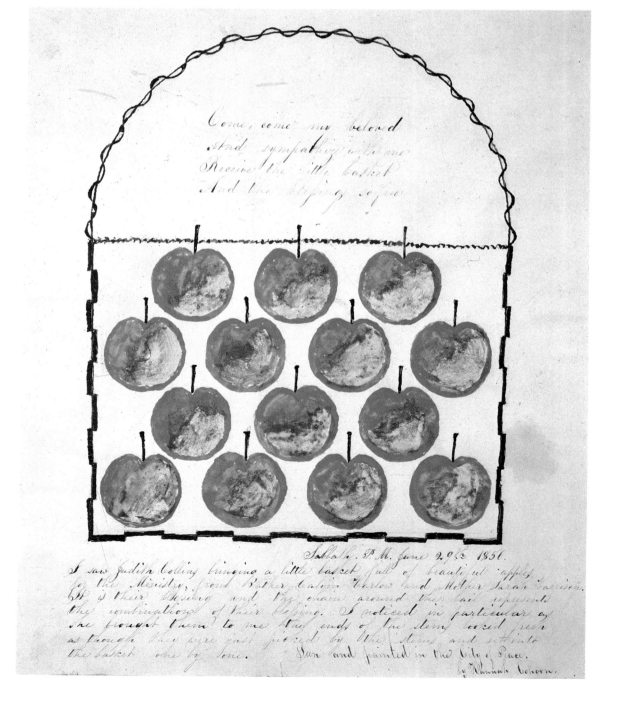

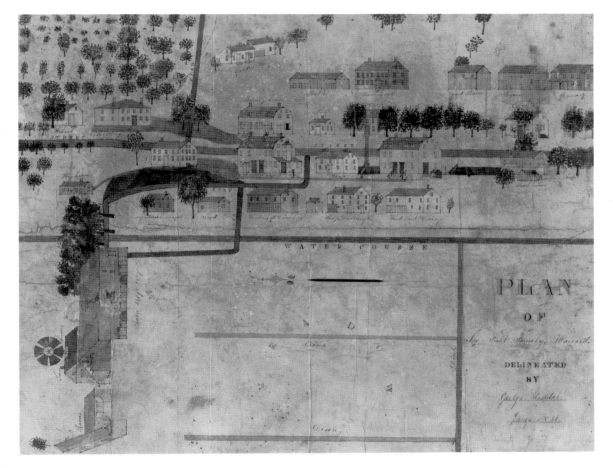

60. George Kendall (active c. 1830s).
Plan of the First Family, Harvard, Map of the First Family Section of the Shaker Community at Harvard, 1836.
Watercolor and ink on paper,
12½ x 16 in.
Fruitlands Museum, Harvard, Massachusetts.

community of Harvard, Massachusetts (PLATE 60). Perhaps by setting it down so carefully he was performing an act of devotion, but this work predates the great period of Shaker mystical work by a decade or so and belongs, perhaps, less to that tradition than to the mainstream of American folk art in which the depiction of places important to either the artist or his patron was a significant genre. America was a wilderness, parts of which were just then being tamed and stamped with the imprint of civilization. Even as the more sophisticated William Dunlap recorded the settlement he stumbled across near Troy, so the relatively primitive artist Joshua Tucker set down his view of Greenville, South Carolina, the buildings looking as fresh and new as toadstools that have popped up after a rain (PLATE 61).

Joshua Tucker was a native of Massachusetts who trained as a teacher, then became an itinerant doctor in the South before spending some years in Cuba; he finally returned to Boston, where he became a dentist of some prominence.[2] It is known that Tucker was a splendid steel-pen calligrapher and draftsman—an example of his work is in the collection of the Museum of Fine Arts, Boston—but this watercolor has little of the firmness of the great American penmen. It displays, rather, an almost feminine touch, as if influenced by the art of embroidery.

A more unusual record of the antebellum South is *The Old Plantation* (PLATE 62), painted by an unknown artist in South Carolina around 1800. It is possible that the artist was black, though the style suggests that this is the work of someone who had received a modicum of training, unlikely for a slave. Black or white, the artist was interested in portraying character and dress accurately, and historians have been able to identify these slaves as being of Hausa and Yoruba origin.[3] The portrayal of African musical instruments and Western architecture, of turbans and frock coats, makes this a fascinating record of the early history of blacks in America.

Each of the slaves in this painting is a fully realized portrait, and the portrait has as important a role in the history of American folk art as it does in the history of early

RIGHT:

61. Joshua Tucker (1800–after 1880?).
South East View of Greenville, South Carolina, 1825.
Watercolor on paper, 10¾ x 16¼ in.
Abby Aldrich Rockefeller Folk Art Center, Williamsburg, Virginia; Gift of Arthur A. Shurliff.

BELOW:

62. Anonymous.
The Old Plantation, late 18th century.
Watercolor on paper, 11¾ x 17⅞ in.
Abby Aldrich Rockefeller Folk Art Center, Williamsburg, Virginia.

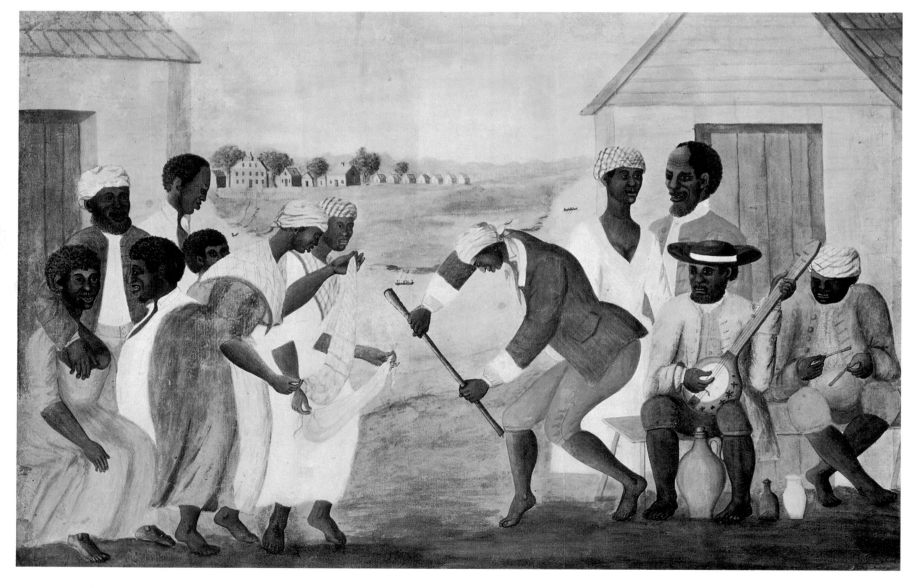

American art as a whole. That the likes of John Singleton Copley and Gilbert Stuart were not available to the merchants and gentlemen farmers of the American hinterlands did not discourage them from having their likenesses, and those of their wives and children, recorded for posterity. So it was that a substantial number of primitive yet professional portraitists accommodated these needs. Most of them favored oil paint on canvas as their medium, but some of the finest preferred watercolor.

Often these artists are unknown to us by name, and for years what attributions did exist were suspect. Until 1965, for example, many portraits now thought to be by Jacob Maentel were attributed to Samuel Endredi Stettinius.[4] Maentel seems at one time to have been a professional portraitist in Maryland and Pennsylvania, then later to have become a farmer and part-time artist in Indiana. The details remain cloudy, but what is certain is that he was a portraitist with the kind of distinctive power that belongs to the primitive artist with talent and dedication (PLATES 63, 64).

What determines this power is the fact that all the energy of the artist is focused on

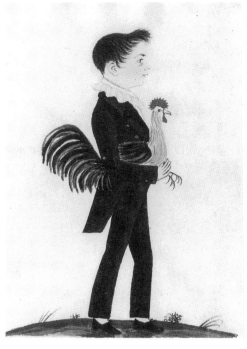

ABOVE:
63. Jacob Maentel (1763–1863).
Boy with Rooster, c. 1815–25.
Watercolor on paper, 7⅞ x 5¾ in.
Henry Francis du Pont Winterthur
Museum, Winterthur, Delaware.

LEFT:
64. Attributed to Jacob Maentel
(1763–1863).
Joseph Gardner and His Son, Tempest Tucker, 1815.
Watercolor on wove paper,
12⅛ x 10 in.
Abby Aldrich Rockefeller Folk Art
Center, Williamsburg, Virginia.

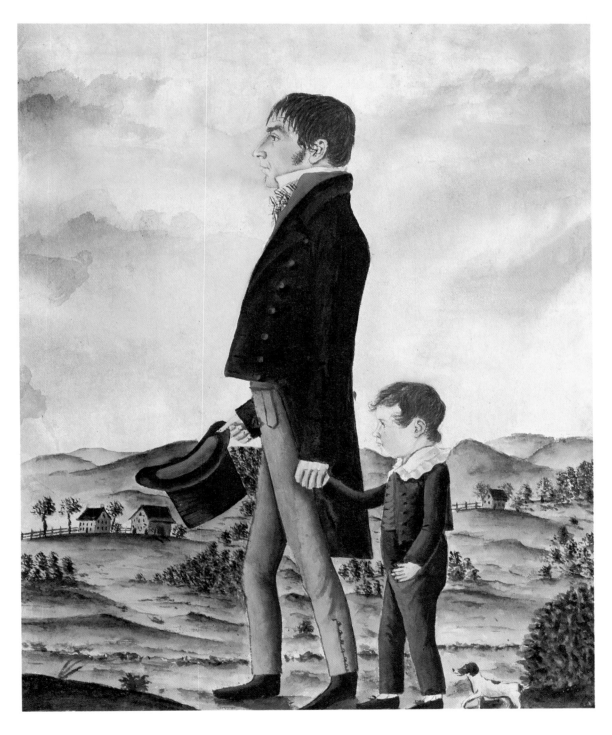

65. James Sanford Ellsworth (1802–1873).
Mary Ann Morgan, c. 1845.
Watercolor on paper, 3⅛ x 2¾ in.
Museum of Fine Arts, Boston.

rendering a likeness. Legs may be stovepipes, hands bundles of bean pods, backgrounds schematic, but the artist fulfills his obligation by concentrating all his attention on the sitter's features (in Maentel's case, generally the profile). Details of hairstyle become important—the way a sideburn grows—but crucial is the accuracy achieved in capturing the curl of a lip, the rake of a nose. Were the artist capable of distributing such accurate observations throughout a painting he would be a Gilbert Stuart, but he is not and so he must concentrate on the essentials of the commission. The face must be faithfully recorded, while the rest is convention, and this has its own special charm since the sitter is portrayed as a provincial archetype and an individual at the same time. More in line with the academic tradition, but equally touching, is James Sanford Ellsworth's diminutive *Mary Ann Morgan* (PLATE 65), actually a miniature painted on paper, made at a time when photography was already threatening the livelihood of the itinerant portraitist. Here is an instance where awkwardness seems to guarantee honesty.

Amateur artists frequently favored watercolor as a medium, with the term *amateur* within the context of nineteenth-century society frequently meaning a gifted woman artist who never had the opportunity to develop her talent beyond the level of a domestic accomplishment. In art classes young ladies were encouraged to copy prints and even to use stencils, called *theorems*. It might be thought that such stencils would stifle creativity, yet Emma Cady of New Lebanon, New York, was able to use them as the basis of a subtly conceived still life in which deft use of watercolor washes gives the fruit form and texture (PLATE 66). The "Precisionist" quality of the stenciled outlines, combined with distortions of perspective that anticipate Cubism, gives this wonderful little picture a curiously modern appearance.

Caroline Joy, if she was indeed the artist, may have copied *Absalom Slain by Joab* (PLATE 67) from a print or illustrated Bible, but she has nonetheless made the subject her

RIGHT:
66. Attributed to Emma Cady (1854–1933).
Fruit in Glass Compote, 1890.
Watercolor and mica flakes on wove paper, 9¹¹⁄₁₆ x 15¹⁵⁄₁₆ in.
Abby Aldrich Rockefeller Folk Art Center, Williamsburg, Virginia.

OPPOSITE:
67. Attributed to Caroline Joy (1819–1892?).
Absalom Slain by Joab, possibly 1840.
Watercolor and ink on wove paper, 7¾ x 5¾ in.
Abby Aldrich Rockefeller Folk Art Center, Williamsburg, Virginia.

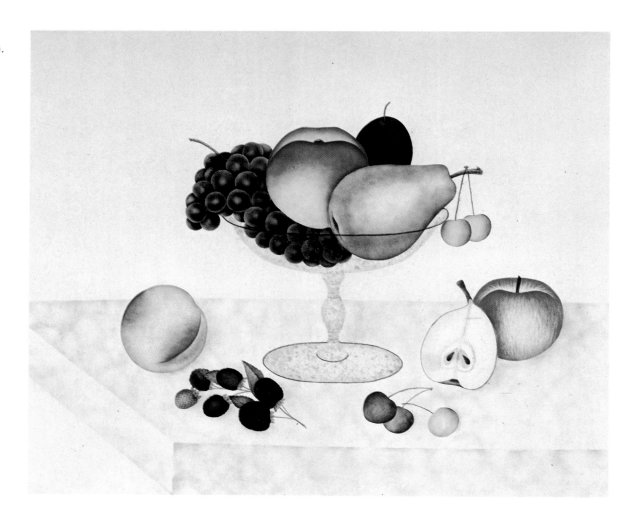

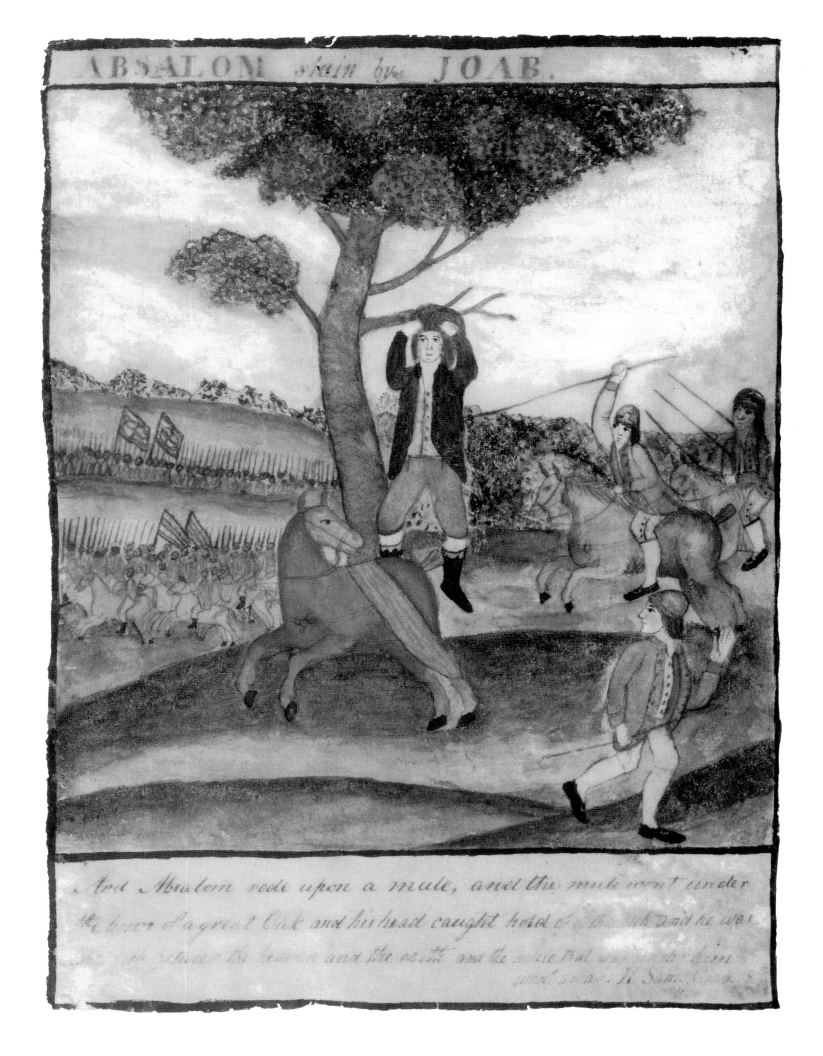

ABSALOM slain by JOAB.

And Absalom rode upon a mule, and the mule went under the bows of a great Oak and his head caught hold of the oak and he was ... between the heaven and the earth and the mule that was under him went away. II Sam.

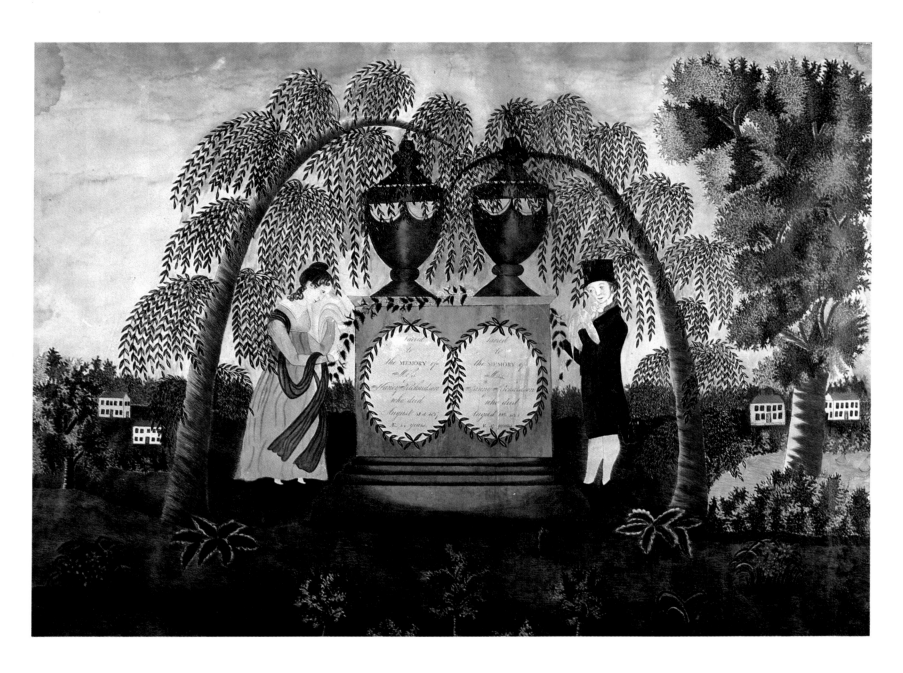

68. Harriet Moore (1802–1878).
Richardson's Memorial, 1817.
Watercolor on paper, 18 x 23¾ in.
New York State Historical Association,
Cooperstown.

own, imposing upon it a style that is, appropriately, somewhat reminiscent of Middle Eastern miniatures.

A popular genre with amateur and professional folk artists alike was the memorial picture, in which conventional symbols, such as weeping willows and funeral urns, were organized into decorative compositions honoring deceased individuals. Harriet Moore's *Richardson's Memorial* (PLATE 68) bears an inscription indicating that it mourns two people: Mrs. Fanny Richardson, age fifty-seven, and Miss Nancy Richardson, age fourteen, who both died during the month of August 1817. Since the artist is known to have been fifteen at the time, Nancy Richardson may well have been a friend, which gives the painting special poignancy.

Mary Ann Willson is one of the great characters in American folk art. Accompanied by a Miss Brundage, with whom she had formed a romantic attachment, Mary Ann Willson took up farming in Greene County, New York, where she also practiced watercolor painting, her often fantastic subjects being set down with pigment squeezed from berries and other items that could be found on the farm (PLATE 69). Although she started as an amateur, her work became popular with neighboring farmers, and she is said to have sold paintings as far afield as Canada and Alabama.

Reflecting the population density, most American folk art of the nineteenth century

came from east of the Mississippi. A quite different tradition flourished in the Southwest, where José Rafael Aragon painted subjects rooted in Spanish Catholicism (PLATE 72). Despite the iconography, however, Aragon's paintings take us full circle, since, like the Pennsylvania Dutch masters, he represents a kind of folk art that is not indigenous to the New World but derives almost entirely from European models.

Primitive art is not an exclusively historical phenomenon, and the American grass-roots tradition has extended into the twentieth century without interruption. Especially rich, as far as watercolor is concerned, has been the work produced in this century by black folk artists, predominantly Southerners. Such black folk art has been largely ignored, but recently it has attracted considerable attention and has even been the subject of a major traveling exhibition originated by the Corcoran Gallery of Art in Washington, D.C.

69. Mary Ann Willson (active
 c. 1810–1825).
 Marimaid, c. 1820.
 Watercolor on paper, 13 x 15½ in.
 New York State Historical Association,
 Cooperstown.

Among the best known of these artists is Bill Traylor, who was born into slavery near Benton, Alabama. He remained in the Benton area until 1938, when, at the age of eighty-four, he moved to Montgomery. There, a year later, he began to draw, setting down simple geometric shapes on paper or cardboard and then elaborating these into human or animal forms. Sometimes the result was an isolated image: a man, perhaps (PLATE 70), or a chicken. In other instances it was an anecdotal composition full of figures acting out some remembered incident from his life back in Benton (PLATE 71).

The striking thing about Traylor's work is that from the first he possessed a sure sense of personal style. Underpinning this style was a geometric armature, sometimes drawn with the aid of a straightedge, which lent his drawings a structural rigor that was offset by the wit with which he conjured up men and beasts. Typically, the forms were outlined in pencil or crayon, then filled in either with gouache alone or with a combination of scribbled pencil and gouache. By academic standards Traylor's skills as a draftsman were very limited, but within the parameters established by his self-imposed stylistic conventions Traylor's figures display considerable flexibility of gesture and expression.

Joseph Yoakum was born on a Navaho reservation in Arizona and claimed Indian blood. According to him, he ran away from home as a teenager and worked as a roustabout for various circuses, acting for a while as a valet to John Ringling. Later he served in France during World War I and worked at various itinerant jobs before settling in Chicago, where he and his wife ran an ice cream parlor.[5] How extensively Yoakum actually traveled is uncertain—he claimed to have visited every continent except Antarctica—but his voyages, real or imagined, provided him with subjects for the great majority of the hundreds of drawings he made during the last decade of his life. Inspired by a dream, Yoakum began, in 1962, to set down landscapes that were designated as portraits of actual places, such as a range of volcanic peaks in Chile (PLATE 73), but that seem to have owed as much to his sense of fantasy as to topographic actuality. He seems, in fact,

73. Joseph Yoakum (1886–1972).
 C. S. Valentin Crater, 1964.
 Watercolor and pen on paper,
 19 x 24 in.
 Phyllis Kind Gallery, New York and Chicago.

THE TWO BEAST OF REVELATION 13

FEAR GOD, AND GIVE GLORY TO HIM, FOR THE HOUR OF HIS JUDGMENT IS COME REV 14 7

DAN. 7. 1

to have improvised the image as he went along, though always with a sense of a specific place in the back of his mind.

Sister Gertrude Morgan became a street preacher in New Orleans after a voice informed her that this was her calling. Later she founded an orphanage and, in the mid-1950s, received divine word that she was to become the bride of Christ. At about the same time, she began to paint, evoking a universe peopled with angels and satanic beings, a universe that would have seemed familiar to William Blake.

Like Blake, Sister Gertrude had a facility for incorporating Biblical texts into startling visual statements (PLATE 74), and, like him, she had a remarkable ability to bring Bible stories to life with great directness (PLATE 75). She also expressed herself by dancing, playing various musical instruments, and singing, and it is easy to think of her paintings as visual equivalents of gospel music, displaying all of the emotional intensity that one associates with the vocal performances of artists such as Sister Rosetta Tharp.

Luster Willis differs from the others in this group in that he began drawing obsessively when he was a schoolboy and has continued to do so ever since. And, of all the black folk artists, he is the one who has the most natural feel for the watercolor medium.

In *Mummie of the Stone Age* (PLATE 76) Willis has started with a strong pencil drawing that makes effective use of an approximation of axonometric perspective, a device that calls to mind the "space boxes" to be found in Francis Bacon's work. It is the confident freedom with which he uses watercolor, however—allowing colors to overrun outlines and blend—that brings the whole image to life, and the scattered glitter adds an element that is entirely his own.

Willis has said that he gets his feeling for drawing "when I get a little lonesome or something like that,"[6] which suggests that it is not unreasonable to draw a parallel between his work and the blues tradition, which has deep roots in rural Mississippi, where the artist has spent his entire life. And just as blues music derives its special resonance from the fact that its pioneers were musically and emotionally sophisticated even though academically untutored, so Willis's paintings, like much of the best folk art, derive their strength from a similar conjunction.

OPPOSITE, TOP:
74. Sister Gertrude Morgan (1900–1980).
The Two Beasts of Revelation,
c. 1965–75.
Pen, pencil, pastel, and watercolor on cardboard, 8⅜ x 15¼ in.
Allan Jaffe, New Orleans.

OPPOSITE, BOTTOM:
75. Sister Gertrude Morgan (1900–1980).
Book of Daniel 7:1, c. 1965–70.
Pencil, pastel, and watercolor on paper, 9 x 16⅛ in.
Allan Jaffe, New Orleans.

ABOVE:
76. Luster Willis (b. 1913).
Mummie of the Stone Age, 1970s.
Watercolor and glitter on posterboard, 15½ x 12⅛ in.
Allan Jaffe, New Orleans.

Cliffs of the Rio Virgin, S. Utah

CHAPTER THREE
FRONTIERS AND WATERWAYS

The first American artist to achieve greatness through the medium of watercolor was John James Audubon. Like so many eighteenth- and nineteenth-century figures we now consider to be American, he was a foreigner by birth, born in Haiti and educated in France, where he studied briefly with the great exponent of classicism, Jacques Louis David. Audubon made his first visit to the United States as a teenager in 1803 and eventually settled in Kentucky, where he established himself as a merchant on the edge of the American wilderness. He found it to be teeming with fascinating wildlife, which he began to record in drawings that were at first rendered chiefly in a combination of pencil, pastel, and watercolor, later primarily in watercolor. After the failure of his business projects and time spent in jail for bankruptcy, he decided—reputedly at the instigation of his wife, Lucy Bakewell Audubon—to pursue a career as an artist-naturalist. He made some skillful pencil and charcoal portraits in a classical idiom, but his chief preoccupation became the ornithological studies that, as engraved by Robert Havell, Jr., in London, made up one of the most spectacular books of all time, *The Birds of America*. Published in sections between 1827 and 1838, *The Birds of America* contains 435 hand-colored plates, with more than 1,000 life-size renditions of almost 500 species of birds. Audubon often made more than one study of a given variety of bird, so that the total number of watercolors considerably exceeds that of the prints. They also differ in character because the engraver supplied much additional background detail, which sometimes interferes with the clarity and design of the original.

Audubon was not the first to embark upon such a work, having been preceded by Alexander Wilson, whose *American Ornithology* began to appear in 1808. Wilson used watercolor to tint his original studies (PLATE 78), but his talent was primarily in line drawing and, handsome though his work is, he lacked Audubon's genius. The two men did meet near the beginning of Audubon's career, however, and Wilson must have helped fire the younger man's ambition.

Audubon prepared his watercolors (PLATES 79, 80) in the course of journeys throughout the North American continent, during which he observed birds in their native habitats and obtained specimens for mounting and reference. Part of Audubon's genius was his ability to combine his powerful sense of design with naturalism of pose and to adapt the pose to the scientific necessity of accurately portraying the subject's coloration and other peculiarities. The naturalism of pose, it is true, was sometimes modified by the influence of a Romantic vision and sometimes by more practical consid-

OPPOSITE:
77. Thomas Moran.
Cliffs of the Rio Virgin, South Utah, 1873.
Detail of plate 95.

ABOVE:
78. Alexander Wilson (1766–1813).
Little or Saw Whet Owl, n.d.
Watercolor on paper, 7¼ x 10⅝ in.
Houghton Library, Harvard University,
Cambridge, Massachusetts.

erations, such as making the image of a large bird fit life-size into the double-elephant–folio format, huge though this was (26½ by 39½ inches). To accommodate the exigencies of format Audubon would sometimes wire his specimens into positions that other naturalists might question but that permitted the artist to twist a neck and head into position just below an impinging margin.

The amount of detail in Audubon's paintings often led people to believe that each must be the product of days, even weeks, of labor. In fact, he worked very rapidly. A sure draftsman, equipped with a thorough knowledge of his subject matter, he sometimes completed a painting in a single sitting of a few hours. His watercolor technique is not that of a purist—largely because the subject demanded extensive use of local color, sometimes opaque, to define its markings—but Audubon had a deft touch with the medium that was perfectly suited to his needs.

While his great work was in progress Audubon shuttled to and fro across the Atlantic, his shoulder-length hair and frontiersman manner making him a great social figure during his stays in London. Back in America he traveled extensively, from Florida to the Canadian tundra, often in the company of George Lehman, who, as the project continued, took on some of the chores of adding details of habitat to the paintings. Meanwhile, Audubon trained his sons, Victor Gifford Audubon and John Woodhouse Audubon, and eventually they joined him as assistants.

The Birds of America made Audubon famous and prosperous, and, at the age of fifty-four, he embarked on a new project, to be titled *The Viviparous Quadrupeds of North*

BELOW:

79. John James Audubon (1785–1851). *Bob White (Virginian Partridge),* 1825. Watercolor on paper, 25¾ x 39 in. New-York Historical Society.

OPPOSITE:

80. John James Audubon (1785–1851). *Carolina Parroquet,* 1825. Watercolor on paper, 29½ x 21¼ in. New-York Historical Society.

81. John James Audubon (1785–1851).
American Black Rat, 1842.
Watercolor on paper, 14½ x 22 in.
American Museum of Natural History,
New York.

America. His powers were undiminished, and, indeed, some of his finest watercolors, such as *American Black Rat* (PLATE 81), were made at this time. Audubon may have worked quickly, but he always took his time when it came to research, and he is said to have studied these rodents for a year before making his painting. In technique it harks back to Dürer's nature studies such as *The Hare* (though there is no reason to suppose that Audubon was familiar with these) and looks forward to the work of the American Pre-Raphaelites, such as John William Hill, who would come under the influence of John Ruskin two decades later. Audubon needed no Ruskin to tell him to study the minutiae of nature, nor did he fall into the Pre-Raphaelite trap of ignoring the tooth-and-claw aspects of the natural world. With his French upbringing, he was a latter-day product of the Enlightenment and, at the same time, a true original, capable of great flights of imagination without ever straying from his goal of scientific observation.

Audubon continued to work on *Quadrupeds* until shortly before his death, when his vigorous health suddenly failed. His sons carried his work to completion, but, accomplished though they were, they lacked the ability to breathe life into a subject, an ability that had been at the heart of their father's genius.

While Audubon was prowling the continent for parakeets and prairie dogs, other artists were traveling to the Western frontier and beyond to observe the habits of native Americans and of the woodsmen and hunters who shared their world. The most distinguished of these artist-explorers were George Catlin, Alfred Jacob Miller, and two Europeans—

Peter Rindisbacher and Karl Bodmer—all of whom employed watercolor to a greater or lesser extent.

Peter Rindisbacher, born in Bern, Switzerland, was the first of these artists to be exposed to frontier life. His family emigrated in 1821 to the Red River Valley Settlement, a colony founded in western Ontario by Thomas Douglas, the fifth Earl of Selkirk, who at that time controlled the Hudson Bay Company. Rindisbacher painted Indian life there and south of the border, too, establishing a considerable reputation before dying from unknown causes in St. Louis at the age of twenty-eight. *Assiniboin Hunting on Horseback* (PLATE 82), painted the year before his death, is a good example of his mature style, in which memories of European classicism blend with keen observation and a sense of elegance to transcend a certain primitiveness that he was never able to overcome in his draftsmanship.

George Catlin was a native of Wilkes-Barre, Pennsylvania, who abandoned the practice of law and headed west in the late 1820s after receiving a modicum of art training, possibly from Charles Willson Peale. In 1830 he crossed the Mississippi for the first time, traveling in the company of William Clark (of Lewis and Clark fame). Over the next several years he wandered between the Great Lakes and the Texas border, making on-the-spot studies wherever he went (PLATE 83), many of which he later worked up into finished paintings. It is the studies that are of most interest to the student of watercolor. Catlin did not enjoy any great gift for the medium, but he did use it with a spontaneity that has the virtue of capturing the immediacy of the thing seen.

Alfred Jacob Miller was the son of a Baltimore grocer who studied with Thomas Sully and, rather surprisingly, at the Ecole des Beaux-Arts in Paris. He then attempted, without much luck, to set himself up as a portraitist, first in his native city, then in New

82. Peter Rindisbacher (1806–1834).
Assiniboin Hunting on Horseback, 1833.
Watercolor on paper, 9¾ x 16⅛ in.
Amon Carter Museum, Fort Worth.

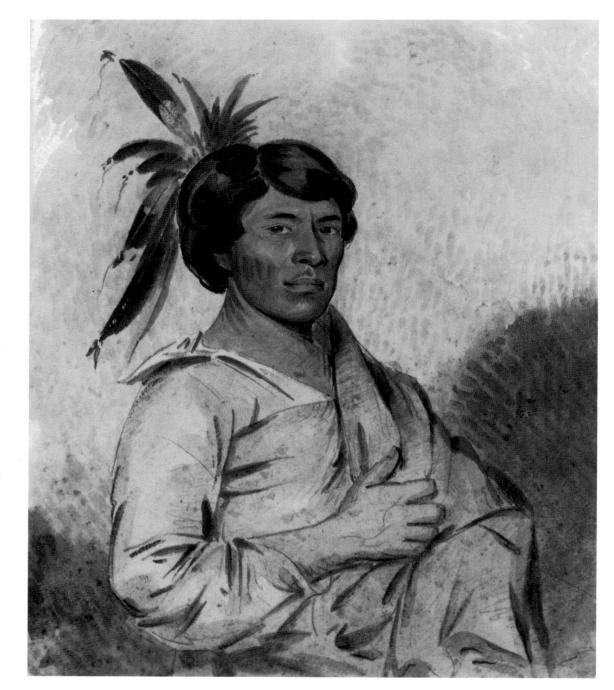

Orleans. It was there that he met the British adventurer William Drummond Stewart, who was impressed by Miller's work and took him along on his 1837 hunting expedition, traveling what was later to be known as the Oregon Trail to Fort Laramie (then called Fort William) and across the Rocky Mountains. It was Miller's only trip to the Far West, but the sketches he made there served as a basis for hundreds of paintings and prints executed over the years.

Miller's watercolors, usually heightened with gouache, are not especially skillful, but, as is the case with Catlin, they do have an authenticity about them, born of honest draftsmanship allied with an integrity of observation. Miller lacked Catlin's abilities as an artist-anthropologist (Catlin, after all, spent years among the Indians and won the trust of such nations as the Mandan). Miller compensated for this, however, with an anecdotal streak and a sense of drama that is evident in examples such as *Storm, Waiting for the Caravan* and *The Grizzly Bear* (PLATES 84, 85), both painted years after he had witnessed the scenes portrayed.

Catlin and Miller enjoyed considerable success in Europe, where interest in American Indians ran high, and the same is true of Karl Bodmer, who traveled to uncharted

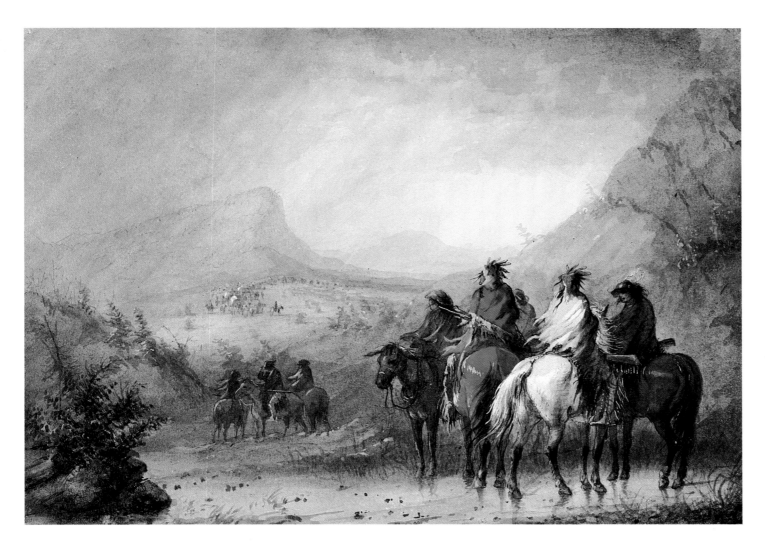

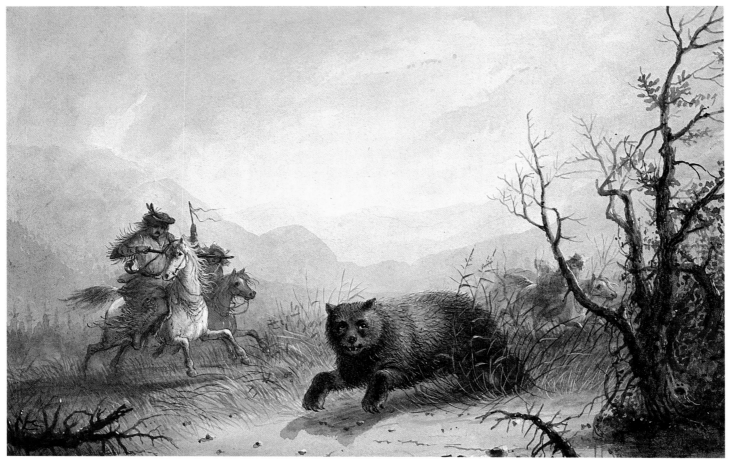

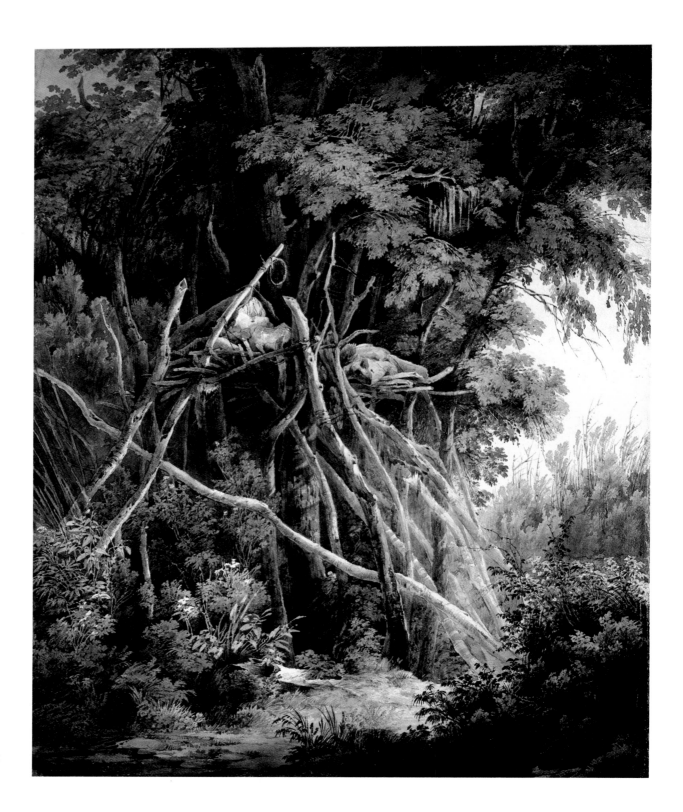

86. Karl Bodmer (1809–1893).
Assiniboin Burial Scaffold, n.d.
Watercolor on paper, 12½ x 9⅞ in.
InterNorth Art Foundation, Joslyn Art
Museum, Omaha.

regions of the New World as part of an expedition led by Alexander Philip Maximilian,
a Prussian prince and amateur scientist. Like Rindisbacher, Bodmer was Swiss, but
unlike his countryman he had received extensive academic training, as well as encourage-
ment from his uncle, Johann Jacob Meier, a leading Swiss watercolorist. (The Swiss
watercolor school was far from negligible and had produced one of the most remarkable
watercolorists of all time, Abraham Louis Rodolphe Ducros, an artist whose sometimes
apocalyptic vision was matched by a virtuosic technique.)

By the time he arrived in America, in 1832, Bodmer was already an extremely
accomplished technician. After time spent in Boston, New York, and Philadelphia, he
traveled with Prince Maximilian's party to St. Louis, from where, in April 1833, it set
off on a thirteen-month expedition that took Bodmer through vast tracts of the trans-

87. Karl Bodmer (1809–1893).
Addih-Hiddisch (Maker of Roads), 1833.
Watercolor on paper, 16½ x 11⅝ in.
InterNorth Art Foundation, Joslyn Art
Museum, Omaha.

Mississippi wilderness. During the course of these travels he made hundreds of watercolors, which were later used as the basis for illustrations in Prince Maximilian's *Reise in das Innere Nord-America in den Jahren 1832 bis 1834,* a key early work on the American interior.[1] Whether painting portraits of the Indians they encountered or recording the unfamiliar scenes they came upon (PLATES 86, 87), Bodmer set down a record of the Old West with a technical facility that was beyond the reach of other artist-explorers. After his Western adventure, however, Bodmer returned to Europe, never to come back, and eventually settled in France, where he became a respected minor member of the Barbizon School.

Later in the century the Western tradition was picked up by such artists as Frederic Remington and Charles M. Russell, who switched the emphasis from a documentary

88. Frederic Remington (1861–1909).
*Lieutenant S. C. Robertson, Chief of the
Crow Scouts,* 1890.
Watercolor on paper, 18⅛ x 13⅛ in.
Amon Carter Museum, Fort Worth.

portrayal of frontier life to a presentation of cavalrymen and Indians as heroic figures
(PLATES 88, 89). Remington was a New Yorker who made many trips to the West and
first gained attention from the sketches he submitted to *Harper's Weekly* and other maga-
zines. His reputation today rests primarily on his oils and bronzes, but he frequently
used watercolor for on-the-spot studies and in his work as an illustrator. Russell was
born in St. Louis and lived most of his life in Montana. Largely self-taught, he also
made oils and bronzes but is often found at his best in his watercolors, which tend to be
somewhat garish in palette but nonetheless display considerable vigor and dramatic
sense. This made him, like Remington, a popular illustrator.

Clearly Audubon and the Western artists were, each in his own way, products of the highly volatile cultural climate that existed in a country that was expanding at a rate unprecedented anywhere else in the world. Audubon was an inspired cataloguer setting down a record of some of the exotic (and not so exotic) fauna of a newly opened continent. Catlin and Miller were skilled documentarians sending back messages from the new frontier, just as men like Jacques Le Moyne de Morgues and John White had brought back visual messages from the New World.

But almost everything in the United States was new. Even the relatively established cities of the East were growing and changing with remarkable rapidity. As a burgeoning population created an ever-increasing demand for food, agriculture transformed the wooded hillsides of New England and the vast plains of the Midwest. Such engineering feats as the Erie Canal and the Brooklyn Bridge brought farmers and manufacturers closer to their markets, while, from the 1830s on, railroad tracks began to crisscross the eastern seaboard, then to push out into the prairies, transforming daily life in a thousand different ways. It was inevitable that artists would want to record all these changes (and also that they would try to capture the old scenes and ways before they vanished forever). Printmakers such as Nathaniel Currier and James M. Ives—many of whose lithographs were based on watercolor originals—kept the public abreast of events, inventions, and explorations, much as photographers would do in the twentieth century. And painters in all media willingly submitted to the impulse to record both the modern miracles of the United States and its great natural wonders.

89. Charles M. Russell (1864–1926).
Indian Signalling, 1901.
Watercolor on paper, 10 x 14 in.
Amon Carter Museum, Fort Worth.

Nicolino Calyo was one of those who were drawn to the excitement of the expanding cities. Born in Malta, he settled in New York after having received some training in Italy. As reportage, his gouaches are extremely lively (PLATE 90), even though he brought nothing new to the emerging American school; his technique instead harked back to the eighteenth-century style of body-color painting practiced by such minor Italian masters as Giovanni Battista Busiri and Francesco Zuccarelli.

As already noted in chapter one, British-born watercolorists such as William Guy Wall were instrumental in shaping the American landscape tradition and were also among those most alert to the changing face of America. This influence was still dominant in the 1830s, when Wall's English contemporary William J. Bennett was busy painting America's bustling urban centers and unspoiled countryside (PLATE 91). While Bennett's was the conventional technique of the topographer, an important shift in approach was introduced by another British-born watercolorist, George Harvey, who, in the mid-1830s, began to exhibit paintings that displayed an innovation he had picked up on a trip back to England. Some British watercolorists were experimenting with the technique of stippling, heightening the intensity and luminosity of their paintings by building each form from hundreds and even thousands of dots of color laid closely together. The method was brought to a peak around mid-century by painters such as John Frederick Lewis and William Henry Hunt. Harvey, however, happened upon this technique so early that he cannot be considered a mere imitator, and, as far as the American scene is concerned, he must be considered an important innovator (PLATE 92). His method was used by lesser artists to produce stiff academic paintings, but his own best works—notably those made for a proposed book to be entitled *Harvey's American Scenery*—are very fine. His most personal paintings—full of gnarled roots and twisted tree limbs (PLATE 93)—hint at a pantheistic view of nature that in certain ways anticipates the art of Charles Burchfield.

90. Nicolino Calyo (1799–1884).
Fairmont Park (The Balloon Ascension of 1834), 1834.
Gouache on paper, 16⅝ x 30 in.
Maryland Historical Society, Baltimore.

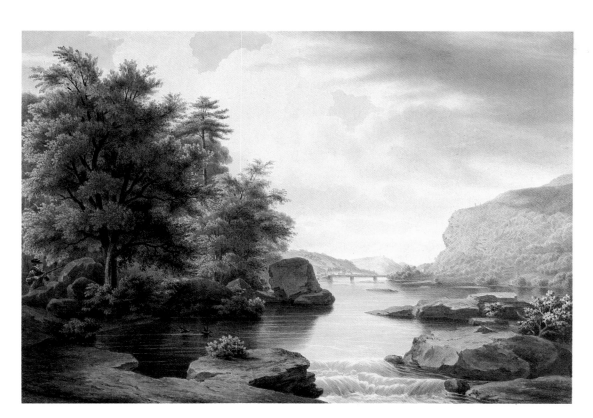

ABOVE, LEFT:

91. William James Bennett (1787–1844).
*View on the Potomac, Looking towards
Harper's Ferry*, c. 1834.
Watercolor on paper, 16¹/₁₆ x 22⁷/₁₆ in.
The Brooklyn Museum; Dick S.
Ramsay Fund.

ABOVE, RIGHT:

92. George Harvey (1800–1878).
*Spring—Burning Fallen Trees in a Girdled
Clearing, Western Scene*, c. 1840.
Watercolor on paper, 13¹³/₁₆ x 10⁵/₁₆ in.
The Brooklyn Museum; Dick S.
Ramsay Fund.

RIGHT:

93. George Harvey (1800–1878).
A Cedar Swamp, c. 1839.
Watercolor on paper, 13¾ x 10¼ in.
The Brooklyn Museum; Dick S.
Ramsay Fund.

94. William Henry Bartlett (1809–1854).
Kaaterskill Falls from above the Ravine,
c. 1840.
Sepia watercolor on paper mounted on
cardboard, 4¾ x 7 in.
New-York Historical Society.

Yet another Briton, William Henry Bartlett, made several trips to the United States and painted watercolors of such American landmarks as Lake George and Kaaterskill Falls (PLATE 94), scenes that were much imitated from the steel engravings that appeared in a two-volume book entitled *American Scenery* (not to be confused with Harvey's project), which appeared between 1839 and 1842. Bartlett's imagery may well have had some influence on the evolution of the Hudson River School, but, for the most part, the Hudson River painters paid very little attention to the possibilities of watercolor, preferring oil paint even for their on-the-spot sketches.

A younger landscapist, Thomas Moran, worked extensively and with great success in watercolor. Born in England, Moran came to America as a child, then returned to his native country in the 1860s for a period of study, during which he came under the powerful influence of Turner. Back in America, he made many trips to the Far West, usually on assignment to produce illustrations for such publications as *Harper's Weekly*, *Scribner's*, and Appleton's *Picturesque America*. The paintings he made on these expeditions are by no means merely illustrations, however, but succeed in capturing the grandeur of the spectacular scenery, without undue rhetoric.

Inevitably Moran's oils are compared with those of his contemporary Albert Bierstadt, and the comparison is not always to Moran's disadvantage since his paintings, although seldom as ambitious as Bierstadt's, are less blatantly ingratiating, less tailored to prevailing bourgeois taste. Instead of conjuring up an American Eden peopled with Noble Savages and brave pioneers, Moran set down what he saw as unadorned fact. This is especially true of his Western watercolors (PLATES 95–97). From his study of Turner, Moran had developed a formidable technique, unsurpassed by any of his contemporaries, that proved ideally suited to his subject matter, with the Rocky Mountains standing in, so to speak, for the Alps and the Apennines. From Turner, Moran had learned how to use layers of wash to establish richly varied tonal and chromatic accents, and, like the master, he did not hesitate to use Chinese white when necessary to pick out highlights or to give a painting an area of tapestrylike brilliance.

During this period of expansion the United States was still, of course, dependent upon the sea for its contacts with the outside world; hence, it is natural that a strong marine-painting tradition should have thrived alongside landscape painting. To a large

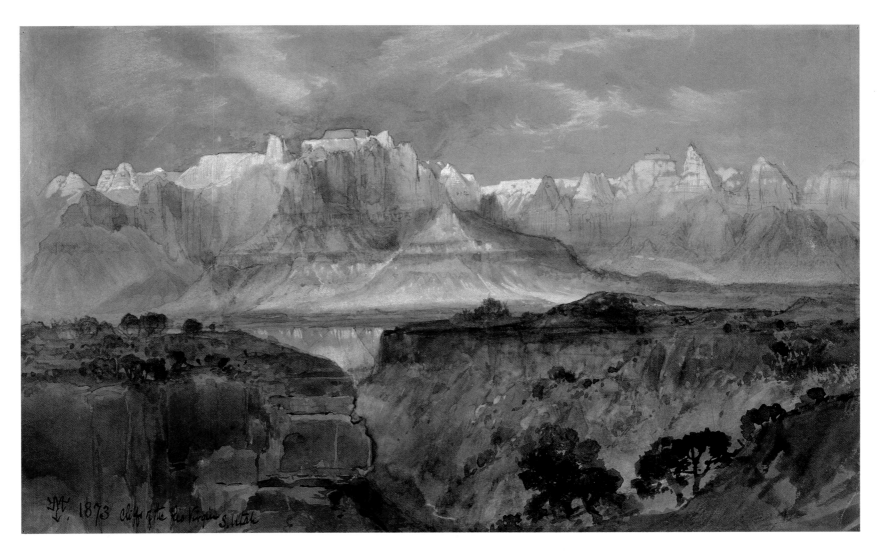

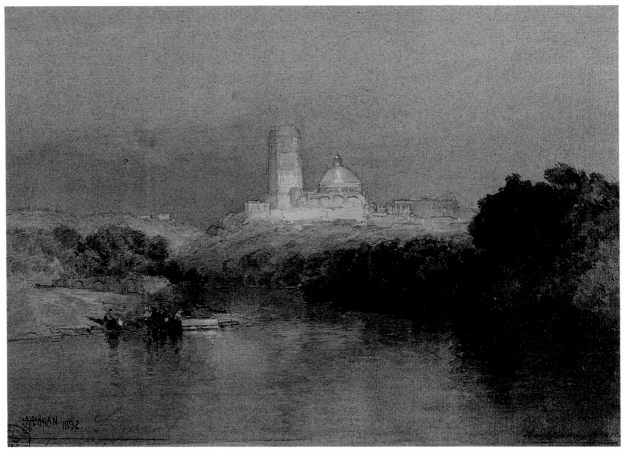

95. Thomas Moran (1837–1926).
Cliffs of the Rio Virgin, South Utah, 1873.
Watercolor, opaque white watercolor,
and graphite on paper, 8⅝ x 14 in.
Cooper-Hewitt Museum, The
Smithsonian Institution's National
Museum of Design, New York.

96. Thomas Moran (1837–1926).
*Hacienda on the Lerma River, San Juan,
Mexico,* 1892.
Watercolor, opaque watercolor, and
pen and red ink on paper, 8¼ x 11 in.
Cooper-Hewitt Museum, The
Smithsonian Institution's National
Museum of Design, New York.

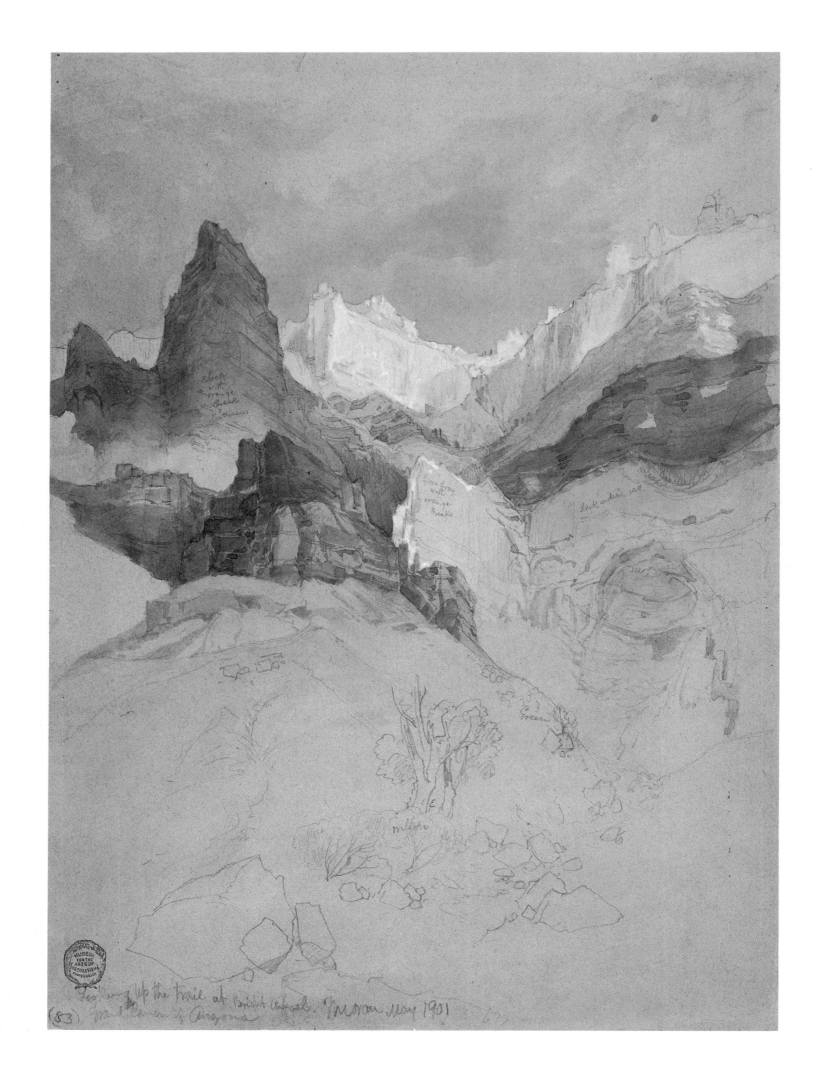

Looking up the trail at Bright Angel. Grand Canyon of Arizona. Moran May 1901

extent the two traditions ran parallel to each other (many artists contributed to both), and yet American marine painting displays its own distinct characteristics. The impact of the English school is felt here, too, but it is joined and sometimes eclipsed by Dutch and French influences. Also, because painting the sea often meant painting ships (with sail rapidly giving way to steam), it also attracted the kind of artist, sometimes from outside the mainstream, whose primary interest was in accurately setting down the lines of a Baltimore clipper or a Hudson River side-wheeler, so that ship portraiture was a genre that influenced much marine art.

It is natural enough that shipowners and captains would want visual records made of their vessels, and American sailors visiting the Mediterranean during the early decades of the nineteenth century discovered the Roux family of Marseilles, headed by Antoine Roux, Sr., whose members executed ship portraits in gouache on commission and were happy to add American seafarers to their list of clients (PLATE 98). Many of these gouaches made their way back to the United States and doubtless influenced the development of the American school.[2]

As far as is known, no member of the Roux family ever visited the United States, but Antoine's contemporary Michele Felice Cornè, a native of Elba, did spend the greater part of his career in the New World, emigrating to Salem, Massachusetts, in 1799 as a fugitive from the Napoleonic Wars. Evidently he was familiar with the conventions of ship portraiture current in Europe at the end of the eighteenth century, and

OPPOSITE:
97. Thomas Moran (1837–1926). *Looking up the Trail at Bright Angel, Grand Canyon, Arizona,* 1901. Watercolor, opaque watercolor, and graphite on blue paper, 14⅞ x 10⁹⁄₁₆ in. Cooper-Hewitt Museum, The Smithsonian Institution's National Museum of Design, New York.

BELOW:
98. Antoine Roux, Sr. (1765–1835). *Brig "Grand Turk" Saluting Marseilles,* 1815. Watercolor on paper, 17½ x 24¼ in. Peabody Museum of Salem, Massachusetts.

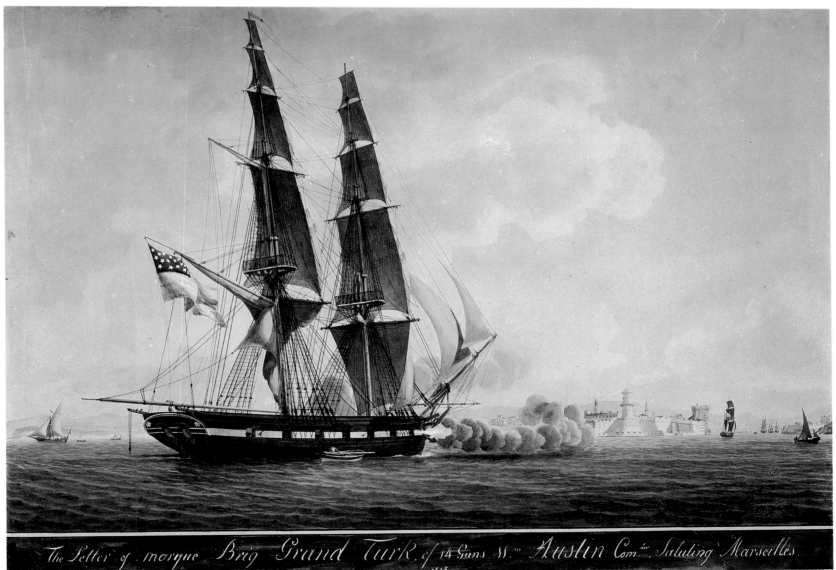

The Letter of marque Brig Grand Turk of 14 Guns W.ᵐ Austin Com.ᵈᵉʳ Saluting Marseilles.
1815

99. Michele Felice Cornè (c. 1762–1845).
Captain Cook Cast away on Cape Cod,
1802.
Watercolor on paper, 13½ x 15½ in.
Peabody Museum of Salem,
Massachusetts.

100. Fitz Hugh Lane (1804–1865).
Burning of the Packet Ship "Boston,"
1830.
Watercolor on paper, 19¼ x 27 in.
Cape Ann Historical Association,
Gloucester, Massachusetts.

he continued these traditions in America. He had a particularly happy knack, as John Wilmerding has pointed out, of being able "convincingly to fill the sails with light and air through crisp modelling of detail and an ability to model form."[3] He frequently worked in oil paint but was equally at home in gouache, in which he occasionally transcended his genre and produced marine paintings with genuine dramatic content, as in *Captain Cook Cast away on Cape Cod* (PLATE 99).

An oddity that bears an idiomatic resemblance to Cornè's *Captain Cook* is Fitz Hugh Lane's early *Burning of the Packet Ship "Boston"* (PLATE 100). Lane went on to master academic technique and became one of the leading marine painters of his generation, a founder of the style that eventually came to be known as Luminism. His later works, mostly oils, capture moments of almost preternatural calm. Like Cornè's painting, however, *Burning of the Packet Ship "Boston"*—made after sketches by the vessel's first officer and one of its passengers[4]—is full of Sturm und Drang and displays tremendous vigor. An 1851 view of Castine Harbor in Maine (PLATE 101) shows Lane's mature watercolor style, which, pleasant though it is, lacks the brilliance and sharp-focus clarity of his best oils.

Lane's work was firmly rooted in folk traditions, which continued to play an important role in American marine art throughout the nineteenth century. In particular, ship portraits lent themselves well to the strong graphic-design tendencies that characterize much folk art. Perhaps the best of the primitives in this field was James Bard, who was active from 1826 to 1890 and specialized in portraits of steamships (PLATE 102), sometimes in collaboration with his twin brother, John. Bard was meticulous in his attention to detail, actually measuring the vessels he painted. Typically, he depicted them from the port side, pennants flying in the breeze, and he peopled their decks with stiffly drawn figures frequently out of scale with the ships themselves.

Thomas Birch came to Philadelphia from England in 1794 along with his father, William Birch, a noted engraver. Thomas Birch learned to paint landscapes and seascapes by studying and copying the Dutch works in his father's collection. Birch was no great stylist—his paintings are frequently a trifle awkward though not to the extent that he should be considered a primitive—but he was an influential figure capable, on occasion, of infusing a subject with considerable energy, especially when portraying naval engagements from a patriotic point of view (PLATES 103, 104).

If Birch was British born but influenced by the Dutch school, Albert van Beest was Dutch born and influenced by the English topographers, from whom he learned to use transparent watercolor with a deceptively casual panache that made him one of the most

101. Fitz Hugh Lane (1804–1865). *Castine Harbor and Town*, 1851. Watercolor on paper, 10⅛ x 31⅛ in. Museum of Fine Arts, Boston.

102. James Bard (1815–1897).
 The Saratoga, 1881.
 Watercolor on paper mounted on
 linen, 29 x 52¾ in.
 New-York Historical Society.

103. Thomas Birch (1779–1851).
 *Attack on the American Privateer "Gen-
 eral Armstrong" at Fayal*, 1814.
 Watercolor and ink on paper,
 4¼ x 8 in.
 New-York Historical Society.

104. Thomas Birch (1779–1851).
 *Capture of the H.B.M. Brig "Avon" by
 the U.S. Sloop of War "Wasp,"* c. 1812.
 Watercolor and ink on paper,
 5½ x 8¼ in.
 New-York Historical Society.

delightful marine painters of the nineteenth century. After serving with the royal Dutch fleet, van Beest came to the United States and settled in Fairhaven, Massachusetts, across the Acushnet River from New Bedford. His *New Bedford from Fairhaven* (PLATE 105), painted soon after his arrival, employs a severely restricted chromatic range but is full of light and atmosphere and compares favorably with the best work of the British topographers. Even better is his *Lighthouse* (PLATE 106), painted a few years later. With its casual but effective composition and slightly comic cows, this lively painting has a distinctly Dutch inflection. Like Willem van de Velde the Younger, van Beest had the ability to make the viewer believe in the motion of the sea. Above all, though, he had a natural gift for using watercolor with a freshness and a spontaneity that were very rare in American art prior to the age of Winslow Homer.

ABOVE:

105. Albert van Beest (1820–1860).
New Bedford from Fairhaven, c. 1848.
Pen and brown and gray wash on paper, 12⁹⁄₁₆ x 28⅜ in.
Museum of Fine Arts, Boston;
M. and M. Karolik Collection.

LEFT:

106. Albert van Beest (1820–1860).
Lighthouse, 1850s.
Pencil and watercolor on paper,
9⅝ x 15⅞ in.
Museum of Fine Arts, Boston.

107. William Bradford (1837–1908) and
Albert van Beest (1820–1860).
New York Yacht Club Regatta, 1856.
Watercolor on paper, 21 x 36 in.
The Whaling Museum, New
Bedford, Massachusetts.

108. Worthington Whittredge
(1820–1910).
Study of Three Boats, 1856.
Pencil and gray wash on paper,
11¹¹⁄₁₆ x 16¹⁵⁄₁₆ in.
Museum of Fine Arts, Boston;
M. and M. Karolik Collection.

Less individualistic as a watercolorist, though still a major marine artist, was van Beest's close associate William Bradford. Bradford was born in Fairhaven and, for a while at least, shared his studio there with the Dutchman, with whom he occasionally collaborated, as is the case with a large-scale watercolor entitled *New York Yacht Club Regatta* (PLATE 107), prepared as a preliminary study for Bradford's oil of the same title. Where such collaborations were concerned, it was the two artists' custom for Bradford to paint the water and sailing vessels while van Beest contributed the sky and figures.[5]

Worthington Whittredge, an artist associated with the Hudson River School and also allied with the Luminist trend, occasionally painted marine subjects of a somewhat domesticated sort. He worked primarily in oil but was also capable of strong line drawings and deft wash studies, such as the sketch of rowboats reproduced here (PLATE 108). His younger contemporary Alfred Thompson Bricher was a skillful painter of seascapes whose highly finished watercolors were well regarded in his day. To the modern eye, however, his most interesting works are the loose sketches that he sometimes made, presumably for his own pleasure. His harbor view (PLATE 109) is of a decidedly unromantic subject, one that might have appealed to Whistler but would not have attracted the interest of many other artists during this period. In this painting Bricher displays a feel for the moment that is almost worthy of van Beest and that looks toward the freedom of handling that would characterize the mature work of the man who is arguably America's greatest watercolorist and America's greatest marine artist, Winslow Homer (see chapter five).

109. Albert Thompson Bricher (1887–1908). *Harbor,* late 1880s. Watercolor heightened with white on paper, 14½ x 20⁷⁄₁₆ in. The Brooklyn Museum; Gift of Mrs. Allison Clement Withers in memory of Grace Graef Clement.

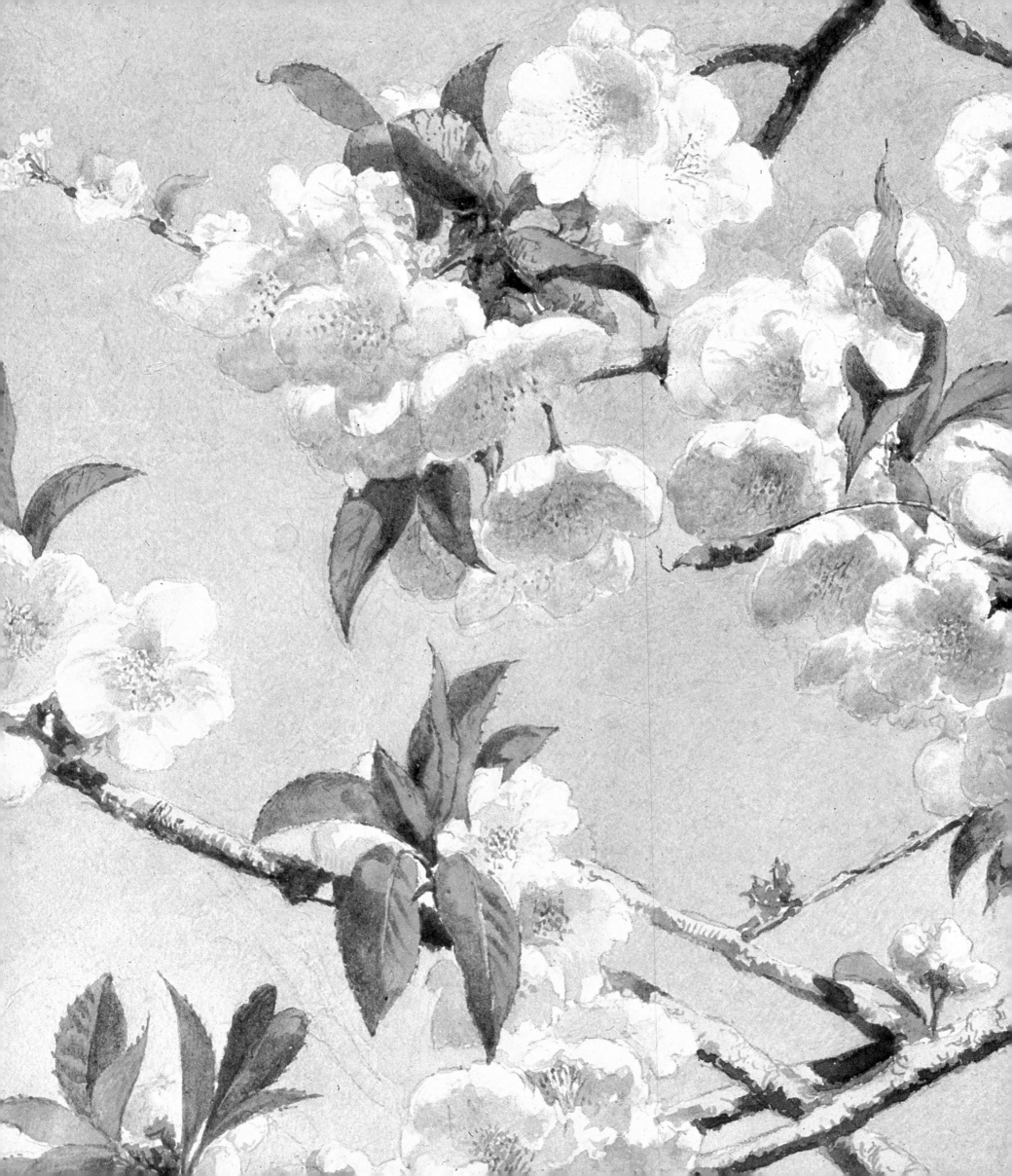

CHAPTER FOUR

ACADEMICS AND ORIGINALS

As the Victorian age reached its apogee two contrasting trends in American art became apparent. On the one hand, there was a tendency toward academicism and toward the formation of professional groups, which had the effect of institutionalizing the art world. On the other hand, there appeared a number of individual geniuses who, though they might belong to various societies and organizations, were gifted with highly personal visions that permitted them to transcend the limitations of academic art.

Such a distinction was also to be found in nineteenth-century Europe, of course, but in America the emphasis was somewhat different. In France, for example, the Académie was firmly established, and it was possible for someone to be a solid bourgeois citizen and an artist at the same time, as long as he had his diploma from the Ecole des Beaux-Arts and followed the rules that put him in line for the ribbon of the Legion of Honor and other official honors. The Académie was a haven for some, but it was also the monolith against which the Impressionists and other dissenters would revolt.

In America conservative and aesthetically adventurous artists alike were still scrambling for respectability. Certainly a handful of artists such as Church and Bierstadt earned great popularity and wealth by peddling America to Americans, but, despite the success of certain genres, wealthy American patrons generally preferred to acquire work by the old masters or by fashionable European contemporaries. Members of the newly rich provincial plutocracy wanted to certify their good taste by hanging the right French, English, and Italian names on the wall. In the face of this, American artists banded together largely as a way of reinforcing their self-esteem. Membership in one of the American mini-academies guaranteed nothing, however, not even respectability. To achieve success in mid-Victorian America an artist had to hit some note that caught the fancy of a largely unsophisticated public, a note that seldom had anything to do with aesthetic achievement.

One of the most successful painters in the United States during the second half of the nineteenth century was John G. Brown. Born and trained in England, Brown came to America in 1851 and a decade later hit upon a formula that was to keep him in comfort for the rest of his life. From that point on, working in both oil and watercolor, he specialized in portraits of male street urchins (PLATE 111)—preadolescent shoeshine boys and newspaper vendors, embryonic capitalists embarking upon the kind of rags-to-riches careers that Horatio Alger made popular in print (though Brown's first urchin pictures were painted several years before Alger's first novel was published). As James Thomas

110. John William Hill.
Apple Blossoms, c. 1867–74.
Detail of plate 119.

85

111. John G. Brown (1831–1913).
Perfectly Happy, 1885.
Watercolor on paper, 19 x 13 in.
Butler Institute of American Art,
Youngstown, Ohio.

112. Samuel Colman (1823–1920).
Lower au Sable, 1869.
Watercolor, pen and ink, and pencil
on paper, 5¾/16 x 9⁹/16 in.
The Brooklyn Museum; Dick S.
Ramsay Fund.

Flexner has pointed out, these winsome, mischievous boys were almost guaranteed to appeal to middle-class mothers, but their eagerness to make a buck made them popular with men, too, and Brown's paintings found their way into hundreds of collections, often those that contained no other works by American artists.[1] Significantly, Brown was an officer of several professional organizations, including the seminal American Society of Painters in Water Color, at whose exhibitions his works were hung alongside contributions from men such as Eakins, Homer, and Moran.

The model for most American academic institutions was England's Royal Academy, whose second president had been an American, Benjamin West. As far as watercolor was concerned, the most significant groups were the American Society of Painters in Water Color, launched in 1866 (in 1877 its name was changed to the American Water Color Society), and its predecessor, the New York Water Color Society, founded in 1850. Of the fifteen founders of the New York Water Color Society, nine were British born,[2] so that the group was understandably biased toward the traditions of the English school. This society organized the first comprehensive show of watercolors ever held in the United States, as part of the 1854 New York Exhibition of the Industry of All Nations. Far more important, however, were the activities of the American Society of Painters in Water Color, which from its inception held regular exhibitions at the National Academy of Design in New York, attracting almost immediately the work of the finest practitioners of the day.

The American Society's first president was Samuel Colman, who devoted a good deal of his long life to promoting the cause of watercolor. His own work is agreeable without being especially distinguished (PLATE 112). Like many artists of the period, Colman traveled extensively, in both Europe and the American West, making watercolor sketches wherever he went. His work had clear roots in the English landscape tradition, and much the same can be said of paintings by another founding member of the society, Jasper Cropsey, who visited England several times and lived there from 1856 to 1863 (PLATE 113). A more powerful exponent of the same general idiom was George Loring Brown. He, too, spent many years in self-imposed European exile, and the watercolors he sent back to America were, if not particularly original in viewpoint, exceptionally accomplished in terms of technique (PLATE 114). At his best Brown had the ability to build up solid forms from skillfully layered washes and occasionally displayed a sense of architectonic structure reminiscent of John Sell Cotman.

Artists like Colman, Cropsey, and Brown might be regarded as classicists where

113. Jasper Cropsey (1823–1900).
The Gates of the Hudson, 1891.
Watercolor over graphite on paper,
16¼ x 25⅞ in.
The Fine Arts Museums of San
Francisco; Achenbach Foundation for
Graphic Arts; Gift of Henry F.
Dickinson to the M. H. de Young
Memorial Museum.

114. George Loring Brown (1814–1889).
View of Palermo, 1841.
Watercolor on paper, 7¹/₁₆ x 8½ in.
Fogg Art Museum, Harvard Univer-
sity, Cambridge, Massachusetts; Gift
of Belinda L. Randall (from the John
Witt Randall Collection).

115. Louis Comfort Tiffany (1848–1933).
Oriental Scene, 1874.
Watercolor on paper, 24⅝ x 36⅝ in.
Detroit Institute of Arts; Gift of the
Archives of American Art.

116. Edwin Austin Abbey (1852–1911).
Stony Ground, 1884.
Gouache on paper mounted on a
stretcher, 28³⁄₁₆ x 48³⁄₁₆ in.
The Brooklyn Museum; Gift of Mr.
and Mrs. Abraham Adler.

their watercolor method is concerned. This approach, however, by no means dominated
the early exhibitions of the American Society of Painters in Water Color or the various
watercolor shows organized by other professional groups in cities such as Boston and
Philadelphia during the balance of the Victorian era. One of the great favorites of the
day, whose prices exceeded even those of John G. Brown, was Louis Comfort Tiffany,
who has found lasting fame as a master of Art Nouveau glass but who, in his time, was
equally well known as a watercolorist (PLATE 115). The son of Charles Lewis Tiffany,
founder of the jewelry firm, the younger Tiffany studied with Colman, but his natural
bent ran more toward the exotic. Like Moran, he seems to have learned a good deal
from Turner, but this influence mingles in his work with that of later British watercolor-
ists such as John Frederick Lewis, whose interests are more frankly anecdotal.

Anecdote ran rampant in the art of the Victorian era, and one of the artists who

best exemplify this is Edward Austin Abbey. Abbey, who spent much of his life in England, illustrated Shakespeare and was a noted muralist, but among his most popular works were elaborately planned historical subjects and genre scenes painted in watercolor or, as in the present example, gouache (PLATE 116). Like many Victorian artists, Abbey seems to have put more effort into researching the historical background of his paintings than conquering new aesthetic territory, but his draftsmanship was always immaculate and, given his decidedly literary aims, his handling of the medium was extremely competent.

Bridging the gap, somewhat, between the anecdotal painters and the followers of the classic English school are artists such as Albert Fitch Bellows. The author of *Water Color Painting: Some Facts and Authorities in Relation to Its Durability*, Bellows was capable of making relatively loose landscape studies but was better known for his highly finished exhibition paintings such as *Coaching in New England* (PLATE 117). There were few artists of the era, indeed, who did not differentiate between sketches made either for study purposes or for their own amusement and such highly finished work intended for public display. In part this seems to have been due to an impulse to make watercolors seem as important as oil paintings. In part it was also due to the pervasive influence of the British writer and theoretician John Ruskin, whose philosophy of art placed much emphasis on the notion that a certain kind of carefully observed, sharp-focus realism had inherent value.

117. Albert Fitch Bellows (1829–1883). *Coaching in New England,* 1876. Watercolor heightened with white on paper, 24⅞ x 35⅞ in. The Brooklyn Museum; Bequest of Caroline H. Polhemus.

118. Charles Herbert Moore (1840–1930). *Landscape: Rocks and Water,* c. 1872. Watercolor and gouache over graphite on off-white paper, 7½ x 10¾ in. Fogg Art Museum, Harvard University, Cambridge, Massachusetts; Transferred from the Fine Arts Department.

Artists of many inclinations were touched by Ruskin's thought, but the hard core of his disciples in America was drawn from the artists who grouped themselves together as the modestly named Association for the Advancement of Truth, which first met in 1863 in the studio of the British-born painter and printmaker Thomas Farrer. Among the watercolorists associated with this group were Farrer's brother Henry, John William Hill, his son John Henry Hill, Charles Herbert Moore, William Trost Richards, and Henry Roderick Newman. What united them, for a few years at least, was an almost evangelical admiration for Ruskin, which led to their being labeled American Pre-Raphaelites. In fact, they displayed little of the British Pre-Raphaelites' longing for a lost, Arthurian past and were primarily motivated by Ruskin's exhortations to artists to make a direct study of nature, where, he assured them, they would find universal truths revealed in a bramble thicket or a cluster of berries.[3]

What these American Pre-Raphaelites had in common with the British group was a predilection for detailed renderings, which again can be traced to Ruskin's doctrine that nothing in a picture should be vague, that one should, for example, be able to tell the difference between trap granite and red sandstone.[4] The fact that his American followers took him seriously is well illustrated by Charles Herbert Moore's *Landscape: Rocks and Water* (PLATE 118), in which the rocks are painted with a precision that would gladden a geologist's heart. Curiously, though, the effect of this is not to invest the painting with a greater feeling of naturalism but rather to lend it a dreamlike, surreal air. One almost expects to find one of Salvador Dali's watches melting into the sand.

John William Hill had been well known as a watercolorist long before he pledged allegiance to the Association for the Advancement of Truth. His earliest works were influenced by William Guy Wall and the topographers, and he was still working in that idiom when he became one of the founding members of the New York Water Color Society. Under Ruskin's influence, however, he adopted a very different style, using meticulous brushwork and stipple effects to build up great detail. In method, as in subject matter, his work came to resemble that of the British watercolorist William Henry Hunt, generally known as "Bird's Nest" Hunt. Although he continued to paint

ABOVE:
119. John William Hill (1812–1879).
Apple Blossoms, c. 1867–74.
Watercolor on paper, 8¾ x 15⅜ in.
The Brooklyn Museum; Museum
Collection Fund.

LEFT:
120. John William Hill (1812–1879).
Bird's Nest and Dogroses, 1867.
Watercolor on paper, 10¾ x 13⅞ in.
New-York Historical Society.

RIGHT:

121. John Henry Hill (1839–1922).
"Sunnyside" with Picnickers, 1878.
Watercolor on paper, 19½ x 29 in.
Sleepy Hollow Restorations,
Tarrytown, New York.

BELOW:

122. Henry Roderick Newman
(1843–1917).
Temple at Philae, 1892.
Watercolor on paper, 25¼ x 30¾ in.
Museum of Fine Arts, Boston; Pur-
chased from the artist; General fund.

landscapes, the elder Hill also narrowed his viewpoint to focus on such items as a dead bird, flowers (PLATE 119), and, inevitably, birds' nests (PLATE 120), all represented about life-size in a near-*trompe-l'oeil* style that was cozier and less hallucinatory than Moore's. John Henry Hill painted many pictures in the same style as his father's, though his handling of paint was generally a little looser. His most interesting work was achieved when he stood back from his subject a bit, as with his relatively large painting of picnickers on the grounds of Washington Irving's home, "Sunnyside" (PLATE 121).

Of the remaining watercolorists associated with the Pre-Raphaelites, Henry Roderick Newman, Henry Farrer, and William Trost Richards all did their most rewarding work outside the auspices of the Association for the Advancement of Truth. Newman spent much of his career in Italy and executed many of his most ambitious watercolors there and during his travels to other parts of Europe and throughout the Middle East. Sometimes the precisionism he had learned from the Ruskinites betrayed him, as in several large watercolors in which he combined Mediterranean landscapes with close studies of grapes, olives, roses, and other vegetation. In these paintings his attempt to render detail faithfully tends to drain the subjects of life: the grapes seem carved out of marble, the landscapes are airless, and the overall effect is decorative. In the paintings he made of architectural subjects, however, aims and method are well suited to each other, and the results are often impressive (PLATES 122, 123).

Despite his admiration for Ruskin, Henry Farrer seems to have been temperamen-

123. Henry Roderick Newman (1843–1917). *View of Santa Maria Novella,* 1879. Watercolor on paper, 18¼ x 22¼ in. Maier Museum of Art, Randolph-Macon Women's College, Lynchburg, Virginia.

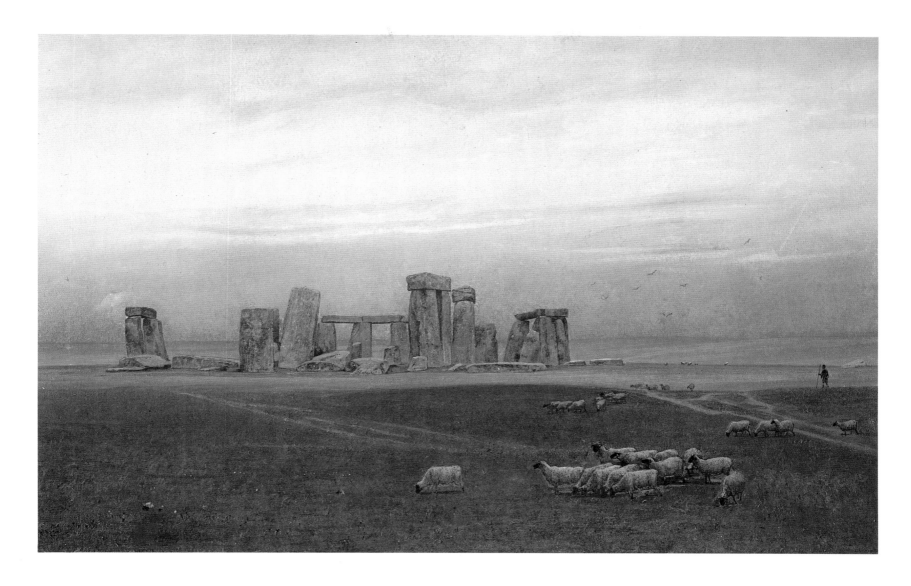

tally unsuited to the kind of close-focus work that was the speciality of John William Hill. Rather, he had a natural flair for landscape and seascape and an ability to handle wide panoramas in small formats. Using densely applied washes, sometimes heightened with gouache, Farrer was capable of evoking subtle effects of light and atmosphere (PLATE 124) somewhat in the Luminist vein of painters such as Martin Johnson Heade. William Trost Richards, once he had worked his way beyond the Pre-Raphaelite idiom, also produced many landscapes and seascapes in an idiom that came close to Luminism. He was a gifted exponent of both the small-scale, intimate watercolor (PLATE 125) and the larger-scale exhibition picture. His handsome *Stonehenge* (PLATE 126), which falls into the latter category, lacks the grandeur of Constable's treatment of the same subject (PLATE 14), but it is nonetheless a striking piece of work.

Associated with the American Pre-Raphaelites are two women artists, Nina Moore and Fidelia Bridges. Only one of Moore's watercolors has survived, and it is best seen as the work of a gifted amateur, one of the thousands of women artists who displayed a talent that was unfulfilled because of the constraints of Victorian society. Bridges, a student of William Trost Richards, falls into a somewhat different category, her gift being of a higher order and her surviving output being considerable enough to prove her an artist of distinction, even if her ambitions were limited. For the most part she confined herself to botanical studies, portraying a clump of grass or a vine-covered stump exactly as they would appear in their natural environment. *Milkweeds* (PLATE 127) is an exquisite little watercolor, every bit as fine as anything painted by her male counterparts and, not incidentally, imbued with far more life than is found in the work of the better-

OPPOSITE, TOP:

124. Henry Farrer (1843–1903).
A Grey Day, 1899.
Watercolor on paper, 12 x 18 in.
The Newark Museum; Mrs. Felix
Fuld Bequest, 1944.

OPPOSITE, BOTTOM:

125. William Trost Richards (1833–1905).
Calm before a Storm, Newport, c. 1874.
Watercolor on paper, 8⅞ x 13½ in.
The Brooklyn Museum; Dick S.
Ramsay Fund.

ABOVE:

126. William Trost Richards (1833–1905).
Stonehenge, c. 1882.
Watercolor and gouache on paper,
23½ x 36⅜ in.
The Brooklyn Museum; Gift of
George Klauber.

known American Pre-Raphaelites. Of all the group she is perhaps the one who followed Ruskin's advice most closely in that she focused on the minutiae of nature (although it should be acknowledged here that the American Pre-Raphaelites' interpretation of Ruskin's thought was very narrow and tended to ignore some of his bolder ideas). Indeed, for the greater part of her output Bridges concentrated almost entirely on plant life, though occasionally she would introduce architectural elements and small animals, as is the case with *Bird on a Gravestone* (PLATE 128).

Equally obsessed with close observation and detail, but for somewhat different reasons, were men like William Michael Harnett, John Frederick Peto, and John Haberle, who practiced the art of *trompe-l'oeil* still life. All three are known to have used watercolor, but the only evidence we have that any of them fully mastered the medium is Haberle's extraordinary *Trompe l'oeil: Yellow Canary* (PLATE 129), in which he makes brilliant use of transparent color.

OPPOSITE:
127. Fidelia Bridges (1834–1923). *Milkweeds,* 1876. Watercolor on paper, 16 x 9½ in. Munson-Williams-Proctor Institute, Utica, New York.

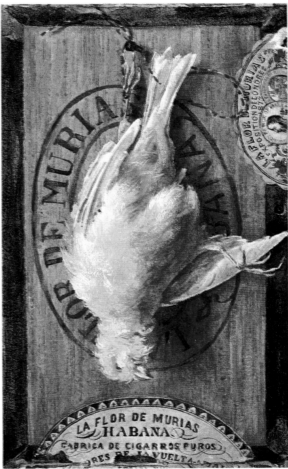

LEFT:
128. Fidelia Bridges (1834–1923). *Bird on a Gravestone,* 1876. Watercolor on paper, 17⅛ x 13⅛ in. Berry-Hill Galleries, Inc., New York.

ABOVE:
129. John Haberle (1853–1933). *Trompe l'oeil: Yellow Canary,* 1883. Watercolor and gouache on paper, 8 x 4¹⁵⁄₁₆ in. Yale University Art Gallery, New Haven, Connecticut; Gherardi Davis Fund.

Claude Raguet Hirst was a talented artist who, until she was in her mid-thirties, exhibited numerous still lifes of fruit and flowers at the National Academy of Design and elsewhere. In 1886, however, William Harnett moved into a studio next door to Hirst, on East Fourteenth Street in Manhattan. She apparently fell under his influence since, from about 1890 onward, she began to paint pipe and book still lifes in the Harnett idiom (PLATE 130).[5] Hirst brought nothing new to the subject, but she did paint it with considerable skill, and her predilection for watercolor gives her a special, if modest, niche in the history of American *trompe-l'oeil* painting.

The last quarter of the nineteenth century saw the United States undergoing tremendous changes. Rails now connected the Atlantic with the Pacific, and in 1890 the frontier was officially closed, an event of great psychological significance. More and more people crowded to the great cities of the Northeast and the Midwest, and in each of those cities—as well as in outposts like San Francisco—there arose a wealthy merchant class that had grown fat on the natural resources of the continent. This was a class that was aggressively nationalistic and not at all shy about voicing the notion that America deserved to become the center of the Western world, a conceit that was given spectacular expression in such outbursts of civic pride as the monumental World's Columbian Exposition staged in Chicago in 1893. The exposition celebrated the ascendancy of the New World, but its architecture was borrowed quite blatantly from such sources as the Arch of Septimus Severus in Rome and Brunelleschi's dome for the Florence cathedral. Nor were the lagoons that fronted the Court of Honor navigated by means of birch-bark canoes but by gondolas imported from Venice. Appropriately, then, when Thomas Moran—back from the mountains—painted the exposition, he did so in a style that echoed the grandest of Turner's Venetian watercolors (PLATE 131).

Along New York's Fifth Avenue, on the shores of Lake Michigan, and overlooking the Golden Gate, shipping magnates and railroad tycoons built marble palaces in which to install their collections of old masters carried back from Europe. Welcoming this American Renaissance, architects and decorative artists catered to the demand for aggrandizement by culling pediments, peristyles, and entire façades from French or

Italian models. Men like Stanford White sometimes managed to transform the purloined models into something genuinely American and magnificent (in the end, a railway station is not a cathedral), but at base this was just another form of provincialism grafted onto the native American stock that would prove more hardy in the long run.

It might be thought that the American Renaissance, with its emphasis on the monumental, would have provided an unsympathetic climate for an art form as inherently modest as watercolor. This proved not to be entirely the case, however. On the one hand, the American Renaissance was just a single aspect, however important, of a new self-confidence that permitted American artists of all persuasions to take their ambitions seriously. Also, the American Renaissance made fashionable once more the idea of the Renaissance man, a man capable of tackling any cultural task, large or small, and working in any medium.

One of the most fascinating figures of the era was John La Farge. An influential art writer and theoretician, a painter of Neoclassical murals, an innovative designer of stained glass, and a sometimes brilliant easel painter, La Farge struggled for decades to master watercolor. At times it must have seemed to him that his efforts were doomed to eternal frustration, but on other occasions he showed a real flair for the medium, and the keenness of his intellect, allied with the range of his curiosity, gave his best watercolors a resonance achieved by few of his contemporaries.

Born in New York to French parents, La Farge traveled to Europe in 1856. He was impressed by the work of the Barbizon painters and the Pre-Raphaelites and spent some time as a student at the atelier of Thomas Couture in Paris. Returning to the United States, he intended to study law but soon abandoned this idea and in 1859 went to Newport, Rhode Island, to study with William Morris Hunt. Later known for his portraits and murals, in the 1850s Hunt was the leading American advocate of the Barbizon style. While studying with Hunt, La Farge and another young artist, Chandler Bancroft (a fellow student was the future philosopher William James), began to make a serious study on their own of color theory, being influenced by such theorists as Michel Eugène Chevreul, whose writings would later have a decisive impact on Georges Seurat.

At about this time, or soon after, La Farge and Bancroft began to collect Japanese prints. Even by European standards, this places La Farge in the vanguard of those aware of Japanese art. (By way of comparison, note that Japanese motifs first appeared in Whistler's work in 1864.) Coincidentally, La Farge married, in 1860, a grandniece of Commodore Matthew Perry, the man who opened Japan to the West. Later La Farge traveled to Japan himself, and, although he seldom quoted directly from Japanese sources, the influence of Oriental art is often felt in his work. Significantly, he seems to have introduced many of his contemporaries, including his friend Winslow Homer, to the art of the Japanese print.

From 1869 onward La Farge devoted himself increasingly to decorative projects (PLATE 132) and to writing, but he remained a prolific watercolorist, one whose ambition sometimes outreached his ability. In the apt words of Theodore Stebbins, "Though he demonstrates at times a great sensitivity to color values, an understanding of pigment and paper, a willingness to take chances, and a knowledge of composition, these are seldom found together in one work."[6] *The Strange Thing Little Kiosai Saw in the River* (PLATE 133) is a good example of what is best and worst in La Farge's work. The subject alone—a severed head floating downstream (inspired by a Japanese story)—sets it off agreeably from the run-of-the-mill Victorian watercolor. The pigment is well handled and the blossom floating alongside the gruesome head adds an interesting Oriental touch, but at the same time there is something overwrought and illustrative about the painting. It simply doesn't work.

On the other hand, some of the sketches that La Farge made on his visits to Japan

132. John La Farge (1835–1910).
 Design for the C. C. Felton Window,
 Memorial Hall, Harvard University,
 1898–99.
 Watercolor on paper, 19⅛ x 14¾ in.
 The Brooklyn Museum; Museum
 Collection Fund.

133. John La Farge (1835–1910).
 The Strange Thing Little Kiosai Saw in
 the River, 1897.
 Watercolor on paper, 12¾ x 18½ in.
 The Metropolitan Museum of Art,
 New York; Rogers Fund, 1917.

and the South Seas (PLATE 134) display a freshness and spontaneity that few of his contemporaries could match. *Sunrise in the Fog over Kyoto* (PLATE 135), for example, effectively describes a landscape in a way that is totally removed from the tradition of the topographers. Line no longer performs a major function. Everything is expressed by juxtaposed patches of color, tone, and texture.

The finest of La Farge's watercolor achievements, however, are his flower paintings (PLATE 136), which he handled with the directness and unpretentiousness that he had applied to still lifes in oil toward the beginning of his career. The best of these flower

137. Thomas Eakins (1844–1916).
John Biglin in a Single Scull, c. 1873.
Watercolor on paper, 16¾ x 23 in.
The Metropolitan Museum of Art,
New York; Fletcher Fund.

138. Thomas Eakins (1844–1916).
*Perspective Study for "John Biglin in a
Single Scull,"* 1873–74.
Pencil, ink, and wash on paper, 27⅜ x
45³⁄₁₆ in.
Museum of Fine Arts, Boston; Gift of
Cornelius V. Whitney.

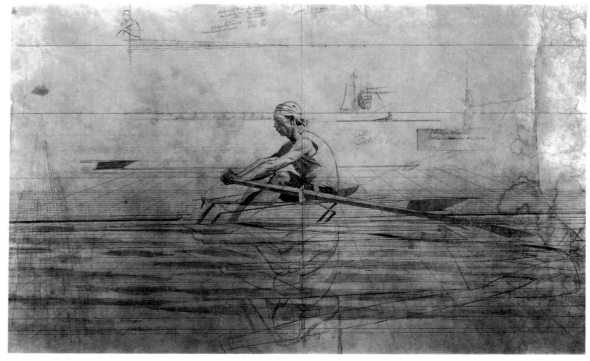

subjects can stand alongside any of the great nineteenth-century watercolors. They display a mastery of the medium that was hard-won and all the sweeter because of it.

La Farge was an artist who, in watercolor, was occasionally capable of approaching greatness. Thomas Eakins was a great painter who, almost incidentally, produced a few magnificent watercolors.

Eakins is the most sober of American painters, and yet there was something almost perverse about the workings of his genius, something that bade him to go against the grain. Nowhere is this more apparent than in his watercolors. When confronted by paintings such as *John Biglin in a Single Scull* (PLATE 137) or *Baseball Players Practicing,* one wonders why they were painted in watercolor rather than the oil paint that Eakins usually preferred. The answer appears to be that he was fascinated by the idea of using layers of transparent color to create luminous effects. (Eakins abhorred the use of opaque paint in any medium.) Beyond that, however, he seems to have bent over backward to avoid benefiting from the lessons of generations of watercolorists. Instead of enjoying the freedom of loose, flowing washes, Eakins frequently applied his paint in patches of densely grouped flecks of color. The technique is almost pedantic, yet when allied with Eakins's obsession with factuality and guided by his superior intuition, it produced extraordinary results.

Eakins was born in Philadelphia in 1844, the son of a writing master, and began his formal art training at the Pennsylvania Academy of the Fine Arts when he was about seventeen years old. Here he was forced to spend hundreds of hours drawing from antique casts before being finally permitted to work from life. (Female models wore masks to shield their identity from the students.) Simultaneously, Eakins took anatomy classes with the students at Jefferson Medical College—a highly unusual practice—dissecting corpses and attaining a knowledge of the human form unsurpassed among American artists.

In 1866 Eakins traveled to Paris and was accepted into the Ecole des Beaux-Arts, where he studied under the French academic master Jean Léon Gérôme. Eakins wrote many letters home, making no reference to having been impressed by (or even having noticed) the great naturalist masters of the day, such as Gustave Courbet and Edouard Manet. Instead, he seems to have been impressed primarily by the academics, Gérôme in particular, though Eakins did deplore the artificiality of much official art, especially the sort that was arbitrarily peopled with naked women doing nothing that related to his own experience in the world (his own experience of the world was always paramount in his mind).

Before returning home four years later, Eakins traveled to Italy, Germany, and, most important, Spain, where he discovered Velázquez and Ribera at the Prado. He found their vision so sympathetic that he elevated them to a preeminent place in his personal pantheon. Back in Philadelphia he settled into the studio that awaited him on the top floor of his father's house and promptly turned his attention to the people of his native city, portraying them at home, at work, or enjoying the countryside and waterways. This subject matter was to satisfy him for the rest of his life, and one of its early fruits was *John Biglin in a Single Scull.*

This is the second of two versions of the subject (the first has been lost) that Eakins sent to his master, Gérôme, for criticism. A true product of the Ecole des Beaux-Arts, Eakins prepared for this painting by first making a large-scale perspective drawing (PLATE 138). He also made an oil study of John Biglin seated in his shell, apparently to establish the sculler's pose on a slightly larger scale than he would be using in the final painting (interestingly, a nearly identical pose is to be found in *The Biglin Brothers Rowing,* an oil that may have been painted before the watercolor).

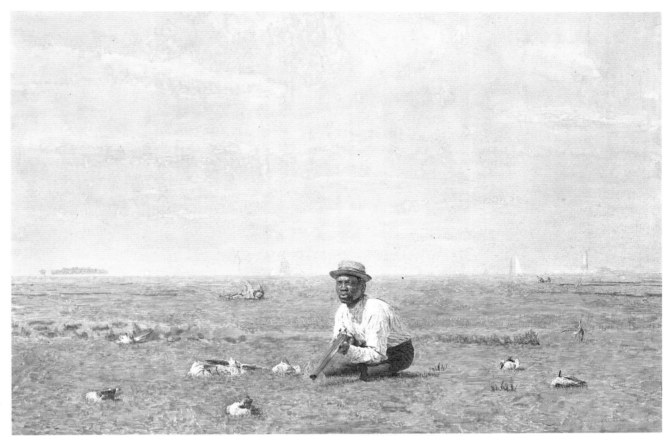

139. Thomas Eakins (1844–1916).
Whistling for Plover, 1874.
Watercolor on paper, 11¼ x 16¹¹/₁₆ in.
The Brooklyn Museum; Museum
Collection Fund.

140. Thomas Eakins (1844–1916).
Baseball Players Practicing, 1875.
Watercolor on paper, 10⅞ x 12⅞ in.
Museum of Art, Rhode Island School
of Design, Providence; Jesse Metcalf
Fund and Walter H. Kimball Fund.

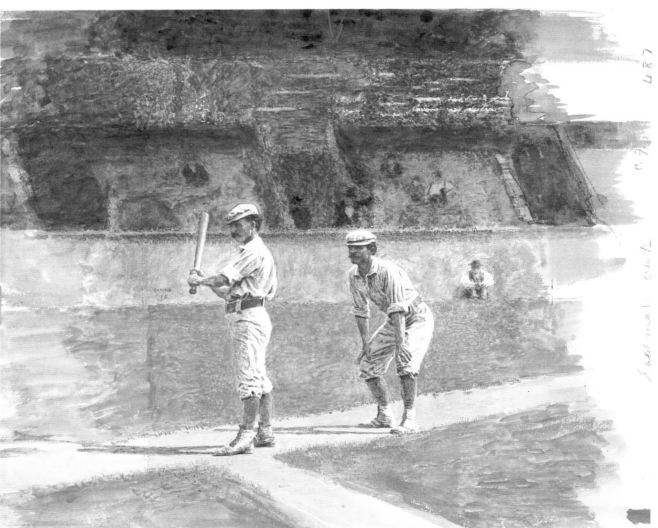

The Biglin watercolor has none of the improvisational esprit that marks most great work in the medium, but seldom has watercolor been used to define surfaces—from the glitter of the water to the knotty muscularity of the oarsman's arm—with such precision. The subject is one that might have attracted the Impressionists, but Eakins never allowed himself to be seduced by mere impressions. He was attempting to set down facts, and the painting's brilliance results from the fact that this obsession with reality did not overwhelm the poetry of the moment.

Eakins exhibited this painting in the 1874 exhibition of the American Society of Painters in Water Color. The following year he sent *Whistling for Plover* (PLATE 139), one of the most atmospheric of his watercolors. The crouching hunter is held in sharp clarity, but everything else—the distant sailboats, the receding plane of the marsh— seems shimmeringly out of focus, which reminds us that Eakins was an expert photographer who sometimes used the camera to assist him in planning his paintings. There is no evidence to suggest that this was the case here, but we may be sure that Eakins brought a knowledge of such scientific concepts as depth of field to all his compositions.

Baseball Players Practicing (PLATE 140) is a splendid figure study, but beyond that it provides an opportunity to understand a little more about Eakins's watercolor technique. The reason for this is that the painting appears unfinished, though Eakins exhibited it alongside *Whistling for Plover* and *Drifting* (PLATE 141) at the 1875 American Society of

141. Thomas Eakins (1844–1916).
Drifting, 1875.
Watercolor on paper, 10¾ x 16½ in.
Private collection.

Painters in Water Color show and later sent it to the 1876 Centennial Exhibition in Philadelphia. It can be seen that Eakins's watercolors, despite the stippling used to define tone and to model form, are in fact built over washes—washes that in this instance seem almost clumsily laid down. Eakins was not, of course, a clumsy painter and knew very well what he was about. The fact is, however, that no responsible teacher could point to this painting as offering a lesson in basic watercolor technique. The average watercolorist employing Eakins's methods would end up with a mass of clotted, muddy pigment. Only Eakins's superb draftsmanship and his knowledge of color, along with the virtuosity of his brushwork, make the painting work.

The third Eakins painting shown at the 1875 watercolor exhibition comes much closer to being a conventional watercolor, somewhat in the Luminist tradition. *Drifting* shows that Eakins could hold his own with any of the great marine painters and, not incidentally, that he could lay down washes with great clarity and delicacy when he chose to. More than any other painting, it illustrates how obsessed with light Eakins was at this stage of his career.

By 1877, when he painted *Young Girl Meditating* (PLATE 142), Eakins was already moving toward the intense involvement with delineation of character that was to predominate in his later work. This diminutive painting is modest in its ambition but shows Eakins's skill at capturing mood and likeness. The planes of the face are conveyed with the utmost economy. As always with Eakins, the hands are wonderfully expressive, and the handling of the paint is freer than in most of his watercolors, especially in the way he has used relatively calligraphic strokes to portray the folds of the satiny dress.

Painted the following year, *Negro Boy Dancing* (PLATE 143) is again most interesting as an example of Eakins's willingness to grapple with character. As Donelson Hoopes has pointed out, Eakins was one of the first major American white artists to treat blacks as individuals rather than stereotypes and each of the three figures here is presented as a full-length portrait in miniature.[7] As with *John Biglin in a Single Scull*, Eakins used larger

BELOW, LEFT:

142. Thomas Eakins (1844–1916). *Young Girl Meditating*, 1877. Watercolor on paper, 8¾ x 5½ in. The Metropolitan Museum of Art, New York; Fletcher Fund, 1925.

BELOW, RIGHT:

143. Thomas Eakins (1844–1916). *Negro Boy Dancing*, 1878. Watercolor on paper, 18⅛ x 22⅝ in. The Metropolitan Museum of Art, New York; Fletcher Fund, 1925.

144. Thomas Eakins (1844–1916).
Drawing the Seine, 1882.
Watercolor on paper, 8 x 11 in.
Philadelphia Museum of Art; John G.
Johnson Collection.

oil sketches to establish the pose of both the banjo player and the boy. The old man is also a well-realized character, yet there is something curiously awkward about the way the figures relate to one another and to their environment.

Hoopes remarks that "the boy dancing and the banjo player seem quite independent from one another in feeling. Eakins may have observed and sketched them separately, joining the two together in a composition at a later time."[8] Beyond that, however, the setting is oddly insubstantial. The two green chairs are solid enough, but the table behind the banjo player seems to melt into the wall, which is rather crudely suggested with blotchy patches of wash. Despite the placement of the cast shadows, only the baseboard and the portrait of Abraham Lincoln and his son hanging on the wall discourage the viewer from reading the background as neutral, receding space. Whether intentionally or not, the effect is to draw the viewer's attention to the figures themselves and to the consummate skill with which they are delineated. *Drawing the Seine* (PLATE 144) dates from 1882, near the end of the only period during which Eakins used watercolor with any consistency. Technically, it relates to images like *Whistling for Plover,* though the handling is decidedly freer.

Eakins's career would continue for another three decades, his uncompromising attitudes and views winning him a few champions and many enemies. In 1886 he was even forced to resign his position as director of the Pennsylvania Academy School, having insisted that a nude male model pose for an all-female class. This did nothing to deflect him from his chosen path, and he went on to paint such masterpieces as *The Agnew Clinic* (1889) and *Between Rounds* (1899), not to mention dozens of insightful portraits. Watercolor, however, would play an inconsequential role in these later stages of his career.

With his blend of homegrown poetic vision, scientific curiosity, and high moral purpose, Eakins deserves to be considered one of the great American Victorians—men as dissimilar as William James and Walt Whitman—who were able to embody the spirit of their times without being subject to the cant and hypocrisy that blunted the talents of so many lesser men.

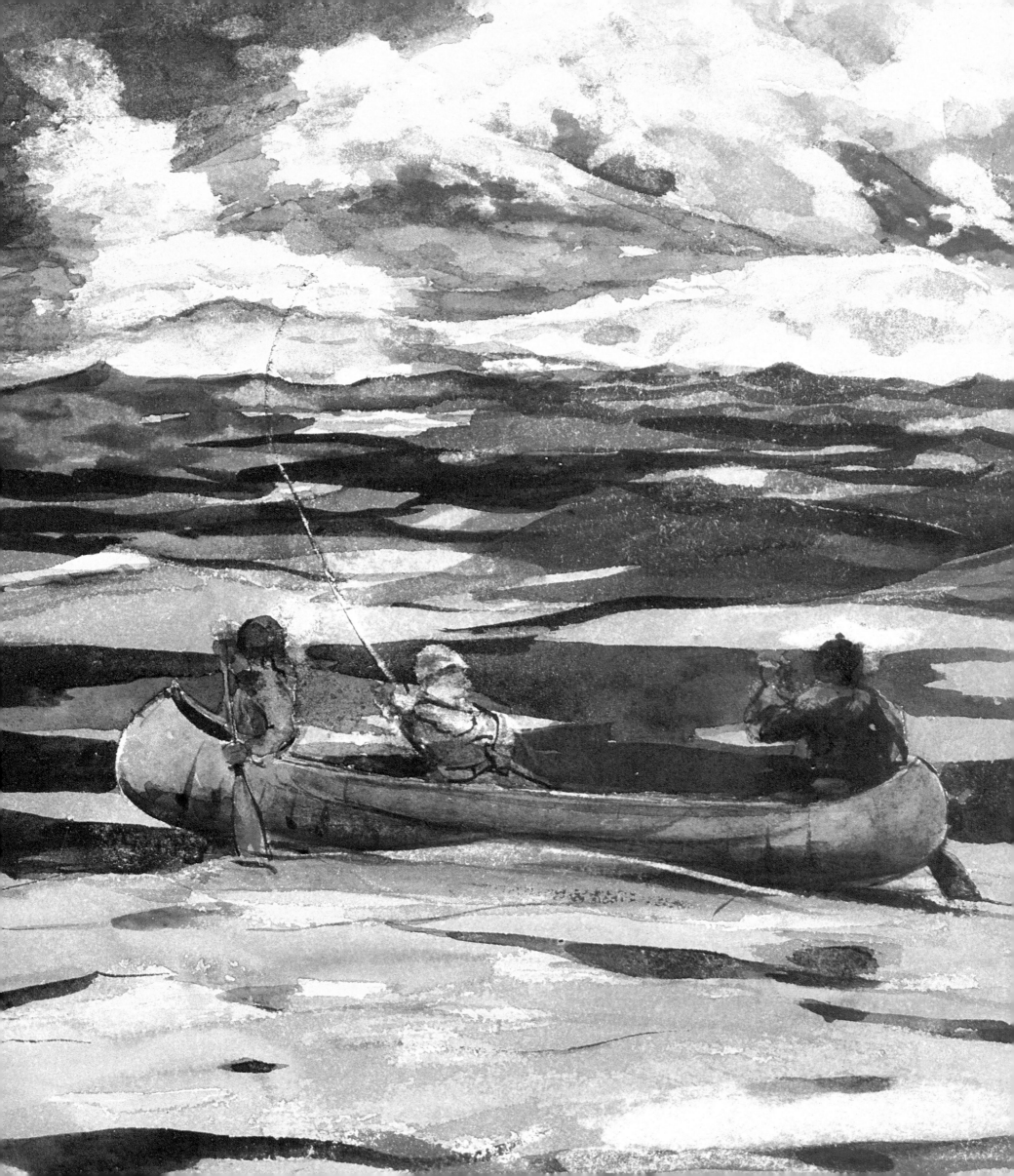

CHAPTER FIVE

WINSLOW HOMER

If Thomas Eakins's contributions to the watercolor tradition are somewhat eccentric, those of his greatest American contemporary, Winslow Homer, are absolutely central to the mainstream. Indeed, insofar as American watercolor is concerned, they are the very source of the mainstream. What Homer and Eakins had in common might be described as a fundamentalist belief in the painter's responsibility to portray the verities of the known world and to remain faithful to himself. To be himself, needless to say, meant to be an American—aware of European trends, certainly, but not in thrall to them.

This said, Homer and Eakins were very different in personality. Despite his tendency to go against the grain, Eakins was plainspoken and straightforward, while Homer was among the most ambiguous of artists, ambiguous to the point of mystification. Clearly one of the most intelligent and thoughtful painters of his generation, he seldom deigned to comment upon his own work or that of others. Something of a dandy, he nonetheless came to feel most at home in rough-and-ready worlds such as those of the hunter and the fisherman. His attitude toward the opposite sex is particularly hard to fathom. In his younger days he seems to have romanced many young women, tending to place them on pedestals (a fact that is reflected in his work). He never married, however, and spent the latter half of his life as a virtual misogynist.

Born February 24, 1836, in Boston, Homer grew up in a middle-class household (his mother was an accomplished amateur watercolorist), and in his late teens he was apprenticed to John Bufford's local lithographic shop. On his twenty-first birthday Homer left Bufford to pursue a career as a free-lance illustrator, a calling that took him to New York, where he became established as a contributor to *Harper's Weekly,* providing drawings from which the periodical's woodblock illustrations were cut. From the start Homer had a notable gift for draftsmanship and character delineation. Among his assignments for *Harper's* was coverage of the Civil War, and this provided him with the subject matter for his first serious oil paintings. When his *Prisoners from the Front* was exhibited in 1866 it established him overnight as a painter worthy of attention.

Homer's war paintings were marked by a matter-of-fact realism that was to become his trademark during the next decade and a half, when he painted many American genre subjects whose down-home, Mark-Twainish plainspokenness was often softened by a somewhat sentimental attitude toward women and children. In 1866 he visited France, where he remained for close to a year, a period that has caused art historians considerable irritation since he, typically, saw no reason to leave a record of what he saw or admired there. (He did remark once that he would not cross the street to look at a Bouguereau, one of his more long-winded statements about art.) If he was impressed by the work of the younger French artists—assuming he saw such work—it did not have any profound effect on his own style, even though certain works of the late 1860s, such

145. Winslow Homer.
Under the Falls, the Grand Discharge, 1895.
Detail of plate 157.

146. Winslow Homer (1836–1910).
The Berry Pickers, 1873.
Watercolor on paper, 9¼ x 13⅛ in.
Colby College Art Museum,
Waterville, Maine.

as the beach scene titled *Long Branch,* now at the Museum of Fine Arts, Boston, do display a kinship with contemporaneous works by the Impressionists.

Interestingly, Homer does not seem to have seriously applied himself to the water-color medium until 1873, by which time he was already thirty-seven years old and a prominent figure in the New York art world. Certainly he had used wash to heighten drawings before, and he had exhibited a single painting at the American Society of Painters in Water Color as early as 1871, but that summer of 1873, while vacationing in Gloucester, Massachusetts, he painted a whole series of charming watercolors, such as *The Berry Pickers* (PLATE 146), many of which later served as the basis for illustrations in *Harper's.* (In the woodblock process, the final image was drawn by the artist directly onto the block itself, which is how a draftsman like Homer could retain a distinctive personality even though the actual carving of the block was done by someone else. The studies for the final drawings were usually made in pen or pencil, but watercolor—or oil paint, for that matter—could serve just as well.)

Homer having been uncommunicative about such matters, there is no way of knowing why he turned to watercolor when he did. Presumably, the portability of the medium had something to do with it, and he must have been aware of the enthusiasm that friends and colleagues such as La Farge were bringing to watercolor painting. The important thing is that Homer discovered that he had a gift for the medium when there

was no independent American watercolor tradition. Within a few years he forged a style so distinctive and powerful that he was to emerge as a primary influence—perhaps *the* primary influence—on the evolution of that tradition. It was not Homer's style itself that helped launch the tradition, however—he perfected it to the extent that followers could appear to be only imitators—but rather the example of his boldness, of his ability to take the fundamentals of the British idiom and push them to new limits. His success showed the watercolorists who came afterward that Americans could be innovators, too—if they were prepared to take the necessary risks.

At first, though, Homer's watercolors were charming exercises rather than tradition-smashing statements. From the very beginning he displayed a clear grasp of how to use washes to evoke light and shadow, and he had an instinctive flair for the calligraphic economy that is so fundamental to classic watercolor technique. Nor were his early watercolors limited to landscape subjects in the British tradition. The Gloucester paintings have strong landscape elements, but, perhaps because Homer always had his illustrating chores in the back of his mind, they were primarily group character studies, such as *The Berry Pickers* or *The Clambake* (PLATE 147), which are not unlike Homer's oils of the period, though fresher and freer in handling. The figures were called to life with an easy facility that again reminds us of Homer's roots in the graphic arts, and his ability to deal so casually with relatively complex groups of characters sets him apart from his contemporaries among American watercolorists.

These first Gloucester watercolors are especially loose and spontaneous. Later in the 1870s Homer retreated somewhat from that spontaneity and produced more studied watercolors, using the medium as a convenient substitute for oil paint in certain of his pleasant but rather contrived genre scenes. A typical example of this period is *The*

147. Winslow Homer (1836–1910).
The Clambake, 1873.
Watercolor on paper, 8⅜ x 13⅞ in.
Cleveland Museum of Art; Gift of
Mrs. Homer H. Johnson.

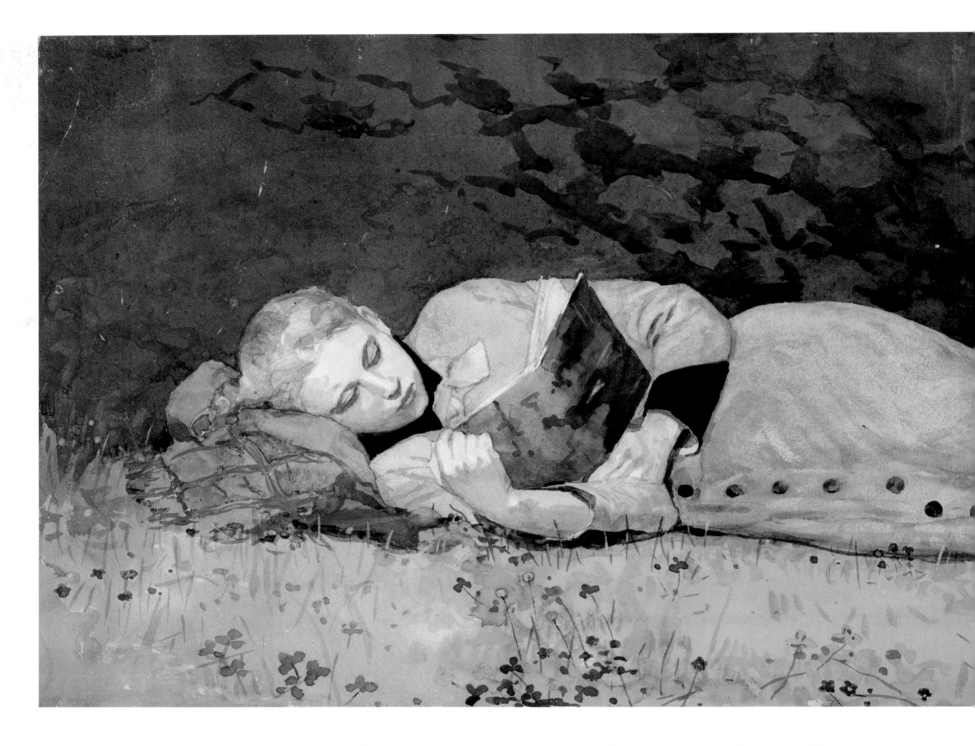

148. Winslow Homer (1836–1910).
The New Novel, 1877.
Watercolor on paper, 9½ x 20½ in.
Museum of Fine Arts, Springfield,
Massachusetts; The Horace P. Wright
Collection.

Trysting Place (PLATE 149), an 1875 painting in which the figure is rather too artfully posed. Around this period he often used the same auburn-haired model, occasionally catching her in a more casual pose, as in *The New Novel* (PLATE 148), which shows that his watercolor technique was maturing rapidly. The figure is evoked in a painterly rather than graphic way, and the foreground vegetation is touched in with a succinctness that has an almost Oriental quality.

Homer continued to work as an illustrator until his increasing success in the mid-1870s enabled him to concentrate on his career as an easel painter. In 1881, when he was forty-five years old, he made a second extended trip to Europe, this time settling for close to two years in Cullercoats, an English fishing village near Tynemouth, where the North Sea batters the Northumberland coast. Here Homer's work underwent a major metamorphosis, and his watercolors began to take on the boldness that was to mark his mature work in the medium. Whether this was due in any way to exposure to the art of the great British watercolorists is open to speculation since Homer left no record of what

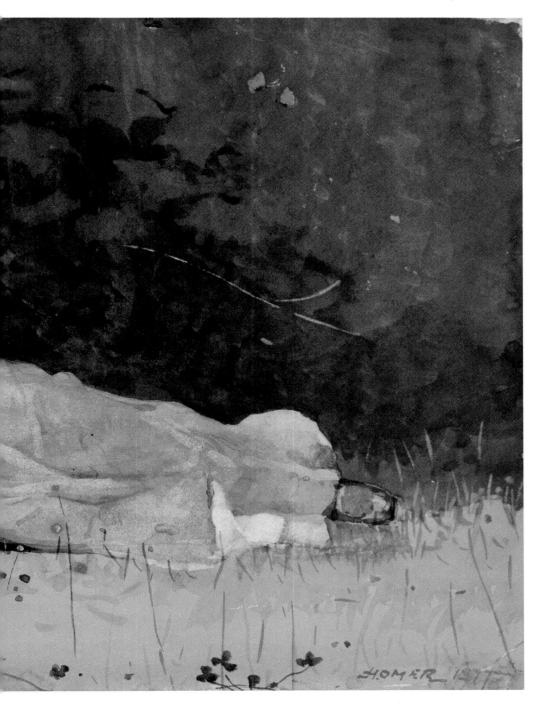

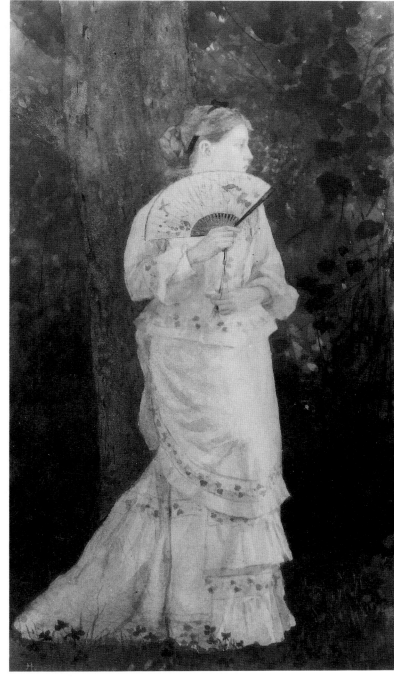

art he saw on this trip. It is known that he exhibited at the Royal Academy in 1882, which suggests that he must have had some contact with the contemporary London art world, and, given the rapid evolution of his watercolor technique, it seems likely that he sought out examples of works by British masters of the recent past.

The remarkable thing about Homer, however, is that the more he was exposed to other people's art, the more his became his own. It is as if he possessed some magnificently efficient built-in system for protecting his own artistic identity. What he had absorbed on his visit to France served only to toughen his native pragmatism and single-mindedness. During his stay in England he was, it is true, deflected once and for all from his gentle American genre scenes, being forced to respond to irresistible local subject matter, but he made the subject his own. The fisherfolk he portrayed remained natives of Cullercoats, but they were perceived through his Yankee eyes.

The fierce power of the North Sea is well known today to the American oil men who crew the drilling rigs erected above its choppy waters. Not a few have lost their

149. Winslow Homer (1836–1910). *The Trysting Place*, 1875. Watercolor on paper, 13⅞ x 8⅛ in. Princeton University, Princeton, New Jersey.

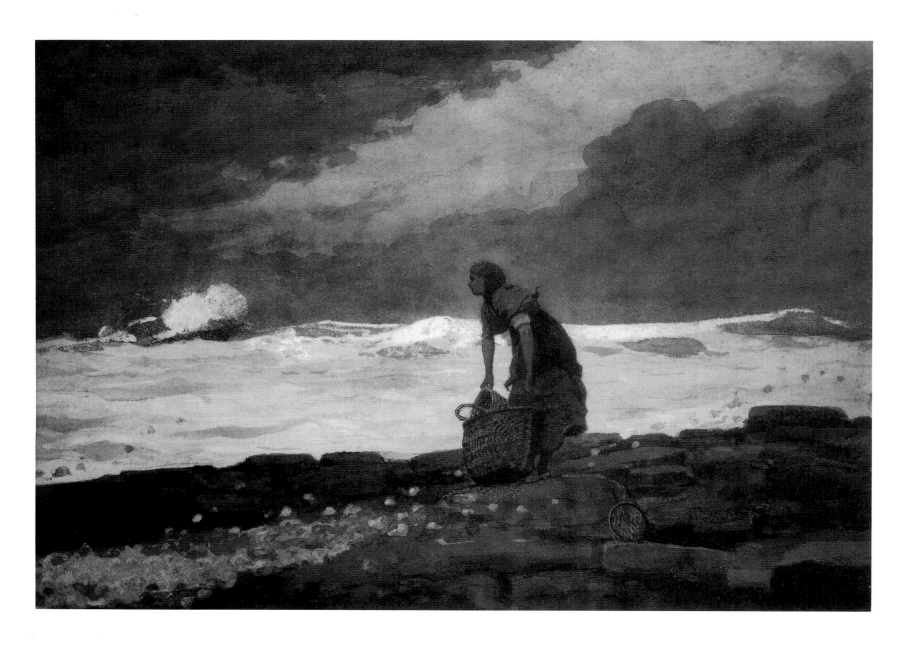

150. Winslow Homer (1836–1910).
Girl in Red Stockings (Fisher Girl),
1882.
Watercolor on paper, 13¼ x 19³⁄₁₆ in.
Museum of Fine Arts, Boston; Bequest of John T. Spaulding.

lives to its fury. A shallow sea, teeming with marine life, it has long been notorious among fishermen for its sudden storms, unpredictable riptides, and shifting shoals, all of them threatening the safety of anyone who depends on the sea for a living. Even now these are dangerous waters, but a century ago, when Homer was witnessing the life struggle of the Northumberland fisherfolk, men took to the North Sea in all but the worst weather in flimsy skiffs and fishing smacks. Villages like Cullercoats were full of widows and fatherless children.

Living in a small cottage, Homer observed village life as closely as a stranger could, and one suspects that the Northumbrians, a dour and parochial breed, must have found the dapper American something of an enigma. He recorded what he saw in numerous drawings—often in charcoal heightened with chalk—and watercolor sketches. From these he worked up finished watercolors such as *Girl in Red Stockings* and *Inside the Bar, Tynemouth* (PLATES 150, 151), some of which were not, in fact, made until he returned to America but which are generally referred to collectively as the Tynemouth paintings (Cullercoats being part of the parliamentary borough of Tynemouth).

Sometimes these paintings focus on the menfolk of Cullercoats, but more frequently it is their wives, sisters, and daughters who hold the foreground. As in Homer's American genre scenes, these women tend to be seen through a distorting lens of Victorian sentimentality, but the sentimentality is no longer overly sweet. Now it takes the

form of a rather stagey heroism that Homer imposed upon his surprisingly handsome fishwives, who—bare-armed even in the rawest weather—tend to look like fugitives from a Greek pediment rather than poor working women.

Inside the Bar features a lone woman facing sternly into a stiff offshore wind, her mussel basket on her arm. She is beautifully drawn, but it is impossible to overlook the artificiality of her pose, and the figure carries a ballast of symbolic significance—she stands for all women who watch and wait—that would weigh down the most buoyantly optimistic spirit. She seems like a forerunner of the peasant heroines who would soon crowd the officially sanctioned canvases of postrevolutionary Russia.

This stilted figure notwithstanding, the viewer is confronted with one of the finest marine paintings ever made by an American to that date. Like other Tynemouth paintings it makes a feature of water that seems to reflect more light than could be radiated by the overcast sky. In part this is due to the churning of the surface by tide and wind, but it is chiefly an accurate account of the way water catches the morning light as one looks seaward from an eastern-facing shore with the sun still low in the sky. It should be noted, too, that Homer, though fundamentally a classicist when it came to the use of transparent washes, was not averse to employing opaque Chinese white when he wanted to evoke a glint or glare or milky foam in his seascapes.

Homer's backgrounds had always been true to nature, but now it was nature in its more violent aspects that he set himself to capturing. Aside from the foreground figure, every detail of *Inside the Bar* rings true. The angle at which the boats meet the current tells us exactly how each helmsman is having to adjust to counter the forces of wind and tide. The breakers beyond the sandbar are muddy with particles stirred up from the shallows. Clearly Homer was setting down something he had observed with great care. Such precise observation is a consistent attribute of Homer's oeuvre, and it was to pay off in his great final period, when everything but truth to nature was eliminated from his

151. Winslow Homer (1836–1910). *Inside the Bar, Tynemouth,* n.d. Watercolor on paper, 15⅜ x 28½ in. The Metropolitan Museum of Art, New York; Gift of Louise Ryals Arkell, 1954, in memory of her husband, Bartlett Arkell.

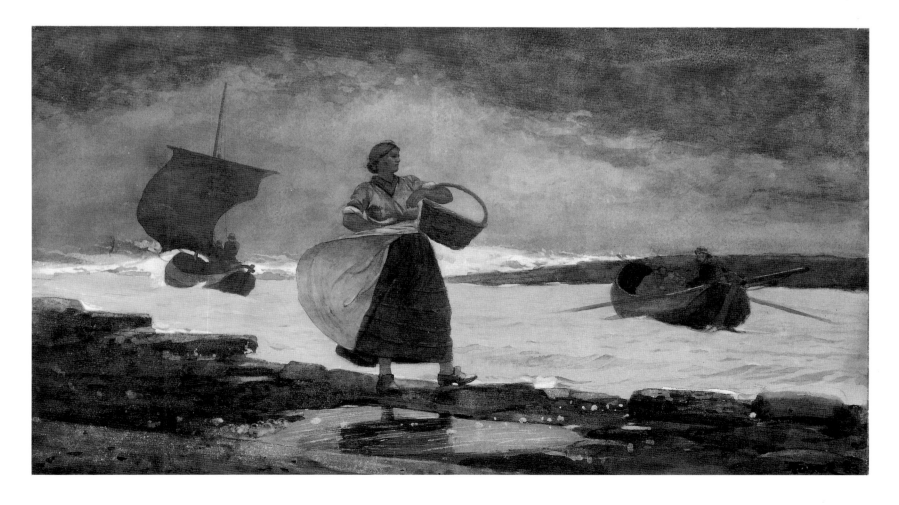

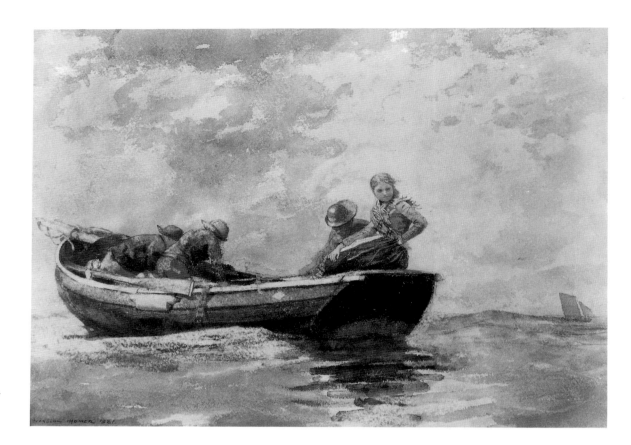

152. Winslow Homer (1836–1910).
Fisherfolk in Dory (*Tynemouth Series*),
n.d.
Watercolor over graphite on wove
paper, 13¼ x 19 in.
Fogg Art Museum, Harvard Univer-
sity, Cambridge, Massachusetts;
Anonymous gift.

watercolors, which came to occupy an increasingly important position in his output.

Back in America, Homer found that big-city life was no longer necessary to his art, and in 1883 he moved to Prouts Neck, Maine, where his family already owned property. Here, in a studio that faced the ocean from a rocky bluff, the artist made his home for the rest of his life, gradually moving toward a more direct aesthetic confrontation with the forces of nature, a confrontation that no longer required stoic fishwives to serve as melodramatic mediators. Remarkably, almost all the work that would ensure Homer's high standing in the history of American art was painted after his fiftieth birthday, and much of that work was to be in watercolor.

In 1883, during his first summer at Prouts Neck, Homer painted the exquisite *Maine Cliffs* (PLATE 154). With its high horizon line, indicated by a sliver of blue ocean, *Maine Cliffs* has a modern, almost abstract look that would make it seem at home alongside work by the most advanced of his European contemporaries. It has a sense of architectural structure that calls to mind the work of Cézanne, three years Homer's junior. The two artists would pursue very different courses, but they had in common the ability to derive strength from the careful and vigorous observation of nature.

Homer was to paint other fine Maine watercolors, but he used his time at Prouts Neck primarily for work on oils while saving watercolor principally for painting from nature—or at least after nature—on the many extended trips he took both to the wilderness of the north woods and to more tropical climes. In the winter of 1884–85 he traveled to the Bahamas and Cuba, celebrating his forty-ninth birthday during the course of the expedition. The next year he made the first of several excursions to Florida, and in 1899 Bermuda was added to his southern itinerary. Meanwhile, Homer and his brother Charles made regular summer and fall hunting expeditions to the Adirondacks and to Quebec. Since Homer reached his prime as a painter in the mid- to late 1880s and retained his full powers almost to the end of his life, it is most useful to consider the watercolors of this last quarter-century by theme rather than chronology, themes that are determined chiefly by the locations in which the various works were made.

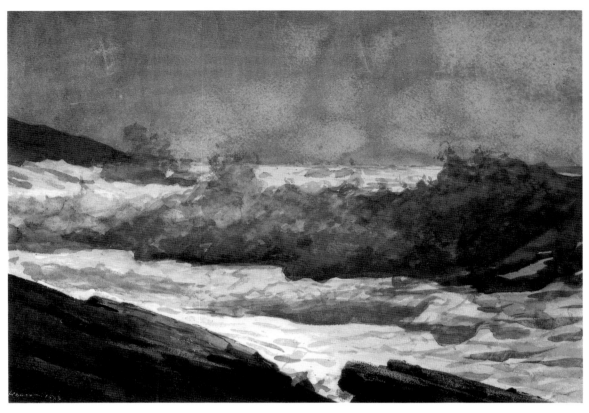

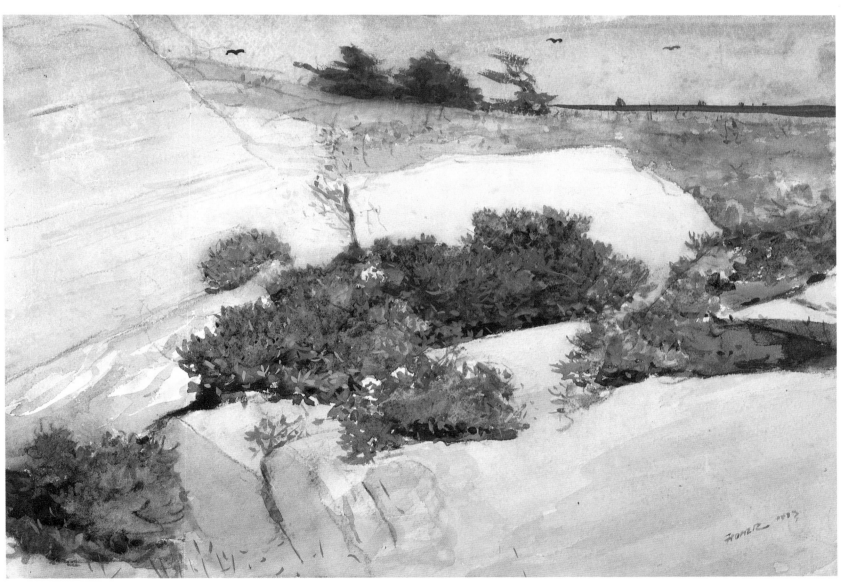

On his trips to the Adirondacks and Canada, Homer naturally turned his attention to the life of the huntsman and angler. An adept woodsman himself, he had first tackled such subjects at least as early as 1874, when he contributed an illustration titled *Camping Out in the Adirondack Mountains* to *Harper's.* In the wake of his English experience, however, Homer was able to respond to the wilderness with far greater spontaneity and with a total freedom from the need to use narrative elements as a crutch.

One of the first fruits of this fresh approach was the Brooklyn Museum's *Jumping Trout* (PLATE 155), made on Homer's 1889 trip to the Adirondacks. Taken on its own, this picture would be enough to signify that Homer was one of the all-time masters of the watercolor medium, worthy of being considered alongside the finest of the Europeans, a claim no other American except Eakins could have made at this date. Unlike Eakins, though, Homer approached watercolor as a purist who valued spontaneous brushwork, clean washes, and the sparkle of white paper above all else. Seldom, if ever, have these values been put to better use than in Homer's late work. Yet these paintings are more than just superb exercises in classic watercolor technique. What they introduced to the artistic vocabulary might be described as a "snapshot" effect. The leaping trout, for instance, along with the flashing leader and the feathery lure, is caught at the split second when the fish is at the apogee of his arc above the water. The dense, almost suedelike washes of the background are rich in texture, but they might have been laid down by any of the better British practitioners. The leaping fish, on the other hand, is completely original.

Interestingly, this painting was made just a year after George Eastman put his first Kodak box camera on the market, at the reasonable cost of $25, and made the modern snapshot possible. Homer is known to have owned such a camera, not long after its introduction, and to have taken it on his trips along with his watercolor kit. Like Eakins, he was an enthusiastic photographer and may have used his camera to produce reference material for his paintings; but more to the point is the fact that it may have helped him become aware of a then-novel way of seeing the world. It is highly improbable, of course, that the primitive Kodak's shutter speed could have enabled Homer to photograph a jumping trout. The Kodak was, however, capable of freezing movement to a modest extent, establishing a principle that was certainly apparent to a man of Homer's

155. Winslow Homer (1836–1910).
Jumping Trout, 1889.
Watercolor on paper, 13¹⁵⁄₁₆ x 20 in.
The Brooklyn Museum; In memory
of Dick S. Ramsay.

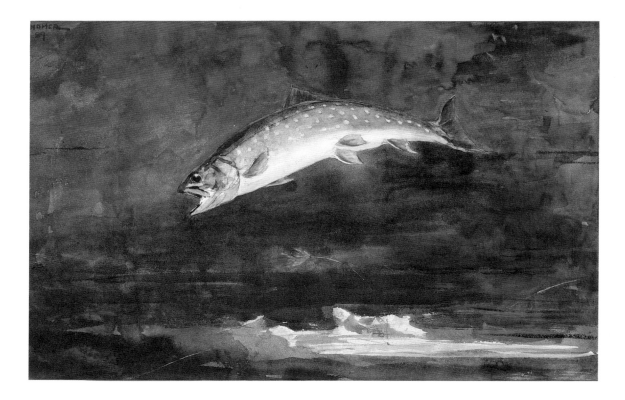

156. Winslow Homer (1836–1910).
Canoeist, Lake St. John, Province of Quebec, c. 1895.
Photograph.
Bowdoin College of Art, Brunswick, Maine; Winslow Homer Collection.

visual perception. Consider, too, that *Jumping Trout* cannot have been painted from nature in the usual sense. Certainly Homer might have made the painting beside the creek where he witnessed the leap, but still it must be presumed that he used a freshly caught trout as his model and transferred it back into its native environment by a combined act of memory and imagination, an act that may have taken into account the challenge posed by the camera as a tool for perceiving the world. Many of Homer's late watercolors raise the same question. They were painted on location, certainly, but they were still acts of imagination in that they recreated fleeting instants. In this they broke entirely with the contemplative mode that had dominated under the influence of the English school.

Some of Homer's finest watercolors were produced during his expeditions to Quebec, where he and Charles joined the Tourilli Fish and Game Club and explored the backwoods in the company of French Canadian and Montagnard Indian guides. Paintings such as *Under the Falls, the Grand Discharge*; *End of the Portage*; and *Shooting the Rapids* (PLATES 157–59) demonstrate the formidable skill Homer had acquired. The viewer is given the impression that the artist has set down each scene without having to think about technique. Turbulent water is conjured up with a few flashing brushstrokes, a summer forest is evoked with seemingly random touches of color.

The wilderness paintings helped project an image, which the artist seems to have studiously cultivated after his sojourn in England, of Homer as a man's man, a lover of solitude. In his New York days he had been sociable, if somewhat taciturn, at least as far as his fellow artists were concerned. Now at Prouts Neck he lived the life of a

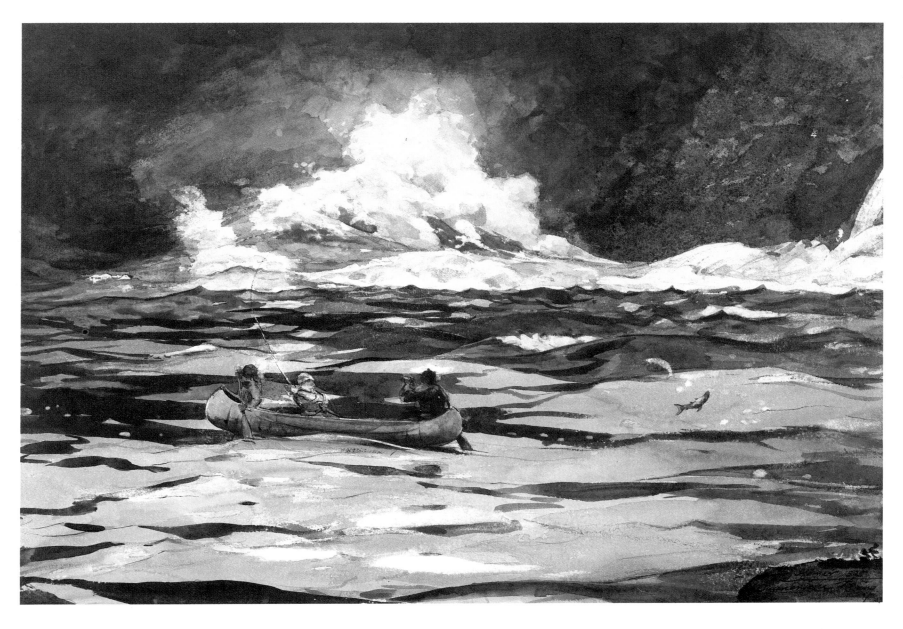

ABOVE:

157. Winslow Homer (1836–1910).
Under the Falls, the Grand Discharge, 1895.
Watercolor on paper, 13¹⁵⁄₁₆ x 19⅞ in.
The Brooklyn Museum; Bequest of
Helen B. Sanders.

RIGHT:

158. Winslow Homer (1836–1910).
Shooting the Rapids, 1902.
Watercolor over pencil on paper,
13⅞ x 21¾ in.
The Brooklyn Museum; Museum
Collection Fund and Special Subscrip-
tion Funds.

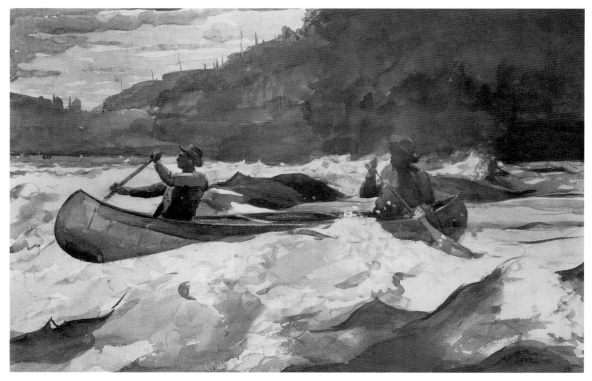

ABOVE:

159. Winslow Homer (1836–1910).
End of the Portage, 1897.
Watercolor over pencil on paper,
14 x 21 in.
The Brooklyn Museum; Bequest of
Helen B. Sanders.

LEFT:

160. Winslow Homer (1836–1910).
The Adirondack Guide, 1894.
Watercolor on paper, 15⅛ x 21½ in.
Museum of Fine Arts, Boston; Be-
quest of Alma H. Wadleigh.

semirecluse, and, while receptive to visits from male cronies as long as they did not interrupt his work, he was assiduous in deterring strangers—especially female strangers—from venturing near his property.

Beneath his gruff exterior, however, Homer was still the man who had painted sentimental studies of Victorian maidens. At heart he was a romantic, but what marks him off from such contemporaries as Albert Bierstadt is the fact that he kept his romantic leanings rigorously under control, especially in the great watercolors he painted from the mid-1880s on. Bierstadt's wilderness scenes are infused with a grandeur that derived as much from the example of European Romanticism as it did from the nobility of the landscape itself. Homer, by contrast, struggled against this tendency. When he painted mountains and rapids he concentrated on setting the subject down as honestly as possible. And yet he possessed the same sense of awe as did the more openly Romantic painters, and this awe is present in all his finest work. It simply does not advertise itself.

It seems reasonable to suggest that Homer had a somewhat pantheistic view of the world; indeed, Lloyd Goodrich has remarked on a dormant streak of paganism that was awakened when Homer visited the Bahamas for the first time. Just as the fishwives of Cullercoats had seized his imagination, so did the black fishermen of Nassau, but now he had the discipline to portray their way of life without forcing the subjects into dramatic postures.

Thought to be from the first visit to the Bahamas, *Shark Fishing—Nassau Bay* (PLATE 161) is an unsentimental celebration of the battle between man and sea monster. As in so many of Homer's tropical subjects, this is also a celebration of the native fishermen's superb physiques. Homer had never been a painter of the nude and lacked academic training in anatomy, but the watercolors he painted in the Bahamas and other tropical settings frequently gave him the opportunity to represent the male torso within a very informal context. Drawing with the brush, he became expert at delineating a man's musculature with a few deft strokes. With equal ease he could create an informal portrait. Homer seems to have shied away from the female nude altogether, though a few works such as his 1889 etching *Saved*—in which a woman rescued from the ocean is draped in wet clothing that adheres closely to her body—suggest that it was inhibition rather than inability that dictated this.

The southern trips introduced Homer not only to fresh and exciting subject matter but also to a new range of colors wonderfully suited to the watercolor palette. One has only to turn to *Shore at Bermuda* or *Road in Bermuda* (PLATES 162, 163) to sense how intoxicated Homer must have been by the spectacle of white buildings standing out against the sparkling blue ocean under a tropical sun. To capture the brilliance of the color Homer was forced to lay down washes of such intensity that turn-of-the-century viewers must have found them startling.

Turner had evoked the sunlight of the Mediterranean by thinning his washes down to the palest yellows, pinks, and blues, allowing the paper to glow through while he picked out highlights with touches of crimson and cobalt. Homer used a very different method to conjure up the sunlight of Bermuda and the Bahamas, letting patches of white paper sparkle through in local contrast to dense washes that at times are almost opaque. Turner, in other words, created his illusion by letting actual light, reflected from the surface of the paper, permeate the entire image. Homer chose the alternative method of suggesting bright sunlight by creating patterns of light and shadow, by setting reflective white walls off against the absorbent leaves of tropical vegetation.

The formal achievement of these tropical watercolors was matched, as always, by Homer's rigorousness as an observer. As Donelson Hoopes points out, *Shore and Surf, Nassau* (PLATE 166) accurately shows the way that waves break over the coral reefs that protect Bahamian lagoons.[1] *The Turtle Pound* (PLATE 164) is about as straightforward as a

161. Winslow Homer (1836–1910).
Shark Fishing—Nassau Bay, 1895.
Watercolor on paper, 13⅞ x 20 in.
Private collection, New York.

162. Winslow Homer (1836–1910).
Shore at Bermuda, c. 1899.
Watercolor over pencil on paper,
14 x 21 in.
The Brooklyn Museum.

163. Winslow Homer (1836–1910).
Road in Bermuda, 1899–1901.
Watercolor over pencil on paper,
14 x 21¹⁄₁₆ in.
The Brooklyn Museum; Bequest of
Helen B. Sanders.

164. Winslow Homer (1836–1910).
The Turtle Pound, 1898.
Watercolor over pencil on paper,
14¹⁵⁄₁₆ x 21⅜ in.
The Brooklyn Museum; Sustaining
Membership Fund, A. T. White
Memorial Fund, A. Augustus Healy
Fund.

165. Detail of plate 164.

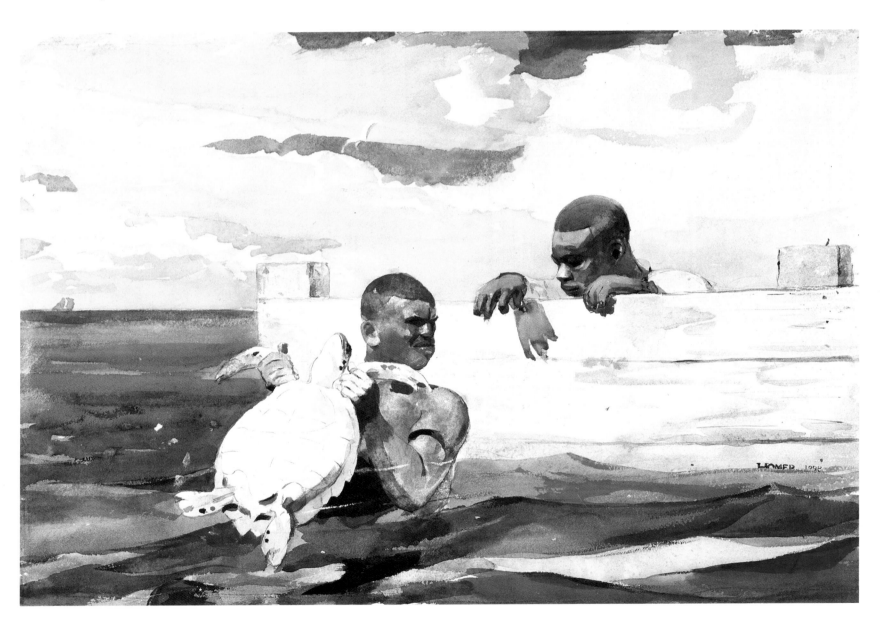

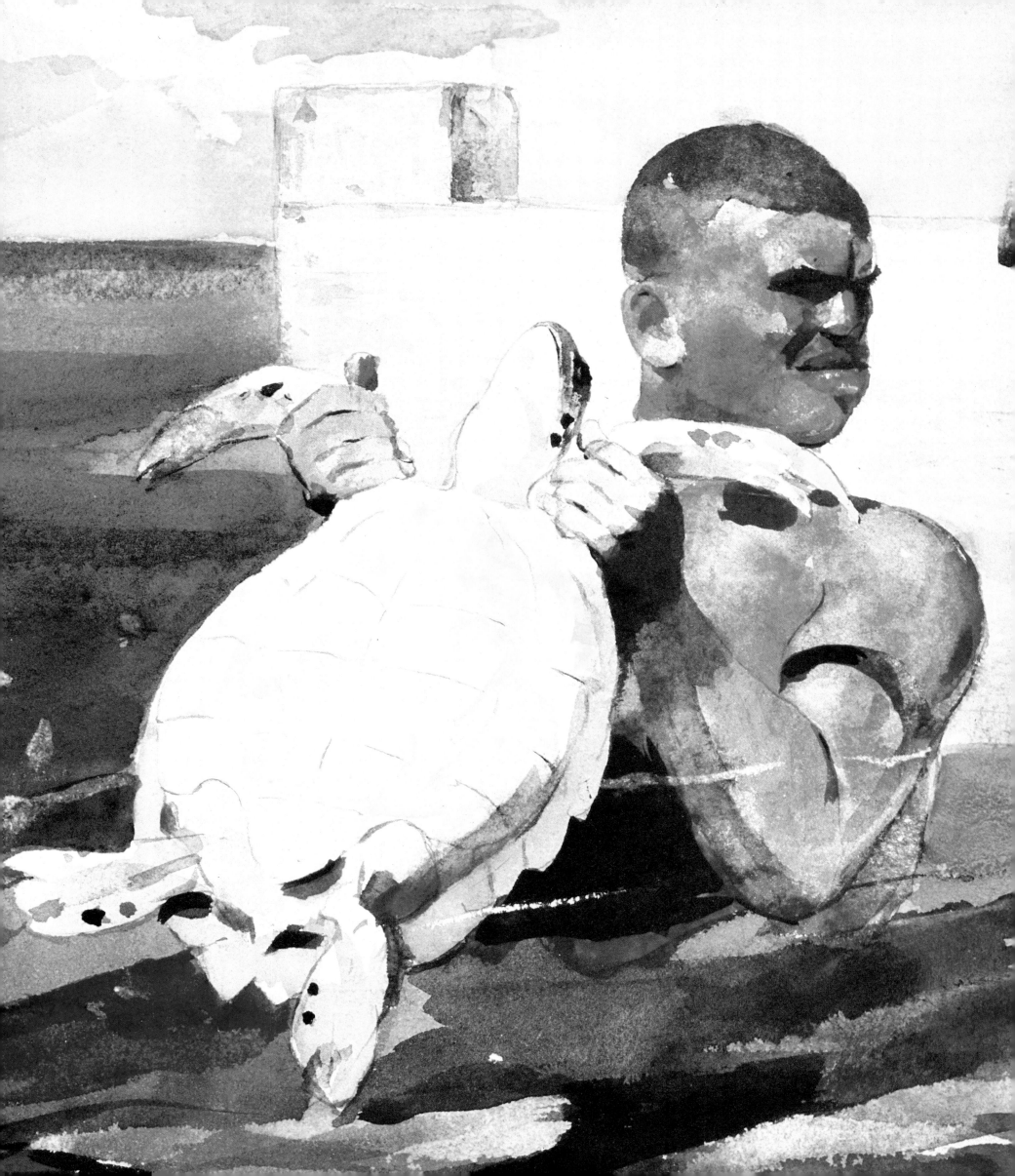

RIGHT:

166. Winslow Homer (1836–1910).
Shore and Surf, Nassau, 1899.
Watercolor on paper, 15 x 23½ in.
The Metropolitan Museum of Art,
New York; Amelia B. Lazarus Fund,
1910.

BELOW:

167. Winslow Homer (1836–1910).
Taking on Wet Provisions, 1903.
Watercolor on paper, 14 x 21¾ in.
The Metropolitan Museum of Art,
New York; Amelia B. Lazarus Fund.

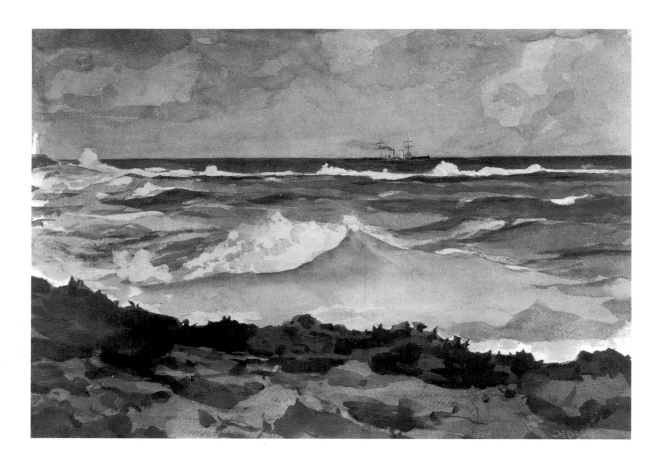

painting can be, but the skill with which the two turtle hunters are characterized is a superb essay in casual portraiture, and this brings an otherwise uninteresting composition vividly to life.

On his southern journeys Homer tackled many marine subjects, such as *Taking on Wet Provisions* (PLATE 167), painted on a 1903 trip to Florida. As always, the water is evoked with an almost throwaway deftness, but perhaps the most remarkable thing about the painting is the skillful play of color, the way that smallish patches of red and reddish brown are used to set off the blues and bluish greens with which most of the painting is saturated (and always, of course, there are the flashes of virgin white, keying the whole work). This is a color scheme characteristic of Homer's tropical works, but seldom did he use it to better effect.

In Florida, Homer was fascinated by the dense palm thickets and tropical under-growth that characterized the swamplands back in those days, still largely unspoiled by careless drainage and random development. He recorded this world in several striking watercolors, such as *In the Jungle, Florida* (PLATE 168), painted in 1904. These paintings are marked by a color scheme unlike that of any of his other tropical watercolors. Here earth colors mix on equal terms with violet blues and a whole range of greens as he evokes a sense of vegetation rotting under overcast skies.

Perhaps the most spectacular of Homer's southern watercolors are those that deal

168. Winslow Homer (1836–1910).
In the Jungle, Florida, 1904.
Watercolor over pencil on paper,
13⅞ x 19¹¹/₁₆ in.
The Brooklyn Museum; Museum Collection Fund.

with storms. *Palm Tree, Nassau* (PLATE 169) is probably the best known of these and shows the first stages of a tropical storm (note the red warning signal flying near the lighthouse). Equally spectacular is *Hurricane, Bahamas* (PLATE 170), also painted in 1898, possibly during the same storm. Never was Homer's brushwork more fluidly calligraphic, never did he express himself more eloquently, never was he more succinct. The lowering sky and wind-battered palms produce an immediate emotional impact, and the whole composition is executed with a disregard for Western conventions of perspective that reminds us of Homer's familiarity with Japanese art.

This one painting might, in fact, be used to sum up Homer's achievement in the watercolor medium. Everything about it tells us that Homer had traveled an immense aesthetic distance from the charming scenes painted in Gloucester twenty-five years earlier. Those first efforts portrayed nature prettily; *Hurricane, Bahamas* seems to be alive with the very forces of nature. The energy in Homer's wrist and fingers is at one with the energy of the storm. Englishmen—Constable, Turner, David Cox—had hinted that watercolor might be an ideal medium to capture the wildness of nature as well as its serenity; but it was the Yankee Winslow Homer who was the first to carry that potential to its logical conclusion.

CHAPTER SIX

AMERICANS ABROAD

As the nineteenth century progressed, the American expatriate became an ever more familiar presence in the cities and spas of Europe, a presence that has been immortalized in the novels and stories of Henry James. James himself was the quintessential American cosmopolite of the era. First taken to Europe as an infant, he received part of his education in Switzerland, France, and England, and as an adult he embarked on a series of pilgrimages to the shrines of the Old World that eventually led to his residing in England. James made no bones about the fact that he found the tapestry of European history infinitely more suitable as a backdrop for serious art than the folksy patchwork quilt of values that he perceived as being characteristic of his native land. In his occasional guise as art critic, he was quick to chastise Winslow Homer for bothering to portray the American scene at all:

> We frankly confess that we detest his subjects—his barren plank fences, his glaring, bald, blue skies, his big, dreary vacant lots of meadows, his freckled, straight-haired Yankee urchins, his flat-breasted maidens, suggestive of a dish of rural doughnuts and pie, his calico sun-bonnets, his flannel shirts, his cowhide boots. He has chosen the least pictorial features of the least pictorial range of scenery and civilization; he has resolutely treated them as if they were pictorial, as if they were every inch as good as Capri or Tangiers. . . .[1]

Hoards of Americans, agreeing with James, were determined to sop up all the culture that Europe could offer. Shoe manufacturers from St. Louis and mill owners from Pittsburgh took their wives to Paris and Florence to trudge the floors of the Louvre and the Uffizi in search of enlightenment. Some of those who received such enlightenment, and who had, incidentally, discovered the pleasure of sipping a *vin mousseux* on a sun-dappled terrace, took up permanent residence in comfortably appointed apartments overlooking the *grands boulevards* or in villas nestled among the ilex and stone pines of the Tuscan hills.

As noted in previous chapters, the artists came too, a few to stay, most for prolonged visits during which they absorbed what they could before returning home. Their destinations were various. Italy was mostly a place for devotional visits, though Venice cast its particular spell, snaring American artists for months and even years at a time, so

171. Maurice Prendergast.
The Mall, Central Park, 1901.
Detail of plate 191.

135

172. William Merritt Chase (1849–1916).
Portrait of a Young Woman, c. 1880.
Watercolor on paper, 14¾ x 10⅜ in.
Mr. and Mrs. Raymond J. Horowitz.

that a steady stream of canvases and drawings of canals and palazzos found their way back across the Atlantic. London, the original mecca for American artists, continued to lose favor as the century progressed, though it became home to the two most significant of the expatriates, Whistler and Sargent. Paris waxed as London waned, and by the turn of the century the ferment of experiment there had made it an irresistible magnet for the adventurous. In the meantime, Munich briefly found great favor with a generation of American painters, attracting influential figures such as Frank Duveneck and William Merritt Chase, who absorbed the Munich School's bravura naturalism and made it part of the vocabulary of American art (PLATE 172).

The greatest of the expatriates—a barbed Yankee presence in the salons of Paris and the drawing rooms of London—was James Abbott NcNeill Whistler, a man able to tackle the Europeans on their own terms and prove himself their equal. Like Winslow Homer, who was two years his junior, Whistler turned to watercolor relatively late in his career, and, although he never invested as much artistic currency in the medium as Homer did, the result was a substantial body of impressive work.

Whistler was born in Lowell, Massachusetts, into a household so rigidly puritanical that the children's toys were taken away on Sunday. After spending some time in St. Petersburg, Russia—where his father, an engineer, had business—the young Whistler entered the United States Military Academy at West Point. There his academic work was deemed unsatisfactory and he was discharged. At the age of twenty-one he left for Europe, never to return. Studying in Paris, he was befriended by Henri Fantin-Latour and Gustave Courbet. He moved to London in 1859, but his ties with Paris and the French avant-garde—Edgar Degas, Edouard Manet, Claude Monet—remained strong. Whistler's work deeply offended the orthodox British taste of the day, leading to John Ruskin's accusation that Whistler was "flinging a pot of paint in the public's face," a piece of criticism that led to a celebrated libel trial.

Whistler did occasionally use watercolor at the beginning of his career, but it was not until the 1880s that he employed it consistently and with real seriousness. An example of his early watercolor style, *The Kitchen* (PLATE 173), shows that Whistler had a deft touch from the outset, even though the subject and treatment are rather conventional. Underpinned by a pencil drawing, the image is built up mostly of dark washes that give it an almost monochromatic feel. The composition is obvious, in an illustrational kind of way, but the handling of the brushwork is free and entirely competent.

Whistler's career as a mature watercolorist began around 1879, when, at the age of forty-five, he fled to Venice, taking refuge there in the wake of his financially disastrous court confrontation with Ruskin. He quickly regained his spirits, exercising his rapier wit on fellow expatriates such as Robert Frederick Blum and Otto Bacher, exploring the city in a gondola that he had fitted as a mobile studio. Whistler's stay in Venice extended into 1880 and was taken up mostly with pastels and etchings, but he did turn to water- color occasionally, as in the sparkling little *Venice Harbor* (PLATE 174), which is part of the

173. James Abbott McNeill Whistler
(1834–1903).
The Kitchen, 1858.
Pencil and watercolor on paper,
12⅜ x 8¾ in.
Freer Gallery of Art, Smithsonian
Institution, Washington, D.C.

174. James Abbott McNeill Whistler
(1834–1903).
Venice Harbor, 1879–80.
Watercolor on paper, 4¹³⁄₁₆ x 10¹⁄₁₆ in.
Freer Gallery of Art, Smithsonian
Institution, Washington, D.C.

175. James Abbott McNeill Whistler
 (1834–1903).
 Grey and Silver: The Mersey, 1880s.
 Watercolor on paper, 5⁵⁄₁₆ x 10¾ in.
 Freer Gallery of Art, Smithsonian
 Institution, Washington, D.C.

176. James Abbott McNeill Whistler
 (1834–1903).
 Grey and Silver: Pier, Southend, early
 1880s.
 Watercolor on paper, 6¼ x 9¾ in.
 Freer Gallery of Art, Smithsonian
 Institution, Washington, D.C.

fine collection of Whistler watercolors now at the Freer Gallery of Art in Washington, D.C. Whistler had already achieved great economy of means in his oils, and so it was natural that economy should be the hallmark of his watercolors. In *Venice Harbor,* painted on a paper with plenty of "tooth"—the watercolorist's word for texture—the predominant water effect is achieved with wet, dragged washes that allow the surface of the paper to sparkle through. The city in the distance and the vessels in the harbor are laid in with calligraphic shorthand.

Another harbor scene from the 1880s shows how Whistler adapted this approach to accommodate the very different weather conditions that he frequently encountered in the British Isles. *Grey and Silver: The Mersey* (PLATE 175) employs the same emphatically horizontal format—to which Whistler was to turn time and again in his watercolors— and displays the same sure calligraphy, but this time the washes are handled somewhat differently. Because Whistler has applied the washes relatively evenly, instead of dragging them with the brush, less of the white paper sparkles through and a different mood is created, in which mist rather than sunlight predominates. One of the most brilliant examples of Whistler's calligraphic approach to watercolor is *Grey and Silver: Pier,*

Southend (PLATE 176), in which he casually evokes a famous Victorian structure. This strongly graphic treatment brings to mind the *ukiyo-e* prints by artists such as Hiroshige and recalls Whistler's early and lasting interest in Japanese art.

Beach scenes and seascapes had a tremendous fascination for Whistler, and in his watercolors he continually strove to simplify these subjects to their essential elements. In 1881, shortly after his mother's death, Whistler spent a few weeks painting on the islands of Guernsey and Jersey in the English Channel. There the tides recede several hundred yards, and it is easy to imagine how Whistler must have been taken with the vast tracts of highly reflective wet sand left in the water's wake. In *Note in Blue and Opal: Jersey* (PLATE 177) he captures a receding-tide effect on a bright winter day and does so with the barest of means, which nonetheless succeed in conveying the character of the place.

Still more minimalist, but at the same time more animated, is *The Ocean Wave* (PLATE 178), painted a couple of years later. This time the idea of beachscape is reduced

177. James Abbott McNeill Whistler (1834–1903).
Note in Blue and Opal: Jersey, 1881.
Watercolor on paper, 5⅜ x 10 in.
Freer Gallery of Art, Smithsonian Institution, Washington, D.C.

178. James Abbott McNeill Whistler (1834–1903).
The Ocean Wave, c. 1883.
Watercolor on paper, 5 x 6¹⁵⁄₁₆ in.
Freer Gallery of Art, Smithsonian Institution, Washington, D.C.

179. James Abbott McNeill Whistler
(1834–1903).
*Nocturne: Grey and Gold—Canal,
Holland*, 1883–84.
Watercolor on paper, 11⁹⁄₁₆ x 9⅛ in.
Freer Gallery of Art, Smithsonian
Institution, Washington, D.C.

to its essentials and set down in saturated washes that have been casually blotted to produce an illusion of cloud and mist and, more important, a feeling of aerial perspective that transforms a flat piece of paper into a palpably real place full of air and light. *The Ocean Wave* is a classic example of the watercolor as controlled accident. Much of its character comes from the use of the technique known as "wet into wet," in which liquid washes are applied to paper already saturated with water. For obvious reasons, such washes are extremely difficult to control, but they also lend themselves to happy accident, and, in the hands of someone as skillful as Whistler, such accidents are seldom entirely a matter of chance. In the watercolor Nocturnes he painted on a visit to Amsterdam (PLATE 179), Whistler pushed the "wet into wet" technique to an extreme, laying wash over wash until it must have seemed that the paper support was drowned in liquid pigment. Yet the effects achieved were fully under the artist's control. It is paintings such as this and *The Ocean Wave* that, on a superficial viewing, make watercolor painting look easy. In fact, such facility was the result of years of experience.

Whistler's base in London was Chelsea. Its closeness to the Thames was its chief attraction perhaps, but Whistler also loved to paint its street life. *Chelsea Children* (PLATE 180) is one of several watercolors that employ storefronts as a motif (he also made oil paintings and etchings of storefronts). The technique is less bold than that of the Amsterdam Nocturnes, but this is still watercolor at its purest, the subject being allowed to gently emerge from the layers of transparent color.

Another masterpiece of economy is *Resting in Bed* (PLATE 181), thought to be an informal study of Whistler's mistress, Maude Franklin.[2] The unfinished nature of the

painting permits the viewer to understand the importance of the paper support in water-color painting. The whiteness of the paper represents pure light, and it is the business of the watercolorist to use his transparent color to modify that light so that forms emerge. In his own way the watercolorist faces the same problem a sculptor does when he seeks to release an Aphrodite or a centaur from the stone that entombs it. To the watercolorist, a fine piece of handmade paper is like Carrara marble. Whereas an artist such as Homer brought his paper to life with rich color, Whistler tended to favor, as in *Resting in Bed,* a chromatic range that did not stray far from his famous grays. In *Milly Finch* (PLATE 182), however, he allowed scarlet to serve as far more than an accent. This informal portrait of a favorite model shows Whistler to be a master of pose as a delineator of character.

180. James Abbott McNeill Whistler (1834–1903). *Chelsea Children,* mid-1880s. Watercolor on paper, 5 x 8½ in. Freer Gallery of Art, Smithsonian Institution, Washington, D.C.

181. James Abbott McNeill Whistler (1834–1903). *Resting in Bed,* early 1880s. Watercolor on paper, 6¹¹⁄₁₆ x 9⁷⁄₁₆ in. Freer Gallery of Art, Smithsonian Institution, Washington, D.C.

182. James Abbott McNeill Whistler
(1834–1903).
Milly Finch, early 1880s.
Watercolor on paper, 11¾ x 8⅞ in.
Freer Gallery of Art, Smithsonian
Institution, Washington, D.C.

 Whistler's little watercolor character studies are wholly delightful, but in the end it is his seascapes that are his primary claim to fame in the medium, and it is worth taking one last look at this aspect of his work. *Blue and Silver: Chopping Channel* (PLATE 183) is a late painting remarkable for its simplicity of design (though actually it is naturalistic enough). What makes it particularly interesting in the context of this book is the fact that Whistler's brushwork and even his tonal range so closely anticipate some aspects of John Marin's work (see chapter eight). There is no hint of Marin's modernist grid, of course, but the handling of the medium itself is remarkably similar.

Whistler was the first American painter of consequence to make contact with the Impressionists, and indeed he was the only American, with the partial exception of Mary

Cassatt, to be accepted as a fellow pioneer by the leaders of the French movement. For the most part, the American Impressionists—men like John Twachtman and J. Alden Weir—were followers rather than leaders. Like Cassatt, they seem to have been more comfortable working in pastel than watercolor. Two exceptions, however, were Childe Hassam and Maurice Prendergast, and each was gifted with a degree of originality.

Both men were born in Boston. Hassam received his basic training there, then spent five years in Paris, starting in 1883, studying at the Académie Julian, where he learned to respect the values of classical draftsmanship while at the same time discovering Oriental art (PLATE 184) and the Impressionists. He was especially taken with Monet and began to emulate his experiments in using prismatic color to represent light. By the time

183. James Abbott McNeill Whistler (1834–1903).
Blue and Silver—Chopping Channel, 1890s.
Watercolor on paper, 5½ x 9½ in.
Freer Gallery of Art, Smithsonian Institution, Washington, D.C.

184. Childe Hassam (1859–1935).
Still Life, 1886.
Watercolor on paper, 9¾ x 14 in.
Worcester Art Museum, Worcester, Massachusetts.

143

ABOVE:

185. Childe Hassam (1859–1935).
The Gorge, Appledore, 1912.
Watercolor on paper, 13¾ x 19⅞ in.
The Brooklyn Museum; Museum
Collection Fund.

RIGHT:

186. Childe Hassam (1859–1935).
Sunday Morning, Appledore, 1912.
Watercolor on paper, 13⁹⁄₁₆ x 19⁹⁄₁₆ in.
The Brooklyn Museum; Museum
Collection Fund.

Hassam returned to the United States, his mature style was well established, and it changed relatively little over the remaining decades of his career.

Equally at home working in oil, pastel, or watercolor, Hassam was also a skilled etcher in the Whistler mode and contributed many elegant drawings to magazines such as *Harper's*, *Scribner's*, and *Century*. Although his oils are fine examples of American Impressionism, they never really succeeded in prismatically dissolving matter in the way Monet's did. Hassam's watercolors display real originality, however, and in them he evolved a way of using color very freely so that it sometimes seems to take on a life of its own, independent of its descriptive function.

In *The Gorge, Appledore* (PLATE 185), of 1912, the rocks are evoked with bold brushstrokes that immediately command the viewer's attention. Even more striking is the boldness of the color scheme, which makes for a strong abstract design that dominates the composition. This is a watercolor that, in its modest way, looks forward to the brave new American art world that would come into existence in the wake of the Armory Show, staged the year after this picture was painted. The same is even truer of *Sunday Morning, Appledore* (PLATE 186), in which the entire foreground is built up from flickering calligraphic strokes. This calligraphy does serve a descriptive purpose, certainly, but it also exists for its own sake. In a sense, Hassam on this occasion went well beyond the tenets of Impressionism and began to explore some of the gestural concerns that would be picked up by another generation of American artists.

Since Hassam's allegiance was above all to Monet, however, it is appropriate that some of his finest paintings are of gardens, and *The Garden, Appledore, Isle of Shoals* (PLATE 187) is a splendid example. Again, the scene is thought to be Appledore, an island off the coast of New Hampshire, where Celia Thaxter, a close friend of Hassam's, laid out a famous garden at the water's edge. In this painting the confident calligraphy is apparent once more, and the way Hassam has crowded the paper with blossoms and selected a viewpoint that makes the horizon line a marginal feature gives the composition a decidedly "abstract" feel. At the same time, it is full of air and sunlight, a fact owing to both the freedom of the handling and the effectiveness of the color scheme, which, once

LEFT:
187. Childe Hassam (1859–1935).
The Garden, Appledore, Isle of Shoals,
1891.
Watercolor on paper, 13¹³/₁₆ x 10 in.
Mead Art Museum, Amherst College,
Amherst, Massachusetts; Gift of
William Macbeth, Inc.

RIGHT:
188. Childe Hassam (1859–1935).
Isle of Shoals Garden, c. 1892.
Watercolor on paper, 19¾ x 13¾ in.
National Museum of American Art,
Smithsonian Institution, Washington,
D.C.; Gift of John Gellatly.

189. Maurice Prendergast (1859–1924).
Revere Beach, 1896.
Watercolor on paper, 10 x 14 in.
Berry-Hill Galleries, Inc., New York.

more, is fresher than anything to be found in Hassam's oils and makes especially good use of the white of the paper.

Although Maurice Prendergast sometimes painted in oil, especially in the latter part of his career, he was primarily a watercolorist, and in this capacity he was a pivotal figure, another who provided a bridge from the nineteenth century to the twentieth. Apprenticed to a commercial artist who painted showcards for Boston stores, Prendergast eventually saved up enough money to study in Paris, arriving in 1891, at the age of thirty-two, and remaining for three years. Like Hassam, he enrolled at the Académie Julian, but the art that really caught his attention was the work of the Post-Impressionists, and it was from painters like Pierre Bonnard and Edouard Vuillard (in their Nabi guise), Paul Signac, Henri de Toulouse-Lautrec, Paul Cézanne, and Maurice Denis that he absorbed the lessons that would stand him in good stead throughout the balance of his career.

Back in Boston, Prendergast lived frugally with his brother Charles, a frame maker, but was unable to earn a living from his paintings and so was forced to letter showcards once more. He persisted with his Post-Impressionist experiments, however, forging a style that soon won him the respect of the more adventurous of his fellow artists. Eventually he was able to move, with Charles, to New York, and in 1908 he became one of the founding members of the then-radical group known as The Eight.

The fundamentals of Prendergast's skills as a watercolorist can be found in his sketches (PLATE 189). These pencil and wash studies use the watercolor vocabulary with a laconic ease that recalls Whistler's approach to the medium, though Prendergast's personal vision is always present, even in the most insignificant notation. Paintings such as *St. Malo No. 1* (PLATE 190) retain the fluency of his sketches but display a more systematic approach, in which dabs of color are laid alongside one another in a way that plainly derives from pointillist practice, though not applied with pointillist rigor. The influence of Cézanne, too, is apparent in the extensive use of white paper. If *St. Malo* is considered as a traditional representational painting, the paper support simply serves to fill the composition with light. If it is taken as a modern painting, however—as it should be— then the white paper also functions as a reminder of the picture plane and thus as a foil to illusionism.

Sometimes, as in *The Mall, Central Park* (PLATE 191), Prendergast applied the same general principle with a greater descriptive precision. In these instances the handling is relatively tight and objects are clearly defined by interlocking patches of color, a technique that has led many commentators to compare Prendergast's paintings to the art of mosaic. (Prendergast did, in fact, make some interesting mosaics.) Superficially, a watercolor of this sort seems more conventional than one like *St. Malo No. 1*, but essentially both are skillful manipulations of the picture plane in a post-Nabi idiom.

Some of Prendergast's finest watercolors were painted during his first stay in

190. Maurice Prendergast (1859–1924). *St. Malo No. 1*, c. 1907. Watercolor on paper, 13½ x 19¼ in. Columbus Museum of Art; Gift of Ferdinand Howald.

191. Maurice Prendergast (1859–1924).
The Mall, Central Park, 1901.
Watercolor on paper, 15¼ x 22⁵⁄₁₆ in.
The Art Institute of Chicago.

OPPOSITE:
192. Maurice Prendergast (1859–1924).
Piazza di San Marco, c. 1898.
Watercolor and pencil on paper,
16⅛ x 15 in.
The Metropolitan Museum of Art,
New York; Gift of the Estate of Mrs.
Edward Robinson.

Venice, which occupied the greater part of an eighteen-month trip to Italy underwritten by a wealthy patron. Perhaps the best known of the Venetian watercolors is the Metropolitan Museum's magnificent *Piazza di San Marco* (PLATE 192), a bird's-eye view of the great square, looking down past the Campanile and the Libreria Vecchia to the column of St. Theodore and the Lagoon. The foreground is dominated by the three gigantic red, white, and green triumphal banners that just barely stir in the late-afternoon breeze. These flags establish a strong feeling of pattern that is sustained throughout the composition, the fragments of architecture—cropped as in a snapshot—becoming design elements no more or less important than the shadows they cast. The tourists and locals who cluster in the piazza—some of them represented by nothing more than a blue gray dot and a patch of virgin paper—animate the scene and prevent Prendergast's powerful sense of design from overwhelming the subject and making it static.

193. Maurice Prendergast (1859–1924).
Piazza San Marco, Venice (Splash of Sunshine and Rain), 1899.
Watercolor on paper, 19⅜ x 14¼ in.
Alice M. Kaplan.

Another view of the piazza, this time made after a downpour (PLATE 193), shows how Prendergast employed animation to offset pattern. Painted in fresh, jewellike colors, the painting again features the three triumphal banners, but this time they are over-whelmed by the façade of the church of San Marco. As if there were not enough pattern in these elements, Prendergast has doubled it by means of the reflections on the wet flagstones. The dangers are obvious. In the hands of a lesser artist the scene would be merely cluttered or decorative, but Prendergast avoids the pitfalls with ease. He makes sure that the sky—laid in wet and deliberately blotted—suggests the passing storm. He fills the flags with gusts of wind, as a good marine painter fills the sails of a boat, thus suggesting unsettled weather. He renders the reflections with such consummate skill—

delicate, clear washes casually applied—that one can almost smell the after-rain freshness in the air. Finally, and most important, he crowds the middle ground with life, taking a leaf from the book of Carpaccio, a painter he learned to admire during his stay in Venice (though Carpaccio only reinforced a predilection that Prendergast had possessed from the outset of his career).

No one has painted rain-drenched Venice with more feeling than Prendergast. In *Umbrellas in the Rain* (PLATE 194) the artist focused on a crowded Ponte della Paglia with the Doge's Palace in the background. The relatively subdued palette suggests overcast conditions, though the women's white dresses tell the viewer that it is a warm summer day. (Although the figures who populate Prendergast's paintings tend to be somewhat anonymous, they impart much information that contributes to the atmosphere of a scene.) The handling is very free, giving the composition a feeling of great spontaneity. Above all, Prendergast uses his transparent color to capture the sense of wetness, so that the pavements of Venice become adjuncts to its waterways.

Unlike other artists—Turner, Whistler, or Sargent, for example—Prendergast seldom painted Venice from the water, preferring to show it as seen from dry land. *Rainy Day, Venice* (PLATE 195) is typical in this respect, resembling *Piazza di San Marco* in its elevated viewpoint. Unlike the other paintings considered here, however, it is a winter scene: "the gondolas wear their *felzi,* or rounded hoods, and the Venetians have abandoned their gay summer garb."[3] The tonal range is not too far removed from

194. Maurice Prendergast (1859–1924). *Umbrellas in the Rain,* 1899. Watercolor on paper, 13¾ x 20½ in. Museum of Fine Arts, Boston; Charles and Henry Hayden Fund.

195. Maurice Prendergast (1859–1924).
Rainy Day, Venice, 1899.
Watercolor on paper, 16½ x 12½ in.
Wichita Art Museum; The Roland P.
Murdock Collection.

Whistler's, and the vertical format causes Prendergast to frame his subject in a way that recalls some of Whistler's Nocturnes. In most regards, however, the image is pure Prendergast, and even with the subdued chromatic range he still fills the painting with light and life while making a formal statement of some originality.

Prendergast was a shy man, one who made few claims for his art. Certainly it would be a mistake to present him as a major figure with the stature of Whistler or Homer, but this should not be allowed to obscure his very real merits. Few Americans of his generation understood the new developments in European art as thoroughly as Prendergast, and yet he was able to absorb these influences without losing his personal identity. In this respect he was a sound example to Americans who came to maturity around the time of the Armory Show. As a watercolorist he had few peers. He demonstrated that the medium could be used to make statements that were by no means quaint

or antiquated. Beyond that, he was a genuine *petit maître,* who could produce master-pieces within the bounds of his own chosen terms.

A lesser but still interesting figure, Robert Frederick Blum also did some of his most rewarding work in Venice, first traveling there in 1880, when he was befriended by Whistler. Blum's oils are not at all in the Whistler manner, however, reflecting instead the influence of Munich-trained painters such as Frank Duveneck and William Merritt Chase. His watercolors, on the other hand, depend less on loaded brushwork and calcu-lated chiaroscuro effects than upon the delicacy of touch that is also evident in his pastels.

A Morning in St. Marks (*Venice*) (PLATE 196) conjures up the interior of the cathedral with considerable compositional ingenuity. Although only a single corner of the mighty structure is shown, the vastness of the enclosed space is evoked by the emptiness of the foreground. The architecture itself is set down without unnecessary fuss or detail and with a softness of outline that helps convey the notion that the centuries have left their mark on the stones of the cathedral. In his day Blum was equally well known as painter and illustrator. His anecdotal gifts are fully evident in *Lady Boarding a Gondola from a Palazzo* (PLATE 197). In 1890 he was commissioned to travel to Japan to illustrate Sir Edwin Arnold's *Japonica,* and while there he made some lively watercolors (PLATE 198) notable for their freshness of observation.

Theodore Robinson is known as the only American Impressionist to have studied with Monet. Some of his watercolors have a somewhat opaque look, as if he were trying to imitate a pastel drawing, but occasionally he used transparent color with con-siderable skill and subtlety. His view of Boissise-la-Bertrande (PLATE 199), for instance, displays an economy of means that is almost worthy of Whistler.

A lesser known artist, but one whose approach to watercolor was very adventurous in its day, was J. Frank Currier, who trained in Germany and evolved a highly improvi-sational technique. His style had an apparent randomness that must have seemed star-tling at the time his work was first shown (PLATE 200).

The artists discussed in this chapter were all greatly affected by the new European art of their time. Whistler was the first American to participate in the aesthetic revolution that began in France in the 1860s. Hassam and Prendergast were important forces in the

BELOW, LEFT:
196. Robert Frederick Blum (1857–1903). *A Morning in St. Marks (Venice)*, n.d. Watercolor on paper, 9½ x 12¹³⁄₁₆ in. Cincinnati Art Museum; Gift of Henrietta Haller.

BELOW, RIGHT:
197. Robert Frederick Blum (1857–1903). *Lady Boarding a Gondola from a Palazzo,* 1885. Watercolor and brush and black ink over pencil on paper, 11⅞ x 9⁹⁄₁₆ in. Sterling and Francine Clark Art Institute, Williamstown, Massachusetts

Americanization of that revolution. But it was the Armory Show of 1913 that first brought the revolution to the United States in full force. The chief organizer of the Armory Show was not, surprisingly, a fierce radical, but Arthur B. Davies—like Prendergast a member of The Eight—who is best known for his lyrical, Symbolist-influenced paintings of female nudes in arcadian landscapes. In the watercolors he painted toward the end of his career, however, he shifted away from the dreamlike world of his personal mythology and painted straightforward scenes such as *From the Quai d'Orléans* (PLATE 201). A highly accomplished watercolor, somewhat in the style of the British virtuoso Hercules Brabazon, it is charged with atmosphere in a way that derives wholly from the natural characteristics of the medium. The architecture seen across the Seine is set down with authority, and the handling of washes in the stormy sky is especially effective.

Davies's watercolor of 1925 is not old-fashioned by the standards of his genera-tion—it belongs firmly to the post-Whistler, post-Homer idiom—but, due to Davies's own efforts in promoting the avant-garde, it was made at the last moment when such straightforward statements could be made without apology. The year 1925 can, in fact, be seen as a kind of watershed for watercolor, in that it marked the passing of the last of the great bravura, realist watercolorists, John Singer Sargent.

CHAPTER SEVEN

JOHN SINGER SARGENT

In many ways John Singer Sargent occupies an ambiguous place in the history of American art. To begin with, he was neither born nor educated in America, nor did he ever really live there, though he did make numerous extended visits to the East Coast and one trip to the Far West. There is no doubt, however, that he considered himself an American (he refused a British knighthood because it would have involved renouncing his United States citizenship). Throughout his European peregrinations he associated extensively with American artists and patrons, he took great care to ensure that examples of his best work found their way into American public collections, and he helped establish the influential Grand Central Art Galleries in New York. Sargent's work was much admired by his American contemporaries, yet it is impossible to think of Sargent as having had much influence on the course of American art. By contrast, Whistler's career is perhaps more totally European than Sargent's, yet the impact of Whistler's work on the American cultural scene is clear enough. Whistler was the first American avant-gardist and, as such, an example to scores of would-be aesthetic revolutionaries.

In a sense, Sargent remained American by default since, despite an early affiliation with Paris and the long period during which he was technically a resident of London, he seems to have led a particularly rootless life, constantly traveling to fulfill a portrait commission here, to install a mural there, but above all on the move for the sake of being on the move, as if incapable of finding a home. If he was something of an outsider in the United States, he was an outsider in Europe, too, belonging to that curious and fascinating class of American expatriates who contributed so much to the cultural atmosphere of the period.

It is tempting to believe that Sargent was also alienated from other artists, both American and European, by his all too evident technical facility. Sargent had the misfortune to be a virtuoso in a generation when much of the most inventive painting was being produced by artists like van Gogh and Cézanne, who had started out with a clumsiness that was the diametrical opposite of Sargent's precocious brilliance. Nor did he have the gift, like his sometime friend Degas, himself a superb draftsman, for keeping such brilliance under a tight rein. For Sargent, virtuosity—and especially the virtuosity of the loaded brush—was tantamount to an artistic identity.

It is not unreasonable, I believe, to compare Sargent to virtuosi in the field of music. If Degas was composer and performer both, Sargent was primarily a performer. And, just as Artur Schnabel might turn from a Beethoven sonata to a Chopin nocturne,

202. John Singer Sargent.
Mountain Stream, 1910–12.
Detail of plate 217.

so Sargent might give an audience a variation on a theme by Velázquez and then on his next canvas an étude in the style of Manet.

Such things were well received at the Royal Academy and the Grand Central Art Galleries, but they were frowned upon in advanced circles where originality was becoming increasingly prized for its own sake. Soon enough, Sargent's Impressionist friends began to disparage him behind his back.[1] Among the American expatriates, Whistler thought Sargent merely facile, and Mary Cassatt accused him of selling out to "High Society."[2] It can be presumed that many younger American artists shared these views. By the turn of the century, if not earlier, Sargent had become alienated from progressive art circles not despite but because of his enormous skill. To return to the music parallel for a moment: Artur Schnabel could never be compared with Beethoven, but that does not disqualify him from being considered an artist of consequence. Similarly, posterity has judged Sargent's virtuosity worthy of admiration. Nobody would call him an innovative genius on a par with Monet or Cézanne (or with Whistler or Homer), but the battles of that generation have been fought and won, the smoke has cleared, and Sargent's paintings still grace the walls of major museums on both sides of the Atlantic.

Sargent's father, FitzWilliam Sargent, was from New England but practiced medicine in Philadelphia, where he married Mary Newbold Singer, the daughter of a Philadelphia merchant. In 1854 they took up permanent residence in Europe, and John, their eldest child, was born in Florence two years later. Growing up in Italy and France and visiting many other parts of Europe, the young Sargent had a quintessentially cosmopolitan childhood, becoming multilingual at an early age and enjoying the cultural treasures of the Continent.

Sargent showed a precocious gift for painting and drawing and had already received a good deal of basic instruction when, in 1874, he began studying at the Paris atelier of Emile Carolus-Duran, taking additional classes at the Ecole des Beaux-Arts and at the studio of Léon Bonnat. Even in this early Paris period Sargent turned his hand to watercolor with considerable competence (PLATE 203), but primarily he concentrated on perfecting his draftsmanship and mastering Carolus-Duran's highly popular style of

203. John Singer Sargent (1856–1925).
The Model, 1876.
Watercolor over graphite pencil on paper, 11¹⁄₁₆ x 9¹⁄₁₆ in.
Museum of Fine Arts, Houston; Gift of Miss Ima Hogg.

204. John Singer Sargent (1856–1925).
Café on the Riva degli Schiavoni, Venice, 1880–82.
Pencil and watercolor on paper, 9¾ x 13½ in.
Ormond Family.

portraiture, which might be described as out of Velázquez by way of Courbet.

Sargent's brushwork possessed a spontaneity that his teacher's lacked, however, and he soon began to evolve his own distinctive approach to portraiture, one that quickly won him commissions. He exhibited at the Paris Salon, at the Royal Academy in London, and, briefly, with the dissident Impressionist group. From 1879 on he also sent pictures to the National Academy of Design in New York on a regular basis (having made his first visit to America in 1876). As his fame grew Sargent painted occasional genre scenes and made many brilliant sketches, generally in oils but sometimes in watercolor (PLATE 204).

Above all, though, his fame came to depend chiefly on his portraits and later, to some extent, on his murals. These murals must be judged the great failures of his career, being totally devoid of the bravura brushwork that animates his best work. His portraits, by contrast, relied on his virtuosity with the brush, but here, too, he sometimes ran into problems because it was so easy for him to flatter. Nor was this flattery always the kind practiced by other society portraitists, who, for the right fee, would straighten a nose or lift a fallen face as readily as any modern-day cosmetic surgeon. Sargent was too good a portraitist to falsify a likeness deliberately, but so deft was his brushwork that it actually seemed to lend grace to a homely sitter's features. In other words, Sargent learned to create an illusion in which the beauty of the paint came to represent the beauty of the flesh.

All of this is of relevance when discussing Sargent's watercolors because it is in these works that he abandoned himself most completely to his facility with the brush. As Carter Ratcliff has pointed out, it was Sargent's practice in his oils to build up a tonal structure, then "lay down signs of spontaneity on top of it," whereas in watercolor the "underlying structure had to be as sparkling, as freely brushed, as all his subsequent effects."[3] Watercolor, then, presented a technical challenge to a man like Sargent, but beyond that it offered him an opportunity to set his own standards, to escape the blandishments and complaints of his fashionable clients, to breathe freely as an artist working for no one but himself. From about 1900, he began to use the medium with regularity. Like Homer, Sargent seems to have had a strong sense that his watercolors were among the works he would be judged by, hence the care with which he guided some of the best examples to institutions such as the Metropolitan Museum of Art and the Brooklyn Museum.

The dating of many of Sargent's mature watercolors is so uncertain that it is perhaps futile to attempt to assign any kind of sequence. In any event, chronology is almost beside the point since there is little evolution in his watercolor style from approximately 1900, when he became prolific in the medium, till the end of his career. Theodore Stebbins suggests that Sargent's use of loosely handled transparent washes leads to the assumption that he was familiar with the watercolors of Whistler and Homer.[4] This seems indisputable, but it is worth remembering that Sargent was as familiar with British art as with American, and he must also have known the watercolors of such contemporaries as Philip Wilson Steer and Hercules Brabazon, also recognized masters of the loosely handled transparent wash. Sargent may also have been acquainted with the work of Richard Parkes Bonington (PLATE 19), an earlier virtuoso whose approach to watercolor anticipated, in some respects, Sargent's own.

Stebbins also asserts that "[Sargent] worked so quickly that many—perhaps most—of his works fail."[5] This is a more questionable statement and raises the question of what standards are being applied. Sargent's watercolors are essentially improvisations, and this must always be kept in mind when questioning their success. In the twentieth century, virtuoso improvisation is best known to us through jazz, an art form far removed from Sargent's world but one that nonetheless offers some useful parallels. A jazz musician

205. John Singer Sargent (1856–1925). *Tiepolo Ceiling, Milan,* c. 1904. Watercolor on paper, 14 x 10 in. The Metropolitan Museum of Art, New York; Gift of Mrs. Francis Ormond, 1950.

206. John Singer Sargent (1856–1925).
A Tramp, c. 1900–1908.
Watercolor on paper,
19¹¹⁄₁₆ x 13¹³⁄₁₆ in.
The Brooklyn Museum; Purchased by
Special Subscription.

improvises on the structure provided by a chord sequence, often one from a popular song. A watercolorist of Sargent's persuasion improvises on the structure provided by the scene in front of him, which might be the Grand Canal or a crashed airplane. The jazz musician weaves brilliant arabesques but never loses touch with the chordal underpinnings. Similarly, Sargent would allow his sable brushes to weave arabesques without ever letting them lose touch with their obligation to describe. And just as a great jazz musician evolves a distinctive "voice"—an individual way of phrasing a musical statement and of exploiting the timbre of his instrument—so Sargent developed in his watercolors a highly personal touch, an inimitable way with the brush that is immediately recognizable.

It is unprofitable to compare a solo by a gifted jazz performer with a piece of music written by, for example, Mozart. What we look for in the jazz musician is an ability to think on his feet, and it is precisely this quality that we find in Sargent's watercolors. Some of them are more finished than others, some are more satisfying from a structural

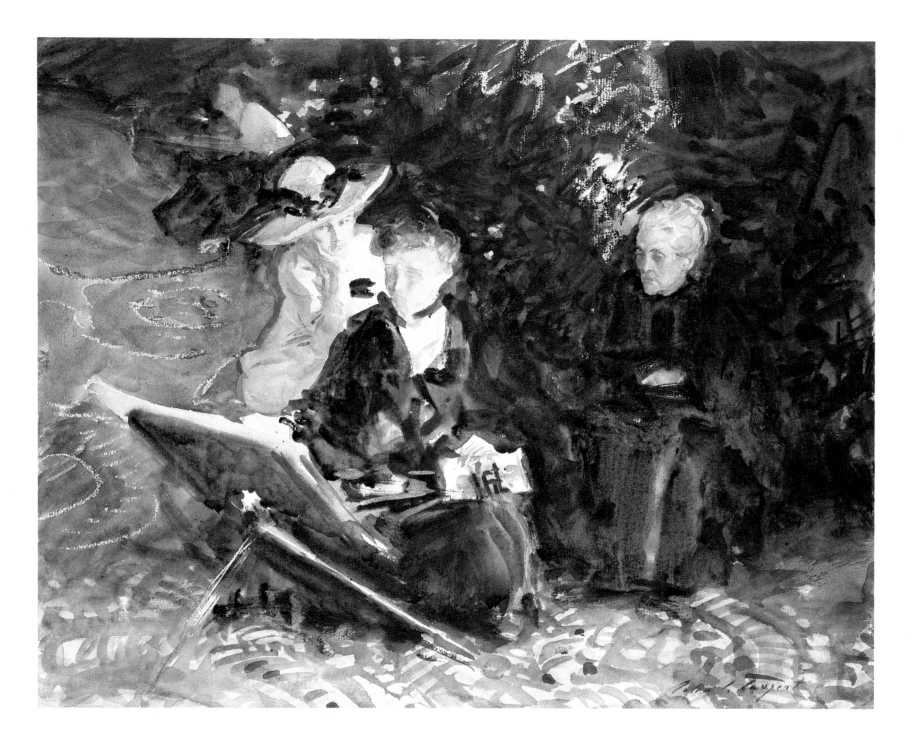

viewpoint, but all seem to possess the Sargent touch, his ability to breathe life into a subject. In a sense, these almost offhand little paintings should be considered not as individual works of art at all but, rather, as a shifting record of an activity that the artist performed with consistent brilliance. For the great extemporary artist—whatever his field—success is the ability to perform up to an established standard time after time.

Sargent used watercolor as a way to escape the chores of portraiture, but the skills of the portraitist were always at his fingertips, and expert likenesses inevitably appear in his watercolors. Sargent invested the subject of *A Tramp* (PLATE 206) with as much dignity as he ever granted any of his society clients. As convincingly as his oils, this painting shows Sargent's ability to reduce a likeness to its essentials—the eyes here are particularly telling—and also to convey character through pose. The man's body is merely sketched in, yet the drawing is so sure that everything has weight. The faces of the three women in the 1912 painting *In the Generalife* (PLATE 207) are brushed in with even less attention to detail, yet in the case of the two observers, if not the artist, Sargent

207. John Singer Sargent (1856–1925).
In the Generalife, 1912.
Watercolor on paper, 14¾ x 17⅞ in.
The Metropolitan Museum of Art,
New York; Purchase, Joseph Pulitzer
Bequest, 1915.

161

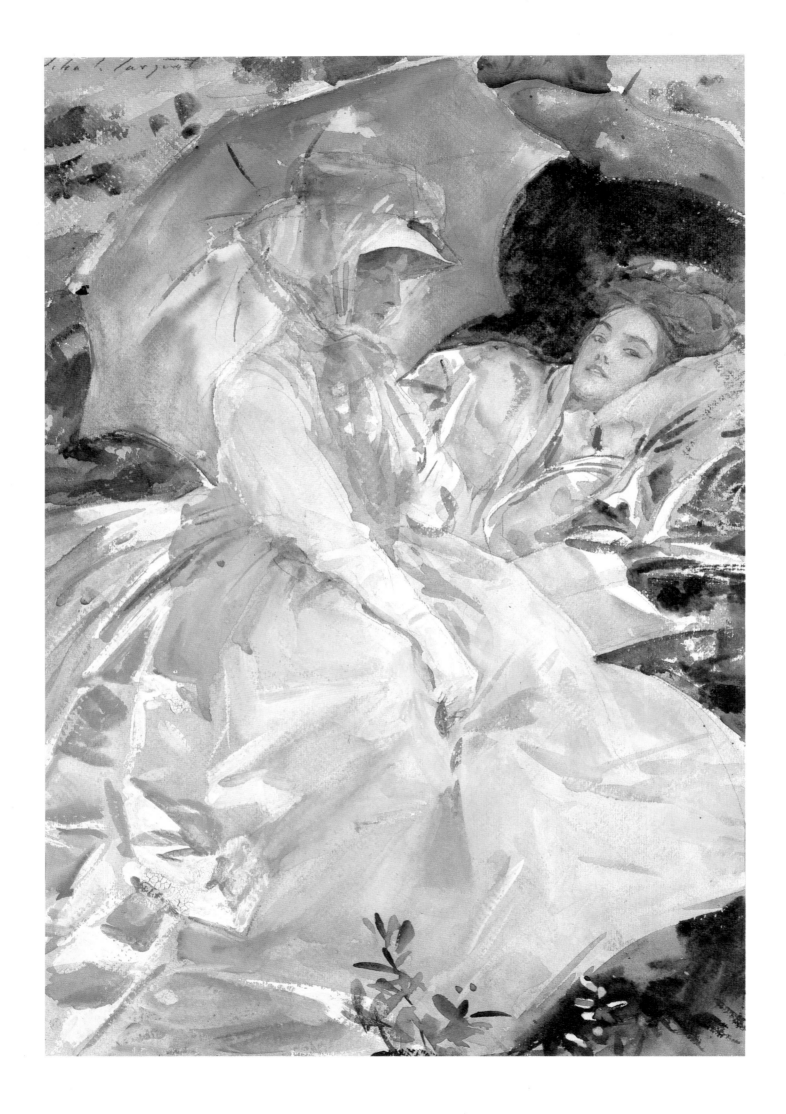

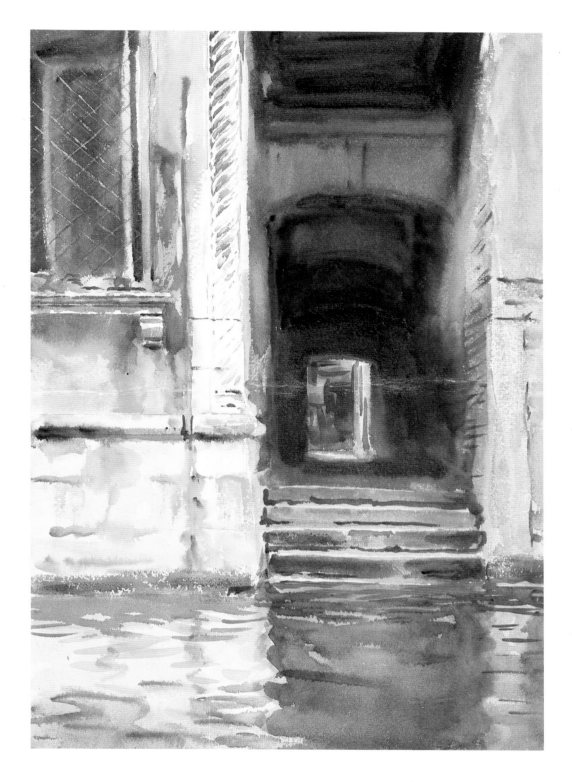

gives us faces full of personality. The artist herself is almost faceless, yet her pose is so skillfully rendered that it is easy to read an expression of concentration into her features. It is worth noting, too, the way that Sargent has captured the texture of the woman's clothing with a few suggestive strokes, a shorthand version of the method he applied to rendering the sumptuous costumes that so often feature in his formal portraits.

Like so many artists, Sargent was strongly drawn to Venice, a city he had known for most of his life. The oils he painted there in the 1880s—many of them interiors—tend to be rather theatrical in concept and somber in tonality. The Venice of Canaletto and Turner is glimpsed through the window of a palazzo or at the end of a dark alleyway. When Sargent began painting watercolors regularly, around the turn of the century, all that changed. The shadowy salons and courtyards no longer interested him; instead, he began to paint the sunlit Venice of the waterways.

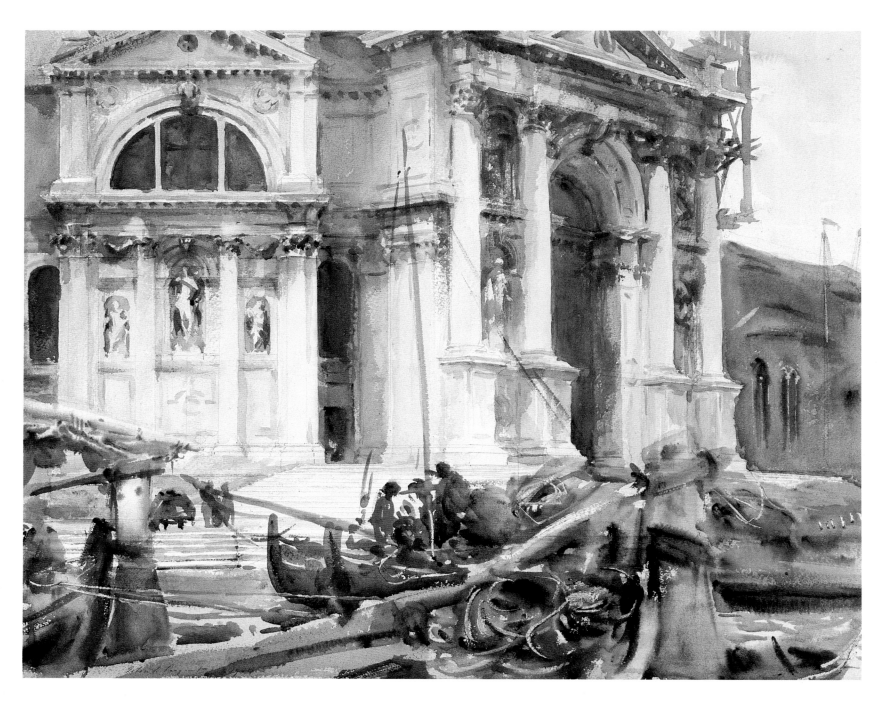

210. John Singer Sargent (1856–1925). *Santa Maria della Salute,* 1904. Watercolor and pencil heightened with white on paper, 18³⁄₁₆ x 22⁵⁄₁₆ in. The Brooklyn Museum; Purchased by Special Subscription.

This was still not quite Canaletto's slant on the city, or Turner's, for Sargent did not step back from the great monuments and present the whole splendid panorama. Rather, he set up his easel in a gondola or alongside a flight of stone steps leading down to a canal and painted what was close at hand. Often the point of view is that of someone looking up at a nearby building. Occasionally the prow of Sargent's own gondola juts up into the foreground, giving the image a feeling of intimacy.

This sense of intimacy is very apparent in *Venetian Doorway* (PLATE 209), yet the intimacy is modified by mystery, since the steps and covered alleyway lead to a world the viewer cannot enter. The building is the Palazzo Giustiniani Faccanon on the Rio de la Fava.[6] The viewpoint is from water level, and the sunlit masonry is conjured up with the help of warm washes of ocher and other earth colors, which also appear in the water to represent reflections. Brickwork and a rope column are suggested with a few quick strokes of the brush, and body color is used to delineate the grille over the window. Interestingly, in so loosely handled a painting, the pencil sketch beneath the washes features lines that appear to have been drawn with the aid of a ruler (this is quite common in Sargent's architectural subjects).

In *Santa Maria della Salute* (PLATE 210) the pencil underdrawing performs an important function. Ruled lines have been used to establish perspective, and pencil lines also help define much of the detail of the façade. The architecture is, in fact, rather exactly rendered, but the canal traffic in the foreground is laid in with extreme looseness, highlights being scraped into the wet paint, probably with the pointed handle of the brush. Most nineteenth-century watercolorists would have maintained an even focus throughout the picture, but Sargent—even more strikingly than Eakins or Homer—employed an approach that relates to photography. It is as if he had focused an imaginary lens on Baldassare Longhena's Baroque masterpiece, leaving the foreground a blur. In another version of the same subject, *A Scene in Venice,* in the collection of Asher Wertheimer, the foreground is more precisely defined while the architecture seems to be melting out of focus.

White Ships (PLATE 211) is another spectacular example of Sargent's way with water. Since the subject recalls some of Homer's tropical watercolors, it is interesting to compare methods. Homer's sailboat subjects tend to rely on densely saturated washes, often applied in rather broad expanses. Everything in Homer's watercolors seems carefully considered (though not at the expense of spontaneity), creating a mood that can best be described as meditative. Sargent's method, in a painting like *White Ships,* is more freewheeling. The washes are less densely saturated, and they are overlaid with a slashing

211. John Singer Sargent (1856–1925).
White Ships, 1908.
Watercolor and pencil on paper,
13⅞ x 19⅜ in.
The Brooklyn Museum; Purchased by
Special Subscription.

212. John Singer Sargent (1856–1925).
Bedouin Women, c. 1905–6.
Watercolor heightened with Chinese
white on paper, 12 x 18¹⁄₁₆ in.
The Brooklyn Museum; Purchased by
Special Subscription.

213. John Singer Sargent (1856–1925).
Arab Stable, c. 1905–6.
Watercolor on paper, 10⁷⁄₁₆ x 14³⁄₈ in.
The Brooklyn Museum; Purchased by
Special Subscription.

calligraphy of brushstrokes that describe rigging, masts, and reflections and that seem to activate the entire picture plane. If Homer's work seems contemplative, philosophical, Sargent's seems to glorify the pleasures of the passing moment.

Sargent's travels took him to North Africa and the Middle East on several occasions, and it was natural that he would respond enthusiastically to the exotic subject matter. *Bedouin Women* (PLATE 212), is another example of how Sargent would use calligraphic strokes to animate the entire image. The tent is so freely brushed as to become almost an abstract shape. The women of the title merge with an enveloping web of shadow, and, despite the interest engendered by the subject, it becomes tempting to read this painting primarily as a sophisticated exercise in tonal contrasts, dark washes being set off against highlights picked out with Chinese white.

Arab Stable (PLATE 213), though not fully resolved, is a remarkable example of Sargent's virtuosity. Note in particular the way the central horse has been painted: overlapping washes of ocher and reddish brown are used along with a flash of blue gray body color to evoke simultaneously the planes of the horse's flank and the sheen of its hide. This graceful passage is as fine as anything Sargent ever painted, and it sums up eloquently the pleasure that is to be found in Sargent as an extemporizer. Taken as a whole, the painting seems incomplete, but the mastery is so self-evident that this little watercolor remains in the mind after many more ambitious efforts, by Sargent and other artists, have been forgotten.

Although not a confirmed woodsman like Homer, Sargent liked to make expeditions to wilderness areas, especially the mountains, and was quite prepared to rough it when necessary—indeed, he was renowned for his fortitude and stamina. These expeditions resulted in many watercolors, including *Mountain Fire* (PLATE 214), a painting remarkable for its economy, its fluidity, and its purity of wash. The nervous energy of Sargent's brushstrokes is perfectly suited to the occasion, capturing the flicker and crackle of the flames. At the same time, the looseness of the treatment seems to dissolve space and to render the distant peaks transparent, to the extent that this work, like *Bedouin Women,* can be read as an exercise in tonal arrangements.

214. John Singer Sargent (1856–1925). *Mountain Fire,* c. 1903–8. Watercolor on paper, 14 x 20 in. The Brooklyn Museum; Purchased by Special Subscription.

In the Simplon Pass (PLATE 215) seems unfinished, yet there is something mysterious about the foreground figure, especially in the way that the net veil hides the woman's face, that would have been lost had Sargent defined it any further. Part of the secret of all painting, but especially of watercolor painting, is knowing when to stop, and it is tempting to think that in this case Sargent chose to quit at the crucial moment. The actual explanation of the "unfinished" condition of this painting may simply be that the

OPPOSITE, CLOCKWISE FROM TOP LEFT:

215. John Singer Sargent (1856–1925).
In the Simplon Pass, c. 1910.
Watercolor and pencil on paper,
14⁷⁄₁₆ x 21³⁄₁₆ in.
The Brooklyn Museum; The Roebling
Society Purchase Fund.

216. John Singer Sargent (1856–1925).
Camp at Lake O'Hara, 1916.
Watercolor on paper, 15¾ x 21 in.
The Metropolitan Museum of Art,
New York; Gift of Mrs. David Hecht
in memory of her son Victor D.
Hecht, 1932.

217. John Singer Sargent (1856–1925).
Mountain Stream, 1910–12.
Watercolor on paper, 13½ x 21 in.
The Metropolitan Museum of Art,
New York; Purchase, Joseph Pulitzer
Bequest, 1915.

LEFT:

218. John Singer Sargent (1856–1925).
A Tent in the Rockies, 1916.
Watercolor on paper, 15½ x 21 in.
The Isabella Stewart Gardner Mu-
seum, Boston.

sitter decided to stretch her legs. In any event, her enigmatic presence, cocooned in luminous washes, is as evocative of a lost Edwardian world as anything Sargent ever painted.

Camp at Lake O'Hara (PLATE 216) commemorates Sargent's 1916 expedition to the Rocky Mountains, but his masterpiece in the wilderness genre is *Mountain Stream* (PLATE 217). The figure of the bather has been elegantly defined with pencil lines but is given no more significance than the boulders that litter the foreground and line the stream. The water, appropriately, is treated very differently from the water in his Venetian paintings. Gone are the oily green reflections; in their stead, Sargent employs blue and indigo washes and makes liberal use of the white paper to suggest the broken water of the rapids. Most striking is the unity of texture that ties the entire composition together. As in most of Sargent's plein-air works, there is no horizon line, nor does he rely on any obvious compositional device. The effect of this is to give a roughly equal value to every part of the painting, which is the opposite of a portrait, in which everything is focused on a central icon. In *Mountain Stream,* Sargent escapes as completely as could be imagined from the constraints of his commissioned works.

Another formidable painting that makes use of "allover" composition in a decidedly modern sense is *Gourds* (PLATE 219). Here Sargent sets his bravura technique loose on fruit hanging from a tangled umbrella of vines. Pencil strokes, liquid washes, and squiggles of gouache flicker across the entire surface. As always, the paint performs its descriptive function, but it also gives pleasure for its own sake. This is often the case with details in Sargent's portraits—the bodice of a dress, perhaps, or a piece of jewelry—but here it applies to the entire composition.

Palmettos (PLATE 220), painted on a 1917 visit to Florida, has a somewhat more conventional format, with the green of the fronds set off against a brown background of dead leaves and grasses; but there is still no tight focus, and elements are rather evenly distributed throughout the composition. It is noteworthy that Sargent's response to Florida was not unlike Homer's—both were attracted to the tropical vegetation—despite

169

ABOVE:
219. John Singer Sargent (1856–1925).
Gourds, c. 1905–8.
Watercolor on paper, 14 x 20 in.
The Brooklyn Museum; Purchased by
Special Subscription.

RIGHT:
220. John Singer Sargent (1856–1925).
Palmettos, 1917.
Watercolor on paper, 15½ x 20⅝ in.
Ormond Family.

the differences in their temperament. Interestingly, when watercolors of similar subjects by Homer and Sargent are hung side by side, they complement each other very well, bringing out the strengths of each artist, a fact that seems to have been evident to Sargent's contemporaries.[7]

Another Sargent watercolor that in some ways recalls Homer while illustrating the differences between the two is *The Green Door, Corfu* (PLATE 221), a painting in which the main interest, along with the door of the title, is shadows of foliage on a rather featureless white wall. In *A Wall, Nassau* (PLATE 222) Homer painted another white wall,

221. John Singer Sargent (1856–1925).
The Green Door, Corfu, 1909.
Watercolor on paper, 13 x 19½ in.
Ormond Family.

222. Winslow Homer (1836–1910).
A Wall, Nassau, 1898.
Watercolor on paper, 14¾ x 21½ in.
The Metropolitan Museum of Art,
New York; Amelia B. Lazarus Fund.

223. John Singer Sargent (1856–1925).
Crashed Aeroplane, 1918.
Watercolor, pencil, and gouache on
paper, 13½ x 21 in.
Imperial War Museum, London.

224. John Singer Sargent (1856–1925).
The Interior of a Hospital Tent, 1918.
Watercolor on paper, 15½ x 20¾ in.
Imperial War Museum, London.

this one topped with broken glass. What unites the two artists is the fact that both find subjects where others, more concerned with uncovering the picturesque, would pass on by. Both treat their walls with great respect and revel in the simplicity of the subject and the fluency of their technique. Both employ vegetation to offset the blankness of the masonry. Beyond that, however, there are patent differences that help define the distinctive approaches of the two men. Sargent permits his wall to blank out whatever lies beyond it. Typically, sky and horizon are eliminated. Homer, on the other hand, looks over his wall and sees the ocean beyond, a passing sailboat, an expanse of blue sky. Homer acknowledges the banality of his wall by the use of a rather drab wash and deliberately awkward brushstrokes. Sargent, by contrast, flatters his wall with an elegant web of thrown shadow in his best calligraphic manner. He elevates the wall's status as he might elevate the status of one of his society sitters. Homer acknowledges his wall's plainness, while celebrating the glory of its setting.

The consensus of opinion is that Homer's art is more profound than Sargent's, and there is no reason to dispute this, but it should not blind anyone to Sargent's own very real merits, including the technical command that puts him in the front rank of watercolorists. Nor should anyone underrate his range. His eye was like that of a photographer—he knew exactly how to crop an image—and he responded to varying situations with unfailing skill and spontaneity.

Sargent could make a notation of a ceiling decorated by Tiepolo (PLATE 205) that conveyed the spirit of the great Venetian's art without bogging down in detail. On the other hand, he could deal with the dour realities of the twentieth century. During World War I, Sargent spent time at the western front, where he painted gassed soldiers, troops at leisure, bombed buildings, the inside of a hospital tent, and even a crashed biplane (PLATE 223). To all of these subjects he brought his usual skill and visual acuity. (Note, for example, the elegance of the lighting scheme in *The Interior of a Hospital Tent,* PLATE 224.)

Sargent's watercolors always seem marvelously fresh, perhaps because they offered him an escape from chores that had become odious, however rewarding in worldly terms. Only in his watercolors, and in his little oil sketches, did he allow himself to forget the demands of the marketplace and to make personal statements. Only in these paintings did Sargent transcend the limitations of virtuosity and become an artist who was a creative original as well as an interpretive genius.

CHAPTER EIGHT

JOHN MARIN

During the same two decades that Sargent was bringing the bravura watercolor tradition to its apotheosis, an artist who was his junior by just fourteen years, John Marin, was inventing an altogether different watercolor language, one that would win him a leading position among the pioneers who were Americanizing the revolutionary art of Europe. Born in Rutherford, New Jersey, Marin was raised by his maternal grandparents and two maiden aunts.[1] Although he displayed some early interest in art, Marin first worked as a clerk in a New York wholesale notions shop, then found employment with various architectural firms, eventually opening his own office in Union Hill, New Jersey, in 1893. During this period he was painting in his spare time, using a watercolor technique that he later said was shaped by studying reproductions of paintings by British masters. Marin's architectural practice did not prosper, and, in 1899, at the age of twenty-eight, he finally began his formal art education, studying at the Pennsylvania Academy, where his teachers included William Merritt Chase and Eakins's protégé, Thomas Anshutz. He remained there for two years, painted on his own for a while, attended some classes at the Art Students League in New York, and then, in 1905, with the reluctant support of his family, left for Europe and settled in Paris. He was thirty-four years old.

In Paris, Marin became part of an expatriate group that included Alfred Maurer, Max Weber, Patrick Henry Bruce, Edward Steichen, and Arthur B. Carles, who was an old friend from the Pennsylvania Academy. This circle was united by an admiration for the French moderns, especially Matisse, and they all belonged to the New Society of American Artists in Paris, a group that espoused new trends in the art world. Marin would later claim that he did not look at much current art during his years in Paris—in fact, that he was not even familiar with the Impressionists at the time—but the visual evidence of his paintings from the period strongly contradicts this, arousing the suspicion that Marin was attempting to mythologize himself as an American "natural." Actually, his paintings were hung at the 1907 and 1908 Salons d'Automne and at the 1907 Salon des Indépendents in the company of work by such artists as Cézanne, Signac, Albert Marquet, and Robert Delaunay. Even if Marin managed to ignore the work of these pioneers at those shows, it would still be absurd to believe that he was not exposed to their influence somehow, at least through the paintings of his progressive American friends.

Marin had learned etching in New York, and during his European sojourn he made more than one hundred plates depicting historic landmarks and picturesque scenes. Intended as a means of supplementing the income he received from his family, these etchings were conceived in a rather conventional, post-Whistlerian style and display little of the imagination and flair that Marin would bring to the medium a few years later. At the same time, though, and primarily for his own pleasure, he painted in oil and, with

225. John Marin.
Maine Coast, 1914.
Detail of plate 234.

226. John Marin (1870–1953).
A Rolling Sky, Paris after Storm, 1908.
Watercolor on paper, 12½ x 14¼ in.
The Art Institute of Chicago; The
Alfred Stieglitz Collection.

much greater regularity, in watercolor, soon displaying a highly distinctive feel for the medium that was to provide his principal means of expression for the balance of his career.

A Rolling Sky, Paris after Storm (PLATE 226) is a good example of Marin's Paris watercolors at their most basic. There is no evidence that Marin was directly influenced by Whistler, yet many of his watercolors of this period have a Whistlerian mood, even more so than the etchings. Typically, the handling is loose, and Marin's ability to reduce a scene to its essentials again recalls Whistler. At the same time, Marin had from the outset a personality that was very much his own, and this is particularly clear in a painting like *River Effect, Paris* (PLATE 227), in which the boldly executed structure of the bridge and the rather blunt strokes that suggest the foreground water look forward to Marin's mature style. William Innes Homer has suggested that this painting may reflect the influence of Signac's watercolors and perhaps also the work of the Fauves.[2] Certainly the daring use of color suggests exposure to the Fauves, and this painting calls to mind, in particular, some of Raoul Dufy's watercolors.

Other paintings of the period, such as *London Omnibus* (PLATE 228), are perhaps less successful but in some ways even more adventurous. There is plenty of evidence in these early works that Marin knew very well how to lay down a clear, clean wash, but in *London Omnibus* he used a different approach, building up a strongly architectonic composition from strokes of color that have apparently been applied to unwetted, richly textured watercolor paper with a relatively dry brush. None of the conventional beauty of the medium is to be found here. What we discover instead is a slightly crude but very effective calligraphic statement in which chromatic effects are achieved by placing colors

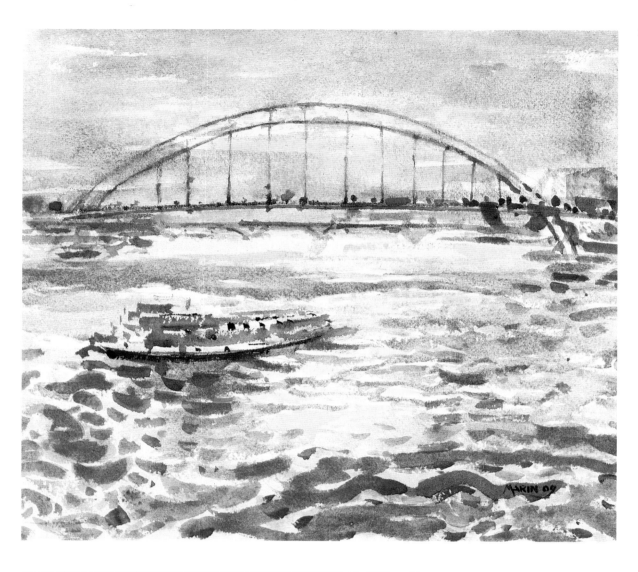

227. John Marin (1870–1953).
River Effect, Paris, 1909.
Watercolor on paper, 13 x 16 in.
Philadelphia Museum of Art;
A. E. Gallatin Collection.

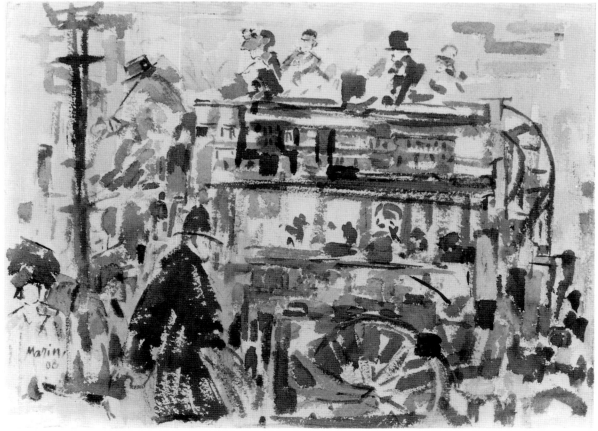

228. John Marin (1870–1953).
London Omnibus, 1908.
Watercolor on paper, 11¼ x 15¹⁵⁄₁₆ in.
The Metropolitan Museum of Art,
New York; The Alfred Stieglitz
Collection, 1949.

229. John Marin (1870–1953).
Buildings, One with Tower, 1910.
Watercolor on board, 21 x 14 in.
The Art Institute of Chicago; The
Alfred Stieglitz Collection.

230. John Marin (1870–1953).
Movement, Fifth Avenue, 1912.
Watercolor on paper, 16⅝ x 13½ in.
The Art Institute of Chicago; The
Alfred Stieglitz Collection.

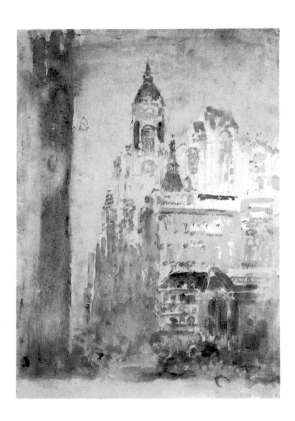

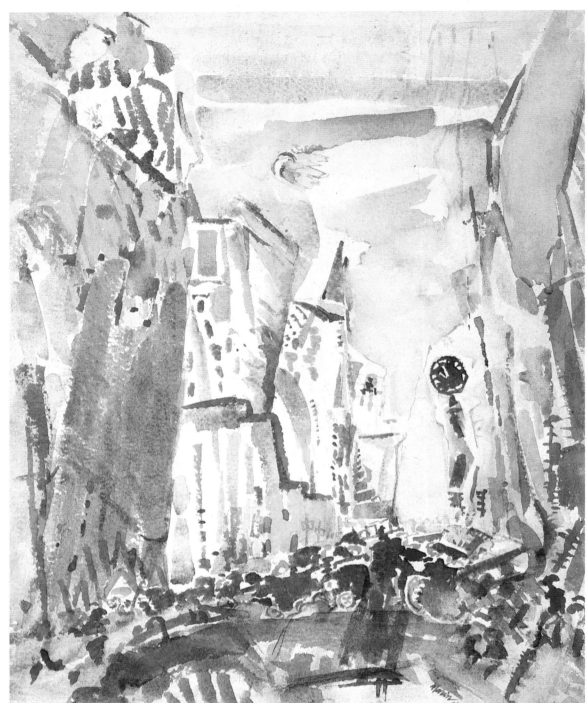

side by side (Post-Impressionist–style) rather than by layering transparent washes. This
again anticipates certain characteristics of Marin's mature idiom.

In 1909 Edward Steichen was instrumental in sending a group of Marin's watercol-
ors to Alfred Stieglitz, who exhibited them at his Little Galleries of the Photo-Secession
at 291 Fifth Avenue (later known as just "291"), the New York home of advanced art.
Marin's works, which were relatively conservative, were well received, several selling
for approximately $25 apiece.[3] When Stieglitz visited Marin in Paris later that year, he
was excited to find him doing much more adventurous paintings. It was natural that
when Marin returned to America the two of them should become staunch allies, both
having similarly passionate views regarding the future of art and America's role in
bringing that future about.

Marin made his permanent return to the United States in 1911, by which time he
was forty-one years old—a tall, lean, angular man, handsome in a decidedly theatrical

way, like the lead in some road-company production of *Arsène Lupin*. His appearance was, in fact, to prove useful to the growth of his reputation, since it made him a very visible and photogenic representative of the New Art (Stieglitz made several striking portraits of him). In addition to this, Marin was vocal and articulate in its defense, a fact that endeared him to the press during the period of the Armory Show, when revolutionary art was briefly a hot topic. Marin was frequently called on for statements or polemical pieces for the Sunday supplements. Sometimes examples of his work were reproduced along with his texts, and it seems to have been of significance to editors, and to the public, that he imposed his modernist distortions not on traditional subjects such as the female nude (as was the case with Matisse, whose work Stieglitz had first shown, to general opprobrium, in 1908) but rather on more novel subjects such as the skyscrapers—the "cathedrals of commerce"—that were transforming the Manhattan skyline. This somehow made Marin seem less of a blasphemer against the gods of art and hence less threatening, more sympathetic.

Marin first turned to this kind of subject matter during an extended visit to New York in 1909–10. *Buildings, One with Tower* (PLATE 229) belongs to a group of watercolors made of Lower Broadway during that visit, several of which, including this one, made a feature of the Singer Tower, one of the most handsome Edwardian skyscrapers. In all of these paintings the handling is relatively straightforward, but the feeling is made modern by the subject matter. This modernity of subject was to become characteristic of much advanced American art during the 1910s, '20s, and '30s. European artists were driven to invent new forms because they felt they were dealing with a moribund world. In America, however, artists saw new wonders springing up all around them, and they felt, therefore, that they could be true to the principles of modernity simply by recording the architectural and mechanical wonders of the changing environment. (Stieglitz and other photographers reinforced this, since they showed that it was possible to be modern simply by looking at the right things.)

This did not mean, in Marin's case at least, that the artist was satisfied with conventional realism. A look at *Movement, Fifth Avenue* (PLATE 230), painted in 1912, shows how he began to use expressionistic exaggeration and a hint of post-Cubist fragmentation—somewhat in the mode of Robert Delaunay—to suggest the frenetic quality of urban life. The scene is Fifth Avenue near the intersection with Thirty-fourth Street. The clock on the pedestal is one of several that once stood in the center of Fifth Avenue, dividing the two streams of traffic (when Fifth Avenue was a two-way street). A dense calligraphy represents the chaos of traffic and pedestrians at the intersection, while swiftly drawn jagged strokes animate the buildings, which seem to have a life of their own. This painting, along with similar New York subjects, was hung in Marin's 1913 exhibition at 291 (which coincided with the Armory Show). Describing these watercolors in *Camera Work,* Marin wrote:

> Shall we consider the life of a great city as confined simply to the
> people and animals on its streets and in its buildings? Are the buildings
> themselves dead? We have been told somewhere that a work of art is a
> thing alive. You cannot create a work of art unless the things you behold
> respond to something within you. Therefore, if these buildings move me,
> they too must have life. Thus the whole city is alive; buildings, people, all
> are alive; and the more they move me the more I feel them to be alive.[4]

This attempt to find life in the city's girders and masonry is even more pronounced in slightly later works, such as two otherwise differing views of lower Manhattan painted in 1920 and 1922. The earlier of these paintings, sometimes known as *The Blue*

231. John Marin (1870–1953).
Lower Manhattan, 1920.
Watercolor on paper, 21⅞ x 26¾ in.
The Museum of Modern Art, New
York; The Philip L. Goodwin
Collection.

Horse (PLATE 231), takes a ground-level viewpoint and makes powerful use of more or less conventional perspective devices to establish a sense of scale. Heavy black lines—which were becoming a feature of Marin's style at about this time—sketch in the diagonal thrust of an elevated railway line and the soaring shape of a skyscraper, apparently the Woolworth Building. More black lines angle in from the sides of the picture to emphasize the vertical perspective without serving any clear descriptive purpose. The composition is enlivened by streaks of blue and reddish brown, sometimes watered down, sometimes used almost raw from the tube. The later painting (PLATE 232) reverses the perspective so that the viewer is looking down from the top of the Woolworth Building (then the tallest building in the world and furnished with a popular observation deck). The summit of the building is represented by a sunburst shape, which is actually cut out and sewn onto the rough-textured watercolor paper. Again, heavy black lines define the composition; in this instance, it is almost as if the city has exploded, the

buildings being fragmented in a way that may derive in part from the Cubists and the Futurists but that retains, nonetheless, all the essentials of Marin's personal calligraphy.

The city was not Marin's only source of inspiration, however, and if his attempt to infuse office towers and bridges with life suggests pantheism with an industrial edge, it is hardly surprising that a full-blown pantheism, in the tradition of Thoreau and Emerson, informed his attitude to nature. Nor is it surprising that he was drawn to landscape and, especially, to seascape as subject matter. Landscape presented Marin with a challenge very different from that offered by the burgeoning city. In landscape he confronted a theme that painters—and particularly watercolorists—had been struggling with for generations. The subject gave him no guarantee of "built-in" contemporaneity. If he wanted to be a modernist with such subject matter he would have to impose his own stamp of originality upon it. Fortunately, Marin was a mature artist by the time he achieved any degree of public visibility, and he did not fall into the trap of trying to prove himself an avant-gardist at every outing. A painting such as *Hilltop, Hoosic Mountains, Massachusetts* (PLATE 233), of 1918, is conventionally representational in a completely

232. John Marin (1870–1953).
Lower Manhattan (Composing Derived from Top of Woolworth), 1922. Watercolor and charcoal on paper with paper cutout attached, 21⅝ x 26⅞ in. The Museum of Modern Art, New York; Acquired through the Lillie P. Bliss Bequest.

233. John Marin (1870–1953).
Hilltop, Hoosic Mountains, Massachusetts,
1918.
Watercolor on paper, 9⅛ x 11⅞ in.
McNay Art Museum, San Antonio,
Texas; Bequest of Marion Koogler
McNay.

234. John Marin (1870–1953).
Maine Coast, 1914.
Watercolor on canvas, 16 x 19 in.
Kennedy Galleries, New York.

235. John Marin (1870–1953).
Breakers, Maine Coast, 1917.
Watercolor on paper, 15⅞ x 18⅝ in.
Columbus Museum of Art; Gift of
Ferdinand Howald.

unselfconscious way. Not just an isolated example, this is typical of the Massachusetts views that Marin produced that year (though a few others are quite abstract), and he occasionally returned to such straightforwardly descriptive landscapes throughout his career.

Maine Coast (PLATE 234) is almost equally direct, though the density of the color and the simplicity of the statement echo the Fauvism first seen in some of Marin's Paris watercolors. What is perhaps most significant about this painting is that it introduced the theme that was to dominate the last four decades of Marin's life. It was in 1914 that he first summered in Maine, renting a beach cottage on Casco Bay, and that rocky coast-line, with its many moods, its islands, and its bays, was eventually to inspire hundreds of paintings. There is nothing monotonous about the long sequence of Maine watercolors that flowed from his brush, for seldom has an American artist successfully rung so many changes on a single theme.

The influence of Whistler can be sensed in *Breakers, Maine Coast* (PLATE 235), to the extent that Whistler transmitted an awareness of Oriental art to an entire generation. The subject is sea and rocks, and Marin paints it with a succinctness that might have satisfied a Sung Dynasty master. Marin's calligraphy has a distinctly Oriental cast, but what the Chinese or Japanese artist would have identified with most readily is Marin's pantheism. For him, as for Oriental artists espousing Taoist beliefs, there was a mysterious life force pervading all nature.

It was Marin's theory, expressed many times, that the shapes and colors of nature could never be accurately transferred to paper or canvas and that it was folly to try.[5] He

236. John Marin (1870–1953).
 Sunset, Maine Coast, 1919.
 Watercolor on paper, 15½ x 18½ in.
 Columbus Museum of Art; Gift of
 Ferdinand Howald.

preferred to believe that his hand would be guided by the same force that caused the winds to blow and the tides to rise and fall.

A 1921 painting, *Off Stonington* (PLATE 237), shows this philosophy in action. Certainly blue is used conventionally to indicate sea and sky, but no effort is made to reproduce the actual appearance of waves or clouds. The choppy motion of the ocean is suggested not descriptively but by the use of choppy brushstrokes. Each of these strokes has a life of its own, existing as a concrete patch of color. This is true not only for the blues but also for the browns and greens that help delineate the island and the ocean swells while also maintaining their independence as expressive marks on canvas. In this respect Marin's work sometimes comes surprisingly close to Sargent's. As noted in the previous chapter, Sargent's bravura brushstrokes often take on an existence distinct from their descriptive function. Marin's calligraphy has a very different personality, of course, and his way of assembling a composition dates very specifically from the post-Fauve era; but the distance between the two artists is not as great as it may seem at first glance.

237. John Marin (1870–1953).
Off Stonington, 1921.
Watercolor on paper, 16 x 19 in.
Columbus Museum of Art; Gift of
Ferdinand Howald.

238. John Marin (1870–1953).
Grey Sea, 1924.
Watercolor on paper, 16½ x 20½ in.
Phillips Collection, Washington, D.C.

Grey Sea (PLATE 238) shows Marin at his boldest, the ocean being suggested with just a few broad strokes. The simplicity of treatment calls up the memory of Whistler once again; but the high horizon line is not Whistlerian, and it has the effect of making Marin's painting seem more abstract. It would be difficult, in fact, to make a more abstract statement without abandoning figuration entirely, which Marin was not prepared to do, although he had toyed with the idea in the late teens. Certainly this is an example of Marin's theory that in watercolor painting, as in golf, one tries to make do with fewer and fewer strokes. It also demonstrates once more his dictum, "In painting water make the hand move the way the water moves."[6]

As Marin grew older, his watercolors sometimes took on what might be described as a "generic" quality, as if inspired not by a specific place but rather by the idea of Maine coastal scenery in the most generalized sense. Sometimes the resulting paintings are weak, seeming like feeble parodies of Marin's best work. In other instances, however, the artist was able to distill something like an idealized, Platonic version of the seascape genre. In *Seascape with Rocks and Sailboat* (PLATE 239) boulders and ocean shaped

239. John Marin (1870–1953).
Seascape with Rocks and Sailboat, 1930.
Watercolor on paper, 15 x 20¼ in.
Mr. and Mrs. Michael Fischman.

240. John Marin (1870–1953).
Sea Fantasy, No. 7, 1943.
Watercolor on paper, 15 x 20½ in.
Kennedy Galleries, New York.

with the aid of richly saturated washes take on a genuinely elemental quality that goes beyond a specific place at a specific time. *Sea Fantasy, No. 7* (PLATE 240) is also somewhat generic, but again it is a fine painting, with some of the Oriental feel that characterizes paintings like *Breakers, Maine Coast.*

These later paintings are, to a large extent, the consequence of Marin's identifying so closely with his subject matter. It was as if he no longer needed to consider a certain piece of Maine scenery and then set down something that approximated its topography. As the decades passed he seemed to feel that he had become a living part of the Maine coast, that he could reinvent it out of his head, and he rarely painted directly from nature as he got older. For some reason—perhaps simply the fact that a change of medium encouraged a freshness of approach—it was often in oil paint that Marin was most successful during this last phase of his career. As a watercolorist, his greatest period had been from about 1910 to the mid-1920s, and it was during this time that he had made his major contribution to the evolution of American art, an evolution that he influenced not only as a painter but also as a spokesman and proselytizer. The most visible and vocal member of the Stieglitz group (except, of course, Stieglitz himself), he was during these crucial years one of a handful of figures around which the American avant-garde crystallized.

At the same time, Marin always remained an intensely personal artist, one who was more concerned with the evolution of his personal iconography than with the public issues this iconography sometimes touched upon. In the end his most telling statements about painting are not those he made as a spokesman for modernism but rather those that he offered, off the cuff, in the highly idiosyncratic letters he wrote to friends.

"I have to paint pictures," he wrote to Charles Duncan in 1948:

> Oh yes I have
> to—Some Cuss inside forces me
> to paint—those things they call
> pictures—The thing to do is to paint
> the perfect pictures then you are
> through—you don't have to paint—
> more—
> One would be a *damn fool*
> to do so—
> but startling things
> can occur on canvas . . .
> Hundreds of canvases—many many
> paint pots—a great stack of brushes
> and—an extended extended extended life.[7]

Marin was seventy-eight years old when he wrote this and had another five years to live, years that were productive almost to the end.

CHAPTER NINE

NEW DIRECTIONS

It is difficult to explain why the advanced American painters who came to maturity just before the 1913 Armory Show, or in its immediate wake, showed such a predilection for watercolor. Such was by no means the case among their contemporaries in Europe. Certainly Matisse was capable of dashing off a watercolor, and Picasso used the medium to make studies for *Les Demoiselles d'Avignon* (perhaps reflecting the pressing influence of Cézanne on his work at that time), but it cannot be said that watercolor played a key role in their careers. This is true of the avant-garde in Europe as a whole, so that such artists as Wyndham Lewis and Paul Klee, who produced a substantial body of important watercolors, are exceptions. In the United States it is possible to point to a dozen or more major figures of the period who either employed watercolor as a primary medium or, at least, used it in important phases of their art.

Perhaps the most obvious reason for this is the uncommon strength of the American watercolor tradition, which made the medium attractive to young artists. Beyond this, it is tempting to look to Stieglitz as an influence, since many of these young radicals first showed at his gallery, 291, or at least belonged to his circle. Stieglitz himself specifically denied this, however, telling Dorothy Norman that until he saw Marin's work he had not much cared for watercolor.[1] True, his remark overlooks the fact that he had, prior to his first showing of Marin's work, hung watercolor drawings by Rodin and Matisse at his gallery and had expressed enthusiasm for them; but there is no reason to doubt his insistence that he was not a watercolor aficionado prior to 1909. It is more likely that Marin removed any prejudice against watercolor that might have lingered in Stieglitz's mind, and, once Marin's work had appeared at 291, watercolors were seen there more often. In 1911, for example, Marin's February show at the gallery was followed by one of Cézanne watercolors, an exhibition of drawings and watercolors by Picasso, and a show of Symbolist-influenced watercolors by the humorist Gelett Burgess.[2]

This is not the place to rehash the story of the Armory Show, but it is of interest that watercolorists were well represented there (naturally enough, given that Arthur B. Davies was a key organizer). More important, of course, was the fact that young American artists, whether watercolorists or not, were exposed to an unprecedented amount and variety of advanced European art. Also, the show brought to America a sometimes overlooked figure who is now seen to have had a great influence on American art, an influence that continues today. At the time of the Armory Show, few Americans—even those familiar with Matisse, Picasso, and Braque—had ever heard of Francis Picabia. In Paris, even in avant-garde circles, the Franco-Cuban painter was considered something of a renegade, having already discarded idioms from Impressionism to Cubism in a career that began with a startling precocity and matured with an insatiable desire for

241. Milton Avery.
Road to the Sea, c. 1938.
Detail of plate 274.

242. Francis Picabia (1879–1953). *New York,* 1913. Watercolor and gouache on white drawing board, 21⅝ x 29⅝ in. The Art Institute of Chicago; The Alfred Stieglitz Collection.

artistic novelty. To make things worse, Picabia also cultivated a playboy image: instead of starving in a garret or at least comporting himself as a proper bohemian, he drove powerful sportscars and held court in an elegant apartment overlooking the Champ-de-Mars. When people dismissed him as a rich dilettante, Picabia replied that he was not wealthy at all but merely had the courage to behave as though he were.

His 1913 trip to America was to inspire some of Picabia's greatest paintings—*Edtaonisl, Udnie, Je revois en souvenir ma chère Udnie*—but, more to the point here, he worked a good deal in watercolor and made a number of New York–inspired watercolors at his rooms in the Breevort Hotel, where he stayed during an extended visit. As early as 1909 Picabia had been making totally abstract works in the medium, and those that he painted in New York were essentially nonfigurative compositions in which he tried to give expression to the energy of Manhattan (PLATE 242). Like his close friend Marcel Duchamp, he was also, at this time, becoming involved with the aesthetics of the machine, from an absurdist point of view that would qualify them both as founding fathers of Dada.

With his easy charm and ready wit, Picabia quickly made friends among New York's cultural elite, and it was natural that he and Stieglitz would encounter each other. It was less predictable, however, that they would hit it off as well as they did, Stieglitz being a man of infinite seriousness of purpose and Picabia being a mercurial individual with the instincts of an iconoclast. Perhaps Stieglitz sensed that under his worldly veneer Picabia was as deadly serious as he was. In any case, Stieglitz and Picabia quickly became close allies, and in March–April of 1913 Picabia exhibited sixteen New York "studies" at 291.

Later, during World War I, Picabia returned to New York for another extended visit, his trip this time coinciding with the first visit by Marcel Duchamp, whose *Nude Descending a Staircase* had been the great sensation of the Armory Show. Duchamp gravitated toward the recently formed art circle of Walter and Louise Arensberg. Picabia

remained faithful to Stieglitz, who was now publishing an ambitious new magazine named *291*, which was greatly enlivened by Picabia's contributions. It was nonetheless inevitable that Duchamp and Picabia would continue to inspire one another, and the result was the birth of New York Dada. All of this has been extensively discussed elsewhere.[3] What is of concern here is the impact that Duchamp and Picabia had on American artists, especially watercolorists. Duchamp was not as much of a watercolorist as Picabia, but he did use the medium confidently in such works as *The King and Queen Traversed by Nudes at High Speed* and *Virgin No. 2*, both of which came early into the Arensberg collection. More important, Duchamp, like Picabia, was opposed to orthodoxies, especially the insistence that oil on canvas is the only proper medium for serious painterly endeavor.

Lloyd Goodrich has pointed out that there is a fundamental difference in the way that the modern movements evolved in the United States and Europe. "To the Europeans, the resources of representational art appeared to have been exhausted, and the only possible direction was the search for new concepts. So within a few years, European art passed through a series of revolutions."[4] Not having been similarly disillusioned with traditional modes, advanced American painters were excited about what they found in the new European art, but they were not driven by the same revolutionary impulses. In Goodrich's words, "The achievements of American modernism were to be in personal expression on an individualistic plane." This describes exactly the work of a man like Marin, and it helps explain why others also sought to explore the brave new world on the modest scale of the watercolor.

One such artist was Charles Demuth. Born in Lancaster, Pennsylvania, in 1883, Demuth came of Pennsylvania Dutch stock who had been established in Bucks County since colonial times. Like Marin, he studied at the Pennsylvania Academy of the Fine Arts and spent time in Paris before World War I. Back in the United States he became a member of the bohemian group that had begun to colonize Provincetown, Massachusetts, where he struck up a friendship with another young painter, Stuart Davis. Demuth was given his first one-man show at the Daniel Gallery in New York in 1914 and quickly became part of the avant-garde set that gathered around Stieglitz and the Arensbergs. Demuth became a good friend of Marcel Duchamp, introducing him to jazz and Harlem nightlife.

Lame since childhood—possibly the result of poliomyelitis—Demuth was plagued by ill health throughout his life, a fact that seems to have influenced his choice of watercolor as a primary means of expression, quite simply because it was more portable and therefore more manageable. (Much the same was true of the gifted British watercolorist Edward Burra, who, like Demuth, made Harlem the subject of some of his finest work.) Demuth did paint in oils, but always on a relatively small scale, and watercolor was undoubtedly his first love. Indeed, he went so far as to tell his friend Susan Watts Street: "I'd much rather do watercolor. Oil paints are so messy."[5] It should be remarked that Demuth affected a Beardsleyesque dandyism, so this statement was likely made tongue-in-cheek, but at the same time it expresses a genuine preference.

Demuth had exhibited at the Pennsylvania Academy's annual watercolor shows since 1908, and all of his early New York exhibitions consisted exclusively of watercolors and drawings. Some of the earlier watercolors are, in fact, basically tinted drawings, but Demuth soon became skilled at using pure washes to establish form, though he never gave up the habit of underpinning the architecture of his watercolors with pencil lines.

Demuth's watercolors may conveniently be divided into four groups, not succeeding each other in any strict chronology but rather coexisting as interwoven strands

throughout his career (though one might gain temporary ascendancy). In the teens and early '20s Demuth painted many relatively straightforward landscapes, most commonly of the coast and dunes near Provincetown. These paintings were original mostly in their use of color, which was given an autonomous role and not asked to serve a purely descriptive function.

Much the same might be said about the figure compositions that Demuth produced with some regularity from the mid-teens on. These lively works often deal with subjects such as black entertainers (PLATE 243), circus and vaudeville acts, and bohemian life (PLATE 244). Also falling into this general category are the watercolor illustrations he did for such literary works as Emile Zola's *Nana,* Henry James's *The Turn of the Screw* (PLATE 245), and Frank Wedekind's *Pandora's Box.*

Typically, these figure compositions are underlaid with a web of pencil lines, the draftsmanship sometimes suggesting Picasso at his most informal. Demuth floated color over this web, using washes sometimes to define the main structural forms, sometimes to deliberately dissolve structure, and sometimes simply as local color to bring a silk dress or a pocket handkerchief to life. The more densely saturated washes were often applied very loosely, then artfully blotted, probably with a rag, or permitted to flow into one another, bringing a great fluidity to many of these paintings, which hark back in spirit to Toulouse-Lautrec's boulevardiers and to Picasso's early acrobats and saltimbanques. In the delicate interplay between line and wash they also recall the work of Jules Pascin, another European expatriate whom Demuth knew and admired. Pascin was in the United States from 1914 to 1920 and, like Demuth, painted a number of scenes of New York night life (PLATE 247).

From 1915 on Demuth exhibited many evocative studies of flowers, fruit, and vegetables, compositions that established him as one of the masters of American still-life painting. Wonderfully direct, at their best these works are exquisite examples of what

can be done with the simplest of means, if the artist's eye and hand are sure enough. Yet this frank simplicity, and the fact that the subject is treated in so lifelike a way, should not obscure the fact that these are very much works of the twentieth century.

A painting like *African Daisies* (PLATE 248) displays the flattened space derived from Post-Impressionism, from Fauvism, and, indirectly, from Cubism. Within this shallow space the elements are organized with a strong sense of pattern that betrays Demuth's early admiration for decorative artists such as Aubrey Beardsley. Some of Demuth's finest still lifes (PLATE 249) combine skillful modeling, achieved with the simplest of means, and a masterful use of unpainted white areas that clearly derives from Cézanne's watercolors. The remarkable thing is that Demuth was able to draw upon so many influences while remaining wholly himself. His art is eclectic, but in the best sense of that word. He might justly be described as a skillful synthesizer.

Demuth had the opportunity to study Cézanne's work closely at 291, at Gertrude Stein's apartment in Paris, and doubtless elsewhere on both sides of the Atlantic. This fact is worth keeping in mind when approaching the fourth major category of Demuth's watercolor oeuvre, the Cubist-inflected, geometrically faceted landscapes and townscapes he first essayed while visiting Bermuda with Marsden Hartley in the winter of 1916–17.

The paintings that Demuth made in Bermuda are, strictly speaking, semiabstrac-

OPPOSITE:
248. Charles Demuth (1883–1935).
African Daisies, 1925.
Watercolor on paper, 17¾ x 11¾ in.
Wichita Art Museum; The Roland P.
Murdock Collection.

ABOVE:
249. Charles Demuth (1883–1935).
Eggplant, Carrots, and Tomatoes,
c. 1927.
Watercolor on paper, 14 x 19 in.
Norton Galleries and Art School, West
Palm Beach, Florida.

250. Charles Demuth (1883–1935).
Red-Roofed Houses, c. 1917.
Watercolor on paper, 10 x 14 in.
Philadelphia Museum of Art; The
Samuel S. White III and Vera White
Collection.

tions derived from nature (PLATE 250). They might be compared with the kind of abstracted landscapes painted by certain other artists such as Lyonel Feininger (PLATE 251) and Ben Nicholson. Space is not fragmented and reorganized in a truly Cubist way. Rather, a geometric grid, derived from memories of Cubist paintings and man-made elements in the landscape, provides a structure from which chopped-up naturalistic details can be suspended in shallow space. Conceptually, they are not especially advanced for the date—not, at least, by European standards—but they derive a distinctive character from Demuth's Cézannesque deployment of "empty" areas in which the white paper is allowed to speak for itself.

Demuth later applied similar geometric grids to Lancaster, Provincetown, and other native American landscapes (PLATE 252), creating always interesting works that have led to his being categorized among the Precisionists, along with artists like Charles Sheeler and Morton Schamberg. His finest paintings in this vein, however, are oils such as *My Egypt* (1927) and *"After All . . ."* (1933). His later oils also include the so-called poster portraits—billboardlike symbolic portraits of people such as Gertrude Stein, Georgia O'Keeffe, and William Carlos Williams—which were to have an influence on the Pop art movement three decades later. In 1920 Demuth was discovered to be suffering from diabetes, which caused, or at least contributed to, his death in 1935. He continued to work almost to the end, however, producing his last known watercolors on a final visit to Provincetown in 1934.

Georgia O'Keeffe was born in rural Wisconsin, spent her childhood on a farm, and had apparently decided to be an artist by the time the family moved to Virginia when she was fifteen. She studied at the Art Institute of Chicago and at the Art Students League in New York, where she fell under the influence of William Merritt Chase. After achieving a certain proficiency in his Munich School manner, however, she abandoned painting for a while, determined not to fall into the trap of being an imitator. In 1912 O'Keeffe became aware of the teachings of Arthur Wesley Dow, who was in the process of revolutionizing art education by downplaying realism and advocating that students work

251. Lyonel Feininger (1871–1956).
Tug, 1941.
Watercolor and ink on paper,
12½ x 19 in.
Solomon R. Guggenheim Museum,
New York.

252. Charles Demuth (1883–1935).
Roofs and Steeple, 1921.
Watercolor and pencil on paper,
14¼ x 10⅜ in.
The Brooklyn Museum; Dick S.
Ramsay Fund.

with only the most basic of compositional elements, such as line and color. (Dow had derived his notions in part from Oriental art and in part from Gauguin and his followers, so to this extent O'Keeffe was exposed to foreign ideas at a crucial stage of her early development.)

For two years O'Keeffe worked as an art supervisor in the public school system of Amarillo, Texas; then she came to New York, where she visited a number of shows at 291 without daring to talk to Stieglitz. In 1915, while teaching in South Carolina, she began a series of radically abstract charcoal drawings in which she made a conscious effort to go beyond anything she had seen—to make a completely original statement. The strongest influence apparent in these early drawings was that of Dow. A friend showed some of these works to Stieglitz, who responded enthusiastically. From that point onward their careers were entwined, and in 1924 they were married.

In 1916, the year O'Keeffe first showed at 291, she began to use watercolor, employing that medium almost exclusively for the next three years. *Light Coming on the Plains I* (PLATE 253), painted in 1917, used transparent pigment in a traditional way, allowing the paper's reflectivity to give life to the color. There is nothing old-fashioned about the image, however: O'Keeffe has combined her ability to generate abstract forms with the pantheistic vision that is typical of so much American experimental art of the period, and she has done so with great confidence.

Never one to take a doctrinaire approach to art, O'Keeffe refused to confine herself to any one idiom, and her watercolors of the period range from outright nonfiguration to straightforward representation. However, even when she painted flowers or the female nude (PLATE 254) she was always simplifying, breaking down a form to its essential elements. After 1918 O'Keeffe turned away from watercolor as a primary medium,

255. Arthur Dove (1880–1946).
Dawn III, 1932.
Watercolor on paper, 9⁹⁄₁₆ x 9⁹⁄₁₆ in.
The Brooklyn Museum; Dick S.
Ramsay Fund.

256. Arthur Dove (1880–1946).
Mars Orange and Green, 1936.
Watercolor on paper, 4 x 6 in.
Terry Dintenfass Gallery, New York.

making the great majority of her paintings in oil and executing her most interesting works on paper in pastel or charcoal. During that brief three-year period, though, watercolor was exactly the fluid, inexpensive medium she needed for her experimentation, and the works she produced with it have a lasting place in the history of American art.

Early in her career, O'Keeffe was greatly impressed by the work of another member of the Stieglitz circle, Arthur Dove, and they continued to show an aesthetic affinity over the years. Dove had visited Paris in 1907 and began showing at 291 two years later. He had already enjoyed some success as an illustrator, and, after absorbing the lessons of Cézanne and the Fauves, he quickly moved on to a form of abstraction rooted in nature. Early examples, dating from around 1911, recall the work that Wassily Kandinsky was producing at about the same time (although there is no evidence that Dove was familiar with the Russian's work). Dove soon evolved a highly personal visual vocabulary that served him well for more than three decades.

Dove's strongest early works were executed in oils or pastels, and he was one of the first artists anywhere to incorporate real objects into his paintings. Later, especially in the last decade of his life, he made frequent use of watercolor, employing it with a forcefulness that is very distinctive (PLATES 255, 256). His technique was anything but classical. No subtle laying down of washes was involved. On the contrary, the color was applied rather crudely, straight from the tube, brushed on with a directness that suggests children's art.

Another Stieglitz artist, Marsden Hartley, was more influential through his work in other media, though his occasional efforts in watercolor are of considerable interest (PLATE 257). More significant as a watercolorist was Abraham Walkowitz. He was born in Siberia in 1880 and nine years later came to New York, where his family settled on the Lower East Side. He studied at Cooper Union and the National Academy of Design, then spent a year in Paris, where he was exposed to the same influences as other adventurous American artists. Returning to the United States in 1907, he became part of the Stieglitz circle and showed regularly at 291. His oil painting never achieved the strength of the best work by O'Keeffe, Dove, or Hartley, nor does it display much

257. Marsden Hartley (1877–1943). *Landscape #32,* c. 1911. Watercolor on paper, 14¹⁄₁₆ x 10¹⁄₁₆ in. The University Art Museum, University of Minnesota, Minneapolis; Bequest of Hudson Walker from the Ione and Hudson Walker Collection.

originality, but his watercolors are often quite bold and occasionally show real power. Walkowitz frequently painted dozens of variations on a theme, such as a woman's head (in the case of Isadora Duncan he made literally thousands of variations). His most interesting watercolors include some early abstractions (PLATE 258) and some larger compositions, such as *Bathers* (PLATE 259), in which he attempted to come to terms with relatively complex subjects in a manner deriving from the Fauves.

Among American artists not under Stieglitz's wing, several key figures, including Joseph Stella, Man Ray, and Charles Sheeler, were loosely associated with the Arensberg circle. Walter Arensberg was a wealthy young man—a poet by avocation—who was so bowled over by the Armory Show that he and his wife, Louise—a musician—uprooted themselves from Boston and settled in New York to be in the thick of things. As already mentioned, Marcel Duchamp was one of the figures drawn to the Arensbergs, staying in their apartment on West Sixty-seventh Street when he first arrived from France in 1915. Picabia, despite his allegiance to Stieglitz, also attended the Arensberg salon (there was some rivalry between the two groups), as did other Paris exiles such as the composer Edgard Varèse and Henri Pierre Roché, whose novel served as the inspiration for Truffaut's film *Jules et Jim.* Other regulars included the proto-Dadaist Arthur Cravan, Isadora Duncan, Max Eastman (editor of *The Masses*), Amy Lowell, and William Carlos Williams. Clearly this was heady company for young artists, and, given the war in Europe, it was a splendid surrogate for Montparnasse.

Joseph Stella had made his own claim to a leading place in American modernism before his exposure to the Arensberg circle. Born in Italy, he came to the United States as a teenager, studied with William Merritt Chase, and proved himself to be a formidable draftsman. For a while he had a successful career as an illustrator; then, in 1909 or 1910, he returned to Europe for a stay that was to last until 1912 or 1913. He went first to Italy but in 1911 found himself in Paris, where he was, at last, exposed to the work of the Fauves, the Cubists, and, most significant, the Futurists.[6] Stella saw the first Futurist exhibition at the Bernheim-Jeune gallery and may have met some of the artists involved. He did not immediately set out to emulate them, but back in New York, apparently aroused by the excitement of the Armory Show—although it included no Futurist works—he began his first Futurist canvas, *Battle of Lights, Coney Island.* When it was shown at the Montross Gallery in New York the following year, it made Stella an overnight cultural celebrity.

Stella displayed great facility in a variety of media—his charcoal drawings are especially skillful—but he seems never to have attempted to master classic watercolor technique. Instead, he used the medium with an almost naive gusto, mixing transparent color and gouache and sometimes applying the pigment with rather crude strokes. *Abstraction, Mardi Gras* (PLATE 260), from his Futurist period, was probably not intended as a finished work, but, in shorthand fashion, it conveys all the energy and spirit of his large oils. *Building Forms* (PLATE 261) is one of Stella's most delicate watercolors, a Cubist-inflected exercise that recalls some of Demuth's architectural studies, which Stella may well have known.

Like so many Americans of his generation, Stella had no qualms about shifting between experimentation and traditional representational art. In the middle of his Futurist period he would pause to make a detailed pencil study, worthy of John William Hill, of a lupine or a gnarled tree trunk. Nor did he feel that his success as a Futurist prohibited him from exploring other forms of new art. There is nothing deliberately surreal about *Cypress Tree* (PLATE 262), but in mood it is reminiscent of the Metaphysical paintings of Giorgio de Chirico and Carlo Carrà, and a letter that Stella wrote to Carrà in the early 1920s suggests that he was aware of the changes in Carrà's work since the Italian had abandoned Futurism, in 1915.[7] In any case, *Cypress Tree* is a striking and original work, and, judging by the scale, it is one to which the artist himself must have attached some significance.

260. Joseph Stella (1877–1946). *Abstraction, Mardi Gras,* c. 1914. Watercolor and gouache on paper, 8½ x 11½ in. Estate of Joseph H. Hirshhorn.

As a teenager, Man Ray studied architecture and engineering but soon switched his ambitions to painting. After the Armory Show he became fascinated with abstraction and other new tendencies. In 1915 he met Duchamp and Picabia and under their influence began experimenting, in a Dadaist spirit, with the possibilities of the machine aesthetic. Not satisfied with simply representing machinelike forms, he sought to create them in a machinelike way. For some of these he used water-based paint in a commercial artist's airbrush to make what are, by the broadest definition, watercolors (PLATE 264). In his famous "Rayographs" he used photographic materials to take this principle one stage further, a fascinating experiment that is beyond the scope of this book.

Charles Sheeler was another who was attracted to machinelike forms (functioning, like Man Ray, as both painter and photographer). He was also drawn to American architecture and to American industrial landscapes, all of which he painted with an attention to geometry and to the simplification of hard-edged forms that makes him the archetypal example of the group of American artists known as Precisionists or Immaculates (the latter term having originally been used pejoratively).

Like Man Ray, Sheeler was born in Philadelphia, where he studied industrial art before attending the Pennsylvania Academy of the Fine Arts. He traveled to Europe, then set up as a photographer in Philadelphia. The following year he exhibited six paintings in the Armory Show. Although not based in New York until 1919, he made frequent visits to the city and through his contacts with the Arensberg group soon became familiar with the entire avant-garde scene.

Although, like many of his contemporaries, Sheeler worked briefly in an Americanized Cubist patois, he very quickly moved on to his mature Precisionist manner, in which structural lessons derived from Cubism were applied to the representation of various functional objects and man-made landscapes. The basics of this approach are already evident in the 1918 *Bucks County Barn* (PLATE 263), in which the way the simple boxy shapes are piled up against one another has clearly appealed to the artist because it relates to his knowledge of Cézanne and the Cubists.

Sheeler occasionally employed watercolor or gouache in its pure form, but more typically he used it as an adjunct to other media, as in the ironically titled *Self-Portrait*

CLOCKWISE, FROM TOP LEFT:

263. Charles Sheeler (1883–1965).
Bucks County Barn, 1918.
Gouache and conté crayon on paper,
16⅛ x 22⅛ in.
Columbus Museum of Art; Gift of
Ferdinand Howald.

264. Man Ray (1890–1977).
Jazz, 1919.
Tempera and ink on paper
(aerograph), 28 x 22 in.
Columbus Museum of Art; Gift of
Ferdinand Howald.

265. Charles Sheeler (1883–1965).
Self-Portrait, 1923.
Gouache, conté crayon, and pencil on
paper, 19¾ x 25¾ in.
The Museum of Modern Art, New
York; Gift of Abby Aldrich
Rockefeller.

(PLATE 265), in which pencil and conté crayon do most of the work, with gouache washes supplying little more than a hint of local color. This beautiful drawing resembles nothing so much as a hand-tinted black and white photograph. More of a conventional watercolor is *River Rouge Industrial Plant* (PLATE 266), in which Sheeler took on the type of factory scene that he portrayed so often in other media and brought to it a looseness of handling that demonstrates he was capable of occasionally dropping his Precisionist guard.

Far more of a Precisionist watercolor is *The Chrysler Building under Construction* (PLATE 267) by Sheeler's friend Earl Horter. Although Horter is a little-known painter, in this instance he managed to capture the spirit of an entire era, the era of artistic optimism and commercial expansion that was brought to an end by the Depression, which was already deepening when Horter painted this picture.

Demuth's Precisionist watercolors have already been considered, and O'Keeffe seldom used watercolor for her Precisionist work, but one other important figure with ties to the movement remains to be considered. Preston Dickinson was born in New York, studied at the Art Students League, lived in France for a while, then returned to America, working sometimes in New York, sometimes in Quebec. His oil paintings tend to emphasize the Cubist roots of Precisionism, but some of his finest works are in pastel or watercolor (he often combined the two).

Paintings like *Outskirts of the City* and *The Bridge* (PLATES 268, 269) display a very distinctive approach, in which color is used rather freely—and not always descriptively—to complement a strong linear structure. Often Dickinson's watercolors are deceptively simple, and it is only on careful consideration that his genius for the exact placement of elements in a composition becomes apparent. Were it not for his early death he might well have won a major place among American artists of his generation.

Three years Dickinson's junior, Stuart Davis was, like Man Ray and Sheeler, a Philadelphian. After studying with Robert Henri in New York, he became an illustrator for *The Masses*. Then, after a brief Fauve-inspired period, Davis turned increasingly toward a personal and highly refined form of Synthetic Cubism that contains echoes of Picasso and Juan Gris, while sometimes verging on total abstraction. (In a 1954 painting he wittily dubbed his own style "Colonial Cubism.") Davis's early naturalistic watercolors, five of which were exhibited at the Armory Show, are of only moderate interest, but once he hit his stride, in the 1920s, he sometimes used watercolor or gouache to good effect.

ABOVE:
268. Preston Dickinson (1891–1930).
Outskirts of the City, n.d.
Watercolor on paper, 9⅞ x 14⅞ in.
Columbus Museum of Art; Gift of
Ferdinand Howald.

RIGHT:
269. Preston Dickinson (1891–1930).
The Bridge, 1922–23.
Pastel, gouache, and pencil on panel,
19 x 12⅜ in.
The Newark Museum; Purchase,
1930, The General Fund.

270. Stuart Davis (1892–1964).
Town Square, 1925–26.
Watercolor on paper, 11¾ x 14¾ in.
The Newark Museum.

271. Stuart Davis (1892–1964).
Windshield Mirror, 1932.
Gouache on paper, 15⅛ x 25 in.
Philadelphia Museum of Art; Gift of
Mrs. Edith Halpert.

 Town Square and *Windshield Mirror* (PLATES 270, 271) are very much in keeping with the idiom of his better-known oils. *Windshield Mirror* is an especially succinct statement of Davis's method, in which Cubist devices are reduced almost to flat pattern and recognizable figurative elements are set free from their commonsense functions and take on a new significance in relation to one another. *Abstraction* (PLATE 272), on the other hand, is a study for a mural and illustrates how watercolor is sometimes used in a supporting role when artists are planning large-scale projects.

ABOVE:

272. Stuart Davis (1892–1964).
Abstraction (*Study for "Swing Landscape Mural"*), 1937.
Watercolor and gouache on paper,
17⅞ x 23⅜ in.
National Museum of American Art,
Smithsonian Institution, Washington,
D.C.; Transfer from General Services
Administration.

273. Andrew Dasburg (1887–1979).
Summer Meadows, 1932–33.
Watercolor on paper, 13⅜ x 21⅜ in.
Whitney Museum of American Art,
New York; Lawrence H. Bloedel
Bequest.

Another first-generation modernist who employed watercolor with some regularity was Andrew Dasburg. Born in Paris, he came to the United States as a child. After studying with Robert Henri, he made two extended visits to his native city before returning to America, where his work showed the influence of Cézanne and the Cubists. Between the wars he reverted to a more representational art, but even then a powerful sense of form and structure informed his work. It was at this time that Dasburg painted his strongest and most characteristic watercolors (PLATE 273).

A little younger than the pioneers of the Armory Show generation, Milton Avery was nonetheless exposed to essentially the same influences and evolved a style that—typical of Americans during this period—was both personal yet highly dependent on European models, especially the Fauves. His strong sense of design and his well-developed feeling for color relationships are evident in both his oils and his watercolors. *Road to the Sea* (PLATE 274) is a particularly fine example of his watercolor technique, washes being laid over a charcoal drawing to build up an effective composition, rich in resonance, with a minimum of fuss.

What we find in Avery's work, however, is not the cutting edge of modernism that is apparent in the early paintings and drawings of O'Keeffe or Dove but, rather, a

274. Milton Avery (1885–1965).
Road to the Sea, c. 1938.
Watercolor over charcoal on paper,
22½ x 35 in.
The Brooklyn Museum; Dick S.
Ramsay Fund.

more leisurely exploration of the new idiom's possibilities. His approach—reflective rather than adventurous—represents one of the mainstreams in American art from the mid-1920s to the coming of Abstract Expressionism. Even the radicals of the Armory Show generation tended to slip gradually into this mode, which often allowed for a return to a modified form of naturalism. Alongside this diluted modernism of the inter-war period, soon to be transcended by men such as Arshile Gorky, existed another current of American art that was firmly rooted in realist traditions, that paid little heed to European trends and yet remained vital and free from anachronism. This tradition of realism—in the hands of artists such as Charles Burchfield and Edward Hopper—produced some of the greatest American watercolors of the first half of the twentieth century.

OPPOSITE:
275. Detail of plate 276.

ABOVE:
276. Milton Avery (1885–1965).
Sun Bather and Sea Watcher, 1948.
Watercolor on paper, 22 x 30 in.
Berry-Hill Galleries, Inc., New York.

CHAPTER TEN

CHARLES BURCHFIELD

Charles Burchfield was born in 1893 in Ashtabula, Ohio. His father, a merchant-tailor, died when Charles was four, and his mother moved the family to Salem, Ohio, the small industrial town where she had grown up. The Burchfields were poor, and from his early teens Charles had to work to supplement the family income. Simultaneously, however, he discovered a gift for drawing. *Wild Flower Study* (PLATE 278), made at this time, is a delicate drawing, lightly tinted with watercolor, that displays the deep involvement with nature that would always be a key aspect of Burchfield's work.

He began his formal studies at the Cleveland School of Art in 1912. At first it was his intention to become an illustrator, but he soon shifted his ambition and determined to become a fine artist. He did not follow a conventional path, however. From the outset, for instance, he abhorred life drawing, and none of his nude studies have survived. It may be that he destroyed them because they did not meet his standards of craftsmanship, but it has been suggested that a deep-seated puritanical streak may also have been a factor in his decision to get rid of them.[1] Burchfield seems to have received no exposure to modern art during this period—not even Post-Impressionism—but he was impressed by the Chinese scroll paintings he saw at the Hatch Galleries in Cleveland.[2] These inspired him to make a series of sketches that attempted to capture the shifting moods of various natural phenomena, such as the gathering and passing of a thunderstorm.

Like a number of other artists in the early decades of the twentieth century, Burchfield was fascinated by the notion of a parallel between art and music, by the idea that painting might become a "universal language" with shapes and colors serving the same function as musical notes, capable of performing nondescriptive functions. This interest led him to make drawings in which he attempted to give visible substance to some of Wagner's compositions. It also led to journal entries such as his response to autumn foliage: "I felt as if the color made sound."[3] This quotation illustrates the difference between Burchfield and artists such as Picabia who were also toying with the art and music parallel. Picabia saw the analogy between the two as providing a license for nonfigurative art. Burchfield—who had no knowledge of Picabia's experiments—saw "music" in nature and therefore found no need to abandon figuration, although he would sometimes drastically simplify forms.

Already in this Cleveland period Burchfield was painting powerful watercolors,

277. Charles Burchfield.
Lavender and Old Lace, 1939–47.
Detail of plate 296.

217

278. Charles Burchfield (1893–1967).
Wild Flower Study, 1911–12.
Watercolor on paper, 20 x 14 in.
Kennedy Galleries, New York.

such as *Battleships* (PLATE 279) and, more typical, *Power Lines and Snow* (PLATE 280), which—with their highly developed sense of pattern and confident reduction of pictorial elements to expressive form—belie his lack of knowledge of the modern movement. In *Power Lines and Snow* he demonstrated his ability to capture, very graphically, the precise mood of a scene, so that weather conditions and even the time of day become charged emotive elements in the composition.

In 1916 Burchfield was awarded a scholarship to the National Academy of Design in New York. He attended the school for just one day, feeling completely out of place,

but stayed on in New York, unhappily, for several months, not wanting to return home and admit himself a failure. The period was not a total disaster, however, since it did give him an opportunity to see contemporary art. It also led to an introduction to Mary Mowbray-Clark, proprietor of the Sunwise Turn Bookshop, who gave the young artist much-needed support, hanging his work in the store and acting as his New York dealer for several years.

Eventually Burchfield returned to Salem and took a job as a cost accountant with a local manufacturing firm, painting as much as he could in his spare time, even during his lunch hour. His efforts were rewarded with what he would later refer to as his "golden year." The year was 1917. Making hundreds of sketches outdoors but painting mostly in his tiny bedroom studio (PLATE 281), he developed a highly personal expressionistic idiom in which what John I. H. Baur has described as Burchfield's pantheism was given free rein for the first time.

In such paintings as *Church Bells Ringing, Rainy Winter Night* and *The Insect Chorus* (PLATES 282, 283), Burchfield used calculated distortions of form to amplify mood. In *The Insect Chorus* scroll-like and zigzag geometric shapes describe the summer vegetation, while other zigzags are used to represent the buzzing flight of insects, the chorus of the title made visible. In *Church Bells Ringing* the architecture is rendered as a virtual caricature and given a grim, glowering personality with windows that look like heavy-lidded eyes. With its totemlike spire, this lugubrious church anticipates the anthropomor-

279. Charles Burchfield (1893–1967).
Battleships, 1915.
Watercolor on paper, 13 x 19½ in.
Private collection.

COUNTERCLOCKWISE, FROM TOP LEFT:

280. Charles Burchfield (1893–1967).
Power Lines and Snow, c. 1916.
Watercolor on paper, 24¾ x 18 in.
Private collection.

281. Charles Burchfield (1893–1967).
The Salem Bedroom Studio, 1917.
Watercolor on paper, 22 x 18 in.
Charles Burchfield Art Center, Buf-
falo, New York; Gift of the Burchfield
Foundation, 1975.

282. Charles Burchfield (1893–1967).
*Church Bells Ringing, Rainy Winter
Night,* 1917.
Watercolor on paper, 30 x 19 in.
Cleveland Museum of Art; Gift of
Louise H. Dunn in memory of Henry
G. Keller.

OPPOSITE:

283. Charles Burchfield (1893–1967).
The Insect Chorus, 1917.
Watercolor on paper, 19⅞ x 15⅞ in.
Munson-Williams-Proctor Institute,
Utica, New York.

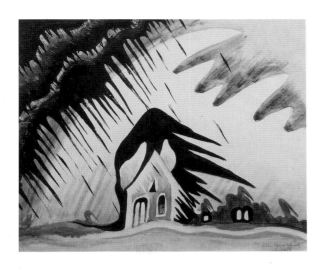

284. Charles Burchfield (1893–1967).
The East Wind, 1918.
Watercolor on paper, 17½ x 21½ in.
Albright-Knox Art Gallery, Buffalo,
New York; Bequest of A. Conger
Goodyear.

phic buildings occasionally found in Walt Disney cartoons. The arabesques of the steeple blend with the swirls of the rain-laden clouds, so that buildings and sky seem to merge. In many ways *Church Bells Ringing* is rather crude, especially when compared with Burchfield's later achievements, but it tells us much about his ambitions and methodology.

By this point in his career, Burchfield presumably knew something about the work of van Gogh and Edvard Munch, and his time in New York may even have made him aware of the German Expressionists, but it must be emphasized that his expressionism was very much his own, rooted in his observation of the Ohio scenes he knew so well.[4] One aspect of Burchfield's expressionism is to be found in the curvilinear fluidity of the brushstrokes he used to build forms, and here he is sometimes reminiscent of Munch. Often he exaggerated the scale of individual objects and creatures, so that an insect, for example, might become gigantic in relation to its surroundings. At times his anthropomorphism was allowed to dominate. In such paintings a storm cloud might be furnished with "fingers" that threaten to snatch a house or a tree from the face of the earth (PLATE 284). Some paintings of the 1917–19 period are calm and relatively naturalistic, but more commonly they feature violent distortions of form and stark simplification.

This period of intense activity came to an end when Burchfield drifted into the army at the end of World War I, an interruption in his career that he spent mostly with a camouflage unit in South Carolina. He continued to paint a little while in the service, then returned to Salem, where he read Sherwood Anderson's *Winesburg, Ohio* with great enthusiasm, impressed by the author's ability to evoke the mood of a small Midwestern town.

That Burchfield was also a master of that small-town world is fully evident in the Brooklyn Museum's *February Thaw* (PLATE 285), the first of his paintings to be bought by a public institution. Once again the buildings are somewhat anthropomorphic, but they are not exaggerated to the extent of becoming cartoonlike. Instead, they seem to take on the character of their owners, the citizens of this desolate town as it emerges, if only temporarily, from the grip of winter. Beyond this anthropomorphism, however, Burchfield makes a powerful composition in which deep blacks predominate. The way he employs reflections both to balance his composition and to create atmosphere is

285. Charles Burchfield (1893–1967).
February Thaw, 1920.
Watercolor over pencil on paper,
17⅞ x 27⅞ in.
The Brooklyn Museum; John B.
Woodward Memorial Fund.

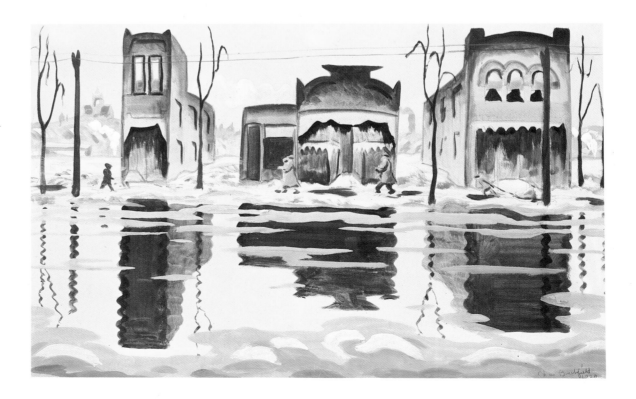

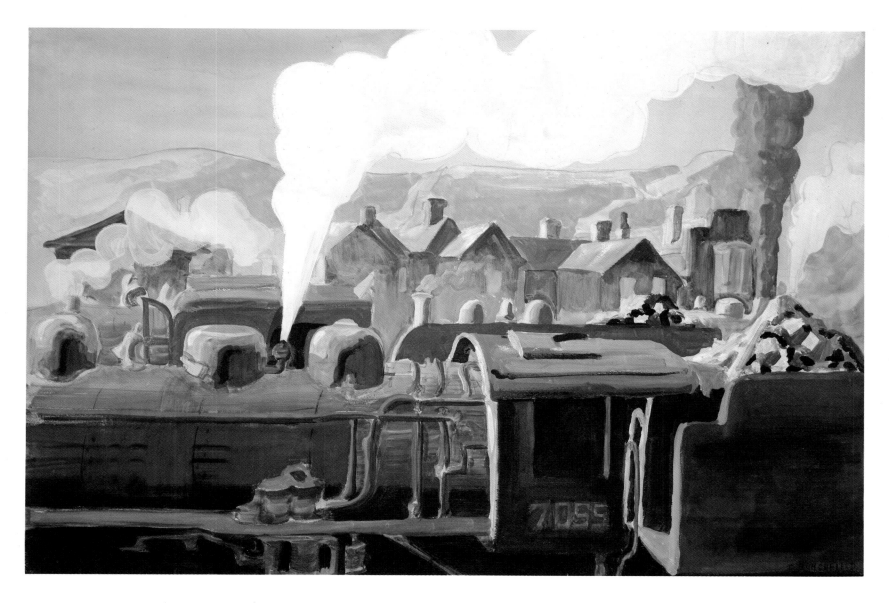

reminiscent of the way Prendergast had used reflections in his view of the Piazza di San Marco after the rain (PLATE 193). Yet this scene is as far from Venice as can be imagined. It emphasizes the fact that Burchfield was every inch an American artist, in very much the same way that Anderson was a quintessentially American writer.

A different aspect of small-town life is captured in *Safety Valve* (PLATE 286). If this is compared with paintings of trains by Reginald Marsh and Edward Hopper (PLATES 310, 311, 328), some interesting differences emerge. Here the emphasis is not on the locomotive itself—Burchfield crops the image so that we do not even see the wheels—but rather on the relationship of the locomotive to its setting, represented by humble trackside homes and distant hills. As in so many Burchfield paintings, sound seems to be made palpable, this time in the form of steam hissing from the locomotive's escape valve.

In his mature paintings Burchfield seldom isolated objects but tended to play up the interrelationship between, for example, weather and landscape or insects and vegetation. What interested him was what unified the different elements of a scene rather than what separated them. (A naturalist such as Audubon, by contrast, was bent on separation—on distinguishing one species from another.) Like Marin, Burchfield seems to have sensed a godlike force inhabiting all of nature—one that did not express a preference for roses over nettles—and it was the unifying power of this force that he celebrated in his art. What is apparent from paintings like *February Thaw* and *Safety Valve* is that Burchfield saw this force as extending even to mundane inanimate objects.

These two paintings also illustrate the fact that by 1920 Burchfield possessed a

286. Charles Burchfield (1893–1967).
Safety Valve, 1921.
Watercolor on paper, 20 x 30 in.
Private collection.

formidable watercolor technique. Generally working over a loose pencil or crayon drawing, he used dabs of color and washes that were often dense and dark to build up patterns of light and shadow. Not afraid of blacks and near blacks, he also made good use of white, often in the form of body color. Few watercolorists have mixed opaque and transparent colors so freely. Broken down into its components, in fact, Burchfield's technique is decidedly unorthodox, yet it is remarkably true to the essential characteristics of the medium.

In the 1920s Burchfield began to shift his emphasis more and more toward a relatively naturalistic treatment of urban and suburban subject matter, imagery that was to remain dominant in his work for two decades. This shift corresponds to some extent to the move that he made from Salem to Buffalo, where he began work in 1921 as a wallpaper designer with the firm of M. H. Birge & Sons. Burchfield contributed some handsome designs to the company's catalog (PLATE 287) and eventually became head designer, a position he held until 1929, after which time the income received from his paintings supported his family in modest comfort. (Burchfield had married in 1922 and by 1929 was the father of five children.)

287. Charles Burchfield (1893–1967). *Wallpaper Design No. 1,* c. 1922. Printed sample from watercolor original, 20 x 14 in. Kennedy Galleries, New York.

Burchfield's more naturalistic style, as applied to urban subjects, occasionally produced pleasant but rather slight results, as in the case of *Promenade* (PLATE 288), where gentle humor predominates in a composition that would not seem out of place on the cover of the *New Yorker*. At other times, however, he was capable of intensifying his vision within this realist idiom to produce paintings of great power and resonance, such as the impressive *Rainy Night* (PLATE 289), in which a bleak Buffalo street is evoked with formidable technical skill. This is one of the relatively rare works in which Burchfield makes effective use of the human presence. The foreground figures, in and around the car, are about to leave the scene; this has the psychological effect of making the street seem emptier than if Burchfield had in fact made it deserted. Soon the people will be gone, and the rainy intersection will be left to the lonely figure silhouetted in a doorway.

288. Charles Burchfield (1893–1967). *Promenade,* 1927–28. Watercolor on paper, 32 x 42 in. Albright-Knox Art Gallery, Buffalo, New York.

289. Charles Burchfield (1893–1967).
Rainy Night, 1930.
Watercolor on paper, 39¾ x 42 in.
San Diego Museum of Art; Gift of
Misses Anne R. and Amy Putnam.

At this level the image is one that might have been conceived by a skilled illustrator of the *Saturday Evening Post* variety. What lifts it above the illustrational is how the intensity of Burchfield's vision is allied with the firmness of his technique. Seldom has watercolor been used to set down form with such solidity. The density of pigment is such that it is virtually impossible to tell from a reproduction that this is, in fact, a watercolor.

Most of the best paintings of Burchfield's realist period are poetic evocations of Buffalo and its suburbs. *Ice Glare* (PLATE 290) is full of long shadows and the blinding light of the winter sun. In his mature paintings Burchfield visually captures a specific time of year and a specific time of day, and does so as well as—perhaps better than—anyone in the entire history of American art. Just as Mark Twain was proud of his ability to convey tiny nuances of Midwestern accent, so Burchfield took satisfaction in his ability to reproduce the subtleties of natural phenomena.

This is evident, too, in *Six O'Clock* (PLATE 291). The repeated pattern of the roofs

290. Charles Burchfield (1893–1967).
Ice Glare, 1932.
Watercolor on paper, 30¾ x 24¾ in.
Whitney Museum of American Art,
New York.

291. Charles Burchfield (1893–1967).
Six O'Clock, 1936.
Watercolor on paper, 24 x 30 in.
Everson Museum of Art, Syracuse,
New York; Museum Purchase with
funds from the Jennie Dickson Buck
Fund.

292. Charles Burchfield (1893–1967).
Night Scene with Clouds, c. 1929.
Watercolor on paper, 18¾ x 26¾ in.
Whitney Museum of American Art;
Gift in honor of John I. H. Baur.

of the row houses gives the composition a strong structural underpinning, but again it is the convincing delineation of a specific time of day that predominates and creates the picture's mood. Six o'clock is mealtime in this industrial suburb, and a family can be glimpsed through the kitchen windows of the nearest building, with mother placing food on the table. There is an effective contrast between the warmth of the kitchen's interior and the cold of the exterior. At the same time, Burchfield uses his idiosyncratic technique, with its dense areas of overlapping strokes, to suggest a solidity of matter.

Even when working on these realist paintings, with their urban imagery,

293. Charles Burchfield (1893–1967).
Late Afternoon in the Hills, 1939–41.
Watercolor on paper, 27 x 40 in.
Private collection.

Burchfield never forgot the expressionistic pantheism of his youth. Occasionally, as in *Night Scene with Clouds* (PLATE 292), he reverted to this old idiom, at about the same time that the world at large was becoming acquainted with the early works. (A group of Burchfield's early paintings was shown at the Museum of Modern Art in 1930.) In the 1940s he began to look to these youthful paintings for a renewal of inspiration, apparently feeling a need to find his primary sustenance in nature once more, a shift that was ushered in by such transitional works as *Late Afternoon in the Hills* (PLATE 293), a masterly large-scale watercolor that is so alive with the sap of a summer day that it threatens to burst in a cloud of exploding seed pods.

Starting in 1943 Burchfield took paintings from his early period and "restored" them, sometimes adding paper to the existing sheet to increase its size (as he had occasionally done in earlier examples such as *Late Afternoon in the Hills*). He would then work over the old painting and expand it into the new areas, employing his early style but modifying it with the technical proficiency he had acquired during the intervening years. *The Coming of Spring* (PLATE 294) was the first of the paintings he updated and enlarged in this way, and many more were to follow. This in turn led Burchfield to create new works in the modified form of his expressionist idiom, an approach that was to yield some of the greatest paintings of his career and in the history of American watercolor painting.

The Sphinx and the Milky Way (PLATE 295) is a greatly enlarged variation on an early painting, a richly textured fantasy of night gardens under a starry summer sky. Inevita-

294. Charles Burchfield (1893–1967).
The Coming of Spring, 1917–43.
Watercolor on paper mounted on
presswood, 34 x 48 in.
The Metropolitan Museum of Art,
New York; George A. Hearn Fund, 1943.

295. Charles Burchfield (1893–1967).
The Sphinx and the Milky Way, 1946.
Watercolor on paper, 52⅝ x 44¾ in.
Munson-Williams-Proctor Institute,
Utica, New York.

296. Charles Burchfield (1893–1967).
Lavender and Old Lace, 1939–47.
Watercolor on paper, 35 x 50 in.
New Britain Museum of American
Art, New Britain, Connecticut;
Charles F. Smith Fund.

bly the image calls to mind van Gogh's *Starry Night,* but Burchfield's art can stand up to
that kind of comparison. Certainly this painting fits into the mainstream of the interna-
tional Expressionist tradition, but, at the same time, it is a totally personal statement.
Burchfield's calligraphy is always idiosyncratic, and no one else has his ability to conjure
up not only the appearance of a summer night but also the buzz and chatter of the insect
chorus.

Not all of Burchfield's paintings of the 1940s were enlargements or reworkings of
early themes. As John I. H. Baur has pointed out, Burchfield sometimes had difficulty
reconciling his old manner with the standards he had set for himself in his mature
work.[5] Perhaps seeking respite from this problem, Burchfield occasionally enlarged and
enhanced more recent works. *Lavender and Old Lace* (PLATE 296), for example, is an
enlargement of a relatively modest painting started in 1939. Burchfield changed the
mood of the painting from gray overcast to twilight and transformed what had been a
portrayal of a specific house in a specific location into an archetypal statement about the
American gothic idiom. *Street Scene* (PLATE 297), based on a drawing made around 1940
(PLATE 298), is one of Burchfield's last urban subjects, a return to realist concerns at a
time when expressionism was beginning to dominate his work once more. Although his
treatment is relatively restrained, a comparison of the final painting with the pencil study
shows how Burchfield both simplified and exaggerated the architecture of some of the

ABOVE:
297. Charles Burchfield (1893–1967).
Street Scene, 1940–47.
Watercolor on paper, 39 x 53 in.
Dallas Museum of Fine Arts; Dallas
Art Association Purchase.

LEFT:
298. Charles Burchfield (1893–1967).
Study for "Street Scene," c. 1940.
Pencil on paper, 16¾ x 34 in.
Charles Burchfield Art Center,
Buffalo, New York; Gift of the
Burchfield Foundation.

231

buildings in order to emphasize character, thereby giving the structures a hint of anthropomorphic personality.

More typical of Burchfield's late period is *Winter Moonlight* (PLATE 299), in which the artist's expressionism is seen at its most basic in a composition that sets off the stark spikes of the trees against the concentric rings around the moon. This is an example of Burchfield's painting in which—instead of architecture impersonating natural forms—natural forms seem to imitate architecture, trees bending into forms that suggest gothic arches. Stylistically there are clear echoes of the 1917 paintings, but the handling here is much broader, the brushwork and calligraphy more suited to the larger formats that Burchfield preferred in his last twenty-five years.

233

This confident handling is characteristic of his approach in the late 1940s and '50s, and it is to be found not only in the purely expressionistic works but also in those paintings where he achieved a happy blend of expressionism and naturalism. This is evident in *Hush before the Storm* (PLATE 300), a powerful painting in which Burchfield blends simplicity of statement—most evident in the economy with which the trees are drawn against the threatening sky—with a sure and very specific sense of atmosphere that captures, by means of color and graphic signs, a feeling of muggy heat. Another humid day is set down in *Overhanging Cloud in July* (PLATE 301), a formidable late work in which the landscape elements are treated in a rather straightforward manner, while the storm cloud is made ominous with Munch-like exaggerations of form. As is the case in many Burchfields from the last period, the painting makes the foreground vegetation a strongly developed pictorial element that lends the composition a great feeling of depth.

In the end, it must be recognized that while Burchfield created some masterpieces that were purely expressionistic and others that were wholly realist, what gives his output as a whole such resonance is the constant tension between the two. The same can be said about his response to nature, on the one hand, and to urban imagery, on the other. These subjects represent opposite sides of the same coin and may also reflect the upbringing of someone who spent his youth in small manufacturing towns, where industry and nature coexisted.

Certainly no other American artist has ever drawn more nourishment from his native environment. Nor has any other major American artist—Marin included—relied on watercolor to the same extent. The scope of Burchfield's ambition and the intensity of his vision are remarkable and entitle him to be considered one of the greatest water-colorists of all time, deserving a place in the tiny band of masters that includes Blake, Turner, and Winslow Homer.

301. Charles Burchfield (1893–1967). *Overhanging Cloud in July,* 1947–59. Watercolor on paper, 39½ x 35½ in. Whitney Museum of American Art, New York; Purchase, with funds from the Friends of the Whitney Museum of American Art.

CHAPTER ELEVEN

EDWARD HOPPER AND THE REALISTS

The art of Burchfield points out how idiosyncratic, not to say eccentric, the finest American art could be in the first half of the twentieth century and demonstrates how easy it was for American artists to move between experimentation and a rather traditional realism. As noted in chapter nine, even some avowed modernists were capable of producing convincing realist work when it suited them, so it is perhaps not surprising that realist painting continued to flourish in the United States. Nor did it necessarily seem conservative or backward-looking.

In Europe the situation was rather different. Certainly an artist such as Pierre Bonnard could continue to explore the Post-Impressionist tradition, and a Giorgio Morandi could evolve a highly personal approach to still lifes. Picasso himself made portraits that would have satisfied any academician, but it was rare in Europe between the wars to find anyone working exclusively in a conventional realist idiom who commanded respect as a serious artist. (Certainly some of the Surrealists employed academic techniques, but they did so to totally nonacademic ends.) The only obvious exception to this rule is Balthus, and it is worth noting that he was better appreciated in America than in Europe.

In Europe there had been a conscious turning against realism by advanced artists. When Picasso began to explore Neoclassical themes, around 1920, he did so from the radically changed perspective of someone who had carried through the Cubist revolution. In America not every artist of modernist conviction felt that the resources of realism had been exhausted, and the artistic community was much smaller, so that there tended to be considerable camaraderie between avant-garde artists and the less conservative realists. (It is indicative of this bonhomie that when a small group of bohemian revelers took possession of the Washington Square Arch, in January 1917, and drew up a document to establish the secession of Greenwich Village from the United States, members included Marcel Duchamp on the one hand and John Sloan on the other.[1])

In a sense, The Eight—Arthur B. Davies, William Glackens, Robert Henri, Ernest Lawson, George Luks, Maurice Prendergast, Everett Shinn, and Sloan (later George Bellows was associated with the group)—were America's first modernists. First exhibiting as a group in 1908, The Eight were linked as much by friendship as by ideology. It has already been seen how Davies's work evolved from French Symbolism and Prendergast's from Post-Impressionism. The others in the group learned the *feel* of Impressionism without ever bothering much with its theory—though Lawson is a partial

302. Edward Hopper.
Yawl Riding a Swell, 1935.
Detail of plate 334.

303. George Bellows (1882–1925).
Under the Elevated, n.d.
Watercolor on paper, 5¾ x 8⅞ in.
The Museum of Modern Art, New
York; Gift of Abby Aldrich
Rockefeller.

exception in this respect—and they turned their fresh vision on the urban scene, either the avenues, the squares, the elevated railways, or else the people of the tenements and the streets. Most of them were experienced as illustrators. They brought a journalistic flair to their work and felt, with some justification, that there was nothing old-fashioned about this work since it was the modern world that they portrayed.

Unfortunately—Prendergast and Davies aside—few of these artists devoted much of their time to watercolor. George Bellows did an occasional lively sketch (PLATE 303). The most interesting watercolorist belonging to the "Ashcan" wing of the group, however, was George Luks. In *The Harlem River* (PLATE 304) Luks freely blended pastel and watercolor to set down an atmospheric rendering of an urban scene. As is typical of Luks's work (in oils as well), no stroke, no patch of color, seems unnecessary. Everything is functional, almost matter-of-fact, and yet the drawing is extremely lively.

Luks is perhaps best known for his portraits in oil. These derive somewhat from the portraits of Frank Duveneck and even more from those of Frans Hals; they are marked by an almost theatrical use of lighting and chiaroscuro. This grasp of the way light can be used to bring a composition to life is evident in *Woman and Turkey* (PLATE 305). Here, employing a very distinctive approach to watercolor, Luks uses blunt strokes and dense overlays of wash to give his subject a remarkable solidity and vitality. This is not the prettiest watercolor anyone is likely to see, but it certainly is vigorous. The energy of Luks's watercolor style is also apparent in *Screecher, Lake Rossignol* (PLATE 306), in which bold overlapping strokes conjure up the intense blue of water on a summer day. The density of color saturation is impressive, and it seems fair to say that Luks,

238

304. George Luks (1867–1933).
The Harlem River, 1915.
Pastel and watercolor on paper,
13¾ x 14⅞ in.
Columbus Museum of Art; Gift of
Ferdinand Howald.

305. George Luks (1867–1933).
Woman and Turkey, 1924.
Watercolor on paper, 19⅞ x 13¾ in.
Whitney Museum of American Art,
New York; Purchase.

306. George Luks (1867–1933).
Screecher, Lake Rossignol, 1919.
Watercolor on paper, 8⅝ x 9¼ in.
Munson-Williams-Proctor Institute,
Utica, New York.

despite his limited output in the medium, was one of the most interesting watercolorists of his generation.

The artist who most obviously inherited the concerns of The Eight, as far as they were devoted to recording the teeming life of the New York streets, was Reginald Marsh. Indeed, his predilection for low life was even greater than theirs, and he captured it wherever he found it—on the Bowery, in burlesque houses, at Coney Island—in hundreds of tempera paintings, ink drawings, prints, and watercolors.

Surprisingly, for one so firmly associated with New York, Marsh was born in Paris, but his family returned to the United States when he was a child, and he received his basic training at the Art Students League, studying with Sloan and Luks. Like them, he worked as an illustrator and cartoonist, contributing to the *New Yorker,* among other publications, and, like them, he brought a journalistic flair to his own work, seeking out scenes that sometimes bordered on the grotesque and setting them down with Hogarthian precision. Marsh sketched incessantly, favoring pen and ink combined with either ink wash or watercolor (PLATE 307). Occasionally, as with *10 Shots, 10 Cents* (PLATE 308), he used ink and watercolor technique on a large scale, but even here he was creating a

307. Reginald Marsh (1898–1954).
Seated Man and Walking Woman, 1943.
Watercolor and Chinese ink on paper,
10⅜ x 8½ in.
Whitney Museum of American Art,
New York; Bequest of Felicia Meyer
Marsh.

308. Reginald Marsh (1898–1954).
10 Shots, 10 Cents, 1939.
Watercolor and pen and ink on paper,
27 x 40 in.
St. Louis Art Museum; Eliza
McMillan Fund.

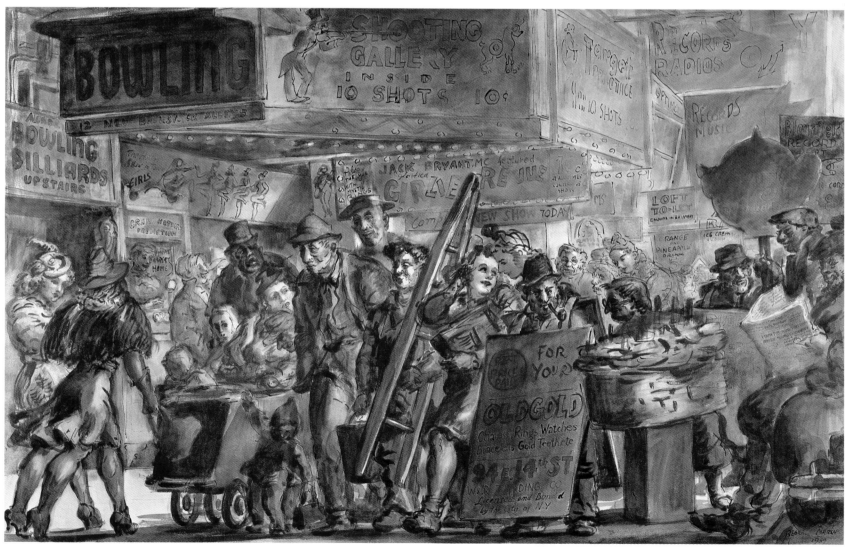

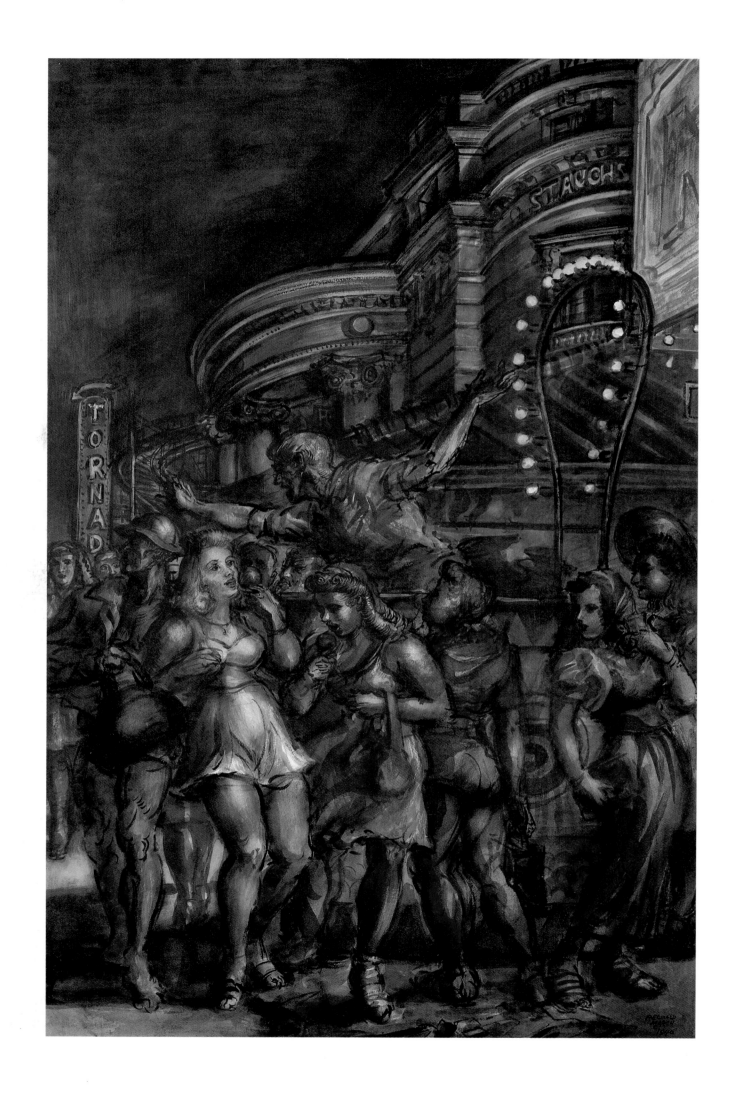

drawing in which line predominates and the watercolor wash plays a subordinate role. More painterly is the Whitney Museum's *New Dodgem* (PLATE 309), but here too it is the draftsman who is in control.

Generally, Marsh's compositions are teeming with humanity—pneumatic young women, derelicts, muscular sunbathers—but one of his favorite subjects, which he returned to again and again over the years, was the steam locomotive. His involvement with this theme resulted in some of his best and purest watercolors. The examples seen here (PLATES 310, 311) were painted a decade apart but display a similarity of intent and means. Again, line is important, but it is now drawn with the brush, not a pen, and it has a confident calligraphic quality; in both instances washes are used to create mood as well as to fulfill the limited descriptive purposes they perform in paintings such as *10 Shots, 10 Cents*. Marsh makes the old locomotive in the earlier painting seem forlorn (though not mawkishly so) by using dark layers of wash to create the effect of backlighting, so that the locomotive stands out in silhouette despite a lowering sky, which also

OPPOSITE:
309. Reginald Marsh (1898–1954). *New Dodgem*, 1940. Watercolor on paper, 40¼ x 26¾ in. Whitney Museum of American Art, New York; Anonymous gift.

RIGHT, TOP:
310. Reginald Marsh (1898–1954). *Train*, 1930. Watercolor on paper, 13¹⁵⁄₁₆ x 19¹⁵⁄₁₆ in. The Brooklyn Museum; Bequest of Felicia Meyer Marsh.

RIGHT, BOTTOM:
311. Reginald Marsh (1898–1954). *Locomotive in Weehawken, New Jersey*, 1940. Watercolor on paper, 15³⁄₁₆ x 22⁹⁄₁₆ in. The Brooklyn Museum; Gift of Friends of Southern Vermont Artists, Inc.

contributes to the atmosphere. For the big freight "hog" in the later painting Marsh used carefully graded washes to capture a feeling of sunlight, and the steam escaping from the smokestack and safety valve tell the viewer that this is very much a working engine.

Isabel Bishop worked in an idiom not unlike Marsh's. In general her drawings are fleshed out with monochrome wash, but occasionally she did use watercolor to good effect (PLATE 312). Marsh and Bishop might accurately be described as New York Regionalists, although the term *Regionalist* is most often used to describe artists like Grant Wood, John Steuart Curry, and Thomas Hart Benton, who painted the American heartland. Of these three well-known figures, Benton—son of a congressman from Missouri—was the only one to develop an interesting watercolor style, a style that retained many of the characteristics of his approach to oil paintings and murals while allowing him to display a freshness that is often missing from his more ambitious works.

Western Tourist Camp and *Lassoing Horses* (PLATES 313, 314) are from the same year, possibly from the same trip, but they are miles apart in spirit. *Western Tourist Camp* shows that Benton was sometimes capable of reacting to the observed world in a straightforward and unrhetorical manner. In *Lassoing Horses,* however, his myth-making instinct takes over. These cowboys are lassoing their way onto the walls of some Midwestern post office or library. Technically, the two paintings are quite similar—strongly linear in a slightly cartoony sort of way, with areas of wash setting up the contrasts that emphasize Benton's sense of pattern.

A curious figure is George "Pop" Hart, an itinerant painter who roamed the world, painting the scenes he came across in Europe and the Middle East, Mexico, the Caribbean, and all over the United States, often—according to the legend he fostered—exchanging watercolors for bed and board. "Pop" Hart was not the most skillful watercolorist of his generation, but—totally free from any doctrinaire inhibitions—he had a knack for setting down a scene with a freshness that derived from his lack of pretension (PLATE 315).

312. Isabel Bishop (b. 1902).
Card Game, c. 1942.
Watercolor, pencil, charcoal, and pen and ink on paper, 14⅜ x 22¹⁵/₁₆ in.
The Brooklyn Museum; Henry L. Batterman Fund.

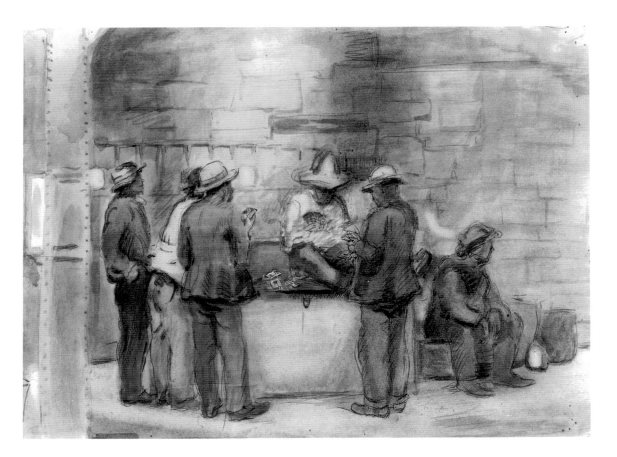

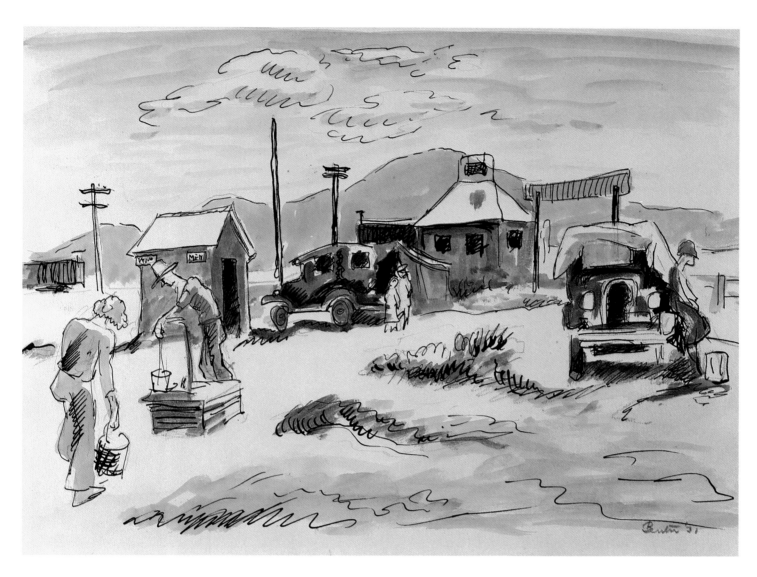

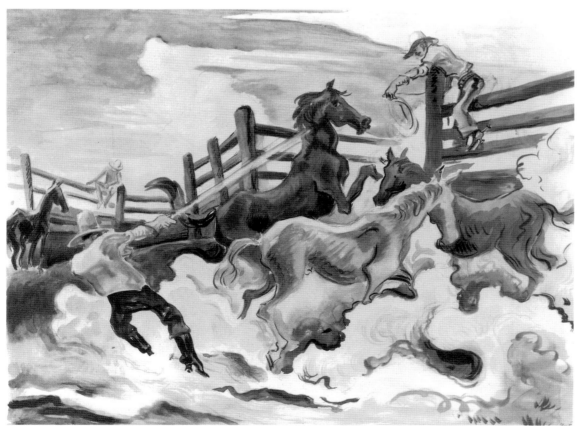

ABOVE:

313. Thomas Hart Benton (1889–1975).
Western Tourist Camp, 1931.
Watercolor over pen and ink on paper,
8¾ x 11¾ in.
Allen Memorial Art Museum, Oberlin
College, Oberlin, Ohio; Gift of Mrs.
Malcolm L. McBride.

LEFT:

314. Thomas Hart Benton (1889–1975).
Lassoing Horses, 1931.
Watercolor over pencil on paper,
21³⁄₁₆ x 27¹¹⁄₁₆ in.
The Brooklyn Museum; John B.
Woodward Memorial Fund.

245

315. George "Pop" Hart (1869–1933).
West Indies Market, 1922.
Watercolor on paper, 11⅞ x 14½ in.
Columbus Museum of Art; Museum
Purchase; Howald Fund.

OPPOSITE, TOP:
316. Louis Eilshemius (1864–1941).
Five Nudes in Landscape, n.d.
Watercolor on paper, 13½ x 19¾ in.
Hirshhorn Museum and Sculpture
Garden, Smithsonian Institution,
Washington, D.C.

OPPOSITE, BOTTOM:
317. Louis Eilshemius (1864–1941).
Train Landscape in Arizona, 1890.
Watercolor over pencil on paper,
6¹³⁄₁₆ x 10⅞ in.
Hirshhorn Museum and Sculpture
Garden, Smithsonian Institution,
Washington, D.C.

Another eccentric figure was Louis Eilshemius, who is often presented as a kind of sophisticated naive. Eilshemius received a conventional training—with the French academician Bouguereau among others—yet his approach to painting remained consistently artless and untouched by any school or tradition. He followed his own path, befriending many of the younger painters of the avant-garde but taking nothing from them, only appreciating their freedom of spirit. A poet and musician as well as a painter, he called himself Mahatma, Mesmerist, and even Supreme Protean Marvel of the Ages, all of which led some observers to think he was not to be taken seriously, though his work was warmly appreciated by Marcel Duchamp, Joseph Stella, and others.

It is easy enough to see why Eilshemius has been considered a naive—sometimes his paintings are littered with nudes of dubious anatomy (PLATE 316)—yet there are passages, especially in his landscapes (PLATE 317), that suggest a facility beyond that of the primitive. Nor was he a *faux naïf:* there is nothing synthetic about his work, which is always illuminated by an authentic and consistent lyrical vision. In writing his entry on Eilshemius for the catalog of the "Société Anonyme," Duchamp referred to this artist's career as a tragedy.[2] The tragedy is that Eilshemius was so much his own man, so untouched by the tides of art history, that historians find him impossible to place and therefore, with a few exceptions, give him no place at all.

Much easier to place are those artists who came to maturity during the Depression and whose work amounts to the programmatic expression of their social and political convictions. Of these Social Realists, only Ben Shahn worked extensively in watercolor and gouache. Born in Lithuania and brought up chiefly in Brooklyn, he was apprenticed to a lithography house, became a master printer, and used the money he earned at this profession to travel to Europe. When he returned to America it was with a sophisticated knowledge of modern developments in art, but this knowledge was subordinated to his desire to deal with subjects of social significance.

Shahn excelled at a kind of shorthand portraiture that leaned heavily on the lessons of Picasso (PLATE 318). He used watercolor, and especially gouache, with skill, but his gift was essentially linear. Even in his most ambitious work his talent is that of a graphic artist.

It is possible that Shahn's approach to art may have been influenced by European-born satirists like George Grosz. Grosz's greatest work was done in Europe, under the auspices of the German wing of the Dada movement, but when he came to America to flee the Nazis, he continued to produce high-quality work. Grosz remained, in particular, a master of the free-flowing watercolor drawing (PLATE 319), in which sureness of line was matched by an ability to use washes with great expressiveness. The old couple in this painting are caricatures, but they are caricatures that have an extremely solid existence. Surface and texture—fur, gabardine, newsprint—are conjured up with a

BELOW, LEFT:

318. Ben Shahn (1898–1969).
Conversations, 1958.
Watercolor on paper, 39¼ x 27 in.
Whitney Museum of American Art,
New York; Gift of the Friends of the
Whitney Museum of American Art.

BELOW, RIGHT:

319. George Grosz (1893–1959).
Couple, 1934.
Watercolor on paper, 25¼ x 17¾ in.
Whitney Museum of American Art,
New York.

confidence that marks Grosz as one of the most accomplished watercolorists of his time.

A less socially vocal artist than either Shahn or Grosz, yet one who has been accused of casting too enthusiastic an eye on the more sordid aspects of life, is Ivan Le Lorraine Albright. He has been aptly described as "a poetic pessimist."[3] Often he depicted old people and environments in a state of advanced decay, but what gives his work its distinctive character is his meticulous technique. Albright frequently worked on a single painting for a year, rendering each wrinkle on a man's face, each piece of detritus, with an obsessive precision that transforms the decrepit into the jewellike. Best known for his oils, Albright successfully adapted his methods to gouache (PLATE 320).

Among the most skilled realist watercolorists of the century have been the illustrators. As has been seen, artists like Luks and Sloan—and even Arthur Dove—sometimes supported themselves by contributing to magazines, but I refer specifically to those men and women who saw themselves as illustrators and nothing else. The majority of them, however brilliant, were derivative, and it would be misleading to suggest that they made any great contribution to the history of American watercolor. Their skill does deserve to be acknowledged, nonetheless.

John Gannam had an almost Sargent-like facility in the medium. Born in Lebanon and raised in Chicago, he became a regular contributor to *Woman's Home Companion,*

320. Ivan Le Lorraine Albright (1897–1983). *Roaring Fork, Wyoming,* 1948. Gouache on paper, 22½ x 30¾ in. Whitney Museum of American Art, New York; Gift of Mr. and Mrs. Lawrence A. Fleishman (and Purchase).

ABOVE, LEFT:

321. John Gannam (1907–1965).
Illustration for Pacific Mills, 1949.
Watercolor on paper, 21 x 18 in.
Illustration House, Norwalk,
Connecticut.

ABOVE, RIGHT:

322. Norman Rockwell (1894–1978).
The Dugout, 1948.
Watercolor on paper, 19 x 17⅞ in.
The Brooklyn Museum; Gift of
Kenneth Stuart.

OPPOSITE, TOP:

323. Edward Hopper (1882–1967).
La Pierreuse, c. 1906–9.
Watercolor on paper, 11⅞ x 6¼ in.
The Art Institute of Chicago; Olivia
Shaler Swan Fund.

OPPOSITE, BOTTOM:

324. Edward Hopper (1882–1967).
The Mansard Roof, 1923.
Watercolor over pencil on paper,
14 x 20 in.
The Brooklyn Museum; Museum
Collection Fund.

Good Housekeeping, Ladies' Home Journal, and *Cosmopolitan.* Gannam drew fluently with the brush, laid down pellucid washes, and had an amazing ability to render textures faithfully. Like Sargent, he took particular pleasure in dealing with large areas of white, and his handling of the different white areas is one of the pleasures of the work reproduced here (PLATE 321). This is not an innovative watercolor, perhaps, but one from which many useful lessons could be learned.

There is little left to say about Norman Rockwell, except that as an illustrator he could occasionally transcend the limitations implicit in that term and that his technical ability was extraordinary, whether he was working with pencil, oil, or watercolor. *The Dugout* (PLATE 322) records the fate of Chicago baseball in 1948, the year when both the Cubs (shown here) and the White Sox finished in the cellar of their respective leagues. The treatment is straightforward, almost photographic, and Rockwell has typically focused on people's reactions to an event rather than on the event itself. His watercolor technique is not as free-flowing as Gannam's, but the drawing is equally sure, the washes equally limpid, and the painting must be considered a technical *tour de force.*

The great realist watercolorist of the post–Armory Show era (along, of course, with Burchfield in his middle period) was Edward Hopper. Unlike Burchfield, he was not primarily a watercolorist—in fact, his watercolors are best understood in relation to his oil paintings, which present his vision in a more conceptualized form. Both deal with a specific American reality, but Hopper's major oil paintings, such as *Early Sunday Morning* (1930) and *Nighthawks* (1942), have an intensity that comes of the artist's having brooded over the subject for long hours in his studio, working from sketches and studies. Frequently, too, these oil paintings explore the relationship between humans and their environment, which is seldom the case with the watercolors. The oils are Hopper's most complete statements, but the watercolors have special significance because they

show the artist responding directly to the physical world, which remains at the core of all his art.

Hopper was born in Nyack, on the Hudson River, a few miles upstream from New York City. He studied illustration at Chase's New York School of Art, where, like so many of his contemporaries, he fell under the spell of Robert Henri, who greatly influenced his early efforts as a painter. Between 1906 and 1910 Hopper made three extended trips to Europe, spending the bulk of his time in Paris, where he produced some watercolors, such as *La Pierreuse* (PLATE 323), which show that he already had a good grasp of the medium and a strong sense of form. Back in America, Hopper was forced to earn a living as an illustrator and a commercial artist, but he painted when he could, turning now to subjects such as tugboats and interiors of El stations. During the late teens and early '20s he made a number of superb etchings, some of which feature the kind of subject matter that was to dominate his mature work.

Hopper lived in New York and spent his summers in New England. At Gloucester, in 1923, he began to paint seriously in watercolor, making views of clapboard houses, sunlit streets, lonely back alleys, and railway sidings that soon won the admiration of his fellow artists and began to gain him some attention from the public. (Like Homer, Whistler, and Sargent, Hopper did not hit his stride as a watercolorist until he was past forty.) *The Mansard Roof* (PLATE 324) is a fine example of the paintings he made that year. Looser in handling than most of his work in the medium, it displays a calligraphic flair that harks back to his Paris period. The way the awnings have been

325. Edward Hopper (1882–1967).
Adams' House, 1928.
Watercolor on paper, 16 x 25 in.
Wichita Art Museum; The Roland P.
Murdock Collection.

set down with a few brisk strokes is especially impressive; they seem to billow in the breeze, and the density of shadow beneath them promises respite from the heat. *The Mansard Roof* was exhibited at the Brooklyn Museum's second watercolor biennial, from which it was purchased for the museum's permanent collection, the first painting the artist had sold in ten years. This gave him the courage to approach the dealer Frank Rehn, who, the following year, gave Hopper his first one-man show, which consisted entirely of watercolors.[4]

Adams' House (PLATE 325) deals with comparable subject matter, presenting it in a way that is already completely typical of Hopper's mature style. The calligraphic flourish, however slight, of *The Mansard Roof,* is gone. Gone with it is the sense of a breeze blowing through the earlier painting; what Hopper set down instead is an unblinking view of buildings on what appears to be a hot, almost airless summer day. Lloyd Goodrich reports that Hopper hated to be watched while painting and often made his watercolors in his parked car.[5] Whatever the case, in this instance it is apparent that he worked directly from the subject, making a rapid pencil sketch and then laying down washes. Mostly applied in broad, flat areas, the washes are layered, though with no great subtlety, to produce a degree of chromatic resonance and are used to describe shapes, shadows, and patches of local color. The artist suggested detail, such as the clapboard facing of the house or the palings of a fence, with a few quick strokes drawn with the tip of the brush. The color is transparent throughout, and the white of the paper is used with great effectiveness.

That is all there is to Hopper's watercolor method. It is the classic English water-color technique, its sensibility modified perhaps by Winslow Homer, employed without bravura flourishes. What makes it notable, and distinguishes it from work by scores of

other accomplished watercolorists, is Hopper's relentless honesty and accuracy of vision. He was determined to falsify nothing, to romanticize nothing, and he had the ability to pick out the essentials of color and tone that would make the eye perceive an image as a convincing facsimile of the original subject. (Hopper also made black and white conté crayon drawings that tell a good deal about the way he simplified a subject to its structural essentials while retaining enough descriptive detail to permit every house, every fire hydrant, to preserve its own distinctive personality.)

Some critics have found Hopper's watercolors cold and almost inhuman in their accuracy. The fact is, however, that his technique is not as impersonal as it might at first appear. Hopper did not flaunt his "handwriting" in the manner of Sargent, but it is always there, nonetheless, in the casualness with which a rectangle of open window is indicated or in the way a brush loaded with dry pigment has been dragged across the paper to conjure up a patch of broken light and shadow. The handwriting is always subordinated to the overall concept, but its presence is still felt.

It is felt especially strongly in *Mrs. Acorn's Parlor* (PLATE 326), an unusual subject among Hopper's watercolors. The artist has permitted his handwriting to show more clearly than usual in the way he has drawn the harmonium, the piano stool, the armchair. The composition also demonstrates how strong was his sense of design, an aspect of his work that is sometimes overlooked. Even more unusual among his watercolors, in that it includes a figure, is *Interior, New Mexico* (PLATE 327), painted the year before. In

326. Edward Hopper (1882–1967). *Mrs. Acorn's Parlor,* 1926. Watercolor on paper, 14 x 20 in. The Museum of Modern Art, New York; Gift of Abby Aldrich Rockefeller.

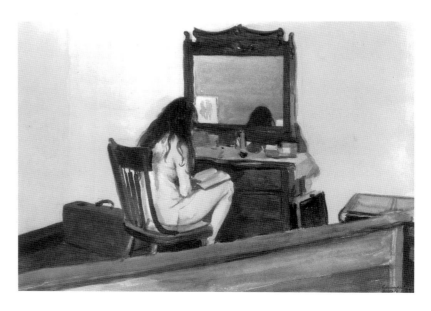

327. Edward Hopper (1882–1967). *Interior, New Mexico,* 1925. Watercolor on paper, 13⁹⁄₁₆ x 19⁹⁄₁₆ in. The Art Institute of Chicago; Olivia Shaler Swan Memorial, Mrs. L. L. Coburn Collection.

this case the handwriting is relatively suppressed and the drawing spare, but again Hopper's design sense is very apparent.

Like Burchfield and Marsh, Hopper was drawn to railroad subjects, and in 1925, when he and his wife were on the first of many trips to the Southwest, he paused to paint an old locomotive and tender belonging to the Denver & Rio Grande Railroad (PLATE 328). This painting has a less finished look than the majority of Hopper's watercolors, and the brushwork is freer than usual. The critics who accuse him of coldness

328. Edward Hopper (1882–1967).
Locomotive, D. & R.G. (Sante Fe, New Mexico), 1925.
Watercolor on paper, 13½ x 19⅝ in.
The Metropolitan Museum of Art, New York; Hugo Kastor Fund.

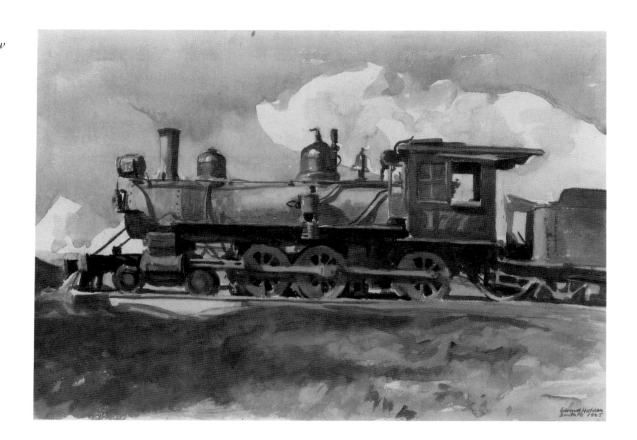

329. Edward Hopper (1882–1967).
Skyline near Washington Square, 1925.
Watercolor on paper, 15 x 21½ in.
Munson-Williams-Proctor Institute, Utica, New York.

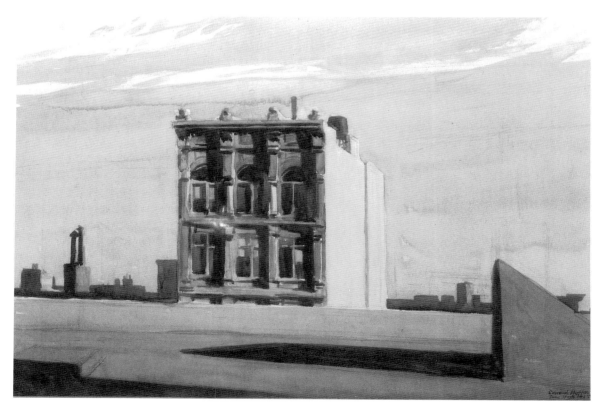

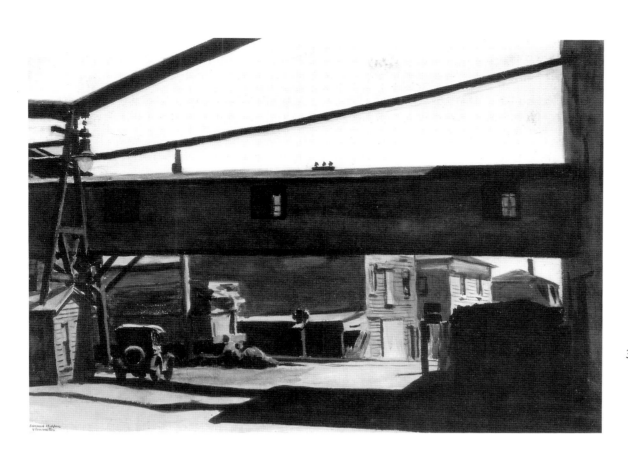

330. Edward Hopper (1882–1967).
Box Factory, Gloucester, 1928.
Watercolor on paper, 14 x 20 in.
The Museum of Modern Art, New
York; Gift of Abby Aldrich
Rockefeller.

would probably argue that the subject inspired a relatively "warm" response, and there
may be some truth in this. Essentially, though, Hopper did not change his technique but
merely freed it up a little, perhaps only because he was in a hurry to reach his destination
before dark and was thus forced to work relatively fast.

More representative of Hopper's work—in fact it might be considered an archetypal
image—is *Skyline near Washington Square* (PLATE 329). Hopper was especially fond of
rooftop views (perhaps this derived from his dislike of public scrutiny), and here this
predilection provides him with a quintessential urban landscape. Chimneys and frag-
ments of cornices peek above an expanse of flat roof, and, just off center, the upper
stories of an ornate building stand sharp against the sky. The time is early morning or
late afternoon, and the long shadows contribute to the powerful design while simulta-
neously providing a sense of drama and contributing a feeling of depth to the façade of
the building that is the main focus of attention.

What makes Hopper's paintings seem so modern, despite the traditional nature of
his method, is the sense of alienation that pervades much of his best work. This is
especially true of his major oils, but it is also very much the case with this particular
roofscape. It would be difficult to think of a more effective way of illustrating the idea of
being alone in the middle of the city, and the efficient matter-of-factness of his water-
color technique heightens the impression that the artist is confronting the viewer with an
urban desert.

Box Factory, Gloucester (PLATE 330) is another powerful design, and studying this
particular image in black and white reproduction helps demonstrate how skillfully
Hopper used contrasts of light and shadow in many of his compositions. This is a
completely naturalistic painting, yet the pattern of lights and darks can be read satisfy-
ingly as a flat, abstract arrangement. Here Hopper has picked a subject that might have
appealed to a Precisionist and has found in it the compositional strengths that would
have attracted Sheeler or Dickinson; but he has retained his own human touch by em-
phasizing the context, the relationship, of the industrial plant to the ramshackle dwellings
nearby.

255

331. Edward Hopper (1882–1967).
The Coal Box, 1930.
Watercolor on paper, 14 x 20 in.
Wadsworth Atheneum, Hartford,
Connecticut; The Ella Gallup Sumner
and Mary Catlin Sumner Collection.

332. Edward Hopper (1882–1967).
The Forked Road (Wellfleet), 1934.
Watercolor on paper, 21¾ x 29¾ in.
Des Moines Art Center; James D.
Edmundson Fund.

Hopper's watercolors discussed so far were all made in the 1920s, before most of his major oils were painted. If some of the important themes of his oils were announced in his etchings, his way of seeing was clarified by his watercolors of this period. For this reason they have a special place in his oeuvre, although he continued to make watercolors throughout his career, always maintaining the same high standards.

The Coal Box (PLATE 331) is so stark that it seems at first like a self-parody, yet it is in fact a fine painting in which Hopper's touch with watercolor is more apparent than usual, as it must be since the sparseness of the subject matter puts all the emphasis on the handling. Only Hopper's sure sense of design makes the composition viable at all, but it is possible to see, too, how Hopper juxtaposed saturated washes with relatively dry brushstrokes that gain vitality from the tooth of the paper.

The Forked Road (Wellfleet) (PLATE 332) features a rural railroad track, familiar from such oils as the Museum of Modern Art's *House by the Railroad* (1925). The subject is a point on the old New York, New Haven & Hartford line that ran up Cape Cod from Buzzard's Bay to Provincetown. The Cape provided Hopper with the subject matter for many fine watercolors, such as *High Road* (PLATE 333), one of his more overtly pleasurable works, the highway and houses basking beneath a summer sky that has been laid in with delicate, pearly washes.

333. Edward Hopper (1882–1967).
High Road, 1931.
Watercolor on paper, 20 x 28 in.
Whitney Museum of American Art,
New York; Bequest of Josephine N.
Hopper.

One of Hopper's most famous watercolors is *Yawl Riding a Swell* (PLATE 334), a subject that begs for comparison with Homer's paintings of pleasure craft. Homer, for all his Yankee crustiness, is positively a sybarite alongside Hopper. Homer's yachts float on waters saturated with Hooker's green and ultramarines that are sometimes warmed with violet. Here and there touches of complementary reds create hot spots that bring the composition to life. *Yawl Riding a Swell*, on the other hand, except for a few light touches of earth color, is painted almost exclusively in cool blues, with the white of the paper being used to amplify the overall coolness. In Homer's marine watercolors, the white of the paper is likely to be employed to represent the tropical sunlight reflected off the water and the hull of the boat. In Hopper's painting the ocean seems to reflect nothing, although clearly it is a sunny day. Instead, the swells are mottled with tiny, dark wavelets. Despite the obvious differences, however, the Hopper could hang alongside a Homer without any embarrassment, since the differences are not so much a matter of quality as of mood. Even in a subject like this, Hopper evokes a feeling of loneliness. If the Bahamas and the Florida Keys became Homer's exotic escape, for Hopper it was the Southwest and Mexico. Even in the many watercolors he made there, a certain coolness tended to prevail, even when warm tints were introduced to describe local color (PLATE 335).

334. Edward Hopper (1882–1967). *Yawl Riding a Swell,* 1935. Watercolor on paper, 20 x 28 in. Worcester Art Museum, Worcester, Massachusetts.

In the end, it all comes down to a matter of temperament. Unlike Homer, Hopper did not treat watercolor painting as an act of almost sublime pleasure. Rather, he used the medium as a kind of intellectual tool to help him define his relationship with the physical world. Such an attitude might have resulted in a rather frigidly detached objectivity, but in Hopper's case objectivity was always tempered by a sense of mystery. In his oils this is sometimes so pronounced that the image seems almost surreal. The watercolors are less extreme in this respect, but they, too, are charged with what might be described as the mystery of the familiar. It is this quality that makes Hopper's work uniquely his own.

335. Edward Hopper (1882–1967).
Church of San Esteban, 1946.
Watercolor on paper, 22½ x 30½ in.
The Metropolitan Museum of Art,
New York; George A. Hearn Fund.

CHAPTER TWELVE

THE POSTWAR AVANT-GARDE

In the 1940s and '50s American painting underwent a revolution—one with roots reaching back to the 1930s and beyond—that transformed New York into the art capital of the world. It also very nearly destroyed the American watercolor tradition. The artists who engineered this revolution—such as Arshile Gorky, Willem de Kooning, Jackson Pollock, Clyfford Still, Mark Rothko, Barnett Newman, and Franz Kline—were determined to shatter the European hegemony in the visual arts. Certainly some of them built upon the achievements of artists like Matisse and Miró, and especially Picasso, but they were determined to go beyond the frontiers that had been staked out by the School of Paris. To achieve this, some were prepared to take any kind of risk. Most took a positive delight in kicking over the traces. Far more completely than in the Armory Show period, adventurous artists turned their backs on traditional values. In such an atmosphere of ferment the notion of watercolor painting as a distinct discipline was an early casualty.

This is not to say that some of the artists who were to dominate the New York School in the post–World War II period did not use watercolor. They simply tended not to use it as a medium with unique properties that suggested certain techniques. Rather, they employed watercolor—whether in its transparent or opaque form—as a convenient way to make colored marks on paper, as useful as (but no more or less so than) ink, pastel, or wax crayon.

Typically, Hans Hofmann's *Untitled* (PLATE 337) does not display any characteristics that distinguish it as being in a water-based medium. It is a powerful composition, revealing a wonderful sense of scale (one expects it to be much larger than it is), but the medium might just as well be oil on panel as gouache on paper. This is particularly significant since Hofmann was one of the great pedagogues of his generation. As a teacher, he had no interest in preserving time-honored traditions or techniques, but he was concerned with encouraging his students to translate their inner emotional states into abstract form, a process that left little time for such niceties as learning how to lay down a clean wash.

Jackson Pollock occasionally employed watercolor early in his career, and if he did so without distinction it is almost irrelevant, because his final achievement is not rooted in conventional notions of technical competence. The poured paintings that are the most famous products of his mature period are remarkable because (among many other reasons) they are made with a minimum of physical contact between painter and canvas.

336. Jim Dine.
20 Hearts, 1970.
Detail of plate 350.

337. Hans Hofmann (1880–1966).
Untitled, 1946.
Gouache on paper, 28¾ x 23⅛ in.
Private collection.

338. Jackson Pollock (1912–1956).
Pattern, c. 1945.
Watercolor, brush and ink, and
gouache on paper, 22½ x 15½ in.
Hirshhorn Museum and Sculpture
Garden, Smithsonian Institution,
Washington, D.C.

339. Jackson Pollock (1912–1956).
Blue (Moby Dick), 1946.
Gouache and ink on composition
board, 18¾ x 23⅞ in.
Ohara Museum of Art, Kurashiki,
Okayama, Japan.

Certainly Pollock stood in the middle of his canvas while painting, but the paint was looped and spattered on, dribbled from a stick, or poured directly from a can, so that the artist's traditional means of control—pressure of fingers upon the brush, pressure of brush upon the canvas—are absent. Instead, it is the hand gesturing in midair that determines how the paint will fall.

It is tempting to think that there is some relationship between the improvisational nature of Pollock's drip paintings and the improvisational aspects of watercolor, but this is probably pushing the point. The poured paintings represent too radical a break with the past. What remains of interest in this context, however, is the fact that, even during his most adventurous breakthrough period, Pollock continued to work on paper, employing relatively conventional technical means, exploring on a small scale some of the formal concepts he was inventing through his action-painting method. Most typically, these drawings were made in black ink, but on occasion he used ink in conjunction with watercolor or gouache (PLATES 338, 339). These works lack the rush of total liberation that enlivens Pollock's large works of the late 1940s and early '50s, but they are still adventurous statements.

Of Pollock's major Abstract Expressionist contemporaries, Mark Rothko and Barnett Newman were the two who did the most interesting work in watercolor and related media. Newman's chief involvement with watercolor occurred at an early and transitional stage of his work. Rothko also used watercolor early on (PLATE 340), and later he used water-based acrylic paint in such a way that it can legitimately be considered an extension of watercolor, creating works that are very similar to his mature work on canvas. Sometimes these were painted on sheets of paper that are, in fact, larger than some of his canvases (PLATE 341). Certainly it would be incorrect to think of these works on paper as being in any way minor. Indeed, the extent to which Rothko concentrated on acrylic on paper toward the end of his life suggests that he turned to this medium as a way of refreshing his art.[1]

Of all the painters influenced by the first generation of Abstract Expressionists, the one who has made the most effective use of watercolor is Sam Francis. A Californian who was for a time a student of Clyfford Still, Francis established a style in which brushed forms combine with drips and dribbles to produce abstract designs that are made all the more elegant by the artist's highly refined sense of color (PLATE 342). It is a technique that lends itself perfectly to watercolor, benefiting as it does from clear washes and the sparkle of white paper. Francis has employed the medium extensively throughout his career.

Another important contributor to the second wave of Abstract Expressionism, though not as well known as a watercolorist as Francis, is James Brooks, who has also produced strong work in the medium. At his best Brooks displays a style that blends the breadth of handling associated with innovators like de Kooning with a sensibility that seems rooted in the organic abstraction of such artists as Miró. *Number 1* (PLATE 343) is typical of Brooks's paintings of the 1950s, with boldly conceived forms suspended against a flat ground.

A somewhat neglected figure who has enjoyed more success in France than in America is Alfonso Ossorio. A close friend of both Jackson Pollock and Jean Dubuffet, the leading French painter of his generation, Ossorio evolved a highly personal style in

which the spirit of Abstract Expressionism was synthesized with elements from the French Art Brut movement. In large canvases that anticipate some of the postmodernist tendencies of the 1980s, Ossorio encrusted Pollock-like swirls and arabesques with a layer of bric-a-brac: broken glass, seashells, junk jewelry. The textures he achieved with this collaging could not be reproduced in his works on paper, but these nevertheless capture the energy that characterized his approach (PLATE 344).

The next generation of nonfigurative artists, including figures such as Morris Louis and Ellsworth Kelly, learned much from the Abstract Expressionists but tended to rely less on energy for its own sake than on a more considered attitude. Often they turned to the new synthetic-polymer paints (acrylics) to create what came to be known as "stain paintings," in which layers of thin transparent paint were applied to the canvas, sometimes by brush or roller, sometimes—a modification of Pollock's drip technique—by pouring directly from the vessel in which the paint had been thinned. Such methods certainly lend themselves to work on paper, but the major figures in this movement rarely seem to have taken advantage of this, perhaps because of their involvement with the notion of scale for its own sake. One notable exception is Helen Frankenthaler, who, along with Louis, has been the leading exponent of the poured stain painting method. In her works on paper Frankenthaler combines brushed, poured, and dripped acrylic paint in a way that takes advantage of its transparency, when thinned, and evokes the feel of watercolor (plate 345).

Some artists associated with Abstract Expressionism and their immediate successors have moved on to forms of figurative art that have been greatly enriched by their non-figurative experience. Richard Diebenkorn began his career as one of California's leading abstractionists. He then switched to an innovative and influential form of realism before returning, in his Ocean Park series, to a more formal kind of abstraction, though one that is rooted in his feeling for landscape or, more specifically, cityscape. Despite the apparent waywardness of this progression, a strong vision underlies all of Diebenkorn's work, making it much more of a whole than might be expected. As far as his watercolors and gouaches are concerned, however, it is the figurative works that have the great-

RIGHT:

344. Alfonso Ossorio (b. 1916).
Red Star, 1944.
Ink and watercolor on paper,
13½ x 19¾ in.
Whitney Museum of American Art,
New York; Gift of the artist.

OPPOSITE:

345. Helen Frankenthaler (b. 1928).
Untitled, March 9, 1984, 1984.
Acrylic on paper, 30¼ x 22¼ in.
André Emmerich Gallery, New York.

346. Richard Diebenkorn (b. 1922).
Man and Window, 1956.
Ink and watercolor on paper,
14 x 17 in.
The Michael and Dorothy Blankfort
Collection.

347. Philip Guston (1913–1980).
Untitled, 1980.
Gouache on board, 20 x 30 in.
David McKee Gallery, New York.

est power (PLATE 346). Within his own distinctive brand of representation, Diebenkorn was sometimes able to conjure up a blend of banality and mystery worthy of Hopper.

Like Diebenkorn, Philip Guston made significant contributions to Abstract Expressionism—evolving a uniquely lyrical style—but toward the end of his career he returned to figuration and to imagery that he had first explored as a young painter in the 1930s. The paintings that resulted were often humorous but sometimes sinister, too, peopled with hooded figures traveling in bulbous cars through landscapes dominated by chunky, cartoon skyscrapers. His was a world in which Giorgio de Chirico met George Herriman, the creator of *Krazy Kat*, yet it was always marked by an advanced spatial sensibility that resulted from Guston's Abstract Expressionist background (PLATE 347).

If watercolor was peripheral to the work of most of the avant-gardists who emerged in the 1940s and early '50s, it was even more so to the wave that followed. Although such artists as Robert Rauschenberg and Jasper Johns were considerably younger than Rothko and Newman, for example, they came to public prominence not too long after the Abstract Expressionist generation. Rauschenberg proclaimed his ambition to work "in the gap between art and life," and the combine paintings that he came to be best known for—works in which brushstrokes were blended with collage elements and three-dimensional objects, such as radios and stuffed birds and animals—seemed to fulfill this ambition. A little later he made paintings by juxtaposing silkscreened images, works that were matched by smaller works on paper in which watercolor or gouache sometimes played a role (PLATE 348).

Jasper Johns is a masterly draftsman and painter, one who is at home in a variety of media, but he has made relatively little use of watercolor. One possible reason for this is that he prefers media, such as encaustic and conté crayon, that can be used to work over an area again and again, making infinite adjustments. Watercolor, of course, does not lend itself to such an approach. Johns's occasional watercolors, however, have all the freshness and sparkle that one associates with the medium (PLATE 349).

Jim Dine is sometimes identified as a Pop artist, although stylistically he has more in common with proto-Pop figures, such as Johns and Rauschenberg, than with artists like Roy Lichtenstein and Andy Warhol. This is most evident in the painterly aspect of his work, which derives from Abstract Expressionism, even as his reliance on various kinds of demotic imagery belies that ancestry. Dine is one of the few innovative artists of his generation who has practiced watercolor painting as an independent branch of his art, in which he explores the same themes addressed in his oils and his sculpture.

One of these themes is hearts—conventional renditions of the human heart such as might be found on a Valentine's Day card or a candy box (PLATE 350). In the example reproduced here Dine uses the repeated heart motif almost as an abstract element, exploring a number of watercolor techniques for their own sakes. He uses fluid washes, dry-brushed paint, spattered paint, washes that have been allowed to run together—and each can be enjoyed as a separate statement about watercolor, while all add up to a harmonious composition.

Another accomplished watercolorist is Claes Oldenburg, a leading figure of the Pop movement. Born in Stockholm, Oldenburg grew up largely in the United States and began to make an impression on the New York art scene in the early 1960s with plaster-of-Paris pies and giant stuffed-fabric hamburgers. Like Dine, he was also a pioneer of the Happenings movement. Unlike Dine, Oldenburg has seldom pursued watercolor purely for its own sake, but he has frequently employed it as a way of setting down ideas, most notably in the proposals for colossal monuments that he began making in 1965. These monuments ranged from a giant vacuum cleaner for Battery Park to a gargantuan hot dog for Ellis Island. Most of these proposals were formulated as sketches in crayon and watercolor or crayon, pencil, and watercolor.

348. Robert Rauschenberg (b. 1925).
Untitled, 1968.
Magazine transfer, pencil, and gouache
on paper, 22¼ x 29⅞ in.
Whitney Museum of American Art,
New York; Purchase with the aid of
funds from the National Endowment
for the Arts.

349. Jasper Johns (b. 1930).
Cicada, 1979.
Watercolor and pencil on paper,
43 x 28¾ in.
Collection of the artist.

350. Jim Dine (b. 1935).
20 Hearts, 1970.
Watercolor and mixed media on
paper, 43 x 34 in.
Private collection.

Oldenburg's notion of replacing the Washington Monument with enormous scissors (PLATE 351) is a typical enough example of his approach. Relying to some extent on the viewer's knowledge of the site, he sketches in the idea quite succinctly with crayon before laying in washes. In this instance the washes are rather loosely applied, and Oldenburg makes no pretense of naturalistic color, beyond allowing the vegetation to be green. His very belated submission to the Chicago *Tribune* architectural competition of 1922 (PLATE 352) is a tad more naturalistic in coloring but displays the same general characteristics. Once again, a great deal is left to the imagination. Nothing is done to suggest the surrounding architectural environment, which is indicated only by the words "Mich. Ave., Chicago" written below the ruled line that signifies street level.

Tom Wesselmann is also generally classified as a Pop artist, though his approach differs from that of Dine or Oldenburg to the extent that he owes little to the painterly tradition established by the previous generation. The dominant theme of his work has been the female nude, frequently placed in a deliberately banal setting such as a bathroom or a kitchen. Sometimes this setting has been evoked with the aid of actual objects: ceramic tiles, towel racks, toilet seats, and so forth. In preliminary works such as *Study for "The Great American Nude #53"* (PLATE 353), Wesselmann uses pencil and transparent acrylic wash in a straightforward and effective way.

OPPOSITE:
351. Claes Oldenburg (b. 1929).
Proposed Colossal Monument to Replace the Washington Obelisk, Washington, 1967.
Crayon and watercolor on paper, 30 x 19¾ in.
David Whitney.

ABOVE:
352. Claes Oldenburg (b. 1929).
Late Submission to Chicago Tribune Architectural Competition of 1922: Clothespin, 1967.
Crayon, watercolor, and pencil on paper, 22 x 23¼ in.
Des Moines Art Center; Gift of Gardner Cowles by exchange, and partial gift of Charles Cowles.

LEFT:
353. Tom Wesselmann (b. 1931).
Study for "The Great American Nude #53," 1965.
Pencil and acrylic wash on paper, 17¾ x 15 in.
Jeffrey Hoffeld and Company, Inc., New York.

354. Michael Heizer (b. 1944).
Untitled, 1969.
Photograph, pencil, and watercolor on
paper, 39 x 30 in.
Whitney Museum of American Art,
New York; Gift of Norman Dubrow.

OPPOSITE, CLOCKWISE, FROM LEFT:
355. Chuck Close (b. 1940).
Self-Portrait/Watercolor, 1977.
Watercolor on paper, 84 x 60 in.
Museum Moderner Kunst, Vienna,
Leihgabe Sammlung Ludwig, Aachen
Anzufuhren.

356. Chuck Close (b. 1940).
Study for Kent, 1970.
Watercolor and graphite on paper,
30 x 22½ in.
Allen Memorial Art Museum, Oberlin
College, Oberlin, Ohio; Mrs. F. F.
Prentiss Fund.

357a–e. Chuck Close (b. 1940).
Linda/Eye I, II, III, IV, V, 1977.
Watercolor on paper, five sheets, each
30 x 22½ in.
Paul Hoffman.

With the exception of the New Realists and the Photo-realists, to be discussed in the next chapter, the artists who emerged in the late 1960s and '70s seldom had much patience for traditional media. It was a time of vehement polemics and far-reaching ambition, in which traditional media such as canvas and bronze were rejected in favor of industrial materials such as plastic and brushed aluminum. Conceptual artists worked with photographs, video, and laser beams, and earthwork specialists took on the landscape. Interestingly, very few of these people abandoned works on paper, partly because large-scale works cannot be generated without proposals, and proposals are best made in the form of drawings. Although some attractive drawings resulted (PLATE 354), this was not a banner era in the history of watercolor painting.

One of the catchwords of the period was *process,* used to suggest that the process of making an art work was as significant as the end product—if there was, in fact, an end product. As understood by many artists, this meant that a work of art made by an industrial process would have some intrinsic merit that freed it from the limitations of the old studio art, now thought effete. One major artist of the period, however, adopted the principles of process art while employing the traditional materials of the artist's studio, watercolor included.

Chuck Close has, since 1968, confined his subject matter to the head-and-shoulders portrait. His are not conventional portraits, however, but painted accounts of photographic portraits sometimes, but not always, made on a very large scale (PLATE 355). This reliance upon photographic source material has led to Close's being bracketed with the Photo-realists, an identification that is at least partially misleading since his roots and ambitions are clearly different from those of others identified with the movement.

Close turned to "reproducing" photographs in paint as a way of escaping the gestural abstraction that he had slipped into, a kind of painting he considered to have become, in his own hands at least, overly facile. After some experimentation he settled on the head-and-shoulders "passport type" portrait as his subject matter, precisely because it was so conventional. He was interested in the notion that it was the camera that made the sitter's likeness—no painterly decisions were involved. His job was simply to interpret that two-dimensional image. Initially he did this by making oversize "copies" of black-and-white photographs in airbrushed transparent acrylic on canvas. Later he played many variations on this theme, often emphasizing the notion of process. In various "dot drawings," for instance, he took a graph paper–like grid and placed dots of varying densities in each of the squares to build up what might be loosely termed a "pointillist" equivalent of the photographic image.

When he began to make full color images, Close borrowed a process from commercial printing in which the full spectrum is recreated by superimposing layers of transparent color. To make a color painting Close first has a color transparency made and sends it to a laboratory, which provides him with three continuous-tone color separations: red (magenta), blue (cyan), and yellow. He then has five dye-transfer sheets made from these separations: one of the red separation alone, one of the blue, one of the red plus the blue, one of the yellow, and one of the red plus blue plus yellow (the final combination reproduces the full chromatic range of the original transparency).

Close then uses these mechanically produced separations and combinations as a guide to creating the final painted image, using only the three primary (or quasi-primary) colors found in the separations and overlaying them to make a fully chromatic painted reproduction of a photograph (PLATES 357 a–e). Clearly transparency is essential to this technique, and watercolor has proved to be an appropriate medium. As noted earlier, watercolorists have known for centuries that the transparency of the medium, allied with the reflectiveness of white paper, permits color to be mixed by the eye rather than on the palette. It is precisely this principle that Close has taken advantage of so effectively (PLATE 356).

"Death lies on her, like an
untimely frost—
Upon the sweetest flower of
the field."
Shakespeare

358. H. C. Westermann (1922–1981).
The Sweetest Flower, 1978.
Watercolor on paper, 22⅛ x 31 in.
Whitney Museum of American Art,
New York; Gift of the Lauder Foun-
dation Drawing Fund.

In any period of vital artistic activity there are always a few figures who stand outside
the mainstream and yet enrich the tradition as a whole. One such artist was
H. C. Westermann, a sculptor and draftsman much admired by more orthodox artists
but himself apparently immune to the influences that have shaped recent movements.
His sculptures are marked by idiosyncratic craftsmanship, enigmatic imagery, and a
highly original sense of humor, and much the same can be said of his drawings, many
of which are tinted with watercolor (PLATE 358).

Westermann's art does work in purely visual terms, but at the same time it has
what can only be described as a literary quality, in that, like poetry, it juxtaposes signs,
symbols, and images to conjure up elusive meanings that are perceived subjectively
rather than objectively. Much the same can be said of the paintings, drawings, and
sculptures of William T. Wiley, a California-based artist who has employed watercolor
as a primary means of expression, although he also works extensively in other media.

Wiley's watercolors are characterized by an intricate linear web, with the artist's pen
or pencil sometimes describing groups of common objects, sometimes inventing new
forms that seem to be invested with ritual meaning. Often these drawings are accompa-
nied by enigmatic written texts. Wiley tints his drawings with watercolor, which is
always beautifully applied and which, in his best works, is used to build up a rich chro-
matic texture that balances the complexity of the linear structure (PLATE 359).

In the 1980s it has become commonplace to talk, in the art world, of postmodernism—an attitude toward art history that implies that the great revolution of modern art that began with the Impressionists and continued until at least the Minimalists and conceptual artists of the 1970s has run its course. This has led to renewed interest in various forms of figurative art, and, while it is too soon to say whether this attitude will prevail or where it will lead, it has already made the mainstream of American art more eclectic, moving it closer to the position of artists like Westermann and Wiley, who formerly seemed somewhat eccentric.

The artists who have come to be associated with this latest wave are notorious for working on an extremely large scale and for specializing in sometimes eccentric forms of

359. William T. Wiley (b. 1937).
Nothing Conforms, 1978.
Watercolor on paper, 29½ x 22½ in.
Whitney Museum of American Art,
New York; Neysa McMein Purchase
Award.

360. David Salle (b. 1952).
 Untitled, 1984.
 Watercolor on paper, 25 x 31 in.
 Mary Boone Gallery, New York.

361. Ronnie Cutrone (b. 1948).
 Out in Inner Space, 1985.
 Watercolor on paper, 60 x 50 in.
 Tony Shafrazi Gallery, New York.

362. Dorothea Rockburne (b. 1934).
Seraphim (Fire) 1982.
Watercolor on vellum, 51 x 42 in.
Private collection.

mixed media. David Salle has made numerous skillful watercolors in which he explores the same themes found in his larger paintings, images being laid over unrelated images in ways that benefit directly from the transparency of the watercolor medium (PLATE 360). Ronnie Cutrone, once a close associate of Andy Warhol, works frequently in watercolor, utilizing the same cartoon characters that appear in his works on canvas and sometimes combining them with religious imagery (PLATE 361). Like Salle, he has a sure feel for the medium, often combining relatively tightly drawn figures with very loosely applied wet-into-wet washes. Dorothea Rockburne has used watercolor to make dramatic nonfigurative works in which folded sheets of paper washed with marbled color create a lyrical geometry (PLATE 362).

It is apparent that the increasing eclecticism of the American art scene in the 1980s leaves plenty of room for watercolor to reassert itself as an important medium. The renaissance of figuration almost ensures this, and, as will be seen in the final chapter, the realist watercolor is already making itself felt as a force on the contemporary scene.

CHAPTER THIRTEEN
THE POSTWAR REALISTS

There was a time in the 1950s and '60s when the gallery listings in New York, Chicago, or Los Angeles might have suggested that the realist watercolor tradition was dead or, at best, moribund. But if you visited provincial art centers such as Provincetown and Santa Fe, however, or thumbed through the pages of a magazine like *American Artist,* you would have become aware of a different story. It would have become obvious that in these places hundreds of artists, professional and otherwise, were working seriously in variants of the idioms practiced by Homer and Sargent, Hassam and Hopper. Some of these artists displayed considerable ability and produced watercolors that were very satisfying within their own frame of reference. More important, they kept alive a body of knowledge about watercolor technique that would be of value to the generation that followed. In an age that had institutionalized the avant-garde, however, the conservatism of these artists kept them from receiving significant critical attention. A singular exception, one of the few important artists to paint realist watercolors throughout this period—and one of the most popular painters of the century—was Andrew Wyeth.

The son of N. C. Wyeth, a major illustrator, Andrew Wyeth showed early aptitude as a draftsman and painter. By the late 1930s he had mastered the bravura watercolor manner that had been popular a generation earlier, and in paintings like *Pirate Country* and *The Coot Hunter* (PLATES 364, 365) he employed fluid brushstrokes to evoke his subjects with a matter-of-fact confidence that sometimes threatened to permit technical facility to overwhelm the individuality of his vision. As he matured, however, the uniqueness of Wyeth's approach became clearly apparent. At the most obvious level his focus on the people and places of rural Pennsylvania and Maine has set him apart from the vast majority of his contemporaries. But it is not just the subject matter that distinguishes his work; it is also the intensity with which he scrutinizes it.

If Wyeth's earliest watercolors are marked by a freedom of handling that derives in part from Sargent, his later work is more often reminiscent of Eakins. He would still employ loose washes for study and notation purposes (PLATE 366), but his watercolor paintings increasingly took on a more finished and closely observed appearance, in which a substratum of carefully considered washes was overlaid with thousands of tiny dabs of color, a technique that Wyeth calls "dry brush." By this term the artist means that he lightly loads his brush with watercolor, then, with his fingers, squeezes much of the moisture from the hairs until all that is left is a little dryish pigment at the tip. When strokes of this dryish pigment are laid side by side, a dense and rich surface is produced,

363. Joseph Raffael.
Return to the Beginning: In Memory of Ginger, 1981.
Detail of plate 388.

OPPOSITE:
364. Andrew Wyeth (b. 1917).
Pirate Country, 1939.
Watercolor on paper, 30 x 22½ in.
Norton Galleries and Art School, West
Palm Beach, Florida.

ABOVE:
365. Andrew Wyeth (b. 1917).
The Coot Hunter, 1941.
Watercolor on paper, 17¾ x 29³⁄₁₆ in.
The Art Institute of Chicago; Olivia
Shaler Swan Memorial Collection.

LEFT:
366. Andrew Wyeth (b. 1917).
The Blue Door, 1952.
Watercolor on paper, 29¼ x 21 in.
Delaware Art Museum, Wilmington.

283

one that provides great tonal and chromatic variety. This technique is not far removed from Eakins's watercolor method—it has, in fact, roots going back to Dürer—yet, as far as the past half-century is concerned, Wyeth has made it his own. It is a technique that demands considerable patience and is especially well suited to Wyeth's subject matter, which is always tinged with the slow erosion of time.

Wyeth's world is hardly touched by the restlessness of urban America. It is a world in which people and places weather as they age, and his dry-brush technique is ideally suited to capturing every wrinkle in a man's face, every flake of paint peeling from a barn wall. It also serves him well as a method for delineating form with a meticulousness that seems to belong to the nineteenth century. Traditional as they are in technique, however, paintings such as *The Slip* and *Young Bull* (PLATES 367, 368) are so rooted in a specific time and place that the artist avoids seeming reactionary. Wyeth's world may change more slowly than other parts of America, but he does not ignore the changes

367. Andrew Wyeth (b. 1917).
The Slip, 1958.
Dry brush on paper, 20 x 29⅛ in.
Private collection.

368. Andrew Wyeth (b. 1917).
Young Bull, 1960.
Dry brush on paper, 19¾ x 41¼ in.
Private collection.

that have occurred, does not paint some lost Arcadia, and this gives his work a funda-. mental honesty that is essentially of its time.

Much the same might be said of David Levine. Best known as an incisive caricaturist, Levine is also a watercolorist of technical brilliance whose skill is aided by a highly developed sense of atmosphere that enables him to charge his subjects with emotional resonance. Unlike Wyeth, Levine is very much an urban artist, but his interests lie primarily in those areas of New York—Coney Island, the Lower East Side—that have been relatively immune to change (PLATES 369, 370). Like Wyeth, he is involved with the aging process, recording the effects of the passage of time on people and places. His method of conveying this is very different, however. Levine is a master of the controlled wet-into-wet technique; while Wyeth details the ravages of time, Levine suggests them with soft edges that convey a sense of erosion.

Wyeth and Levine exemplify artists who followed traditional realist paths almost as if there were no radical alternative. Other painters, such as Fairfield Porter, practiced realism despite a deep appreciation of, and ongoing dialogue with, the most avant-garde elements in European and American art. Porter was an essentially intellectual artist who transcended this proclivity to bring considerable sensuality to his landscapes and figure paintings. He studied art history as well as painting and was slow to recognize his primary vocation. (When he did so it was, significantly, largely due to the encouragement of Abstract Expressionist Willem de Kooning.) Even after becoming a full-time painter, Porter continued to publish art criticism, and his writings show him to have possessed a very catholic taste that encompassed everything from realism to radical abstraction.

For his own master Porter selected the French Post-Impressionist Edouard Vuillard, a practitioner of the proto-abstract art of reducing form to pattern. Vuillard's art is full of banal domestic interiors transformed by his skill into a vibrant, richly textured geometry. Such interiors exist in Porter's work as well, often as a context for his many portraits, but it is his landscapes that are especially memorable. They are the paintings most highly charged with Porter's sensuality, a quality that sometimes recalls the art of Vuillard's early associate, Pierre Bonnard. The majority of Porter's landscapes—primarrily of Maine or Long Island—are in oil, but a significant number were executed in watercolor (PLATE 371). These works on paper frequently display to good effect Porter's ability to simplify form without losing touch with the concreteness of matter.

John Button was another artist who dealt with landscape in a relatively straightforward way that nonetheless took full account of twentieth-century radical art. Although he was not drawn to industrial subjects, his approach sometimes recalls that of the Precisionists. In Button's best work, architectural elements were selected for their inherent interest and then portrayed from a carefully selected viewpoint that enabled the artist to relate them to the edges of the canvas or paper, almost as if he were dealing with abstract elements (PLATE 372). As in Porter's paintings, however, the purely compositional aspects of Button's work are always balanced by a strong sense of concrete reality and also of atmosphere. Sometimes he would silhouette buildings against a sky full of fluffy white clouds that give the painting the innocent feel of a children's-book illustration.

Although Button worked in a variety of media, it is his gouaches that are of particular interest. Few artists have used body color with such purity. It gave his work a solidity that he could not have attained with transparent color, yet at the same time it allowed him the freedom of handling and the economy of statement associated with a water-based medium.

Philip Pearlstein studied at the Carnegie Institute in Pittsburgh and came to New

369. David Levine (b. 1926).
Atlantis, 1967.
Watercolor on paper, 14½ x 10⁹⁄₁₆ in.
The Brooklyn Museum; Dick S.
Ramsay Fund.

370. David Levine (b. 1926).
Orchard Street, 1972.
Watercolor on paper, 11 x 14 in.
Private collection.

371. Fairfield Porter (1907–1975).
Morning from the Porch, 1974.
Watercolor on paper, 22 x 30 in.
Heckscher Museum, Huntington,
New York; Museum Purchase.

372. John Button (1929–1982).
Lincoln Tower, 1978.
Gouache on paper, 25¾ x 19¾ in.
Estate of the artist.

York in 1949, where he roomed, for a while, with fellow Carnegie student Andy Warhol. Like Warhol, he supported himself as a graphic artist. During much of the 1950s he painted landscapes that for the most part focused on geological formations or ancient monuments. Then, toward the end of the decade, he shifted his attention to concentrate primarily on the nude figure.

To the casual observer it might seem that in making this choice of subject matter Pearlstein was espousing very traditional values, but this is not really the case. To begin with, his paintings and drawings commonly juxtapose two nude figures in such a way as to make the spatial relationship between them as important as the artist's delineation of the individual anatomies. Nor is this relationship charged with erotic or psychological undertones. Rather, it is a matter of formal considerations, a question of deciding the way in which masses are displaced within a clearly defined studio environment (PLATE 373).

The painter poses his models with a minimum of props, lighting them carefully in a manner designed to "facilitate Pearlstein's abilities of description rather than to create mood or drama."[1] By Pearlstein's own account, he generally begins by focusing on one small area—often it will be a hand or a pair of hands—rendering this in some detail, then building the rest of the image from there, describing volume and contour "correctly measured against each other."[2] He is concerned, he insists, not with such matters as knowledge of anatomy but only with accurate representation of mass and spatial relationships. In a sense, then, the fact that Pearlstein is painting naked human bodies is almost irrelevant. The nude has been selected as a useful convention (in much the same way that Chuck Close chose the portrait as the basis for his art). What Pearlstein is attempting to confront here is objectivity of observation in a way that recalls the theories of the French writer Alain Robbe-Grillet.

In Pearlstein's oils, the unpleasant pallor of the subjects' flesh—remorselessly illuminated by artificial light—tends to produce a sense of distance, even alienation, from the subject. His watercolors, however, are somewhat warmer, and the landscape subjects he still paints occasionally (PLATE 374) show him to possess many purely traditional skills.

373. Philip Pearlstein (b. 1924). *Two Female Models on Chrome and Wooden Stools*, 1979. Watercolor on paper, 59¾ x 40 in. Gilda and Henry Buchbinder.

374. Philip Pearlstein (b. 1924). *Temple at Abu Simbel*, 1979. Watercolor on paper, 29 x 41 in. Private collection.

375. Richard Haas (b. 1936).
One William Street at Night, 1981.
Gouache on paper, 33½ x 23 in.
Private collection.

376. Richard Haas (b. 1936).
*The Metropolitan Museum, Central Park
(Day),* 1979.
Watercolor on paper, 21¾ x 40 in.
Brooke Alexander, Inc., New York.

Richard Haas is best known for the *trompe-l'oeil* paintings that he uses to transform architectural exteriors and interiors. (He will, for example, enhance a blank wall by furnishing it with painted "windows.") His large-scale watercolors also deal with architecture (PLATES 375, 376) and do so in a way that is as matter-of-factly objective as Pearlstein's nudes.

Haas favors a fairly classical watercolor technique, which he deploys with a deadpan lack of flourish that makes Edward Hopper seem positively expressionistic. Whatever Haas's eye falls on—whether a classical pediment or an air conditioner—he sets down with the same almost mechanical economy of means. This is a world in which no distinction is made between significant and insignificant detail, a world in which everything appears equal. It would be inaccurate to describe Haas as a Photo-realist, yet his paintings often seem to have been captured as much by a mechanical eye as by a skilled hand (though close study of any of his watercolor images will reveal that his hand is more than adequately skilled).

Photo-realism is a kind of realist painting that enjoyed a great vogue in the 1970s, though the roots of the style reach back into the 1960s and beyond. It is (or was) practiced by artists such as Richard Estes, Robert Bechtle, Ralph Goings, Tom Blackwell, John Baeder, Ben Schonzeit, and Idelle Weber. What these artists have in common is the fact that their paintings are derived from photographic images transcribed—by way of brushes, airbrushes, or other means—to canvas or paper. That said, there is more variety to the Photo-realists' methods than at first seems apparent. Estes, for example, will sometimes refer to several photographs to arrive at a single image, while Goings feels free to alter colors and physical details.[3] But all seek to create the illusion of a painted photograph, and, when one is confronted by these artists' work in oils or acrylics, it is sometimes difficult to tell one from another, except for the artist's preference for a

377. Richard Estes (b. 1936).
Food, 1968.
Watercolor on paper, 11⅝ x 14¼ in.
Private collection.

certain kind of subject matter. In some instances it is harder to guess the name of the artist than it is to identify the film stock used to generate the source image. Interestingly, this changes somewhat when these artists work in watercolor. Estes—the preeminent exponent of the style—has produced occasional watercolors such as *Food* (PLATE 377) in which the handling is relatively loose, so that while the origin of the image is clearly photographic, the overall effect is decidedly more painterly than in his oils.

Of all the Photo-realists, Bechtle and Baeder are perhaps the most prolific as water-colorists. In subject matter, Bechtle's watercolors are closely related to his oils (occasion-ally he uses the same image to generate works in both media). Working on the smaller scale of watercolor, however, he allows himself greater liberties in terms of simplifica-tion and also permits the texture of the paper to supply a certain sensuousness that is not evident in his larger works (PLATE 378). Much the same can be said of Baeder's works on paper. His watercolor technique is especially skillful and firmly rooted in the realist traditions that reach back to the classic methods of the British school. His favorite subject matter—the exteriors of diners—often possesses a warmth that is well suited to his touch with watercolor (PLATE 379).

The texture of the paper is sometimes a factor in Ralph Goings's watercolors, too. In some instances he uses the medium to focus closely on simple still-life subjects (PLATE 380), but often, as in the case of *Country Girl Diner* (PLATE 381), he compresses a good deal of action and detail into the relatively small-scale format that, for some reason, is favored by the majority of Photo-realist watercolorists. Tom Blackwell's watercolors relate closely to his oils. *GM Showroom* (PLATE 382) is, in fact, a quarter-scale facsimile of an earlier canvas, and other watercolors portray airplanes or motorcycles, two of the chief themes of his oeuvre.

If most of the Photo-realists celebrate popular culture and urban and suburban America in a fairly straightforward way, others, such as Idelle Weber and Ben Schonzeit, have been drawn to imagery that is more offbeat and enigmatic. Schonzeit has, for example, combined shirts and peaches—both elements rendered photographically but in unrelated scales—in a way that suggests a hand-painted (or airbrushed) enlargement of a

OPPOSITE, TOP LEFT:
378. Robert Bechtle (b. 1932). *Solano Avenue Pinto,* 1977. Watercolor on paper, 10 x 16 in. Louis K. and Susan Pear Meisel.

OPPOSITE, CENTER LEFT:
379. John Baeder (b. 1938). *Matamoras Diner,* 1977. Watercolor on paper, 13 x 18½ in. Harvey Schuman Collection, New York.

OPPOSITE, RIGHT:
380. Ralph Goings (b. 1928). *Diner Still Life,* 1977. Watercolor on paper, 11 x 11 in. George Sturman.

OPPOSITE, BOTTOM:
381. Ralph Goings (b. 1928). *Country Girl Diner,* 1985. Watercolor on paper, 11 x 16 in. O. K. Harris, Inc., New York.

BELOW:
382. Tom Blackwell (b. 1938). *GM Showroom,* 1977. Watercolor on paper, 15 x 22 in. Louis K. and Susan Pear Meisel.

383. Ben Schonzeit (b. 1942).
The Music Room #7, 1977.
Watercolor on paper, 30 x 30 in.
Glenn Janss, Sun Valley, Idaho.

384. Idelle Weber (b. 1932).
Vampirella I—East 2nd Street, 1975.
Watercolor on paper, 24⅜ x 35 in.
National Museum of American Art,
Smithsonian Institution, Washington,
D.C.; Museum Purchase.

385. Idelle Weber (b. 1932).
Color Lesson I—Watercolor, 1983–84.
Watercolor on paper, 7½ x 20 in.
Mr. and Mrs. Ted Swinney, Dallas.

386. Don Nice (b. 1932).
Classic Still Life, 1982.
Watercolor on paper, 40 x 60 in.
Eduardo Strumpf.

photomontage. In other instances, such as *The Music Room #7* (PLATE 383), he has dealt with imagery remote from the world of chrome and neon that generally comes to mind when Photo-realism is mentioned. Schonzeit is a skilled photographer, and much of his method is concerned with manipulating imagery in the camera or in the printing process. At the same time, this photographic manipulation derives from painterly concerns that are related to styles—such as color-field painting—far removed from Photo-realism. Schonzeit's paintings often involve considerable risk taking and gain strength from their ambiguities.

Idelle Weber gained a reputation in the 1970s for large-scale paintings of trash seen and photographed on the streets of New York. Some of these paintings were made in watercolor (PLATE 384) and are among the most ambitious examples of Photo-realist work in the medium. More recently Weber has moved on to a more painterly style, in which she attempts to bring fresh life to familiar subject matter, such as flowers and water, by the use of carefully considered color relationships and symmetrical compositions (PLATE 385).

387. Wayne Thiebaud (b. 1920).
Candy Ball Machine, 1977.
Gouache and pastel on paper,
24 x 18 in.
John Berggruen, San Francisco.

A form of realism very different from Photo-realism is practiced by Don Nice, who frequently singles out individual objects, or groups of objects, for special attention, treating them as icons. In the *Classic Still Life* paintings from his American Predella series (PLATE 386) he takes clusters of demotic icons—some of which have been occurring in his work for two decades—and organizes them with an almost primitive sense of symmetry against the bare white ground of the paper. The concept is stark, but because of his generous handling of the medium Nice's end product is rich in texture and accessible. Another artist whose work is characterized by generosity of handling is Wayne Thiebaud, who, like Nice, presents familiar American icons—and sometimes landscapes and figures, too—with sympathy and warmth. His work on paper is most frequently executed in pastel, but sometimes, as is the case with *Candy Ball Machine* (PLATE 387), he effectively blends pastel with body color.

Joseph Raffael studied at Cooper Union and Yale. In the mid-1960s he began to attract critical interest with large paintings in which disparate and apparently dislocated

elements—an eye, an ear, a German shepherd—were scattered as if at random across a white ground. Late in the decade, however, he moved to Northern California and began to work in an idiom that, on the surface at least, was more traditional, in that the emphasis was on conventional single images rather than dislocated multiple ones. (In fact, the new images were generally on a larger-than-life scale, which gave them a faintly disturbing presence typical of the New Realism of the 1970s.) At about the same time, Raffael became a prolific watercolorist, quickly evolving a virtuosic technique in which free but accurate brushwork was frequently combined with areas of blotted, overlapping washes to create bravura effects that are occasionally reminiscent of Sargent (PLATES 388, 389).

Like Marin and Burchfield—though his technical approach is very different—Raffael is essentially an American pantheist, a fact that is apparent not only in his choice of subject but also in the way he encourages the image to emerge as if it were an organic consequence of the medium itself. Beyond this, Raffael is a gifted colorist, and his large-scale watercolors are among the most distinctive of recent years.

One of Raffael's favorite subjects of the 1970s was water, and he sometimes

388. Joseph Raffael (b. 1933).
Return to the Beginning: In Memory of Ginger, 1981.
Watercolor on paper, 33½ x 41 in.
Richard Brautigan/David Kaplan.

389. Joseph Raffael (b. 1933).
Matthew's Branch, 1981.
Watercolor on paper, 14 x 30 in.
Nancy Hoffman Gallery, New York.

390. William Allan (b. 1936).
Rainbow Head, Four Hours from Life,
Mill Valley, 1972.
Watercolor on paper, 24 x 29½ in.
Odyssia Gallery, New York.

391. Neil Welliver (b. 1929).
Immature Great Blue Heron, 1977.
Watercolor on paper, 24 x 22 in.
Brooke Alexander, Inc., New York.

392. Sondra Freckelton (b. 1936).
Trailing Begonia, 1979.
Watercolor on paper, 46 x 28½ in.
Reader's Digest Association, Inc.

393. Red Grooms (b. 1937).
Desert Sands, 1973.
Watercolor on paper relief, 10 x 30 in.
Mimi Gross.

worked from photographs of fishing creeks taken by fellow artist William Allan. Allan is probably best known for his large allegorical paintings, but—an enthusiastic sportsman— he has also made many watercolor studies of game fish. Unlike Winslow Homer, who brought leaping fish to life, Allan has concentrated on accurate renditions of landed trout, still fresh but already, as in the present example, "hours from life" (PLATE 390).

Equally involved with nature imagery is Neil Welliver, whose landscape and animal subjects are painted in an easily recognizable style in which images are built from elongated patches of color, each of which appears to be a single, broad brushstroke (PLATE 391). There is something about this approach that recalls Prendergast's mosaiclike method, though Welliver's sensibility is very different from Prendergast's, especially with regard to chromatic preferences. Welliver's pictures seem to be constructed so systematically that they take on an almost hieratic quality—a bird becomes an icon, a New England scene is transformed into a Platonic statement about landscape.

A far more demotic approach is displayed by Sondra Freckelton, whose large-scale watercolors often seem to be an almost boisterous celebration of domestic fecundity. In her world the American garden is presented as a cornucopia (PLATE 392). Like a number of other artists discussed in this book, Freckelton displays a pantheistic attitude toward the world; but what makes her work a little different from that of, say, Homer or Burchfield, is the fact that it is firmly rooted in the home and its immediate surroundings.

Another artist whose work is a direct response to his everyday surroundings— though in this case we are talking about urban America—is Red Grooms. Best known for his three-dimensional environmental works, Grooms is a prolific exponent of many different media, including watercolor and gouache. On occasion, Grooms has indeed made imaginative use of watercolor in a three-dimensional context, as in *Desert Sands* (PLATE 393). Making use of the technique of paper sculpture, once a staple of window-display artists, Grooms created a number of works in which the beauty of transparent color takes on a role that it has seldom played before. In *Desert Sands* it is the cut-and-

394. Red Grooms (b. 1937).
Marat, 1980.
Watercolor on paper, 18⅛ x 24 in.
Private collection.

folded paper that serves the primary descriptive function (we could read the subject matter even if the sculpture were not painted), but it is the watercolor, handled with a wonderful freedom that is typical of Grooms's art, that brings the entire thing to life.

Marat (PLATE 394) looks almost as if it had been painted by a child, but, in reality, the use of watercolor here is very skillful. Noteworthy in particular is the way Grooms has drawn with the brush directly onto the water-saturated paper and the way in which he has preserved the clarity of his washes. Always leavened with humor, Grooms's art demonstrates again and again that there are many ways of tackling the problem of reality in the final quarter of the twentieth century.

A more traditional, but very impressive, approach to realism is to be found in the art of Carolyn Brady. There is nothing remarkable about her subject matter—she paints the objects in her own home, the flowers from her garden—nor is she intellectually adventurous in the style of the avant-garde. At the same time, her pictures are like none that have ever been seen before because they employ classic watercolor technique on an almost monumental scale, and that technique is deployed with a rigor that is matched by the quiet poetry of the artist's vision.

Virtually all of Brady's paintings utilize the full range of tonal densities that are available to the watercolorist. The darkest of her washes are so deeply saturated that an area of untouched white paper seems like a source of pure light. In a painting such as *Night Flowers* (PLATE 395), for example, virgin white is used to represent the translucent dome of a table lamp, whereas the shadows that occupy a substantial part of the picture plane and that function as key compositional elements are built up from layered washes that approach blackness without losing chromatic resonance. In this and other paintings Brady seems to be intent upon stretching the medium to its limits. She habitually works

395. Carolyn Brady (b. 1937).
 Night Flowers, 1985.
 Watercolor on paper, 43 x 48 in.
 Mr. and Mrs. Louis Zorensky.

396. Carolyn Brady (b. 1937).
Emerald Light (Black Desk for Zola),
1984.
Watercolor on paper, 60 x 40 in.
Dr. James Schutz.

on a large scale and builds her images with enormous care, yet she always retains a hint of spontaneity and manages to avoid the labored look that deadens so many technically ambitious watercolors.

When we consider artists such as Brady, Nice, and Raffael or, for that matter, Salle and Grooms, it is clear that we are in the midst of a full-scale revival of interest in watercolor. As was the case a century ago, and even half a century ago, painters feel once more that watercolor can be used to make major artistic statements. This renaissance is a relatively recent phenomenon, and it would be inaccurate to claim that it has yet become responsible for a body of work comparable to that produced by artists such as Homer, Sargent, and Prendergast at the turn of the century or by artists such as Marin, Burchfield, Hopper, and Demuth a few decades later. Rather, the situation is somewhat as it was during the 1880s, when a number of gifted and relatively young artists were beginning to explore the potential of the medium. As has been proved again and again, that potential is virtually limitless.

NOTES

INTRODUCTION: A Brief History of Watercolor (pages 9–25)

1. For a complete account of the technical development of watercolor painting, see Marjorie B. Cohn, *Wash and Gouache: A Study of the Development of the Materials of Watercolor* (Cambridge, Mass., 1977).

1. First Views of the New Land (pages 27–45)

1. *Narrative of La Moyne, an Artist Who Accompanied the French Expedition to Florida under Laudonnière, 1564* (Boston, 1875), pp. 3–4.

2. Paul Hulton and David Beers Quinn, *The American Drawings of John White, 1577–1590, with Drawings of European and Oriental Subjects* (Chapel Hill, N.C., 1964), p. 11.

3. Ibid., p. 24.

4. John A. Kouwenhoven, *The Columbia Historical Portrait of New York* (New York, 1972), p. 74.

5. Gloria-Gilda Deak, *American Views, Prospects and Vistas* (New York, 1976), p. 48.

2. A Grass-Roots Tradition (pages 47–59)

1. Edward Denning Andrews and Faith Andrews, *Visions of the Heavenly Sphere: A Study of Shaker Religious Art* (Charlottesville, Va., 1969), p. 91.

2. Nina Fletcher Little, *The Abby Aldrich Rockefeller Folk Art Collection* (Colonial Williamsburg, Va., 1957), p. 212.

3. Ibid., p. 132.

4. Mary C. Black, "A Folk Art Whodunit," *Art in America* 53 (June 1965): 97–105.

5. Jane Livingston and John Beardsley, *Black Folk Art in America, 1930–1980* (Jackson, Miss., 1982), p. 163.

6. Ibid., p. 157.

3. Frontiers and Waterways (pages 61–83)

1. William H. Goetzmann, Joseph C. Porter, and David C. Hunt, *The West as Romantic Horizon* (Omaha, 1981), p. 54.

2. John Wilmerding, *A History of American Marine Painting* (Boston, 1968), p. 89.

3. Ibid., p. 90.

4. Barbara Novak, *American Painting in the Nineteenth Century* (New York, 1979), p. 111.

5. Wilmerding, *History of American Marine Painting,* p. 194.

4. Academics and Originals (pages 85–109)

1. James Thomas Flexner, *History of American Painting, Vol. Three: That Wilder Image* (New York, 1970), p. 196.

2. Theodore E. Stebbins, Jr., *American Master Drawings and Watercolors* (New York, 1976), p. 148.

3. For a detailed account of the history of the American Pre-Raphaelite movement, see Linda Ferber and William H. Gerdts, *The New Path: Ruskin and the American Pre-Raphaelites* (New York, 1985).

4. Ibid., p. 18.

5. Alfred Frankenstein, *The Reality of Appearance* (Greenwich, Conn., 1970), p. 142.

6. Stebbins, *American Master Drawings and Watercolors,* p. 238.

7. Donelson F. Hoopes, *Eakins Watercolors* (New York, 1971), p. 44.

8. Ibid.

5. Winslow Homer (pages 111–33)

1. Donelson F. Hoopes, *Winslow Homer Watercolors* (New York, 1969), p. 50.

6. Americans Abroad (pages 135–55)

1. Henry James, *Galaxy 20,* July 1875, pp. 93–94.

2. David Park Curry, *James McNeill Whistler at the Freer Gallery of Art,* (Washington, D.C., 1984), p. 198.

3. Margaretta M. Lovell, *Venice: The American View, 1860–1920* (San Francisco, 1984), p. 87.

7. John Singer Sargent (pages 157–73)

1. Carter Ratcliff, *John Singer Sargent* (New York, 1982), pp. 176–77.

2. Ibid.

3. Ibid., p. 213.

4. Stebbins, *American Master Drawings and Watercolors,* p. 251.

5. Ibid.

6. Lovell, *Venice: The American View,* p. 122.

7. As early as 1917 the Carnegie Institute staged a show titled *Winslow Homer and John Singer Sargent: An Exhibition of Watercolors.*

8. John Marin (pages 175–89)

1. For Marin's early life, see autobiographical sketches published in *The Selected Writings of John Marin*, Dorothy Norman, ed. (New York, 1949).

2. William Innes Homer, *Alfred Stieglitz and the American Avant-Garde* (New York, 1980), pp. 94–95.

3. Dorothy Norman, *Alfred Stieglitz: An American Seer* (New York, 1973), p. 99.

4. John Marin, *Camera Work*, nos. 42–43 (April–July 1913): 18.

5. A number of verbal expressions of this attitude are to be found in *John Marin by John Marin,* Cleve Gray, ed. (New York, n.d.). On page 120, for example, is the statement: "sometimes I like to paint a red ocean . . . what makes the painted ocean look real is a suggestion of the motion of water. . . ."

6. Ibid., p. 92.

7. John Marin, *Art in America* 53 (August–September 1965): 79.

9. New Directions (pages 191–215)

1. Norman, *Alfred Stieglitz: An American Seer,* p. 97.

2. Ibid., p. 234.

3. For an account of the New York Dada group, see William S. Rubin, *Dada and Surrealist Art* (New York, 1968).

4. Lloyd Goodrich, *Pioneers of Modern Art in America: The Decade of the Armory Show, 1910–1920* (New York, 1963), p. 44.

5. Emily Farnham, *Charles Demuth: Behind a Laughing Mask* (Norman, Okla., 1971).

6. John I. H. Baur, *Joseph Stella* (New York, 1971), pp. 29–31.

7. Ibid.

10. Charles Burchfield (pages 217–35)

1. John I. H. Baur, *The Inlander* (New Jersey, 1984), pp. 198–200.

2. Ibid., p. 27.

3. Charles Burchfield, journal entry, October 15, 1915; quoted in Baur, *The Inlander,* p. 30.

4. One European whose style, for a while at least, was close to Burchfield's was Karl Schmidt-Rottluff. This must be seen as purely coincidental, however, since it is almost inconceivable that Burchfield could have been aware of Schmidt-Rottluff's work at this time.

5. Baur, *The Inlander,* pp. 198–200.

11. Edward Hopper and the Realists (pages 237–59)

1. Peter Morse, *John Sloan's Prints* (New Haven, Conn., 1969), p. 209.

2. *Marchand du sel: Ecrits de Marcel Duchamp,* Michel Sanouillet, ed. (Paris, 1959), p. 127.

3. Daniel M. Mendelowitz, *A History of American Art* (New York, 1970), p. 416.

4. Lloyd Goodrich, *Edward Hopper* (New York, 1971), p. 57.

5. Ibid., p. 151.

12. The Postwar Avant-Garde (pages 261–77)

1. Bonnie Clearwater, *Mark Rothko: Works on Paper* (New York, 1984), p. 56.

13. The Postwar Realists (pages 279–303)

1. John Arthur, *Realist Drawings and Watercolors* (Boston, 1980), p. 56.

2. Ibid., p. 21.

3. For a detailed account of the varied approaches of Photo-realist artists, see Louis K. Meisel's *Photo-Realism* (New York, 1980).

397. Winslow Homer (1836–1910). *Fresh Air,* 1878. Watercolor over charcoal on paper, 20 1/16 x 14 1/16 in. The Brooklyn Museum; Dick S. Ramsay Fund.

SELECTED BIBLIOGRAPHY

GENERAL

American Watercolors, Pastels, Collages. New York, 1984. Catalog of works in the Brooklyn Museum's permanent collection.

Brett, Bernard. *A History of Watercolor.* New York, 1984.

Cohn, Marjorie B. *Wash and Gouache: A Study of the Development of the Materials of Watercolor.* Cambridge, Mass., 1977.

Deak, Gloria-Gilda. *American Views, Prospects and Vistas.* New York, 1976.

Gardner, Albert Ten Eyck. *History of Watercolor Painting in America.* New York, 1966.

History of American Watercolor Painting. New York, 1942.

Hoopes, Donelson F. *American Watercolor Painting.* New York, 1977.

Reynolds, Graham. *A Concise History of Watercolor.* New York, 1971.

Stebbins, Theodore E., Jr. *American Master*

Drawings and Watercolors. New York, 1976.

Two Hundred Years of Watercolor Painting in America: An Exhibition Commemorating the Centennial of the American Watercolor Society. New York, 1966.

Watercolor USA: A Survey of Watercolor, USA, from 1870 to 1946. Minneapolis, 1946.

Wilton, Andrew. *British Watercolors, 1750–1850.* Oxford, 1977.

SELECTED ARTISTS

JOHN JAMES AUDUBON
The Original Water-Color Paintings by John James Audubon for "The Birds of America." Introduction by Marshall B. Davidson. New York, 1966.

KARL BODMER
Goetzmann, William H.; Seahunt, David; Gallagher, Marsha V.; and Orr, William J. *Karl Bodmer's America.* Omaha, 1985.

CHARLES BURCHFIELD
Baur, John I. H. *The Inlander.* New Jersey, 1984.

CHUCK CLOSE
Close Portraits. Minneapolis, 1980.

STUART DAVIS
Kelder, Diane, ed. *Stuart Davis.* New York, 1971.

CHARLES DEMUTH
Farnham, Emily. *Charles Demuth: Behind a Laughing Mask.* Norman, Okla., 1971.

ARTHUR G. DOVE
Rich, Daniel Catton. *Paintings and Watercolors by Arthur G. Dove.* Worcester, 1961.

THOMAS EAKINS
Goodrich, Lloyd. *Thomas Eakins: His Life and Work.* New York, 1933.
 Hendricks, Gordon. *Life and Works of Thomas Eakins.* New York, 1974.
 Hoopes, Donelson F. *Eakins Watercolors.* New York, 1971.

RED GROOMS
Ratcliff, Carter. *Red Grooms.* New York, 1984.

CHILDE HASSAM
Childe Hassam, 1859–1935. Tucson, 1972.

WINSLOW HOMER
Gardner, Albert Ten Eyck. *Winslow Homer, American Artist: His Life and Work.* New York, 1961.
 Goodrich, Lloyd. *Winslow Homer.* New York, 1944.

———. *Winslow Homer.* New York, 1973.
 Hoopes, Donelson F. *Winslow Homer Watercolors.* New York, 1969.

EDWARD HOPPER
Goodrich, Lloyd. *Edward Hopper.* New York, 1971.
 Levin, Gail. *Edward Hopper.* New York, 1984.

JOHN LA FARGE
Cortissoz, Royal. *John La Farge: A Memoir and a Study.* Boston, 1911.

GEORGE LUKS
George Luks, 1867–1933: An Exhibition of Paintings and Watercolors. Utica, N.Y., 1973.

JOHN MARIN
Reich, Sheldon. *John Marin: A Stylistic Analysis and Catalogue Raisonné.* 2 vols. Tucson, 1970.

REGINALD MARSH
Goodrich, Lloyd. *Reginald Marsh.* New York, 1972.

ALFRED JACOB MILLER
Tyler, Ron, ed. *Alfred Jacob Miller: Artist on the Oregon Trail.* Fort Worth, 1982.

THOMAS MORAN
Thomas Moran: Drawings and Watercolors of the West, from the Collection of the Cooper-Hewitt Museum of Design. New York, 1974.

GEORGIA O'KEEFFE
Messinger, Lisa Mintz. *Metropolitan Museum of Art Bulletin* 42 (1984). Issue devoted to O'Keeffe's work.
 Turner, David, and Haskell, Barbara. *Georgia O'Keeffe: Works on Paper.* Santa Fe, 1985.

CLAES OLDENBURG
Baro, Gene. *Claes Oldenburg: Drawings and Prints.* London and New York, 1969.
 Rose, Barbara. *Claes Oldenburg.* New York, 1970.

CHARLES WILLSON PEALE
Sellers, Charles Coleman. *Charles Willson Peale.* New York, 1969.

MAURICE PRENDERGAST
Rhys, Hedley Howell. *Maurice Prendergast, 1859–1924.* Boston, 1960.

FREDERIC REMINGTON
Hassrick, Peter H. *Frederic Remington: Paintings, Drawings and Sculptures in the Amon Carter Museum and the Sid W. Richardson Collections.* New York, 1973.

MARK ROTHKO
Clearwater, Bonnie. *Mark Rothko: Works on Paper.* New York, 1984.

CHARLES M. RUSSELL
Renner, Frederic G. *Charles M. Russell: Paintings, Drawings, and Sculpture in the Amon G. Carter Collection.* Austin, 1966.

JOHN SINGER SARGENT
Adelson, Warren. *John Singer Sargent: His Own Work.* New York, 1980.
 Hoopes, Donelson F. *Sargent Watercolors.* New York, 1970.
 Ratcliff, Carter. *John Singer Sargent.* New York, 1982.
 Spassky, Natalie. *John Singer Sargent: A Selection of Drawings and Watercolors from the Metropolitan Museum of Art.* New York, 1971.

CHARLES SHEELER
Charles Sheeler. Essays by Martin Friedman, Bartlett Hayes, and Charles Millard. Washington, D.C., 1968.

JOSEPH STELLA
Baur, John I. H. *Joseph Stella.* New York, 1971.

JAMES ABBOTT MCNEILL WHISTLER
Curry, David Park. *James McNeill Whistler at the Freer Gallery of Art.* Washington, D.C., 1984.

JOHN WHITE
Hulton, Paul, and Quinn, David Beers. *The American Drawings of John White, 1577–1590, with Drawings of European and Oriental Subjects.* Chapel Hill, N.C., 1964.

ANDREW WYETH
Richardson, Edgar P. *Andrew Wyeth: Temperas, Watercolors, Dry Brush Drawings, 1938–1966.* Philadelphia, 1966.

INDEX

Abbey, Edward Austin, 89; works of, 88

Absalom Slain by Joab (Joy), 52, 53

Abstract Expressionism, 266, 269

Abstraction, Mardi Gras (Stella), 205

Abstraction (Study for "Swing Landscape Mural") (Davis), 211, 212

Abstraction #2 (Walkowitz), 204

Adams' House (Hopper), 252

Addih-Hiddisch (Maker of Roads) (Bodmer), 69

Adirondack Guide, The (Homer), 123

African Daisies (Demuth), 196, 197

"After All…" (Demuth), 198

Agnew Clinic, The (Eakins), 109

Akbar Viewing a Wild Elephant Captured near Malwa in 1564 (Lal and Sanwalah), 12

Albright, Ivan Le Lorraine, 249; works of, 249

Allan, William, 299; works of, 298

American Black Rat (Audubon), 64

American Society of Painters in Water Color, 25, 86, 88, 107–8, 112

American Water Color Society, 86

Anshutz, Thomas, 175

Apple Blossoms (J. W. Hill), 91; detail of, 84

Arab Stable (Sargent), 166, 167

Aragon, José Rafael, 55; works of, 56

Arensberg, Louise, 192, 193, 204

Arensberg, Walter, 192, 193, 204, 206

Ariadne Asleep on the Island of Naxos (Vanderlyn), 34

Artist in His Museum, The (C. W. Peale), 34

Assiniboin Burial Scaffold (Bodmer), 68

Assiniboin Hunting on Horseback (Rindisbacher), 65

Association for the Advancement of Truth, 90, 93

At a House in Harley Street (Demuth), 195

Athore and Laudonnière at Ribault's Column (Le Moyne de Morgues), 27, 28; detail of, 26

Atlantis (Levine), 286

At Marshall's (Demuth), 194

Attack against Fort Washington (Davies), 37, 38

Attack on the American Privateer "General Armstrong" at Fayal (Birch), 80

Audubon, John James, 14, 61–64, 71, 223; works of, 62, 63, 64

Audubon, John Woodhouse, 62, 64

Audubon, Lucy Bakewell, 61

Audubon, Victor Gifford, 62, 64

avant-garde, 25, 135, 157, 189, 191, 193, 206, 237, 281; postwar, 261–79

Avery, Milton, 213–15; works of, 190, 213, 214, 215

Backwater in a Park (Cotman), 20

Bacon, Francis, 59

Baeder, John, 291, 293; works of, 292

Bancroft, Chandler, 100

Baptismal Wish (Tauf-Wunsch) (Sussel-Washington), 48

Bard, James, 79; works of, 80

Bard, John, 79

Bartlett, William Henry, 74; works of, 74

Baseball Players Practicing (Eakins), 105, 106, 107

Basket of Apples (Cahoon), 47, 48

Bathers (Walkowitz), 204

Battle of Lights, Coney Island (Stella), 204

Battleships (Burchfield), 218, 219

Beardsley, Aubrey, 197

Bechtle, Robert, 291, 293; works of, 292

Bedouin Women (Sargent), 166, 167

Beest, Albert van, 79, 81, 83; works of, 81, 82

Bellini, Giovanni, 14

Bellows, Albert Fitch, 89; works of, 89

Bellows, George, 237, 238; works of, 238

Bennett, William J., 72; works of, 73

Benton, Thomas Hart, 244; works of, 245

Berry Pickers, The (Homer), 112, 113

Between Rounds (Eakins), 109

Between Troy and Lansingburg (Dunlap), 41, 42

Bierstadt, Albert, 74, 85, 124

Biglin Brothers Rowing, The (Eakins), 105

Birch, Thomas, 79; works of, 80

Bird on a Gravestone (Bridges), 97

Bird's Nest and Dogroses (J. W. Hill), 91

Birds of America, The (Audubon), 61

Bishop, Isabel, 244; works of, 244

black folk art, 55–59

Blackwell, Tom, 291, 293; works of, 293

Blake, William, 21, 25, 59, 235; works of, 21

Block, Laurens, 30

Blue (Moby Dick) (Pollock), 263

Blue and Silver—Chopping Channel (Whistler), 142, 143

Blue Door, The (Wyeth), 283

Blue Man with Pipe and Bottle (Traylor), 56

Blum, Robert Frederick, 137, 153; works of, 153, 154

Bob White (Virginian Partridge) (Audubon), 62

Bodmer, Karl, 65, 66, 68–69; works of, 68, 69

Boissise-la-Bertrande, France (Robinson), 153, 154

Bonington, Richard Parkes, 23, 159; works of, 22

Bonnard, Pierre, 146, 237, 285

Bonnat, Léon, 158

Book of Daniel 7:1 (Morgan), 58

Book of Kells, The, 11

Boucher, François, 31

Bouguereau, Adolphe William, 246

Box Factory, Gloucester (Hopper), 255

Boy with Rooster (Maentel), 51

Brabazon, Hercules, 25, 155, 159

Bradford, William, 83; works of, 82

Brady, Carolyn, 300–302; works of, 301, 302

Braque, Georges, 191

Breakers, Maine Coast (Marin), 183, 189

Bricher, Alfred Thompson, 83; works of, 83

Bridge, The (Dickinson), 210

Bridge over the Mohawk at Schenectady (Dunlap), 41, 42

Bridges, Fidelia, 95, 97; works of, 96, 97

Brig "Grand Turk" Saluting Marseilles (Roux), 77

Brooks, James, 265; works of, 265

Brown, George Loring, 86; works of, 87

Brown, John G., 85–86, 88; works of, 86

Bruce, Patrick Henry, 175

Bucks County Barn (Sheeler), 207

Bufford, John, 111

Building Forms (Stella), 206

Buildings, One with Tower (Marin), 178, 179

Burchfield, Charles, 23, 25, 72, 215, 217–35, 237, 250, 254, 296, 299, 302; works of, 216, 218–34

Burgess, Gelett, 191

Burning of the Packet Ship "Boston" (Lane), 78, 79

Burra, Edward, 193

Busiri, Giovanni Battista, 72

Button, John, 285; works of, 287

Cady, Emma, 52; works of, 52

Cafe on the Riva degli Schiavoni, Venice (Sargent), 158

Cafe Scene #1; The Purple Pup (Demuth), 194

Cahoon, Hannah, 47; works of, 48

Calm before a Storm, Newport (Richards), 94

Calyo, Nicolino, 72; works of, 72

Camp at Lake O'Hara (Sargent), 168, 169

Camping Out in the Adirondack Mountains (Homer), 120

Canaletto, 163, 164

Candy Ball Machine (Thiebaud), 295

Canoeist, Lake St. John, Province of Quebec (Homer), 121

Captain Cook Cast away on Cape Cod (Cornè), 78, 79

Capture of the H.B.M. Brig "Avon" by the U.S. Sloop of War "Wasp" (Birch), 80

Card Game (Bishop), 244

Carles, Arthur B., 175

Carolina Parroquet (Audubon), 63

Carolus-Duran, Emile, 158

Carpaccio, Vittore, 151

Carrà, Carlo, 205

Cassatt, Mary, 142–43, 158

Castine Harbor and Town (Lane), 79

Catlin, George, 64, 65, 66, 71; works of, 66

cave paintings, 10

Cedar Swamp, A (Harvey), 73

Cézanne, Paul, 23, 118, 146, 147, 157, 158, 175, 191, 197, 198, 202, 206, 212; works of, 23

Chase, William Merritt, 136, 153, 175, 198, 204; works of, 136

Chelsea Children (Whistler), 140, 141

Chevreul, Michel Eugène, 100

Chicago World's Fair (Moran), 99

Ch'ien Hsuan: works of, 11

Chirico, Giorgio de, 205, 269

Chrysler Building under Construction, The (Horter), 208, 209

Church, Frederic Edwin, 85

Church Bells Ringing, Rainy Winter Night (Burchfield), 219, 220, 222

Church of San Esteban (Hopper), 259

Cicada (Johns), 270

Clambake, The (Homer), 113

Classic Still Life (Nice), 295

Cliffs of the Rio Virgin, South Utah (Moran), 75; detail of, 60

Close, Chuck, 274, 289; works of, 275

Coaching in New England (A. F. Bellows), 89

Coal Box, The (Hopper), 256, 257

Colman, Samuel, 25, 86, 88; works of, 86

Color Lesson I—Watercolor (Weber), *294*

Coming of Spring, The (Burchfield), 228, *229*

Constable, John, 18, 95, 133; works of, *19*

Conversations (Shahn), *248*

Coot Hunter, The (Wyeth), 281, *283*

Copley, John Singleton, 31, 33, 34, 51; works of, *31*

Cornè, Michele Felice, 77, 79; works of, *78*

Corner of Greenwich Street (Hyde de Neuville), *44*

Cotman, John Sell, 18, 20; works of, *20*

Country Girl Diner (Goings), 292, *293*

Couple (Grosz), *248*

Courbet, Gustave, 105, 137, 159

Couture, Thomas, 100

Cox, David, 20, 133; works of, *20*

Cozens, Alexander, 16

Cozens, John Robert, 16, 17; works of, *17*

Crashed Aeroplane (Sargent), *172, 173*

Craven, Arthur, 204

Cropsey, Jasper, 86; works of, *87*

Crucified Christ (Aragon), *56*

C. S. Valentin Crater (Yoakum), *57*

Cubism, 197, 198, 207, 210

Currier, J. Frank, 153; works of, *154*

Currier, Nathaniel, 71

Curry, John Steuart, 244

Cutrone, Ronnie, 279; works of, *278*

Cypress Tree (Stella), 205, *206*

Dada, 192, 193, 206

Dali, Salvador, 90

Dasburg, Andrew, 213; works of, *212*

Daumier, Honoré, 23

Davies, Arthur B., 155, 191, 237, 238; works of, *155*

Davies, Captain Thomas, 37–38, 39; works of, *38*

Davis, Stuart, 193, 210–11; works of, *211, 212*

Dawn III (Dove), *202*

Death of General Mercer at the Battle of Princeton (Trumbull), 34; preliminary sketch for, *35*

Degas, Edgar, 137, 157

de Kooning, Willem, 261, 265, 285

Delacroix, Eugène, 23; works of, *22*

Delaunay, Robert, 175, 179

Demoiselles d'Avignon, Les (Picasso), 191

Demuth, Charles, 193–98, 205, 208, 302; works of, *194–98*

Denis, Maurice, 146

Desert Sands (Grooms), 299–300

Design for the C. C. Felton Window, Memorial Hall, Harvard University (La Farge), *101*

Dickinson, Preston, 208, 210, 255; works of, *210*

Diebenkorn, Richard, 266, 269; works of, *268*

Dine, Jim, 269, 273; works of, *260, 271*

Diner Still Life (Goings), *292*

Distinguished Air (Demuth), *195*

Dove, Arthur, 202, 203, 213, 249, 290; works of, *202*

Dow, Arthur Wesley, 198, 201

Drawing the Seine (Eakins), *109*

Drifting (Eakins), *107, 108*

Dubuffet, Jean, 265

Duchamp, Marcel, 192–93, 204, 206, 237, 246

Ducros, Abraham Louis Rodolphe, 14, 68

Dufy, Raoul, 176

Dugout, The (Rockwell), *250*

Duncan, Isadora, 204

Dunlap, William, 33, 41, 49; works of, *33, 42, 43*

Dürer, Albrecht, 14, 64, 284; works of, *8, 14*

Dusky Wolf Devouring a Mule Deer Head (T. R. Peale), *36*

Duveneck, Frank, 136, 153, 238

Dyck, Anthony van, 14

Eakins, Thomas, 23, 24, 25, 86, 105–9, 111, 120, 165, 281, 284; works of, *104, 106, 107, 108, 109*

Early Sunday Morning (Hopper), *250*

East Wind, The (Burchfield), *222*

Edtaonisl (Picabia), *192*

Eggplant, Carrots, and Tomatoes (Demuth), *197*

Eight, The, 146, 237, 240

Eilshemius, Louis, 246; works of, *247*

Ellsworth, James Sanford, 52; works of, *52*

Emerald Light (Black Desk for Zola) (Brady), *302*

End of the Portage (Homer), 121, *123*

Entrance to Lake Drummond, Dismal Swamp (Latrobe), *43*

Everdingen, Allart van, 14

Expressionism, 222, 233, 235

Fairmont Park (The Balloon Ascension of 1834) (Calyo), *72*

Falls of the Passaic (Wall), *40*

Fantin-Latour, Henri, 137

Farrer, Henry, 90, 93, 95; works of, *94*

Farrer, Thomas, 90

Fauves, 176, 197, 202, 204, 213

February, from Les Très Riches Heures du Duc de Berry (Limbourg brothers), 11, *13*

February Thaw (Burchfield), 222, *223*

Feininger, Lyonel, 198; works of, *199*

Figures Construction, Black Dog, Brown Jug (Traylor), *56*

Fisherfolk in Dory (Tynemouth Series) (Homer), *118*

Five Nudes in Landscape (Eilshemius), *247*

folk art, 47–59

Food (Estes), 291, *294*

Forest Glen (Inman), *41*

Forked Road (Wellfleet), The (Hopper), 256, *257*

Fragonard, Jean Honoré, 14

"Fraktur" paintings, 47

Francis, Sam, 265; works of, *265*

Frankenthaler, Helen, 266; works of, *267*

Freckelton, Sondra, 299; works of, *298*

Fresh Air (Homer), *305*

From the Quai d'Orléans (A. B. Davies), *155*

Fruit in Glass Compote (Cady), *52*

Futurists, 204

Gabriel de Saint Aubin, 14

Gannam, John, 249–50; works of, *250*

Garden, Appledore, Isle of Shoals, The (Hassam), *145*

Gates of the Hudson, The (Cropsey), *87*

Gauguin, Paul, 201

Gaw-Zaw-Que-Dung—He Who Halloes (Catlin), *66*

Géricault, Théodore, 23

Gérôme, Jean Léon, 105

Girl in Red Stockings (Fisher Girl) (Homer), *116*

Girtin, Thomas, 17; works of, *17*

Glackens, William, 237

GM Showroom (Blackwell), *293*

Gogh, Vincent van, 157, 222

Goings, Ralph, 291, 293; works of, *292*

Gorge, Appledore, The (Hassam), *144, 145*

Gorky, Arshile, 215, 261

Gourds (Sargent), 169, *170*

Goya, Francisco José de, 31

Great Piece of Turf, The (Dürer), 14

Green Door, Corfu, The (Sargent), *171*

Grey and Silver: Pier, Southend (Whistler), *138–39*

Grey and Silver: The Mersey (Whistler), *138*

Grey Day, A (Farrer), *94*

Grey Sea (Marin), *186*

Gris, Juan, 210

Grizzly Bear, The (Miller), 66, *67*

Grooms, Red, 299–300, 302; works of, *299, 300*

Grosz, George, 248–49; works of, *248*

Guston, Philip, 269; works of, *268*

Haas, Richard, 291; works of, *290*

Haberle, John, 97; works of, *97*

Hacienda on the Lerma River, San Juan, Mexico (Moran), *75*

Hagar and Ishmael (West), *34*

Hals, Frans, 238

Harbor (Bricher), *83*

Hare, The (Dürer), *8, 14, 64*

Harlem River, The (Luks), 238, *239*

Harnett, William Michael, 97, 98

Harriet Mackie (The Dead Bride) (Vallée), *33*

Hart, George "Pop," 244; works of, *246*

Hartley, Marsden, 197, 203; works of, *203*

Harvest Moon, The (Palmer), *21*

Harvey, George, 72, 74; works of, *73*

Hassam, Childe, 143–46, 153, 281; works of, 143–45

Havell, Robert, Jr., 61

Heade, Martin Johnson, 95

Heizer, Michael: works of, *274*

Henri, Robert, 210, 212, 237, 251

Herriman, George, 269

High Road (Hopper), *257*

Hill, John, 41

Hill, John Henry, 90, 93; works of, *92*

Hill, John William, 64, 90, 93, 95, 205; works of, *84, 91*

Hilliard, Nicholas, 15

Hilltop, Hoosic Mountains, Massachusetts (Marin), 181, *182*

Hiroshige, 139

Hirst, Claude Raguet, 98; works of, *98*

Hofmann, Hans, 261; works of, *262*

Holbein, Hans, 31

Holland, John Joseph, 45; works of, *44*

Home Again (Ch'ien Hsuan), *11*

Homer, Charles, 118, 121

Homer, William Innes, 176

Homer, Winslow, 9, 10, 23, 24, 25, 81, 83, 86, 111–33, 135, 137, 141, 152, 158, 159, 165, 167, 169, 171, 173, 235, 251, 252, 258, 259, 281, 299, 302; works of, *front cover, 110, 112–23, 125–33, 171, 305*

Hopper, Edward, 9, 25, 215, 223, 250–59, 281, 291, 302; works of, *236, 251–59*

Horter, Earl, 208; works of, *209*

House by the Railroad (Hopper), *257*

Hudson River Portfolio, The (J. Hill), *41*

Hudson River School, 41, 74, 83

Hunt, William Henry, 72, 90

Hunt, William Morris, 100

Hurricane, Bahamas (Homer), *133*

Hush before the Storm (Burchfield), 233, *235*

Hyde de Neuville, Baroness, 45; works of, *44*

Ice Glare (Burchfield), *226*

illuminated manuscripts, 11, 47

Illustration for Pacific Mills (Gannam), *250*

Immaculates, 206

Immature Great Blue Heron (Welliver), *298*

Impressionism, 25

Indian Conjurer (White), *29*

Indian Signalling (Russell), *71*

Indian Village of Secoton (White), *29*

Inman, Henry, 33, 41; works of, *33, 41*

Insect Chorus, The (Burchfield), 219, *221*

Inside the Bar, Tynemouth (Homer), 116, *117*

Interior, New Mexico (Hopper), *253*

Interior of a Hospital Tent, The (Sargent), *172, 173*

Interior of Peale's Museum (C. W. and T. R. Peale), *36*

In the Generalife (Sargent), *161*

In the Jungle, Florida (Homer), *131*

In the Simplon Pass (Sargent), *168*

Isle of Shoals Garden (Hassam), *145*

Ives, James M., 71

James, Henry, 135
James, William, 100, 109
Japanese prints, 100
Japonica (Arnold), 153
Jarvis, John Wesley, 33
Jazz (Ray), 207
Jeremiah Lee (Copley), 31
Je revois en souvenir ma chère Udnie (Picabia), 192
John Biglin in a Single Scull (Eakins), 104, 105, 107, 108; perspective study for, 104, 105
Johns, Jasper, 269; works of, 270
Johnston, Henrietta, 30
Joseph Gardner and His Son, Tempest Tucker (Maentel), 51
Joy, Caroline, 52; works of, 53
Jumping Trout (Homer), 120, 121

Kaaterskill Falls from above the Ravine (Bartlett), 74
Kandinsky, Wassily, 202
Kelly, Ellsworth, 266
Kendall, George, 47, 49; works of, 49
King and Queen Traversed by Nudes at High Speed, The (Duchamp), 193
Kitchen, The (Whistler), 137
Klee, Paul, 191
Kline, Franz, 261

Lady Boarding a Gondola from a Palazzo (Blum), 153
La Farge, John, 100, 102, 105, 112; works of, 101, 102, 103
Lal: works of, 12
Landscape: Rocks and Water (C. H. Moore), 90
Landscape #32 (Hartley), 203
Landscape Sketch (Currier), 154
Lane, Fitz Hugh, 79; works of, 78, 79
Lassoing Horses (Benton), 244, 245
Late Afternoon in the Hills (Burchfield), 228
Late Submission to Chicago Tribune Architectural Competition of 1922: Clothespin (Oldenburg), 273
Latrobe, Benjamin Henry, 41; works of, 43
Lavender and Old Lace (Burchfield), 230; detail of, 216
Lavreince, Nicholas, 14
Lawson, Ernest, 237
Le Bouteux, Jean Baptiste Michel, 30–31; works of, 30
Lehman, George, 62
Le Moyne de Morgues, Jacques, 27–28, 30, 71; works of, 26, 28
Leonardo da Vinci, 14
Levine, David, 285; works of, 286
Lewis, John Frederick, 72, 88
Lewis, Wyndham, 191
Lichtenstein, Roy, 269
Lieutenant S. C. Robertson, Chief of the Crow Scouts (Remington), 70
Light Coming on the Plains I (O'Keeffe), 200, 201
Lighthouse (van Beest), 81
Limbourg brothers, 11; works of, 13

Lincoln Tower (Button), 287
Linda/Eye I, II, III, IV, V (Close), 275
Little or Saw Whet Owl (Wilson), 61
Locomotive, D. & R.G. (Sante Fe, New Mexico) (Hopper), 254
Locomotive in Weehawken, New Jersey (Marsh), 243
London Omnibus (Marin), 176, 177
Long Branch (Homer), 112
Longhena, Baldassare, 165
Looking up the Trail at Bright Angel, Grand Canyon, Arizona (Moran), 76
Lorrain, Claude, 14
Louis, Morris, 266
Lower au Sable (Colman), 86
Lower Manhattan (Marin), 179–80
Lower Manhattan (Composing Derived from Top of Woolworth) (Marin), 180–81
Luks, George, 237, 238, 240, 249; works of, 239, 240

Maentel, Jacob, 51–52; works of, 51
Maine Cliffs (Homer), 118, 119
Maine Coast (Marin), 182, 183; detail of, 174
Malbone, Edward Greene, 33; works of, 33
Mall, Central Park, The (Prendergast), 147, 148; detail of, 134
Man and Window (Diebenkorn), 268
Manet, Edouard, 23, 105, 137, 158
Mansard Roof, The (Hopper), 251–52
Marat (Grooms), 300
Marimaid (Willson), 55
Marin, John, 23, 25, 142, 175–89, 191, 193, 223, 235, 296, 302; works of, 174–78, 180–88
marine painting, 74–83
Marquet, Albert, 175
Marsh, Reginald, 25, 223, 240–44, 254; works of, 241, 242, 243
Mars Orange and Green (Dove), 202
Mary Ann Morgan (Ellsworth), 52
Matamoras Diner (Baeder), 292
Matisse, Henri, 175, 179, 191, 261
Matthew's Branch (Raffael), 297
Matthias and Thomas Bordley (C. W. Peale), 32
Maurer, Alfred, 175
Meier, Johann Jacob, 68
memorial pictures, 54
Metropolitan Museum, Central Park, The (Haas), 290
Michelangelo, 10, 14
Military Dance in Samoa (La Farge), 102
Milkweeds (Bridges), 95, 96
Miller, Alfred Jacob, 64, 65–66, 71; works of, 67
Milly Finch (Whistler), 141, 142
miniature painting, 11, 15, 31, 32–33, 52
Miró, Joan, 261, 265
Model, The (Sargent), 158
modernism, 204, 213, 215, 237
Monet, Claude, 137, 143, 145, 153, 158

Moore, Charles Herbert, 90, 93; works of, 90
Moore, Harriet: works of, 54
Moore, Nina, 95
Moran, Thomas, 74, 86, 88, 98; works of, 60, 75, 76, 99
Morandi, Giorgio, 237
Moreau, Gustave, 23
Morgan, Sister Gertrude, 59; works of, 58
Morning from the Porch (Porter), 287
Morning in St. Marks (Venice), A (Blum), 153
Mountain Fire (Sargent), 167
Mountain Stream (Sargent), 168; detail of, 156
Movement, Fifth Avenue (Marin), 178, 179
Mrs. Acorn's Parlor (Hopper), 253
Mummie of the Stone Age (Willis), 59
Munch, Edvard, 222, 235
Music Room #7, The (Schonzeit), 294, 295
My Egypt (Demuth), 198

Narrows at Lake George (Pierie), 39
National Academy of Design (New York), 41, 86, 98, 159, 218
naturalism, 136, 215, 235
Negro Boy Dancing (Eakins), 108–9
New Bedford from Fairhaven (van Beest), 81
New Dodgem (Marsh), 242, 243
Newman, Barnett, 261, 264, 269
Newman, Henry Roderick, 90, 93; works of, 92, 93
New Novel, The (Homer), 114–15; detail of, *front cover*
New Realists, 274
New York (Picabia), 192
New York from Long Island (A. Robertson), 39
New York School, 261
New York Taken from Brooklyn Heights (Wall), 40
New York Water Color Society, 86, 90
New York Yacht Club Regatta (Bradford and van Beest), 82, 83
Nice, Don, 295, 302; works of, 295
Nicholson, Ben, 198
Night Flowers (Brady), 300, 301
Nighthawks (Hopper), 250
Night Scene with Clouds (Burchfield), 227, 228
Nocturne: Grey and Gold—Canal, Holland (Whistler), 140
Note in Blue and Opal: Jersey (Whistler), 139
Nothing Conforms (Wiley), 277
Nude Descending a Staircase (Duchamp), 192
Number 1 (Brooks), 265

Ocean Wave, The (Whistler), 139–40
Off Stonington (Marin), 185
O'Keeffe, Georgia, 198, 201–2, 203, 208, 213; works of, 200, 201
Old Bridge, The (Delacroix), 22

Oldenburg, Claes, 269, 273; works of, 272, 273
Old Plantation, The (anonymous), 50; detail of, 46
Oliver, Isaac: works of, 15
One William Street at Night (Haas), 290
Orchard Street (Levine), 286
Oriental Scene (Tiffany), 88
Ossorio, Alfonso, 265–66; works of, 266
Ostade, Adriaen van, 14
Out in Inner Space (Cutrone), 278
Outskirts of the City (Dickinson), 210
Overhanging Cloud in July (Burchfield), 234, 235
Oyster Bar (Pascin), 195

Palmer, Samuel, 21; works of, 21
Palmettos (Sargent), 169, 170
Palm Tree, Nassau (Homer), 132, 133
Pascin, Jules: works of, 195
Pattern (Pollock), 262
Peale, Charles Willson, 31, 32, 33, 34, 37, 65; works of, 32, 36
Peale, James, 32, 33
Peale, Raphaelle, 32, 33
Peale, Titian Ramsay, 34, 37; works of, 36
Pearlstein, Philip, 285, 289, 291; works of, 288, 289
Pennsylvania Dutch art, 47
Perfectly Happy (J. G. Brown), 86
Perspective Study for "John Biglin in a Single Scull" (Eakins), 104, 105
Peto, John Frederick, 97
Phillips, Thomas: works of, 15
Photo-realists, 274, 291–95
Piazza di San Marco (Prendergast), 148, 149, 151
Piazza San Marco, Venice (Splash of Sunshine and Rain) (Prendergast), 150–51, 223
Picabia, Francis, 191–93, 204, 206, 217; works of, 192
Picasso, Pablo, 191, 210, 237, 248, 261
Pierie, Captain William, 38–39; works of, 39
Pierreuse, La (Hopper), 251
Pirate Country (Wyeth), 281, 282
Plan of the First Family, Harvard, Map of the First Family Section of the Shaker Community at Harvard (Kendall), 47, 49
Pollock, Jackson, 261, 262–64, 265, 266; works of, 262, 263
Pop art, 198, 269, 273
Porter, Fairfield, 285; works of, 287
Portrait of a Young Man (Oliver), 15
Portrait of a Young Woman (Chase), 136
Portrait of James Peale (C. W. Peale), 32
Post-Impressionism, 146, 178, 197, 237
postmodernism, 277
Power Lines and Snow (Burchfield), 218, 220
Precisionists, 198, 206–8
Preliminary Sketch for "The Death of General Mercer at the Battle of Princeton" (Trumbull), 35
Prendergast, Charles, 146

Prendergast, Maurice, 25, 143, 146–53, 223, 237, 238, 299, 302; works of, *134, 146–52*
Pre-Raphaelites, 90, 93, 95, 97, 100
primitive art, 55
Prisoners from the Front (Homer), 111
process art, 274
Promenade (Burchfield), *224*
Proposed Colossal Monument to Replace the Washington Obelisk, Washington (Oldenburg), *272, 273*
Prospect of St. Peters Port and Castle Cornett—in the Island of Guernsey, A (Phillips), *15*
Prouts Neck, Breakers (Homer), *119*

Raffael, Joseph, 295–96, 299, 302; works of, *280, 296, 297*
Rainbow Head, Four Hours from Life, Mill Valley (Allan), *298, 299*
Rainbow over the Exe (Girtin), *17*
Rainy Day, Venice (Prendergast), 151, *152*
Rainy Night (Burchfield), 224, *225–26*
Rauschenberg, Robert, 269; works of, *270*
Ray, Man, 204, 206, 210; works of, *207*
"Rayographs" (Ray), 206
Reading (Sargent), *162*; detail of, *frontispiece*
realism, 89, 111, 215, 237–59
Realists, postwar, 281–302
Redouté, Pierre Joseph, 14
Red-Roofed Houses (Demuth), *198*
Red Star (Ossorio), *266*
Reeves, William, 21
Rembrandt, 14
Remington, Frederic, 69–70; works of, *70*
Resting in Bed (Whistler), *140–41*
Return to the Beginning: In Memory of Ginger (Raffael), *296–97*; detail of, *280*
Revere Beach (Prendergast), *146*
Rhyl Sands (Cox), *20*
Ribera, José, 105
Richards, William Trost, 90, 93, 95; works of, *94, 95*
Richardson's Memorial (H. Moore), *54*
Rindisbacher, Peter, 65, 68; works of, *65*
River Effect, Paris (Marin), *176, 177*
River Rouge Industrial Plant (Sheeler), *208*
Road in Bermuda (Homer), 124, *127*
Road to the Sea (Avery), *213;* detail of, *190*
Roaring Fork, Wyoming (Albright), *249*
Robert, Hubert, 14
Robertson, Archibald (Captain), 37, 39; works of, *37, 38*
Robertson, Archibald (civilian), 39–40; works of, *39*
Robinson, Theodore, 153; works of, *154*
Rockburne, Dorothea, 279; works of, *279*

Rockwell, Norman, 250; works of, *250*
Rodin, Auguste, 191
Rolling Sky, Paris after Storm, A (Marin), *176*
Roofs and Steeple (Demuth), *199*
Rothko, Mark, 261, 264, 269; works of, *264*
Roux, Antoine, Sr., 77; works of, *77*
Rubens, Peter Paul, 14
Ruins of Paestum, near Salerno, The (Cozens), *17*
Ruskin, John, 24, 64, 89–90, 93, 97, 137
Russell, Charles M., 69, 70; works of, *71*

Safety Valve (Burchfield), *223*
St. Malo No. 1 (Prendergast), *147*
Salem Bedroom Studio, The (Burchfield), *220*
Salle, David, 279, 302; works of, *278*
Sandby, Paul, 16, 37, 41; works of, *16*
Sandby, Thomas: works of, *16*
Santa Maria della Salute (Sargent), *164, 165*
Sanwalah, 294; works of, *12*
Saratoga, The (Bard), *80*
Sargent, John Singer, 9, 10, 136, 151, 155, 157–73, 175, 185, 250, 251, 253, 281, 296, 302; works of, *frontispiece, 156, 158–72, back cover*
Satan Arousing the Rebel Angels (Blake), *21*
Saved (Homer), *124*
Scene in Venice, A (Sargent), *165*
Schamberg, Morton, 198
Schonzeit, Ben, 291, 293, 295; works of, *294*
Screecher, Lake Rossignol (Luks), 238, *240*
Sea Fantasy (Marin), *188, 189*
Seascape with Rocks and Sailboat (Marin), *186, 187*
Seated Man and Walking Woman (Marsh), *241*
Seated Nude X (O'Keeffe), *201*
Self-Portrait (Dunlap), *33*
Self-Portrait (Sheeler), *207–8*
Self-Portrait (West), *31*
Self-Portrait/Watercolor (Close), *275*
Seraphim (Fire) (Rockburne), *279*
Seurat, Georges, 100
Shahn, Ben, 248, 249; works of, *248*
Shakers, art of the, 47, 49
Shark Fishing—Nassau Bay (Homer), 124, *125*
Sheeler, Charles, 198, 204, 206–8, 210, 255; works of, *207, 208*
Shinn, Everett, 237
Shipping in a Swell (Bonington), *22*
Shooting the Rapids (Homer), 121, *122*
Shore and Surf, Nassau (Homer), 124, *130*
Shore at Bermuda (Homer), 124, *126*
Signac, Paul, 146, 175, 176
Six O'Clock (Burchfield), *226–27*
Skyline near Washington Square (Hopper), *254, 255*

Slip, The (Wyeth), *284*
Sloan, John, 237, 240, 249
Solano Avenue Pinto (Bechtle), *292*
South East View of Greenville, South Carolina (Tucker), 49, *50*
Sphinx and the Milky Way, The (Burchfield), 228, *229*, 230
Spring—Burning Fallen Trees in a Girdled Clearing, Western Scene (Harvey), *73*
"stain paintings," 266
Starry Night (van Gogh), 230
Steer, Philip Wilson, 25, 159
Steichen, Edward, 175, 178
Stein, Gertrude, 197, 198
Stella, Joseph, 204–5, 246; works of, *205, 206*
Stettinius, Samuel Endredi, 51
Stieglitz, Alfred, 178, 179, 189, 191, 192, 193, 201, 202, 203, 204
Still, Clyfford, 261, 265
Still Life (Hassam), *143*
Still Life (Hirst), *98*
stippling, 72, 90, 108
Stonehenge (Constable), *19*, 95
Stonehenge (Richards), *95*
Stony Ground (Abbey), *88*
Storm, Waiting for the Caravan (Miller), *66, 67*
Stoutenburgh, John, 45
Strange Thing Little Kiosai Saw in the River, The (La Farge), 100, *101*
Street in Ikao, Japan, I, A (Blum), *154*
Street Scene (Burchfield), 230, *231*; study for, *231*
Stuart, Gilbert, 34, 51
Study for Kent (Close), *275*
Study for "Street Scene" (Burchfield), *231*
Study for "The Great American Nude #53" (Wesselmann), *273*
Study of Ariadne (Vanderlyn), 34, *35*
Study of Rocks and Trees (Cézanne), *23*
Study of Three Boats (Whittredge), *82*
Sully, Thomas, 34
Summer Meadows (Dasburg), *212*
Sun Bather and Sea Watcher (Avery), *215*; detail of, *214*
Sunday Morning, Appledore (Hassam), *144, 145*
"Sunnyside" with Picnickers* (J. H. Hill), *92, 93*
Sunrise in the Fog over Kyoto (La Farge), *102*
Sunset, Maine Coast (Marin), *184*
Sunset on Wet Sands (Turner), *18*
Sussel-Washington: works of, *48*
Sweetest Flower, The (Westermann), *276*

Taking on Wet Provisions (Homer), *130, 131*
Temple at Abu Simbel (Pearlstein), *289*
Temple at Philae (Newman), *92*
10 Shots, 10 Cents (Marsh), 240–43, *241*
Tent in the Rockies, A (Sargent), *169*
Thaxter, Celia, 145
theorems, 52
Thiebaud, Wayne, 295; works of, *295*

Tiepolo, 173
Tiepolo Ceiling, Milan (Sargent), *159*, 173
Tiffany, Charles Lewis, 88
Tiffany, Louis Comfort, 88; works of, *88*
topographers, 15–16, 31, 39, 41
Toulouse-Lautrec, Henri de, 146
Town Square (Davis), *211*
Trailing Begonia (Freckelton), *298*
Train (Marsh), *243*
Train Landscape in Arizona (Eilshemius), *247*
Tramp, A (Sargent), *160, 161*
Traylor, Bill, 57; works of, *56*
Très Riches Heures du Duc de Berry, Les (Limbourg brothers), *11*
Trompe l'oeil: Yellow Canary (Haberle), *97*
trompe l'oeil painting, 97–98
Trumbull, John, 34; works of, *35*
Trysting Place, The (Homer), 114, *115*
Tucker, Joshua, 49; works of, *50*
Tug (Feininger), *199*
Turner, Joseph Mallord William, 18, 74, 88, 98, 124, 133, 151, 163, 164, 235; works of, *18, 19*
Turtle Pound, The (Homer), 124, 128, 131; detail of, *129*
Twachtman, John, 143
20 Hearts (Dine), 269, *271*; detail of, *260*
Two Beasts of Revelation, The (Morgan), *58*
Two Female Models on Chrome and Wooden Stools (Pearlstein), *288*

Udnie (Picabia), *192*
Umbrellas in the Rain (Prendergast), *151*
Under the Elevated (Bellows), *238*
Under the Falls, the Grand Discharge (Homer), 121, *122*; detail of, *110*
Untitled (Guston), *268*
Untitled (Heizer), *274*
Untitled (Hofmann), 261, *262*
Untitled (Rauschenberg), *270*
Untitled (1945–46) (Rothko), *264*
Untitled (1969) (Rothko), *264*
Untitled (Salle), *278*
Untitled, March 9, 1984 (Frankenthaler), *267*

Vallée, Jean François de, 33; works of, *33*
Vampirella I—East 2nd Street (Weber), *294*
Vanderlyn, John, 34; works of, *35*
Varèse, Edgard, 204
Velázquez, Diego Rodriguez de Silva, 105, 158, 159
Velde, William van de, the Younger, 81
Venetian Doorway (Sargent), *163, 164*
Venice: The Grand Canal with the Salute (Turner), *19*
Venice Harbor (Whistler), *137, 138*
View of Broad Street, Wall Street, and the City Hall, A (Holland), *44*

View of Diest from the Camp at Meldart, A (T. Sandby), *16*

View of New Amsterdam (unknown artist), *30*

View of Palermo (G. L. Brown), *87*

View of Santa Maria Novella (Newman), *93*

View of the Camp of Mr. Law's Concession at New Biloxi, Coast of Louisiana (Le Bouteux), *30*

View of the Narrows between Long Island and Staten Island (Capt. A. Robertson), *37*

View of the North River Looking towards Fort Washington (Capt. A. Robertson), *37, 38*

View of West Point from the Side of the Mountain (C. W. Peale), *36*

View of Windsor Forest, A (P. Sandby), *16*

View on the Potomac, Looking towards Harper's Ferry (Bennett), *73*

View on the Seneca River (Dunlap), 41, *43*

Virgin No. 2 (Duchamp), 193

Viviparous Quadrupeds of North America, The (Audubon), 62, 64

Vuillard, Edouard, 146, 285

Walkowitz, Abraham, 203–4; works of, *204*

Wall, Nassau, A (Homer), *171*

Wall, William Guy, 40–41, 72, 90; works of, *40*

Wallpaper Design No. 1 (Burchfield), *224*

Warhol, Andy, 269, 279, 289

Washington Allston (Malbone), *33*

watercolor, brief history of, 9–25

Watercolor Class, The (anonymous), *24*

Watson, John, 30

Weber, Idelle, 291, 293, 295; works of, *294*

Weber, Max, 175

Wehlsch Pirg—Landscape (Dürer), *14*

Weir, J. Alden, 143

Welliver, Neil, 299; works of, *298*

Wesselmann, Tom, 273; works of, *273*

West, Benjamin, 31, 32, 33, 34, 86; works of, *31, 34*

Westermann, H. C., 276, 277; works of, *276*

Western Tourist Camp (Benton), 244, *245*

West Indies Market (Hart), *246*

Whatman, James, 23, 25

Whistler, James Abbott McNeill, 10, 24, 25, 83, 100, 136, 137–43, 145, 151, 152, 153, 157, 158, 159, 176, 183, 186, 251; works of, *137–43*

Whistling for Plover (Eakins), *106, 107,* 109

White, John, 28–30, 71; works of, *29*

White, Stanford, 100

White Ships (Sargent), *165*; detail of, *back cover*

Whittredge, Worthington, 83; works of, *82*

Wild Flower Study (Burchfield), *217, 218*

Wild Roses and Water Lily (La Farge), *103*

Wiley, William T., 276, 277; works of, *277*

William Cullen Bryant (Inman), *33*

Williams, William Carlos, 198, 204

Willis, Luster, 59; works of, *59*

Willson, Mary Ann, 54; works of, *55*

Wilson, Alexander, 61; works of, *61*

Windshield Mirror (Davis), *211*

Winsor and Newton watercolors, 23, 25

Winter Moonlight (Burchfield), *232, 233*

Woman and Turkey (Luks), 238, *239*

Wood, Grant, 244

Wyeth, Andrew, 281; works of, *282, 283, 284*

Wyeth, N. C., 281

Yawl Riding a Swell (Hopper), *258*; detail of, *236*

Yellow, Violet and White Forms (Francis), *265*

Yoakum, Joseph, 57, 59; works of, *57*

Young Bull (Wyeth), *284*

Young Girl Meditating (Eakins), *108*

Zuccarelli, Francesco, 72

PHOTOGRAPHY CREDITS

The photographers and the sources of photographic material other than those indicated in the captions are as follows: Art Resource, New York: plate 4; John Baeder: plate 379; Geoffrey Clements, New York: plates 290, 301, 309, 320, 348; Corcoran Art Gallery, Washington, D.C.: plates 74–76; Forum Gallery, New York: plate 370; Xavier Fourcade, New York: plate 362; Allan Frumkin Gallery, New York: plates 373, 374; Hirschl and Adler Modern, New York: plate 72; Hirshhorn Museum and Sculpture Garden, Smithsonian Institution: plate 260; Nancy Hoffman Gallery, New York: plates 382, 387, 388, 396, 397; Kennedy Galleries, New York: plates 239, 279, 280, 286, 293; Los Angeles County Museum of Art: plate 346; Marlborough Gallery, New York: plates 394, 395; Robert E. Mates: plate 251; Louis K. Meisel Gallery, New York: plates 337, 378, 383; Pace Gallery, New York: plate 357; Eric Pollitzer, New York: plate 393; George Roos, New York: plates 337, 351, 375; Sandak, Inc.: plate 319; Robert Schoelkopf Gallery, New York: plate 392; Mark Sexton: plate 99; Watson-Guptill Publications, New York: plate 141.